REMEMBER THE HAND

FORDHAM SERIES IN MEDIEVAL STUDIES

Mary C. Erler and Franklin T. Harkins, series editors

CRITVM MAGNVM QVIDĒ DONVMS VSISTIABBĒ IOTMDE

AGVSTIOR PROMICANS MENĒ IEILANI ABBAIVE

VTILRTER LIBRVM DE AVRAIVM CONSPICE FINCTV:

ME SCRIPTORI INMENTE ARETE QVI HOC PATIPRO VSONNE

ILLe ABBA

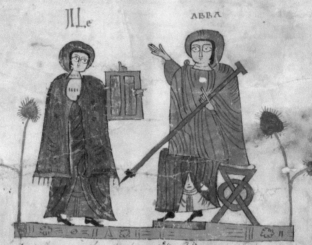

REMEMBER THE HAND

Manuscription in Early Medieval Iberia

CATHERINE BROWN

FORDHAM UNIVERSITY PRESS

New York 2023

Frontispiece: Here's the book you asked for.
León, AC, MS 8, f. 1v. By permission of the Archivo
Catedralicio de León.

Fordham University Press has no responsibility for
the persistence or accuracy of URLs for external
or third-party Internet websites referred to in this
publication and does not guarantee that any content
on such websites is, or will remain, accurate or
appropriate.

Fordham University Press also publishes its books in
a variety of electronic formats. Some content that
appears in print may not be available in electronic
books.

Visit us online at www.fordhampress.com.

Library of Congress Cataloging-in-Publication Data
available online at https://catalog.loc.gov.

Printed in the United States of America

25 24 23 5 4 3 2 1

First edition

CONTENTS

ABBREVIATIONS

AC	Archivo Catedralicio
AHN	Archivo Histórico Nacional
BL	British Library
BNE	Biblioteca Nacional de España
BnF	Bibliothèque nationale de France
RAH	Real Academia de la Historia
AEHTAM	*Archivo Epigráfico de Hispania tardoantigua y medieval.* Edited by David Sevillano, Rocío Gutiérrez, and Eduardo Orduña. http://hesperia.ucm.es/consulta_aehtam/web_aehtam/.
CCCM	*Corpus Christianorum Continuatio Mediaevalis.* Turnhout: Brepols, 1971–.
CCSL	*Corpus Christianorum Series Latina.* Turnhout: Brepols, 1953–.
CCV	Millares Carlo, Agustín. *Corpus de códices visigóticos.* 2 vols. Las Palmas: Universidad de Educación a Distancia, 1999.
CLE	*Carmina Latina Epigraphica.* Anthologia latina sive Poesis latinae svpplementvm pars II. Ed. Franz Buecheler. Leipzig: Teubner, 1895–97.
CLEH	*Carmina Latina Epigraphica Hispaniae.* Ed. C. Fernández Martínez, J. Gómez Pallarès, and J. del Hoyo Calleja. http://cle.us.es/clehispaniae/index.jsf.
CSEL	*Corpus Scriptorum Ecclesiasticorum Latinorum.* Vienna, 1866–.
ICERV	José Vives. *Inscripciones cristianas de la España romana y visigoda.* Barcelona: Balmes, 1941.
ILCV	*Inscriptiones Latinae Christianae Veteres.* Ed. Ernst Diehl. 4 vols. Berlin: Weidmann, 1961–67.
OED	*Oxford English Dictionary.* Ed. J. A. Simpson and E. S. C. Weiner, 2nd ed. 20 vols. Oxford: Clarendon, 1989–.
PL	Jean Paul Migne. *Patrologiae Cursus Completus. Series Latina.* 1841–55.

FIGURES

PLATES

PREFACE

The book is finished. It is not yet in a reader's hands, but the person making it imagines the scene, and then, on the back side of what will be the codex's first page, paints a picture of it (Frontispiece).

On the right, seated on a stool with his feet raised off the ground by a footrest, is a chunky figure robed in two shades of blue, labeled helpfully over his head with the word "ABBA": this is the abbot, the monastic man in charge. The strong diagonals of his upraised right hand and the staff he holds in his left draw our attention to the center of the composition: the thing proffered by the slender figure on the left. The offering is a red-framed rectangle bisected vertically into two golden panels.

It is a codex. Like all good icons, this one condenses its referent down to its essence—which, for the person who painted this, is not the bound book, but a single page framed and ruled, with text boxes so precious that their content can only be gold. This is the scribe's-eye-view book, as the maker sees it every day on the worktable before the pages are bound into the codex.

The text above the image puts words in the mouth of that figure in alternating lines of red and blue capitals.

> O what a great merit, indeed what a gift you began, Abbot Totmundus.
> Here you live with all the good; may you in future rejoice with the angels.
> And you, more venerable Abbot Ikila, brilliant of mind:
> see now the book usefully completed, fulfilling your pledge;
> see it gilded and painted.
> Thus may I deserve to be supported by your prayers.
> Keep me in mind, the scribe who suffered this for your name.

[O MERITUM MAGNUM QUIDEM DONUM SUMSISTI, ABBATE TOTMUNDE
ET HIC HAUITAS CUM OMNIBUS BONIS ET IN FUTURO LETERIS CUM
ANGELIS
AGUSTIOR PROMICANS MENTE IKILANI ABBA TUE
IAM NUNC UOTUM UT CEPERAS TUUM CERNE PERFECTUM
UTILITER LIBRUM DEAURATUM CONSPICE PINCTUM
SIC MEREAR PRECIBUSUE TUIS ESSE SUFFULTUM.
ME SCRIPTORI IN MENTE ABETE QUI HOC PATI PRO UESTRO NOMINE][1]

The book here introduced to us is a tenth-century Antiphoner in the collection of the Cathedral of León (León, AC, MS 8). In these lines, the scribe speaks in the first person, talks about this book's growth from vow to votive, and anchors that process—and the resulting codex—in his own suffering body. The book was commissioned, the text says, by the abbots Totmundus and Ikila, who understood it as a gift; that gift figures in the words "pledge" [uotum] and "gift" [donum] even as the image we see below the text presents the giving visually. Text and image together present the Antiphoner both as artifact, "gilded and painted," and as event—the scribe's painful labor and its "useful" completion.

It is worth noting that, while the commissioners of the book are named, the laborer is not. In the image, he is indicated by the curious *titulus* over the left-hand figure's head: ILLE, literally HE who made it. His name might not matter, but his activity does: this is the one "who suffered this for your name." He is identified not by a name but by the pointed finger of a pronoun and the noun *scriptor*. The associated verb is *patior*, to suffer. It was not easy to make a book.

"Ille" is only a pronoun and an occupation. His brothers and sisters studied in this book are freer with their names. They are the monastic bookmakers of tenth-century northern Iberia, and they are generous with information. They tell us where they worked, for whom, and how they felt about it. They name themselves and date their activity. They know they will be read, too, and speak directly to those who will hold and use the books they made. They are insistent in their reminders that reading is not just an encounter with "text," nor even with a book, but also and essentially a relationship with the work of someone's hands. This is for you, they say; keep me and my labor in mind.

This book wants to remember the labor of "Ille" and of many other book-workers like him. It began in response to an invitation extended from a monastery in what is now north-central Spain. At 6 A.M. on Friday, April 11 of the year 945 CE a monastic named Florentius wrote a colophon into what would be the last gathering of the book he was finishing. "If you want to know," he wrote, "I will explain to you in detail how heavy is the burden of writing" [si uelis scire singulatim nuntio tibi quam grabe est scribturae pondus].[2]

Without waiting for an answer, Florentius laid it out: writing "mists the eyes. It twists the back. It breaks the ribs and belly. It makes the kidneys ache and fills the whole body with every kind of annoyance" [oculis caliginem

facit. dorsum incurbat. Costas et uentrem frangit. Renibus dolorem inmittit et omne corpus fastidium nutrit].[3] Invitation: come feel what it's like to make a book by hand.

On first encountering this colophon, I was taken aback at being addressed so directly. The writer was looking right at me, it seemed: "You, Reader: Turn the pages slowly," he said, "and keep your fingers far away from the letters" [Tu lector lente folias uersa. Longe a litteris digitos tene].[4] This long-dead scribe was telling me about his work in particular and precise detail, and what mattered to him was the book and the body—his and mine.

Delighted by Florentius's blunt directness, I did my best to follow his instructions. I went to the library that now houses the book he made and looked carefully at it. I turned the pages slowly. I looked at the pictures. I studied the hand he wrote in, and haltingly read the words he wrote. What I found surprised me: Florentius's colophon was no afterthought appended to the book, but rather an integral part of its activity.

The more I read and looked at other books made in Florentius's textual community, the more scribes I saw explicitly writing their own labor into the books that they made. Their first-person interventions were integral to the activity of the books themselves, inextricably and explicitly connecting whatever meanings can be made from the work copied to the work required to make the copy. Not to make a name for themselves, but because, for them, making was inextricable from meaning.[5]

This book in your hands (or on your screen) is the result of many years spent in the company of these ardent makers of books. As I learned about this scribal culture, I found that I was also learning with and from it, for these scribes spoke to an unease I had long felt about my work as a scholar and writer. The academic textual community in which I work often seems to understand intellectual work and manual labor as fundamentally different—even opposed—occupations. These scribes do not. Rather, manual and mind-work are for them two hands whose fingers interlace. Attentive to materiality and to labor, their understanding of intellectual work is affective, embodied, and—above all—lively.

What is the agency of the body in intellectual work? The scribes you will come to know here raise their hands to this question. Call on them, and they say, three fingers write, the whole body labors.[6] Better yet, let them call on you. And if you are not used to thinking as a form of manual labor, the resulting conversation could be revelatory. It certainly has been for me.

This book is built around the work of three great monastic book artists of tenth-century Iberia, supported by conversations with their bookish brothers and sisters and by excursions into the inscribed environment in which they lived and worked. Accomplished scribes and painters, the three protagonists of this book present themselves as protagonists in the codices they made. They ask that we remember their names: Florentius, Maius, and Vigila. We will meet their students and associates Sanctius, Emeterius, Sarracinus, and Garsea; we'll meet bookmakers from other north Iberian monasteries whose names and work are also worth remembering: Aeximino, Endura, Leodegundia.

We begin, in Chapter 1, "Florentius's Body," where this book itself began: with the great colophon that Florentius composed for the copy of Gregory the Great's *Moralia* that he completed at 6 A.M. on Friday, April 11, 945. Studying the colophon as an active participant in the codex, we shall see that it is the result of a careful reading of Gregory. We'll watch Florentius articulate his work on this codex with the work of the author in its past and the labor of the reader in its future.

After Chapter 1 puts the great colophon that started this book back into its manuscript context, Chapter 2, "Monks at Work: *Grammatica* and Contemplative Manuscription," places the work of making books in the larger sphere of lettered labor in Iberian monasticism. It is an intimate review of the elements of monastic life that most actively shaped the lettered habitus of these book artists: labor, grammar, and meditation.

Chapter 3, "The Garden of Colophons," returns to Florentius to study the colophons of other codices from his hand in dialogue with the equally prolix work of his neighbor and contemporary Endura. We shall see that, if monastic writing is metaphorically a form of agricultural labor, then the best scribes in Castile's monasteries understood their work as a common garden and used one another's words to think and write about their shared vocation of plowing parchment with a pen.

Chapters 4 and 5 temporarily set the codex aside to consider how other texts these scribes made and the lettered spaces in which they made them shaped their understanding of relations between writing, making, and the world. Our scribes copied legal documents as well as books. Chapter 4, "*Manu mea*: Charters, Presence, and the Authority of Inscription," examines how notarial practice might have shaped the way they thought about what writing does and why scribal activity matters enough to be documented for

posterity. Chapter 5, "Makers and the Inscribed Environment," visits in imagination the monasteries in which monastics lived and worked and finds their walls as rich with inscribed names of makers, dates of making, and calls to readerly attention as the codices we've been reading. There is an authority to making, those walls say, and the scribes listened and understood.

Because our scribes are so concerned with marking the place of their work in time, Chapters 6 and 7 turn to the temporalities of manuscript writing and reading. Chapter 6, "Remember Maius: The Library and the Tomb," introduces our second scribal protagonist, Florentius's Leonese contemporary Maius, who designs, writes, and illuminates a commentary on the end of time (New York, Morgan Library, MS M644) explicitly for our future use. Reading the handwritten words Maius addressed to us, unimaginable centuries in his future, we are cast into a strange kind of time, for the moment of Maius's writing is both many hundreds of years distant and right here before our eyes. The uncanny temporality of the handwritten trace itself occupies Chapter 7. "The Strange Time of Handwriting" watches, among other things, a copy of Augustine's *City of God* grow under the hands of a talented team of writers at the Riojan monastery of San Millán de la Cogolla in the years 977–78.

Of all the books we study here, the legal pandect called the Codex Vigilanus, the subject of Chapter 8 ("The Weavers of Albelda"), is most insistent about foregrounding the craft of its manufacture and the agents responsible for it. In the poems and images that its makers composed, wrote, and painted, we will be led to understand our work as readers as an encounter with the writing process as well as the written product. Bookmaking is work both manual and intellectual, and these scribes have no doubts about its importance.

When they sat down to work, the writers studied in this book had to make decisions about how to present their text: what script to use and how to lay it out on the page in a way that respected both the authority of their source material and the expectations of their readers. I, too, have had to ask some of these questions about the best way to represent handwritten parchment on paper and screen.

Imagining you there with my finished book in front of you, I want you to be comfortable as you read. But I also want to help you enter as deeply as possible into the experience of reading these codices in their medieval

form. My citation practices thus aim to balance this desire for accessibility to a modern reader with respect for the particularity of the texts as the scribes wrote them.[7] Throughout, my goal has been to have these printed pages communicate crucial particularities of the manuscript without raising insurmountable barriers between modern readers and what the manuscripts are doing.

I will cite from published editions where possible and keep editorial markings to a minimum. Abbreviations will be silently resolved. When the scribes use majuscules, I will use majuscules in the Latin but, because reading printed text in all caps is difficult, not in the English translation. Bible quotations are drawn from the Vulgate unless otherwise noted, and corresponding translations from the Douay-Rheims version.

Translations will always accompany Latin quotations. This has proven to be no small matter, since the Latin in which these scribes composed is ambitious, ostentatious, creative, and occasionally incomprehensible. In some cases, I gratefully cite from published translations; elsewhere, I have done my best with the help of many friends and advisers. Uncredited translations are my own; others are duly acknowledged in the notes.

When I cite a work frequently in both an edition and a published translation, a note after the Latin at first appearance in the chapter will provide full bibliographic information for both sources. In future citations of that work, a note after the Latin will provide short-form citations by editor's or translator's last name, prefaced respectively by the abbreviation "ed." or "trans."

Since this book is about a very particular manuscript culture and the ways in which participants in that culture understood themselves and their work, it is important that the translations communicate the very terms through which these scribes expressed proper names and times. Thus, unless the text quoted refers to a place or person well-known by another name, I will leave names as the scribes knew and wrote them rather than translating them. Translations preserve the *era hispana* reckoning used in Iberian Christian communities up until the late Middle Ages;[8] they will also reflect the exact way the scribe chose to write the number, whether by spelling it out or by using Roman numerals. When a scribe figures the day of the month by the Roman calendar or names the day of the week by numbered *feria*, so will I. These literally translated dates will always be followed by their modern equivalents.

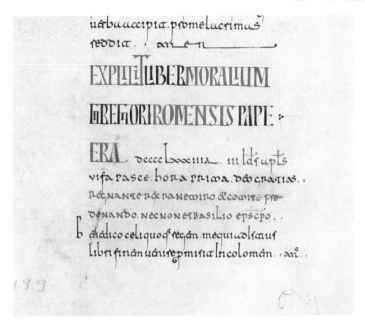

Figure 1. Florentius' *Moralia*, First colophon. Madrid, BNE, MS 80, f. 499r detail.
By permission: Biblioteca Nacional de España.

Take, for example, the scribe whose long and very embodied colophon
was the starting place for this book. He locates his work in time and con-
nects it to very precisely identified human beings. But he does this in a way
that is worth our attention if we want to see his book as he might have seen
it. If you had a copy of his book in front of you (it's manuscript 80 in the
collection of the Biblioteca Nacional de España in Madrid), I would ask you
to turn to f. 499r (Figure 1).

The page has been planned so that the work being copied ends twelve
lines from the bottom of the right-hand column. The scribe then writes:

> The Book of Morals of Pope Gregory the Roman ends, era DCCCCLXXXIII,
> VI feria, III of the Ides of April in the Easter season, at prime. Thanks be
> to God. In the reigns of King Ranemirus and count Fredenandus and
> bishop Basilius.
>
> [EXPLICIT LIBER MORALIUM GREGORII ROMENSIS PAPE ERA DCCCCLXXXIIIa
> III idus aprilis VI feria pasce hora prima. deo gratias. regnante rex Ranemiro
> et comite Fredenando necnon et Basilio episcopo.][9]

What would be lost if I told you simply that the book was finished around 6 A.M. on Friday, April 11, 945 CE? It is certainly much faster and easier to fix the date this way, using twenty-three characters instead of the scribe's sixty. But on the verso of the next leaf, the scribe will choose to record the date using even more penstrokes: *perfectum est hoc opus III idus aprilis,* he will write, *currente era centena nobies bis dena et quater decies terna* [this work is completed on the III of the Ides of April during the era nine times one hundred, twice ten, and four tens plus three]. Here Florentius chooses to write the year with thirty-nine characters instead of the twelve he used for DCCCCLXXXIII on f. 499r, and the three that we now use to designate the year 945.

You will also note that, in the way we reckon time, the elements composing the date are discrete, their signification self-contained: Thursday and Friday are separate points like keys on a piano. In contrast, the early medieval way of expressing the date is complexly analogue, each element being understood as a mark on a scale figured in relation to a reference point—not Friday, but the sixth day, not April 11, but three days before the Ides of April. Expressed as a sum, even the year must be figured. You don't just read the time; you have to calculate it.

Doing all this work to place yourself in time is a very different experience from simply looking at a wall calendar or an app on your phone. It is a complex labor of articulation of one element in relation with another—of today in relation to the Ides, of dawn in relation to a communal religious service. The codices in which these dates appear make similar demands upon their users. They will be talking to you all the time, at times quite explicitly, articulating your body with the book and the body that made the book, your work of reading with the work of manuscript. This book aims to introduce you into that conversation.

When I was training to be an archivist, my mentor told me, "A thing is just a slow event."

<div align="right">—Isaac Fellman, Dead Collections</div>

Monastic Scriptoria in Castile-León, c. 1000 CE

Atlantic Ocean

Bay of Biscay

FRANCE

Oviedo•

Santiago
de Compostela•

León•

KINGDOM OF
PAMPLONA

Burgos

②

④ Pamplona

KINGDOM
OF LEÓN

⑦

⑤ ③ ①

COUNTY OF
RIBAGORÇA

COUNTY OF
BARCELONA

•Girona

⑥

Duero

COUNTY OF
CASTILE

•Zaragoza

Duero

Zamora

Ebro

•Barcelona

Balearic
Sea

Tagus

•Toledo

CALIPHATE
OF CÓRDOBA

Guadiana

Guadalquivir

Córdoba

Mediterranean Sea

Atlantic Ocean

© 2021 Jeffrey L. Ward

0 Miles 100 200

0 Kilometers 200

• Major cities

✎ Principal scriptoria

① San Martín de Albelda

② San Miguel de Escalada

③ Santo Domingo de Silos

④ San Millán de la Cogolla

⑤ San Pedro de Cardeña

⑥ San Salvador de Tábara

⑦ San Pedro de Valeránica

Map. Monastic Scriptoria in Castille-León, c. 1000 CE. Map by Jeffrey L. Ward.

INTRODUCTION: THE ARTICULATE CODEX, MANUSCRIPTION, AND EMPATHIC CODICOLOGY

I n the decades around the turn of the first millennium, north Iberian monasteries produced spectacular codices remarkable not only for their beauty, but also for an explicit concern with their activity as books and the process of their making. Yet outside of a few spectacular examples (most of them illuminated Apocalypse commentaries), they are not generally known among the wider scholarly community. The field of early Iberian manuscript studies is still the province of prodigiously learned specialists, its riches hidden from outsiders by longstanding (and sometimes jealously guarded) disciplinary traditions. This book seeks to introduce a wider audience to this rich and unfamiliar culture. Methodologically, it aims to model a way of sympathetically inhabiting books from the distant past—a practice that both respects their difference from what is familiar to us and emphasizes what we can learn from that difference.

The literate culture of early medieval Iberia is religiously, politically, linguistically, and paleographically complex. During the period covered in this study (roughly 925–1080 CE), the Emirate and later Caliphate of Córdoba controlled the southern two-thirds of the peninsula, while the northern portion was divided among various Christian powers—the main ones being, from west to east, the kingdom of León, the county of Castile, the kingdom of Pamplona, and Catalonia (the counties of Barcelona and Ribagorça). Book cultures were shaped by language, script, and religious practice— and often by their intersections. Arabic, Hebrew, Latin, and what we'd now call Romance were all in use. Generally speaking, we can start by thinking of five textual communities in tenth- and eleventh-century Iberia: Arabic al-Andalus, Latin al-Andalus, Latin Catalonia, the rest of the Latin north, and Hebrew-using communities of Jews that, scattered throughout the peninsula, adopted also the spoken language of their particular region.

The imaginative world of north Iberian monastics was probably not limited to Latin Christianity. Many of the monasteries where these books were made were close to the fluid border with al-Andalus, and some of their inhabitants were undoubtedly emigrants perhaps more fluent in Arabic

than Latin.[1] The most bookish among those emigrants might have had some familiarity with the rich Arabic colophon tradition.[2]

"During the tenth century," Otto Werckmeister observed, "monastic artists to the north of the frontier were able at times to adapt Islamic motifs in a context of both rivalry and confrontation."[3] This book's focus upon the Latin and Christian traditions is shaped by its author's training in the Romance languages. It is not and should not be the only approach to this glorious scribal culture. I look forward to seeing what scholars versed in the other linguistic and cultural traditions of the peninsula make of the imaginative world of these very self-conscious book artists.

When Florentius set pen to parchment in April of 945 to tell readers how hard it was to make a book, he wrote in an ornate and confident Latin.[4] Like other writers of Latin outside Catalonia,[5] he formed his letters in the family of scripts now known, somewhat anachronistically, as "Visigothic."[6] The *Corpus de códices visigóticos* compiled by Agustín Millares Carlo catalogs and describes some 350 books in this hand,[7] of which some eighty-three by my unscientific count contain interventions by named scribes. A reasonable chronological limit for the investigation was provided by the turn of the twelfth century, for in the year 1090 the Council of León replaced the Visigothic with the Caroline hand by fiat.[8]

THE ARTICULATE CODEX

The codices studied here were clearly major book projects. Copies of authoritative works, they were assigned to the most skilled workers available. Once finished and bound, they would certainly be the jewels of any monastic library. They are also clearly conceived *as codices*—that is, as coherent compositions from first folio to last. As art historian Mireille Mentré observed, these books "present themselves from the outset as both constructed and structured."[9] And, I might add, they emphatically identify the persons responsible for that construction. Scribal interventions, colophons, and even portraits are not addenda to, but rather integral parts of, their composition. These programmatically bookish codices foreground their artifactuality, thematize their operations as books, document the process of their manufacture in all its contingent particularities, and represent the use to which their makers expect them to be put in the future.

The scribes who made these books worked from a thoroughly material and embodied understanding of the written artifact and its uses; their work

articulates reading and writing together as analogous forms of intellectual and corporeal labor. These early medieval Iberian codices offer spectacular examples of how, in John Dagenais's words, "the medieval page often dramatizes its own production, keeps us mindful of the processes which brought the written word to the page."[10] The result is an understanding of inscription that is not confined to the page, but extends into the corporeal, imaginative, intellectual, and spiritual lives of scribes and readers alike. These are books that quite literally reach out toward their readers. To draw attention to their graspy activity, I will call these medially self-aware books "articulate codices."

"Articulation" appears in Roget's *Thesaurus* under the category of "Words Expressing Abstract Relations," the abstract relation in question being *junction*.[11] What is especially handy about this term is that it allows us to think about the "abstract relations" of hermeneutics in concrete bodily terms, for "articulation" comes from the Latin noun *artus*, or joint. A tenth-century monastic reader would know this well from the definition in the encyclopedic *Etymologies* of Isidore of Seville:

> The joints are so called because being bound to each other by the tendons, they are drawn together, that is, they are bound tight. The diminutive form of *artus* is *articulus*; we use the word . . . *articulus* in reference to minor limbs like the fingers.

> [Artus dicti, quod conligati invicem nervis artentur, id est stringantur; quorum diminutiva sunt articuli. Nam artus dicimus membra maiora, ut brachia; articulos minora membra, ut digiti.][12]

Joints are bound together (*conligati*). Thus articulated, they can do things in the world. Similarly, the articulate codex is a book whose multiple parts are carefully sequenced and joined to work as a whole. Unlike the elaborately programmed Carolingian codex with which it could be beneficially compared, the Iberian articulate codex is not self-enclosed:[13] its explicit verbal and visual representations of scribal labor articulate the codex with the world of bodies and minds outside its pages.

MANUSCRIPTION

Although this inquiry is historical, these scribes have taught me to consider their work as something *present*, an activity still in a sense underway.

Although the word writing is both substantive and verbal, it is easy to forget this in print, which encourages us to consider it primarily as a noun—something written, with an emphasis on the something rather than on the action that produced it. It is, however, hard to miss the sheer activity of the manuscript page. Letters may not march from left to right in perfectly ruled and justified lines. They may be irregular in form, testifying mutely to variable inkloads in the pen or differing angles of the hand that made them. A page of a printed book is text; manuscript is quite visibly textile, the weaving no dead metaphor but plain in the movement of a very particular hand across the very particular texture of a very particular page.

The scribes studied here go out of their way to make sure that readers regard the books before them not only as works of literature, law, or theology, but also as the products of very particular human hands. The print-era noun manuscript, however, effaces the movement of those hands.[14] To evoke the pre-print sense of manuscript as simultaneously artifact and event, I propose the coinage manuscription. As completion is a noun made upon the verb to complete, so manuscription turns the lively verb to manu-script into "a noun of action."[15] When we engage with these books in the ways their makers anticipated, we're not just reading manuscript, we're reading manuscription, an ongoing event that calls repeatedly for our participation.[16]

EMPATHIC CODICOLOGY

This book seeks to do something that has not yet been done: it aims to read these articulate codices primarily as the work of the scribes that made them.[17] Let me explain: I noted in the preface that Remember the Hand was inspired by the colophon of a manuscript of Gregory the Great's Moralia (Madrid, BNE, MS 80). This is true but limiting. If the idea that BNE MS 80 is primarily a copy sets the terms of my encounter with the manuscript, then I will be measuring Florentius's work against a print version of the text and an idea of the Moralia as an abstract Work, a type of which BNE MS 80 is but a token.[18] There are things I will be able to see when I approach the manuscript this way, but those things may not really be about BNE MS 80 itself. As John Dagenais has pointed out, I'll be looking with hindsight through a printed page that has little relation to the handwritten parchment in front of me.[19] To read a manuscript primarily as the work of the scribe that made it enriches such print-era hindsight with a scribe's-eye view.

Unlike print culture, manuscript culture produces readers who engage with books not as instantiations of an abstract Work, but rather as single and particular artifacts that, through manuscription, make *present* both author and writer.[20] The best analogy for the manuscript book's relation to its contents would not be the Platonic Form and its shadows, but rather the Christian understanding of body and spirit. Eighth-century Iberian theologian Beatus of Liébana (whose works our scribes knew well) writes:

> The person who reads Scripture frequently [knows that] the letter is the body. But there is a spirit in the letter. This letter has a spirit, that is, a meaning. But no one can understand this meaning without the letter, that is, without the body.

> [Qui Scripturam frequentat legere, ipsa littera corpus est, sed spiritus in littera est. Habet ista littera spiritum, id est intellectum. Sed tamen ipsum intellectum sine littera, quae corpus est, nemo intelligere potest.][21]

Reading a book like *City of God* in the early Middle Ages, you would understand yourself to be engaging with both the spirit of Augustine's teaching and the particular body of the book available in your library. In manuscript culture, there is no access to *City of God* without the manuscript letter—"that is, without the body."

Thus, *Remember the Hand* looks at the early medieval book, as it were, from the inside out—through the lens of the things said about manuscripts by the very people who made them: medieval scribes. Modern scholars generally think of medieval manuscripts as finished objects to be studied, interpreted, admired. This study does all those things, but it also wants to engage with these handmade books as things-in-process. It will consider—live with, really—manuscript books not only as they are encountered in the archive or in virtual facsimile on our computer screens, but also as they were assembled for our use—bifolium by bifolium, gathering by gathering. This necessarily will involve some imagination, but mostly it involves a shift in our scholarly looking: what we look at, what we look for, what we judge to be worth our attention. *How* we look, in other words: our *theoria*.

The *theoria* known and practiced by these writers is contemplative, for that is what the word meant in the texts they studied.[22] Cassian, whose works were important in early Iberian monastic libraries, would have told them that "the good is in *theoria* alone, that is, in divine contemplation"

[bonum in theoria sola, id est in contemplatione diuina].[23] As we shall see in Chapter 2, when monastics read theoretically, they turned the gaze inward to contemplate the articulation of reader and read. Florentius, whose colophon about writing is so somatically precise, was thinking theoretically in this monastic way when he addressed himself to "you who, in the future, might read in this codex" [qui in hoc codice legeritis].[24] Not "you who might read this codex," but "you who read *in* this codex," as if the book were a space that enclosed us.

The English sentence "I read a book" is a simple subject-verb-object construction, with the book as passive recipient of the reader's action. In ancient and early medieval practice, however, the activity went both ways, like a conversation. Quintilian, for example, declares that

> We should read none save the best authors and such as are least likely to betray our trust in them, while our reading must be almost as thorough as if we were participating in the writing.
>
> [Ac diu non nisi optimus quisque et qui credentem sibi minime fallat legendus est, sed diligenter ac paene ad scribendi sollicitudinem.][25]

For Florentius and the other writers studied in this book, readers are in a sense inside the books they read, doing things with what they find there—and being done to. Reader, author, scribes, and materials are articulated by the handmade artifact that connects them all. "A coming together of materials in movement,"[26] the manuscript codex is, in the terms of thing theory, less an object than a *thing*.[27] "To witness a thing," writes anthropologist Tim Ingold, "is not to be locked out but to be invited in to the gathering."[28]

When Florentius imagines us reading *in this codex*, he understands the book as exactly this sort of gathering place. This is a place where reading is not an action performed upon a text, but rather an encounter in which both participants act upon each other and are changed as a result. The page might gain new marks upon its surface: pointing fingers, pen-trials, doodles, sweat. And what St. Paul calls "the fleshly tables of the heart" [tabulis cordis carnalibus] (2 Cor 3:3), inscribed by reading, become themselves living copies of the book.

The monastics who made these codices expect their audience to be, like them, seasoned practitioners of monastic reading, knowing in their own

flesh what it feels like "to be possessed by the word, not to manipulate it."[29] "The attentive reader," writes Isidore of Seville, "will be more concerned with putting what is read into practice than with acquiring knowledge" [lector strenuus potius ad implendum quae legit quam ad sciendum erit promptissimus].[30] For such a reader, "study" refers not to the operations that scholars perform with (and sometimes on) objects of study, but rather to a *studium*— that is, according to Lewis and Short, "assiduity, zeal, eagerness, fondness, inclination, desire, exertion, endeavor."[31]

Such a *studium* does not rely upon the subject/object distinction upon which scholarly endeavors like philology, codicology, and paleography are built.[32] A studious encounter in the Isidorean mode is driven mainly by fondness, inclination, desire, and exertion. Such exertion is certainly necessary here because the books studied in *Remember the Hand* are a thousand years old, written in difficult Latin and in a script that most medievalists are not taught in graduate school. A shared inclination toward bookishness encouraged me to take seriously the work of people with whom I had otherwise nothing at all in common. These writers and makers of books showed me a way of living intellectual labor as embodied and affective, engaging the body, the heart, and the imagination together with the mind.[33]

The more I felt myself instructed by these writers, the deeper my affection for them grew. They read carefully, worked hard, and paid scrupulous attention as books took shape page by page under their fingers. Though I am neither Christian nor monastic, I will not hide my identification with these solitary workers in dialogue with the dead, laboring for years to make something, and to make it for an audience they could only imagine. They wanted their names and labor to be remembered. When they address a future reader, as they often do, I know myself to be one of those addressees, and feel the responsibility of that interpellation.

I understand that responsibility to be historical and scholarly, of course, but it is also imaginative. The skills and knowledge of specialist experts are precious and necessary if we are to respond to the invitation extended by the articulate codex. This book has benefited immeasurably from the erudition of such scholars and would not be possible without their rigorous work. However, it will also suggest that, in addition to using these codices to answer our scholarly questions and fulfill the scholarly desire to share our knowledge, we allow these books to work on us as their makers designed them to do.

The people who made these books made them for a particular kind of contemplative use. If we want to understand how these manuscripts work, then it's a worthy undertaking to accept the invitation of these scribes and enter their books as participants,[34] willing to let the books work on us as much as we work on them. We thus learn *with* and *from* medieval manuscripts as well as *about* them.[35] I hope to demonstrate in the pages that follow that there is much to be learned from reading not only as a scholar but also, more modestly, as a student of practice—the practice of engaging attentively with a carefully crafted verbal and visual artifact. Not because savor is better than science,[36] but because both have much to teach us, if we are willing to answer their respective calls.

Writing about later north European devotional manuscripts, art historian Corine Schleif writes that "in order to be used or studied, the manuscript must become the object of prolonged and intense 'fascination.'"[37] The book artist who called himself only "Ille" tells the readers to whom he presents the León Antiphoner that he suffered to make the book he offers for our contemplation and use (Frontispiece).[38] Mindful of and, yes, fascinated by, the hard labor of "Ille" and his monastic brothers and sisters, the reading practice of *Remember the Hand* is slow, descriptive, and immersive.

You could call this a practice of "empathic codicology"—a feeling-into the study of the codex, *scientia* unashamed by the flushed cheeks of affect. Each chapter grows from attentive encounters with texts and artifacts studied in person or in digital facsimile. With codices, those encounters proceeded page by page: I read anything that offered itself to be read, looking at illuminations, initials, mise-en-page, signs of wear and use.[39] Our discussion will thus often dive into small details—the puddle of ink in the ascender of an S, for example, or the abstruse particularities of early medieval dating systems. This kind of absorbed engagement embraces the presence of the past in the present, a present understood in Augustinian fashion as attention: "The mind expects, and pays attention, and remembers. What it expects becomes what it remembers through what it pays attention to" [Nam et expectat et attendit et meminit, ut id quod expectat per id quod attendit transeat in id quod meminerit].[40]

For the scribes and readers studied here, reading, writing, and scholarship are all intimate encounters, mediated by the codex, between people understood as embodied, thinking, feeling individuals. The artisans who made these books anticipate and even script such close encounters with

manuscript, speaking from their embodied individuality to readers evoked in *their* embodied individuality. Because my scholarship has been so enriched by the intimately embodied intellectual practice of these scribes, I have emulated their directness of speech in my own prose. I hope that this book will help you imagine that you are sitting in front of the books and engaging with them yourself.[41] As if you too were reading *in* the codex, enclosed in its painted and lettered space; as if you too were, as the scribes expect, holding the codex in your hands. I hope that you will come away from this book feeling as if you knew this handmade world intimately—both as you would know a fact and as you would know a friend.

Again and again, the articulate codices of these Iberian scribes will remind us that we are not just reading a handwritten book, but reading with hands, writing. The activity of the books they made is inseparable from their manu-scriptedness. That is why the scribes want us to remember the hand.

CHAPTER 1

FLORENTIUS'S BODY

> Of making many books there is no end: and much study is an affliction
> of the flesh.
>
> <div align="right">—Eccles. 12:12</div>

T his book began when I encountered a piece of writing by a tenth-century Iberian monastic scribe. Like the "Ille" who helped introduce the book you have in your hands, this person imagined me reading what he wrote, as he wrote it. He addressed me directly, and, like "Ille," he wanted to be sure that I knew how hard it is to write a book. Not how hard it is to *compose* a book—though I could tell you a great deal about that, if you want to know—but how hard it is to *write* it: to hold the pen day after day and bend over parchment in the gathering dark.

It was a colophon—the scribe's last word about a finished book. I can't remember now where I first came across it. Parts of it were occasionally cited, without attribution and always untranslated, as a sort of codicological local color. It took some doing to trace it to a copy of Gregory the Great's *Moralia in Job* now held in Madrid at the Biblioteca Nacional de España as manuscript 80.

When this precious volume was delivered to my table at the Biblioteca Nacional, I turned to f. 500v (Plate 1) and was surprised to see that the colophon was much longer and more elaborate—both visually and linguistically—than the citations I'd seen led me to expect. The maker of the book had a great deal to say about its making. He told me that his name was Florentius and that he was in his early twenties. He said that he worked in the monastery of Sts. Peter and Paul at Valeránica. He placed himself in time even more precisely than he placed himself in space: six A.M., Friday April 11, in the year 945 CE. And he located the act of writing firmly in his own body: it twists my back, he said, makes my eyes blurry and my kidneys ache.

This direct address from Valeránica to Madrid, from 945 to 2008, from Florentius to Catherine, unsettled me. It felt like a message in a bottle from one writer to another. It felt, as North American undergraduates would say,

personal. I wondered: what did it mean for a monastic to identify the self by name as a maker of books? Why tie that act of naming to a precise date? And above all, why did this scribe—trained in the monastic culture of humility as he surely was—feel that his individual bodily experience was important enough to be written into a copy of what was surely going to be one of the most important books in his monastery's library?

With these questions in mind, I opened manuscript 80 again and worked my way through it from the beginning. I was surprised to find that there was little tension between the colophon and Gregory's great exegesis of Job. Visually, the colophon was as much a part of the volume's design as the luminous incipits for each of the *Moralia*'s thirty-five books; textually, it was in deep dialogue with *Moralia* themselves.

This chapter retraces that journey, paging through BNE MS 80 from beginning to end to see how Florentius structured this codex and how he seamlessly articulated into it the laboring body—not only of the bookmaker but also of the reader—that is, you; that is, me. We'll see that BNE 80 is a codex that programmatically thematizes its bookish operations, foregrounds its artifactuality, and represents the use to which its maker expects it will be put in the future. The result is a book in which making is inextricable from meaning.[1]

"'WHO WROTE THE BOOK OF JOB?'"

> Who will grant me that my words may be written? Who will grant me that they may be marked down in a book?
>
> Job 19:23–25

Gregory the Great begins the *Moralia* with a very bookish question: "It is often asked, 'Who was the writer of the book of Job?'" [Inter multos saepe quaeritur, quis libri beati Iob scriptor habeatur?].[2] For a paragraph and a half he entertains various attributions of the biblical book, but then dismisses them as insignificant: "It would be foolish indeed to inquire who might have written the book," he says, "when one faithfully believes that the Holy Spirit is the author" [Sed quis haec scripserit, ualde superuacue quaeritur, cum tamen auctor libri spiritus sanctus fideliter credatur].[3]

The author is the one that matters, Gregory says, not the writer. But this hierarchy is hard to maintain, given the fact that, by using the noun *scriptor* to refer to the agent responsible for the book of Job, Gregory has left the door open for other interpretations. The verb "to write," in Latin as well as

English, can refer not only to the intellectual work of composition but also the manual labor of inscription.

In the ensuing discussion, Gregory backpedals strenuously to rescue writing for immaterial authority.

> Therefore, the writer is the one who dictated things to be written. The writer is the one who inspired the work, and transmitted to us through the voice of the scribe the deeds we are to imitate. If, having received a letter from some great man, we read the words but inquired after the pen they were written with, what a ridiculous thing it would be—to know the author of the letter and to understand its meaning, but instead to direct our research into what kind of a pen those words were written with.

> [Ipse igitur haec scripsit, qui scribenda dictaûit. Ipse scripsit, qui et in illius opere inspirator exstitit, et per scribentis ûocem imitanda ad nos ejus facta transmisit. Si magni cujusdam ûiri susceptis epistolis legeremus ûerba, sed quo calamo fuissent scripta, quaeremus; ridiculum profecto esset, epistolarum auctorem scire sensumque cognoscere, sed quali calamo earum ûerba impressa fuerint, indagare.][4]

Gregory expects that his readers are well-trained enough by this point not to wonder what kind of pen the *Moralia* were written with or to spend much time thinking about whether they were dictated or written with his own hand. They would be less likely still to wonder about who pushed the pen in the book of Job, for, as Gregory concludes triumphantly, "Since we understand the meaning, and hold the Holy Spirit to be the author of that meaning, when we seek after the writer, what are we doing but reading the letters and asking about the pen? [Cum ergo rem cognoscimus, eius que rei spiritum sanctum auctorem tenemus, quia scriptorem quaerimus, quid aliud agimus, nisi legentes litteras, de calamo percontamur?]."[5] With writing, it would seem, the more thought and the less body, the better. "For what is the purpose of the body except to be an instrument for the heart?" [Quid namque est officium corporis nisi organum cordis?], Gregory asks in a letter to Leander of Seville usually included among the prefaces to the *Moralia*.[6] Gregory's epigrammatic confidence would seem to close the discussion. If the body is but the instrument of the mind, the book too must be a vehicle whose sacred cargo far transcends the grubby menial labor required to make it.

But *scribo* still means both "I inscribe" as well as "I compose," and there is much more to be said about the agency of the pen and, by extension, the agency of the body in book production and use in the early Middle Ages. Florentius will have a lot to say about it. So, perhaps surprisingly, will the *Moralia*. For when Gregory the Great speaks about the book and the body, he's not the only one talking: in manuscript culture, of course, there is no access to *auctor* except through the hand. What Gregory calls the "voice of the scribe" [vox scribentis] is never just a channel for the author's words; sometimes it has some things of its own to say.

FLORENTIUS WROTE IT

For when we write, we attribute the agency of writing not to the pen by which the letters are traced, but to the hand of the writer.

[Nam et nos, cum scribimus, scripturam ipsam non calamo, quo litterae caraxantur, sed scriptoris manui deputamus.][7]

Attributed to Rabanus Maurus

The principal voice heard in this chapter belongs to the person who made the copy of the *Moralia* shelved as BNE MS 80 and made it, in spite of Gregory's assertions, be in part about its own making. His name was Florentius, and we know nothing about him beyond what he tells us himself and what can be surmised from his surviving work.[8] We can follow his activity over a period of nearly forty years (from 937 to 978 CE) in twelve surviving texts—seven charters (studied in Chapter 4) and five codices (the remainder to be studied in Chapter 3) (see Table).

Though Florentius makes himself very present in the codices that survive from his hand, where he came from was not one of the things he thought important enough to mention. Spoken Latin was most likely his native tongue. His written Latin, though ornate and challenging for a reader trained in Classical or later medieval versions of the language, is confident and clearly the product of much reading.

Little remains today of the place where Florentius spent his working life, the monastery of Saints Peter and Paul at Valeránica.[9] It was located near the modern town of Tordómar, about forty kilometers as the crow flies from the city of Burgos. In Florentius's day it lay within the zone between the

TABLE. FLORENTIUS OF VALERÁNICA: WORKS

	Author, title		Archive & shelf number	Date
Codices	Bible	fragments	Silos, Archivo del Monasterio, frag. 19 (1 folio)	943 June 10
			Rome, Hermandad de Sacerdotes Operarios Diocesanos, no shelf number (11 ff.)	
	Gregory the Great, *Moralia*		Madrid, BNE, MS 80	945 April 11
	Smaragdus et al., *Homilies*		Córdoba, Archivo Catedralicio, MS 1	[945–949]
	Cassiodorus, *In Psalmos*	lost	(León, San Isidoro)	953 July 9
	Bible	copied with Sanctius	León, San Isidoro, MS 2	960 July 20
Charters	Charter 1		London, British Library, Add. Ch. 71356	937 March 1
	Charter 2	original lost	transcribed in the (now lost) Becerro de Arlanza	937 March 1
	Charter 3	original lost		942 March 15
	Charter 4		Burgos, Archivo Catedralicio, vol. 69, 1ª parte, f. 87r	972 September 7
	Charter 5		Covarrubias, Colegiata de S. Cosme y S. Damián, leg. I no. 4 (same text as charter 6)	978 November 24
	Charter 6		Burgos, Archivo Catedralicio, vol. 69, 1ª parte, f. 85r	978 November 24
	Charter 7	original lost	(Covarrubias, Colegiata de S. Cosme y S. Damián, leg. I nº. 7) (11th-century copy)	978 November 24

Charter 1 edited in Escalona et al. "Identification"; remainder in García Molinos, "Florencio de Valeránica," 393–414.

county of Castile and the Caliphate of Córdoba, one bead in the collar of monasteries that Christian authorities in the kingdom of León founded and restored to anchor the border with Muslim al-Andalus.[10]

It is clear that Florentius was at the top of the scribal heap at Valeránica.[11] In two of the three surviving codices attributable to him (Madrid, BNE, MS 80; Córdoba, AC, MS 1), Florentius was responsible for copying almost every word of the text as well as executing the illuminations. In the third, the León Bible of 960 (León, San Isidoro, MS 2), he shares the execution with his student Sanctius, but clearly as the senior partner. The fourth, the Oña Bible of 943, survives only in fragments. We have notice of a fifth, a copy of Cassiodorus's Commentary on the Psalms, now lost.[12]

Florentius thought a great deal about books and bookmaking, as is apparent from the elaborate first-person interventions carefully worked into each of these five codices. Three of these interventions survive in situ (Madrid, BNE, MS 80; Córdoba, AC, MS 1; León, San Isidoro, MS 2); we know about the others thanks to early modern transcriptions made before the codices themselves disappeared. These interventions explicitly articulate both the scribe's and the reader's bodies into the codex and thus into the meanings that reading the codex produces. This chapter will introduce us to the way that books, bodies, and the bodies of books drive Florentius's *Moralia*; the rest of his corpus will occupy us in Chapters 3 and 4.

FLORENTIUS'S MORALIA (BNE MS 80)

If, having received a letter from some great man, we read the words but inquired after the pen they were written with, what a ridiculous thing it would be—to know the author of the letter and to understand its meaning, but instead to direct our research into what kind of a pen those words were written with.

[Si magni cujusdam ûiri susceptis epistolis legeremus ûerba, sed quo calamo fuissent scripta, quaeremus; ridiculum profecto esset, epistolarum auctorem scire sensumque cognoscere, sed quali calamo earum ûerba impressa fuerint, indagare.]

Gregory the Great, *Moralia* Praef. I.1

Florentius wrote these words punctiliously on f. 18v of BNE MS 80, carefully flagging Gregory's appeal to the audience's letter-reading practices with a marginal indication that this is a *comparatio* (Figure 2).

Figure 2. "What a ridiculous thing it would be—to know the author but to ask about the pen the words were written with." Madrid, BNE, MS 80, f 18v detail. By permission: Biblioteca Nacional de España.

There is of course no way of knowing what the scribe was thinking as his pen made these characters. It is, however, also true that before we reach this page and hear Gregory's voice through Florentius's hand, we pass through a carefully designed framing sequence that extends a most spectacular invitation to ignore the advice that Gregory so authoritatively gives here.

To read BNE 80 sequentially is to be struck by the way it programmatically articulates the immaterial Work with the material labor necessary to produce it—the book-work, that is, of composition, editing, writing, publishing, and, finally, reading. In this *Moralia*, we will read Gregory's authoritative words, but we will also be led to consider not only the pen that wrote them, but also whose hand held that pen, and how the hand felt that held it. We will be led to do this by the scribe himself.

BNE MS 80 contains in a single volume all thirty-five books of Gregory's *Moralia*. With the possible exception of ff. 16v–94v, which may have been written by an apprentice,[13] Florentius executed the work alone, text and image alike—no mean feat, since the codex runs to 501 folios and measures a massive 490 × 350 mm (19¼″ × 13¾″). The text of Gregory's great commentary is laid out on sparkling parchment in two columns of elegant Visigothic minuscule, ornamented with carefully composed and colored chapter headings and elaborate interlace initials. Once the *Moralia* get

started, the text rolls out uninterrupted; it is framed, however, according to an elaborate verbal and visual plan.

BNE MS 80 is constructed in order to surround Gregory's commentary on the book of Job with additional layers of commentary on the *Moralia* themselves and on this codex in particular: how they were made, by whom, and where; how copied, published, reproduced, and read. This careful framing articulates the exegetical Work with the human labor that produced it, making the meanings of both intimately interdependent.

Florentius's codex frames the *Moralia* in layers of commentary. Let us move through that lettered treasure binding sequentially, as if unwrapping a gift. The outer layers, of Florentius's design and composition, treat the making of the codex itself; let's call this outer layer the *scribal frame* (ff. 1v–4r; 499r–501v). Moving inward, the next layer is a dossier of supporting texts that often accompany the *Moralia* in early medieval Iberia, including two documents relating to their edition and publication: call this the *editorial frame* (ff. 4v–15r). After that comes the *authorial frame*—Gregory's own prefaces explaining the work's genesis (ff. 16v–22r; 498v–499r). Finally, at the center, are the *Moralia* themselves, followed by the closing half of the scribal frame (499r–501v). As far as its scribal protagonism might seem from Gregory's strenuous defense of immaterial *auctoritas*, we shall see that this elaborate frame in fact grows from Gregory's own words.

THE SCRIBAL FRAME: FLORENTIUS'S BODY

As befits a monastic, Florentius took his studies to heart. He read the *Moralia* well as he copied them. But if we start reading the book he made at the first page, we won't know this is the *Moralia* until we reach f. 15v, and when they conclude on f. 499r, Florentius will still have more to say. The scribe is the protagonist of this part of the volume's paratext; its introductory section is constructed to foreground the elements of a bookish world: the codex, the page, and the letter. The first page of the codex is, in fact, devoted to a letter: a full-page Alpha (f. 1v; Plate 2) marks the beginning not only of the book and the alphabet from which it is made, but also a biblical quotation. Both alphabet and quotation require Omega to be complete: "I am Alpha and Omega, the beginning and the end, saith the Lord God, who is, and who was, and who is to come" (Apoc. 1:8).

Such completion arrives at the end of the codex (f. 501r; Plate 1) but is already in play here at the book's beginning. The alphabetic framing of the codex casts it into Apocalyptic time,[14] over which rules Christ in Majesty. And on the page facing the Alpha, there he is, the Word in human form, gripping an open book (f. 2r; Plate 2). Below him, winged evangelists engage in intense discussion, presumably of the books that they, too, hold in their hands. Turn the page to 2v for the Word in the lettered form of a full-page chrismon (Figure 3), not spelled out but doubly represented in four Greek letters.

Chi and rho summon *Christus* monogrammatically; the smaller alpha and omega that dangle from the upraised arms of the rho repeat the apocalyptic metaphor: "I am Alpha and Omega, the beginning and the end."

Facing the chrismon, on f. 3r, is more alphabet, but this time the meaning of the letters is not immediately apparent (Plate 3).

This page is a framed grid of multicolored diamonds. Each white diamond contains a single letter written carefully in black ink; their sequence, however, seems completely arbitrary. Starting as we're trained to do at the upper left and reading right, what we produce is nonsense: TNEROLFLORENT is all it says.

Here's another alphabetic puzzle. Though less theologically exalted than chi-rho and Alpha-Omega, it is infinitely more labor-intensive in both production and interpretation. Start halfway through the first line and you'll see a pattern: the F at the exact center of the line initiates something that could be a word, or part of one: FLORENT. The letters turn the corner and drop down the right margin of the grid, running down the final column to complete the thought. It is a sentence: FLORENTIUM INDIGNUM MEMORARE: Remember unworthy Florentius.[15]

From that F, the only one in the entire composition, the name and the request spin out to fill the page, not just left to right, but right to left; not just horizontally from that central F, but dropping vertically from it, too, right down the center of the page. And from the central vertical axis the request keeps spinning out backward to the left and forward to the right with each new row—endlessly, it seems. Left to right, right to left, up and down, again and again, watch the sentence weave the carpet page: FLORENTIUM INDIGNUM MEMORARE.

This is a signature that is not one, that hides itself as it is revealed. It is both a request and a puzzle: as you follow sense through the alphabetic labyrinth,[16] you fulfill the request, as it is written, over and over. Mouthing

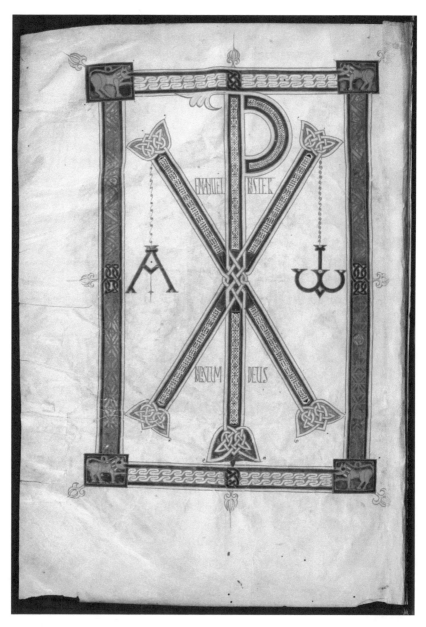

Figure 3. Chrismon. Madrid, BNE, MS 80, f. 2v. By permission: Biblioteca Nacional de España.

the words each time you find yet another iteration of the sentence, you are held in contemplative arrest, remembering unworthy Florentius.

Before you even know the author of the Work contained between the covers of this codex, you know who pushed the pen to make it. You've spelled out his name so many times, and in so many ways, that you're not likely to forget it. You've worked with letters as the building blocks of grammatical sense, and you've worked with them as religious symbols. Thus trained to navigate this alphabetic labyrinth, you are ready to read the work announced on f. 15v as SCT GREGORII PAPAE ROMENSIS IN EXPO-SITIONE IOB.

Once that is done, thirty-five books and 484 folios later, the scribal frame resumes. On f. 499r, the conclusion of the *Moralia* is announced thus (Figure 1):

The Book of Morals of Pope Gregory the Roman ends, era DCCCCLXXXIII, VI feria, III of the Ides of April in the Easter season, at prime [= six A.M., Friday, April 11, 945 CE]. Thanks be to God. In the reigns of King Ranemirus and count Fredenandus and bishop Basilius. Blessed be the king of heaven who has permitted me to reach the end of this book safely. Amen.

[EXPLICIT LIBER MORALIUM GREGORII ROMENSIS PAPE ERA DCCCCLXXXIIIA III idus aprilis VI feria pasce hora prima. Deo gratias: regnante rex Ranemiro et comite Fredenando necnon et Basilio episcopo. Benedicto celi quoque regem me qui ad istius libri finem uenire permisit incolomem. amen.][17]

This explicit is followed by the shocking silence of an opening—two facing pages—left expensively blank. The *Moralia* might be finished, but Florentius isn't: turn the blank f. 500r, and a full-page colophon (f. 500v) faces a grand Omega supported by two small human figures (f. 501r; Plate 1).

Two kinds of lettered endings face each other here: on the right, the Omega—a single letter, cosmic, allegorical, transcendent; on the left, a whole page of letters testifying to the writer's labor. Here is a book that reaches into two worlds: the transcendent world of the Logos, and the immanent, particular, bodily detail that constitutes the individual lettered life.

As we shall see in Chapter 3, Florentius did not invent every word of this colophon. What he did do is weave motifs from the scribal tradition into a glorious amplification of the common trope "three fingers write, but the

whole body labors"[18] that is a tour-de-force performance of scribal work. This colophon has been waiting for us since the beginning of this book. Now we are ready to read it in full.

As it begins, the colophon repeats information from the explicit on f. 499r, adding further detail about places, persons, and emotions. The explicit provided information in remote third person. From the very first words of the colophon, it's clear that this is something else entirely:

> I say that with the support of thundering celestial mercy this work is finished on the III of the ides of April, during the era nine times one hundred, twice ten, and four tens plus three.[19] At the house set in a consecrated place and called Valeránica, in the honor, namely, of its patrons, saints Peter and Paul, great apostles and martyrs. I, Florentius, inscribed this book, at the command of the whole monastery represented in abbot Silvanus, when I had accomplished twice ten-and-two or nearly five and double-ten years of my little lifetime. These things certainly being done, I copiously pray and amply request that you who, in the future, might read in this codex direct your frequent prayer to the Lord for me, miserable Florentius, that we might deserve to please Lord Jesus Christ. Amen.

> [Suffragante tonanti inquam alti clementia. perfectum est hoc opus III idus aprilis, currente era centena nobies bis dena et quater decies terna ob honorem scilicet sanctorum Petri et Pauli maximi apostolorum et martirum domum dicatum locum situm uel uocitatum Baleria. hic nempe liber ego Florentius exaraui imperante mihi uel uniuersa congeries sacra monasterii Silbani uidelicet abbati quum iam mee etatule annorum spatia peregissem bis deni bini aut circiter quini et bis deni. His nempe explosis, copiosissime uobis precor et affatim rogo qui in hoc codice legeritis, ut frequens uestra pro me Florentio misero ad dominum dirigatur oratio ita ut in hac uita placere mereamini domino Ihesu Christo, amen.][20]

The explicit on f. 499r told us when the writing ended. Now that same information is presented by a first-person speaker, who surrounds the information with indicators of his own activity: the emphatically first-person "I say" (*inquam*) and, in the very next sentence, "I, Florentius, inscribed this book" (*hic nempe liber ego Florentius exaraui*). The explicit placed the book's completion in human as well as calendar time, linking it to King Ramiro

(II of León, d. 951), Count Fernán González (of Castile, d. 970), and Basilio, bishop of Muñon.[21] Here, human time is reckoned on a much smaller scale: not by reference to living monarchs, but in terms of the "little lifetime" of the first-person speaker (*mee etatule*), now in his twenty-fourth or twenty-fifth year. The paradoxical combination of properly humble vagueness (twenty-four or twenty-five; what kind of monk keeps track of birthdays?) with unnecessary precision (why does it matter how old he was?) gives this contingent reckoning of time a disarming intimacy.

This intimacy deepens when the writer turns to his expected readers (that's us). He doesn't just evoke us; he addresses us directly as "you who, in the future, might read in this codex" [qui in hoc codice legeritis]. Our place, too, is intimate: Florentius doesn't imagine us as readers *of* this codex, but rather as readers *in* it.[22] *This* codex: the very one that Florentius is finishing. We're in it now, both in Florentius's imagination and because he's written us there. We're in the book just as he is, and in the same way: through the activity of his writing hand.

Rhetorically, the colophon turns around the first and second persons of scribe and reader, I and you: *ego exaraui-uos qui legeritis*. After a paragraph praying that scribe and readers alike be eventually joined in Christ, Florentius then returns to the relationship of scribe and reader. We, too, are linked.

The labor of the scribe is the refreshment of the reader: one damages the body, the other benefits the mind. Whoever you are, therefore, who benefit from this work, do not neglect to remember the laboring worker: and so may God, thus invoked, forget your faults. Amen. And for the voice of your prayer may you be rewarded in the time of judgment when the Lord will command that his saints be recompensed afresh.

[Labor scribentis refectio est legentis, hic deficit corpore ille proficit mente quisquis ergo in hoc proficis opere operarii laborantis non dedignemini meminisse ut Dominus inuocatus inmemor sit iniquitatibus tuis, amen. et pro uocem tue orationis mercedem recipies in tempore iudicii quando Dominus sanctis suis retribuere iusserit retributionem.][23]

Scribe and reader are joined, and joined now, in our respective times, by this artifact, the book. I don't mean this connection figuratively. In the

handmade world in which Florentius works and thinks, any reader of this book is also a *toucher* of this book; our hands will lie where his have been. The artifact held by scribe and readers—this book—lies open at the intersection of our different times and activities. Writing and reading, manual labor and interpretive work, are not two separate realms of activity. Rather, Florentius imagines them conjoined in reverse analogy (labor:refreshment; damage:benefit). It's not simply that we would have nothing to labor over had the scribe not done his work. His manual labor already includes, anticipates, even *represents* our mental labor, while simultaneously, of course, representing itself.

The articulation of the two realms—reading and writing, I and you, here and there, now and then—is emphasized by emphatic repetitions. The verb *proficio*, to benefit, is first linked to reading in general as a fruitful act (*ille proficit mente*) and then to the very particular act of reading in this codex (*quisquis ergo in hoc proficis opere*). In a single sentence, the work we read and the work that produced it rhyme in two forms of the word *opus*: "Quisquis ergo in hoc proficis *opere operarii* laborantis non dedignemini meminisse." Reproducing the polyptoton in English requires a slightly awkward literal translation: "Whoever you are, therefore, who benefit from this work, the working laborer do not neglect to remember."

Opus, the work we read, points to *operarius*, worker. The individual writer is thus linked to readers—first materially, through our bodily act of reading "in the codex" and then immaterially, through mental activity (the scribe thinks of readers; the readers remember the scribe). Now that we have been invited into the work, Florentius can converse with us. And he does, offering a master class in the somatics of *scriptura*.

"I, Florentius, inscribed this book" [Hic nempe liber ego Florentius exaraui], the scribe says in the first paragraph of the colophon. The verb he uses for his activity is worth our attention. *Exaro* does mean to write, but it is a buried metaphor, from *aro*, to plow. Of the words at his disposal to describe his work, Florentius has chosen the dirtiest, sweatiest one. In the next text block of the colophon, Florentius goes out of his way to make clear that painting a page with the fingers is labor as backbreaking as writing the soil with a plow.

One who knows little of writing thinks it no labor at all. For if you want to know I will explain to you in detail how heavy is the burden of

writing. It mists the eyes. It twists the back. It breaks the ribs and belly. It makes the kidneys ache and fills the whole body with every kind of annoyance. So, reader, turn the pages slowly, and keep your fingers far away from the letters, for just as hail damages crops, so a careless reader ruins both writing and book. For as homeport is sweet to the sailor, so is the final line sweet to the writer. Explicit. Thanks be to God always.

[Quia qui nescit scribere laborem nullum extimat esse nam si uelis scire singulatim nuntio tibi quam grabe est scribture pondus oculis caliginem facit, dorsum incurbat, costas et uentrem frangit, renibus dolorem inmittit et omne corpus fastidium nutrit. Ideo tu lector lente folias uersa, longe a litteris digitos tene, quia sicut grando fecunditatem telluris tollit sic lector inutilis scribturam et librum euertit. Nam quam suauis est nauigantibus portum extremum ita et scribtori nobissimus uersus. Explicit Deo gratias semper.][24]

The homeport analogy with which the colophon concludes is well-attested in manuscripts of the period. So, too, the plea for mindful use of the reader's hands.[25] Equally well-known is the popular distich "Scribere qui nescit nullum putat esse laborem / tres digiti scribunt totumque corporis laborat."[26] Florentius, however, amplifies the couplet's laconic *totum corporis laborat*, listing symptoms in vigorously corporeal enumeration: Writing "mists the eyes. It twists the back. It breaks the ribs and belly. It makes the kidneys ache and fills the whole body with every kind of annoyance." This is not just a complaint. It's a truly radical move rooting the text not only in its materiality as words on a page, but in the suffering corporeality of the particular person that put them there.

We read the lines of black and red letters, and organ by organ, joint by joint, the scribe's laboring body is represented. According to medieval grammatical theory (as we'll see in Chapter 2), his body is *presented*, too—that is, made present—right here, under our very eyes. And under our hands, too, for Florentius has written not only his own body into the codex, but his reader's as well. We have been caught out, foreseen, perhaps, as we trace a path along the alphabetic labyrinth of f. 3r or keep our place with a finger on the page as we read the colophon.[27] "Reader, turn the pages slowly, and keep your fingers far away from the letters."

Figure 4. A reader responds to a colophon. Madrid, BNE, MS 80, f. 500v detail.
By permission: Biblioteca Nacional de España.

As Florentius strategically ignores Gregory's warning that readers should focus on the immaterial meaning rather than the material writing (a warning that he carefully copied on f. 18v), so too later readers have flouted Florentius's warning to keeps their mind's eye on the writing body and their fingers away from the written page. The wide margins around the colophon on f. 500v left space where other pens could exercise: the word "de" floats suspended in the upper left margin, followed a few centimeters below by the partially legible phrase "deinde dominus dicit . . . exaudiuit," and finally, to the left of "Labor scribentis refectio est legentis," a tentative imitation of the page's patterned border. At the bottom of the page, another early medieval person who held this book answers Florentius's call to pay attention, writing in an unplanned and ungrammatical hand this gnomic statement: "For the purpose of desiring the kingdom, you lost the sense [or: your understanding]. Open the sense [or: your understanding] and you shall win the kingdom" [ad concupiscendum regnum perdisti sensum. Aperi sensum et adquires regnum] (Figure 4).

A "you" is addressed, a kingdom desired, senses lost and opened. But who that "you" might be, what kind of kingdom (earthly? celestial?), what kind of sense (perceptual? hermeneutic?) might be at issue we will never know.[28] Whatever the annotator's sense of the intervention might have been, as soon as he or she lifted the pen from the page, the cryptic line's address to a "you" has interpellated all future users of this book, tossing us a puzzle that writes senses (intellectual, hermeneutic, perceptual) into the codex as surely as did Florentius's labyrinthine request (f. 3r) that we remember him. Florentius's page and our understanding now provide the context for this inscription, and, if we take it as being about the relation between meaning-hunting and the kingdom (of heaven?), we are negotiating the same material-immaterial ratio that the colophon has already laid out for its future users. Florentius imagined these people as readers *in* this codex; they've made themselves at home.

THE EDITORIAL FRAME: TAIO'S HAND

As these annotators violate Florentius's command to keep hands off his pages, so the scribal frame has flouted Gregory's authoritative declaration that only a fool wonders about the pen that made the book. The scribal frame reminds us that we are not just reading a Work, a text, or even a codex. We are reading *writing*, not just the noun but the bodily activity itself. The next layer of Florentius's *Moralia* continues to direct our attention toward writing as an activity as well as the artifact. The scribal frame wove into the codex BNE, MS 80 the particularities of its own production; the next section does the same for the Work called *Moralia in Job*.

The editorial frame is composed of a series of texts designed to support the reading of the *Moralia*. Some of them—Jerome's prologues to the book of Job and then the biblical book itself—circulate with the work outside Iberia; four of them, however, are particular to the work in its Iberian circulation and appear only in manuscripts copied there.[29] This Iberian dossier articulates the *Moralia* with a web of Iberian Latin texts, their producers, and their consumers. It contains (1) a letter of Taio, Bishop of Zaragoza (c. 600–c. 683 CE); (2) an extract from the "Mozarabic" *Chronicle of 754*; (3) a catalog of Gregory's works; and (4) a biography of Gregory from Isidore of Seville's *De viris illustribus*.

The works that concern us here are the first two: Taio's letter and the extract from the *Chronicle of 754*. The good bishop was a bibliophile—in the words of the *Chronicle*, a man "well-trained in the order of letters and a friend of the Scriptures" [ordinis litterature satis inbutum et amicum scripturarum].[30] Taio's fondness for the works of Gregory the Great gives him a starring role in the Iberian dossier.[31] In the first text in the collection (beginning on f. 14r of BNE MS 80), Taio writes to bishop Eugenius of Toledo about a trip to Rome on which, he writes, he saw Gregory. Taio doesn't mean he saw Gregory bodily, since the author of the *Moralia* had died in 604, during Taio's infancy. He has in mind a different kind of vision.

> We saw, we saw our Gregory in Rome, not with the sight of the body but with the contemplation of the mind; we saw him not only in his secretaries but also in his close associates.

> [Vidimus, uidimus Gregorium nostrum Romae positum, non uisibus corporis, sed obtutibus mentis; uidimus eium non solum in suis notariis sed etiam in familiaribus.][32]

Taio went to Rome not only to see "our Gregory" in his imagination or even in the pope's surviving friends and secretaries, but also in what those secretaries produced: the "volumes of his that we did not have in Hispania" [eius que in Hispaniis deerant uolumina].[33] Once in Rome, Taio set out to locate those volumes so that he could bring copies back home with him. To do the hard manual work of copying, he could hire a *notarius*, but he does no such thing. He instead says that, having found the volumes, his desire was to "transcribe them with my own hand and so that such sweetness of words might delight my soul with immeasurable charm" [propria manu transcriberem tantaque dulcedo uerborum animum meum inextimabili suauitate mulceret].[34]

Taio is emphatic about the protagonism of his own hand here, and about the relation between the hand's involvement and readerly joy. He wanted to see a parchment Gregory and touch him—transcribe him—with his own hand (*propria manu*). It is as if Gregory's words could only yield their full deliciousness in the process of transcription—a sort of contact nourishment, absorbed through the fingers as well as the eyes.

The journey was successful. Taio writes to Eugenius to announce his discovery—a new addition to Gregory's corpus: not just Gregory's, but also Taio's *Moralia in Job*. For not only did Taio transcribe this massive work himself, he also says he edited it—arranged it in six codices (*in sex codicibus*), introducing each with prefaces (*praefatiunculas*) for ease of navigation.[35] Gregory's *Moralia*, through Taio's hand.

Immediately after Taio's letter, and as if produced by it, BNE MS 80 offers an excerpt from the *Chronicle of 754* (f. 15r) giving an imaginative reconstruction of what might, in fact, have happened in Rome. At issue in the *Chronicle*'s reframing of Taio's letter is the archiving, editing, and publication of the *Moralia*. At issue, you might say, is the authorization of Taio's edition of the *Moralia*.

According to the chronicle, Taio went to Rome on the order of King Chindaswinth, his charge being specifically to find and bring back missing sections from the *Moralia*, whose incompletion in Hispania was apparently a problem of state security serious enough to merit royal intervention. Arriving in Rome, Taio presents himself and his mission to the pope, who puts him off, saying that, what with all the books in the archive, well, it's hard to find anything. Day after day the pope makes excuses, until finally, at wits' end, Taio spends a night in prayer and appears the next morning before

the astonished pontiff with the complete *Moralia* in his hands. Chagrined, the pope gives Taio permission to copy the book. But first, he asks, how ever did you find it?

Taio explains: as he prayed through the night he saw a crowd of saints bathed in brilliant light. Asked what he was looking for, Taio explained his bibliophile mission. No sooner said than satisfied: the holy visitors showed him where the books were hidden. Marveling, Taio asked who these holy visitors might be. "One of them answered that he was Gregory, whose book [Taio] so wanted to examine" [unus ex illis respondit se esse Gregorium, cuius et ipse desiderabat cernere librum], come expressly to reward Taio's interest and effort.[36]

As Leonardo Funes puts it in his witty retelling of this Borgesian tale, "It must be said that one does not encounter every day a pack of saints so well-disposed to give bibliographical advice."[37] Thus, Taio the sedulous researcher takes the opportunity to ask Gregory if St. Augustine might be around, "for he had since infancy been just as passionately eager to read the works of that holy man as those of Gregory himself" [eo quod ita libros eius sicut et ipsius sancti Gregorii semper ab ipsis cunabulis amaret legere satis perauidus].[38] Augustine, alas, is not available (he is "in a higher place than we" [altior a nobis eum continet locus],[39] says Gregory), but the fact remains that Taio has met his bibliography: he saw, he saw his Gregory in Rome—in person now as well as in parchment. And the person of Gregory makes possible Taio's contact with the parchment, just as Gregory's lesser successor, his papal hand forced by authorial intervention, concedes the publication rights to the Spanish bishop. The pope "assigned [the *Moralia*] to be copied and sent it to the Hispani that they might read it" [tribuit ad conscribendum et Hispanis eum transmisit ad relegendum].[40] Taio's *Moralia* is thus quite explicitly the authorized edition.[41]

THE AUTHORIAL FRAME: GREGORY'S STOMACH

For we must transform what we read into our very selves.

[In nobismetipsis namque debemus transformare quod legimus.]
Gregory the Great, *Moralia* I.24

Only after this elaborate introduction does Gregory's own presentation of the *Moralia* begin (f. 16v), and once we have worked through Gregory's

prefaces, the elaborate framing of MS 80 opens up in its fullest sense. We come now, sixteen leaves in, to Gregory's own presentation of the *Moralia*, the authorial frame. To get here, we have engaged with layer after layer of commentary insistently articulating books with their makers: we've been asked to remember the one who made this book and told the story of how the text he copied was itself copied, edited, and brought to Spain; we've seen the editor's encounter with his author, experienced the joy of physical contact with the parchment body, and seen the reproduction and dissemination of multiple *Moralias*.

Taio's hand is in intimate conversation with the Gregorian corpus. So, too, as you have already seen—and that sequential readers of MS 80 will see when they get to the end of the codex—is Florentius's body. This is not surprising, since the Gregorian corpus, in addition to being one of the most frequently copied in the early Middle Ages, is also one of the most media-aware. So much so that, notwithstanding Gregory's confident dismissal of the scribal pen, he is one of the teachers from whom Florentius and book-artists like him learned to articulate their writing and reading bodies with the body of the book.[42]

As Florentius's prefatory material grounds his copy of the *Moralia* in its editorial and scribal transmission (Taio's letter, the story of how he found the autograph text, Florentius's labyrinth and colophon), so Gregory's framing of the *Moralia* roots them in the circumstances of their own composition and in the very particular bodily experience of the "I" who composed them. In the opening epistle to Leander of Seville, Gregory describes the circumstances of the *Moralia*'s production. They began, he says, as oral commentary and were gradually revised to produce the thirty-five-book commentary that the letter purports to present as a gift to the Sevillian bishop. Here is how, according to Gregory, the *Moralia* began:

> The brothers straightaway sat down in front of me, and I began my oral exposition of the text. When I found more leisure I dictated a commentary on the later chapters of the book. Still later, a greater amount of available time allowed me to edit the notes taken while I was speaking; thus I added a great deal of material while removing very little and leaving most of it exactly as I found it; in this way I formed material into books.
>
> [Vnde mox eisdem coram positis fratribus priora libri sub oculis dixi et, quia tempus paulo uacantius repperi, posteriora tractando dictaui, cum

que mihi spatia largiora suppeterent, multa augens pauca subtrahens atque ita, ut inuenta sunt, nonnulla derelinquens ea, quae me loquente excepta sub oculis fuerant, per libros emendando composui.][43]

Though by his own account Gregory made books by dictation and not by hand,[44] his engagement with the *Moralia* was anything but disembodied. During the work's long gestation, he tells Leander, "I have for many years now suffered from constant stomach pains. At every hour and even every minute I am exhausted because my appetite is gone; because of the fever, low indeed but constant, I breathe with difficulty" [Multa quippe annorum iam curricula deuoluuntur, quod crebris uiscerum doloribus crucior, horis momentis que omnibus fracta stomachi uirtute lassesco, lentis quidem, sed tamen continuis febribus anhelo].[45] Lest his reader take this statement as mere confession or complaint, he moralizes: "Perhaps this was the plan of divine providence so that I might comment on the stricken Job after having been stricken myself, and so that I might the better understand the soul of one whipped through the lashes I myself received" [Fortasse hoc diuinae prouidentiae consilium fuit, ut percussum iob percussus exponerem, et flagellati mentem melius per flagella sentirem].[46]

So the vivid description of Gregory's physical distress has as much of hermeneutics as it does of confession. So too, in the closing bracket of the *Moralia*, where, after thirty-five books' worth of intimate engagement with the book of Job, Gregory turns inward once again to represent the effect of that engagement on the first-person reading and writing self:

Now that this work is finished, I see that I must return to myself. For, even when it attempts to speak rightly, our mind is scattered outside itself. For when we think about how words are expressed, they diminish the integrity of the soul because they draw it out of itself. . . . Therefore I beg that anyone who reads this to offer the solace of his prayer for me before the strict judge, and that all he finds sordid in me might be cleansed by his tears. When I compare the power of prayer with that of my commentary, I see that my reader will repay me well if, for the words received from me, he offers his tears in return.

[Expleto itaque hoc opere, ad me mihi uideo esse redeundum. Multum quippe mens nostra etiam cum recte loqui conatur, extra semetipsam spargitur. Integritatem namque animi, dum cogitantur uerba qualiter

proferantur, quia eum trahunt extrinsecus, minuunt. . . . Igitur quaeso ut quisquis haec legerit, apud districtum iudicem solatium mihi suae orationis impendat, et omne quod in me sordidum deprehendit fletibus diluat. Orationis autem atque expositionis uirtute collata, lector meus in recompensatione me superat, si cum per me uerba accipit, pro me lacrimas reddit.][47]

Gregory is insistent about rooting his discourse in bodies—his own: composing, dictating, performing, editing, and sometimes suffering, and those of others: writing, reading, listening. Both Gregory and his Iberian scribes cast their textual interventions in a first person precisely articulated with the contingent conditions of book production in particular times and places. Publication for Gregory, Taio, and Florentius isn't simply a matter of "getting the word out there": it is a matter of articulation both in the sense of speaking and in the sense of weaving a work to the circumstances of its ideation, composition, revision, publication.

Gregory, Taio, and Florentius cast their textual interventions in a first person precisely articulated with the contingent conditions of book production and the contingent particulars of time and place. For these writers (and they all *are* writers, though two are *auctores* and one, as Gregory might say, merely a scribe), the book, the book user, and the bookmaker are closely articulated together like the joints of a hand. They understand book, user, and maker as working not only *on*, but also *in* the codex around which they gather, intellectually, spiritually, and bodily. All are imagined to be present—intellectually, spiritually, even bodily—in the codex around which they gather. Their labors of composing, writing, and reading call to one another across page and time.

MONKS AT WORK: *GRAMMATICA*
AND CONTEMPLATIVE MANUSCRIPTION

H er task complete, at least for the moment, the writer lifts her pen from the text she's just completed to make a place for you. She writes:

Oh all you who might read this codex in the future, remember me, poor servant Leodegundia, I who wrote this in the monastery of Bobatella in the reign of Prince Alfonsus in era DCCCCL. One who prays for another commends the self to God.

[O uos omnes qui legeritis hunc codicem mementote clientula et exigua Leodegundie qui hunc scripsi in monasterio Bobatelle regnante Adefonso principe in era DCCCCL quisquis pro alium orauerit semetipsum domino commendat.][1]

Leodegundia writes her activity into the page of her book and anchors it explicitly in a place called Bobatella[2] and time (era DCCCCL; that is, 912 CE). From that moment in the year 912, Leodegundia throws her thought forward in time. She imagines the gathering beneath her pen transformed by assembly with others like it into a codex—this one right here (*hunc codicem*, she writes), the one she wrote (*hunc scripsi*, she says) in 912 at Bobatella. She sees you sitting in front of this codex, at work in it as a reader as she is as a writer. She hopes that you are thinking of her.

Florentius saw you, too, and worried about where your fingers were. Other scribes working in north Iberian monasteries invoke your presence just as concretely. Gomez, for example, finished his copy of Gregory the Great's *Moralia* at San Pedro de Cardeña on November 26, 914.[3] You were on his mind even as he worked. On f. 80v, before lettering the incipit of book 11, he addresses you in your gendered specificity (*O bone lector lectrixque Gomiz peccatoris memento*); on f. 142r, he hopes that, whoever you may be, you will benefit from reading this book (*quisquis hunc librum ob utilitatem tui legeris*).[4] At Santo Domingo de Silos in Castile, at noon on Thursday,

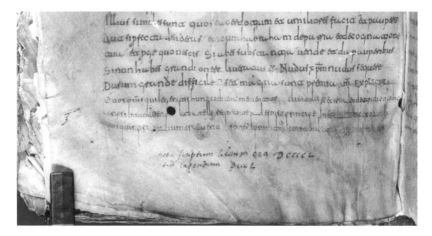

Figure 5. A reader responds to a colophon. El Escorial, Biblioteca del Monasterio, a.I.13, f. 186v detail. By permission: Patrimonio Nacional, Biblioteca del Real Monasterio de San Lorenzo del Escorial.

April 18, 1091,[5] Dominicus and his kinsman Munnius look out from the final gathering of a commentary on the Apocalypse and see us "in the present and in the future"; they imagine us before this "gleaming explanation of the Apocalypse" that they have made. They address us and tell us what we're doing: we are, they imagine, reading "avidly" [Presentibus et futuris, qui in hoc libro fulgidam sacre explanationem Apocalipsis avide legeritis].[6]

Leodegundia, Gomez, Dominicus, Munnius, and Florentius work their readers into their books. Monastics themselves, they imagine us in their own image, and write us into their work. Thus conscripted into the monastic book, we are made—at least temporarily and in imagination—into monks and nuns. Whoever we might in fact be, if we are curious about how these things they made work, it is worthwhile to imagine, at least for a while, that we are the users that these writers have made us out to be.

The monastic scribes studied here expect us to use the books they made as they themselves used books. They understand us not as students of an abstract "Work" separable from its material instantiation, but as participants in a very concrete and particular thing—*hunc codicem*, as Leodegundia says. Leodegundia would not have been at all surprised, were she reading over my shoulder now, to see that another reader participated in the book she made at Bobatella by drawing a quick *maniculum* in the outer margin of f. 186v (Figure 5). Its extended index finger points to the colophon in

which the scribe reveals her name: this reader answers the call to think of her, in the book itself, with her own hand.[7]

Leodegundia, Gomez, Florentius, and their bookish brothers and sisters imagine a community around the books they make; they conscribe their readers as participants in that community and experts in its culture of contemplative reading and manual labor. In this chapter, we shall see how the monastic practice of manual and grammatical labor shaped these bookworkers' understanding of how written language works on and in those who live with it—bodily, intellectually, spiritually. We look at labor first—in the fields and on the page—and then step back to see how the way writing was taught shaped the way that labor was understood and performed upon the page.

MONKS AT WORK

Antonio Linage Conde estimates that between 759 and 1109, 1,400 monasteries were active in León and Castile.[8] Until the Gregorian Reform in 1080,[9] the Benedictine was but one of the codes under which monastic communities in the peninsula were organized.[10] Abbots were relatively free to govern according to the Benedictine as well as the Hispanic rules of Isidore, Leander, and Fructuosus,[11] the traditional pactual system,[12] or some combination of them all.

The book that Leodegundia was finishing when this chapter began collects various rules from which a community could be governed. In addition to the Benedictine, her book contains the rules of Augustine, Pacomius, and Cassian, as well as some disciplinary letters of Jerome and the traditionally Iberian rules of Fructuosus of Braga, Isidore of Seville, and his brother Leander.[13] When she signed off in 912, Leodegundia had just finished copying a letter of St. Jerome, which ends by praising monastic life as labor: it is, he says, "hard, great, and difficult, but the rewards are also great" [durum, grande, difficile, sed magna sunt praemia].[14]

Labor was central to monastics' understanding of their way of life, as definitive of their existence as the Rule under which they lived.[15] Writes Isidore of Seville in his *Rule*, "A monk should always work with his hands in such a way that he devote himself with zeal to some craft or work of artisans, following the apostle who says: 'we do not eat bread for nothing but in labor and in exhaustion, working by night and day' (2 Thess 3:8): and again, 'who does not wish to work should not eat' (2 Thess 3:10)" [Monachus

operetur semper manibus suis ita ut quibuslibet uariis opificum artibus laboribus que studium suum inpendat, sequens Apostolum qui dicit: Neque panem gratis manducauimus, sed in labore et fatigatione nocte et die operantes].[16]

The rules under which Leodegundia and her scribal colleagues lived go out of their way to frame monastic work not only as a practical necessity, as Isidore does here, but also as a spiritual practice drawing body and mind together in a single activity. Isidore, for example, also states in his *Rule* that monastics "must work with their body and with the attention of their mind fixed on God. Thus the hand must be involved in the work so that the mind is not turned away from God" [Laborandum est ergo corpore et animi fixa in Deum intentione sic que manus in opere inplicanda ut mens non auertatur a Deo].[17] For Isidore, monks don't just do bodily work; they work *with* the body (*laborandum est corpore*). In his view, the hand is not only involved with work, it's *implicated* in it (*manus in opere inplicanda*). Hand and mind are both absorbed into the matter attended to—or, like the laboring hand itself, articulated with it.

The *Regula Complutensis* of Fructuosus of Braga declares that "the following methods are to be observed at work":

> In spring or summer, after reciting Prime [6 A.M.], the senior monks are to be advised by the prior what work to undertake and they are to inform the rest of the brothers. Then, when the signal is given, they are to take their tools and gather together and say a prayer and go forth to their labor with recitations until the third hour [9 A.M.]. Then, returning to the church, after celebrating Terce, they are to sit in their places and give attention to reading or prayer. But if the work is such that it cannot be interrupted, then Terce may be recited during the work and so, with recitations, they are to return to their cells and to gather immediately into the church after praying and washing their hands.

> [In operando haec ratio conseruatur uerno uel aestate. Dicta prima commoneantur decani a praeposito suo quale opus debent exercere, adque illi reliquos admonet fratres. Tunc demum ducto signo adsumtis que ferramentis congregantur in unum; facta que oratione pergent recitantes ad opus usque ad horam diei tertiam. Reuertentes que ad ecclesiam tertia celebrata residentes locis suis student orationi siue lectioni. Veruntamen si opera talis est quae non intermittatur, in opere ipso tertia dicitur

et sic recitando ad cellam reuertuntur. Et consummata oratione ablutis manibus confestim ad ecclesiam conueniunt.][18]

Although the day is divided into ritual Hours and the activities appropriate for them, it is important to observe that work, prayer, and recitation are not separate operations. Rather, they accompany each other in activity that conjoins mind and body with the laboring hand. Monks, says Isidore in his *De ecclesiasticis officiis*, "work with their hands at those things that can support their body without being able to distract their mind from God." "They chant," he continues, "working by their hands, and they are consoled in their work as by a divine shout or rhythmic call" [Operantur autem manibus ea quibus et corpus pasci possit et a deo mens inpediri non possit. Canent autem manibus operantes et ipsum laborem tamquam diuino celeumate consolantur].[19]

Not all manual labor took place in the field, of course; the monastics who made the books we study here worked in the scriptorium as their brothers and sisters labored in field and orchard. "One who does not write the earth with the plow must paint the page with the finger," declares the Rule of Ferreolus of Uzès [Ut paginam pingat digito, qui terram non praescribit aratro].[20] Cassiodorus, too, understood the scriptorium as a field for working hands—conjoined, as in Isidore, with both intellectual and spiritual exertion:

Among those of your tasks which require physical effort that of the scribes, if they write correctly, appeals most to me . . . for by reading the Divine Scriptures they wholesomely instruct their own mind and by copying . . . they spread them far and wide.

[Quod inter vos quaecumque possunt corporeo labore compleri, antiquariorum mihi studia, si tamen veraciter scribant, non immerito forsitan plus placere, quod et mentem suam relegendo Scripturas divinas salutariter instruunt et . . . scribendo longe late que disseminant.][21]

The presbyter Munnionus, who copied a collection of sayings of the desert fathers in the late ninth century at the Riojan monastery of San Millán de la Cogolla, leaves testimony in his own hand of the centrality of scribal labor in the monastic way of life. Folio 28r of the codex he made (now at the Real Academia de la Historia in Madrid as MS 60) is full of praise for monastic life (Figure 6).

Figure 6. "This is the way and the work of the monk." Madrid, RAH, MS 60, f. 28r detail. By permission: Real Academia de la Historia.

"Truly," reads the text Munnionus copied, "great is the order of monks" [uere magnus est ordo monachorum]. The scribe took those words to heart. At the bottom of that same page he drew a knobby green horizontal line and outlined it in red. Repeating the sentiment copied at the top of the page, he wrote in small letters above the green line: *Hec est uia et opus monaci.* And below the line, he signs off: *Munnioni prsbr librum.* The cases don't line up as one would expect, so multiple translations are possible. The division imposed by the green line, however, suggests this reading: "This is the way and the work of the monk. The book of Munnionus the presbyter." (That this is the way at least one medieval reader understood it is suggested by an inscription added below in another hand that seems to be a grammar correction: "munnioni prsbri librum," it clarifies).[22]

In the letter that Leodegundia copied to conclude her codex in 912, Jerome advised his readers to give themselves to work: "Let nets be also woven for catching fish, and let books be copied so that your hand may earn your meals and your mind be nourished with reading" [Texantur et lina

capiendis piscibus, scribantur libri, ut et manus operetur cibos et anima lectione saturetur].[23] Let nets be texted, Jerome advises; Leodegundia's labor as she copies this letter both takes and materially manifests his advice. To write was also to read, and both were essential forms of monastic labor.

The ideal scribe as imagined by someone like Jerome or Cassiodorus is not just a skilled transcriber, twisting a net of letters to catch attentive reader-fish; he or she is at the same time a reader caught up in someone else's lines, reaping the benefits of a previous writer's labor. Scribes like this are the very engine of monastic *Schriftlichkeit*—artisans, as Claudia Rapp observes, of "the active force of the word in and of itself, especially in its written form."[24] And the active force of the written word is nowhere clearer in monasticism than in the practice of *lectio divina*, a system, in Guy Stroumsa's words, "in which reading morphed into meditation and meditation led back into reading."[25]

If we are to learn *with* as well as *about* these monastic scribes, it is important to do more than simply nod our heads in learned recognition of the term *lectio divina*. Instead, let us attempt to enter the practice imaginatively to see how it might change the way we think about and engage with carefully crafted language. Ivan Illich helps us to imagine what living with text in this way might have felt like:

> Each week all the 150 Psalms of David had to be recited at least once. Soon the [novice] would know them by heart. . . . Within a few weeks the child would associate the rustling of cloaks at the end of each prayer with the rising of the monks and the *Gloria patri*. The rhythmic repetition of the gesture of rising and bowing and its coincidence with a small canon of short formulas was easily associated with pious feelings and habits even before the novice was able to spell out the literal meaning of the Latin words. *Deo gratias*—thanks be to God—is felt as a response of relief at the end of a long Bible reading which takes place in the middle of the night. So also, in the refectory at noon time, it is the anxiously awaited sign that mealtime prayers are over and dinner may begin.[26]

Lectio divina, whether practiced at work or at rest, thus took place in an environment already saturated with text. A habitus grounded in such conditions will associate written language with movements of both body and mind; text is absorbed and experienced as much as thought about. Writes Jean Leclercq—himself a practitioner as well as a scholar of the Benedictine

way—"One pronounces the words in an interior fashion, ruminating, repeating in order to absorb the reading into the memory and into the self and to put the reading thus into practice."[27]

"All improvement comes from reading and meditating," writes Isidore of Seville. "That which we do not know we discover by reading; that which we learn we preserve by meditating" [Omnis profectus ex lectione et meditatione procedit. Quae enim nescimus, lectione discimus; quae autem didicimus, meditationibus conservamus].[28] In the practice of *lectio*, reading and meditating cannot easily be distinguished. "To meditate," writes Leclercq, "is to read a text and to learn it 'by heart' in the fullest sense of this expression, that is, with one's whole being: with the body, since the mouth pronounces it, with the memory which fixes it, with the intelligence which understands its meaning, and with the will which desires to put it into practice."[29] Monastic reading is thus a meditative, attentive, intimate encounter with written language—words that, eventually, through repetition, become the reader's own, incorporated into memory, imagination, and even the body.

If you try this yourself, you can learn *with* the practice instead of just *about* it. Start with a piece of writing—juicy, difficult, or otherwise delicious. It doesn't have to be religious. Break your text into blocks of twenty-five or thirty words. Take the first block and read it aloud. Read it aloud again. Listen to yourself speaking it. Listen to yourself listening to it. If something arises in your mind in response, speak the passage again and examine what comes up. Connect the passage in memory to what arose in answer to it. Listen for sound patterns that will help you remember it. Notice where you make mistakes. Fix them and find hooks in your memory on which to hang the corrections.

Check back in after breakfast to see if the section you started on this morning is still active. Repeat the words quietly as you drive or walk to work. Speak them to the changing scenery: how is your text different in the car, in the woods, in the bathroom? Run through it silently as you wait for the bus. Feel free to move your lips.

It may take as long as six months to memorize a complicated text in this kind of layperson's *meditatio*—a little every day, over and over, building each week on the block laid down the week before, over and over.[30] It is repetitive but, if you like words, the furthest thing imaginable from boring. The piece shows new things about itself with every recitation, and new

things about the world show themselves too, as you speak it to and with your activities.

The meanings that are made, discovered, and invented here come not through research, but through bodily repetition—the very activity of *lectio*. In Cassian's *Collationes*—an essential book for any monastic library, of which multiple exemplars survive in Visigothic hand[31]—this process is understood as experience itself: "Thus we shall penetrate its meaning not through the written text but with experience leading the way" [Ut eorum sensus non textu lectionis, sed experientia praecedente penetremus].[32]

Your practice must be, the early monastic writers love to say, assiduous.[33] Sit down with your text, sit inside it, walk it, work it.[34] You might be surprised to find bits of it slipping into your conversation. Eventually, with practice, it will be yours—and vice-versa. Gregory the Great said it thus in the *Moralia*: "We must transform what we read into our very selves" [In nobismetipsis namque debemus transformare quod legimus].[35] Cassian agrees: "Give yourself over assiduously or rather continuously, to sacred reading, until continual meditation fills your heart, and fashions you so to speak after its own likeness" [Adsiduum te ac potius iugem sacrae praebeas lectioni, donec continua meditatio inbuat mentem tuam et quasi in similitudinem sui formet].[36]

Your reading fills you, takes you over—you are a vessel for it but, as Cassian also makes clear, the boundaries between container and contained are not fixed. It should feel, he says, not only as if the words you're reading "were composed by the prophet" but also "as if they were [your] own utterances and [your] own prayer" [ut eos non tamquam a propheta conpositos, sed uelut a se editos].[37] The book is not now the object of your reading; rather, it is an *agent* of reading every bit as much as you are. In assiduous *lectio divina*, you read a book, you read *in* a book—in order eventually to *become* it.

In his polemical *Adversus Elipandum* (c. 798 CE), Beatus of Liébana tries to convince Elipandus, bishop of Toledo, to read in this way, taking text bodily into the self.[38] Reading is communion without a priest, Beatus argues: "What is this letter that you read in the Gospels or in the other holy Scriptures, but the body of Christ, the flesh of Christ, which is eaten by Christians? And it is eaten when it is read and when it is heard" [Quid est haec littera, quam in Evangelio legis uel in ceteris Scripturis sanctis, nisi Corpus Christi, nisi caro Christi, quae ab omnibus christianis comeditur? Et tunc comeditur, quando legitur et quando auditur].[39]

Read it, eat it, become it: Beatus animates the bready letter of Scripture with a powerful imaginative exercise. "We are what we have received," he begins.

> Remember what this creation was in the field: how the earth engendered it, how rain nourished it, and how it grew to be grain. How later human labor threshed it, winnowed it, gathered it up, carried it off, milled it, and cooked it, and soon enough made it into bread.

> [Quod accepimus, nos sumus. . . . Recordamini, quid fuit creatura ista in agro: Quomodo eam terra peperit, pluuia nutriuit, ad spicam perduxit, deinde labor humanus ad aream portauit, triturauit, uentilauit et recondidit, portauit, moluit et coxit, et uix aliquando ad panem perduxit.][40]

Beatus trains our attention on one particular created thing, a host wafer, and then guides it back to the wheat from which that wafer came, then to the soil that nourished the wheat and the labor that turned wheat to wafer.

Though neither the manuscript nor the modern edition provides a citation, this mystical thought experiment was Augustine's before it was Beatus's.[41] Beatus chewed up the doctor's words thoroughly; they are part of him now, and he brings them home by adding a sentence of his own that effectively digests the quotation and makes everything enumerated in it part of his reader as well as himself. *Hoc totum uos estis*, Beatus concludes: All of this—earth, rain, grain, labor—you are.[42]

Augustine's intimate attention joined the host wafer with the conditions that made it possible: the elements of bread, past and present. Beatus's attentive citation opens the passage still further, to the very present moment of reading, whenever it might be. His coda articulates this bread not only with the world and labor, but also with the body—this body, his body, your body—that consumes it. We are what we eat, and when we chew up and ruminate on a book, we transform it into our very selves.

This is the way Gregory the Great read, and the way Florentius, Gomez, and Leodegundia read, taught by their books and by the daily rhythms of their own lives. On their good days at least, they read hungrily, meditatively attentive not only to the meaning of their reading, but also to the books themselves—their created status, and the human labor that worked those white fields of parchment and plowed those furrows across the page.[43] This is also the way they expected us in turn to read the books they made: attentively,

assiduously, ruminatively. They constructed the books they made to help us read this way, articulating them to foreground their artifactual status and spinning nets out from the created thing to the conditions of its creation and reception—and especially to the laboring bodies that made and use it.

FLORENTIUS AT WORK

If Florentius were to read Beatus's agrihermeneutical thought experiment, he might not identify the repurposed quotation from Augustine, but he would certainly recognize its attentive articulation of a made thing with the conditions of its manufacture. He does the same thing himself in the colophon he composed for the *Moralia* when he reminds us "how heavy is the burden of writing" [quam grabe est scripturae pondus].[44]

Florentius makes Gregory's great commentary inseparable from the cramped fingers that produced it. He draws attention to the way the reader's refreshment depends upon his labor and writes that work explicitly into the codex, where it continues to generate merit and meaning with every re-reading.[45] Remember, the *Moralia* colophon says, what this codex was on the worktable, how a human hand traced the letters, painted the images. Remember unworthy Florentius and his eyes, ribs, back, belly, and kidneys. Remember your fingers, too.

The monastic understanding of work and reading underpins and directs the way these scribes think about what written language is and what it does. For them, their laborious writing is itself a form of reading: their practice, as Claudia Rapp observes, is "*lectio divina* with the pen."[46] Such manual *lectio* so nourished Taio of Zaragoza that he chose not to pass the project of copying the *Moralia* to a secretary. He copied them with his own hand for the full-body understanding that such labor makes possible, "so that such sweetness of words might delight my soul with immeasurable charm" [tantaque dulcedo uerborum animum meum inextimabili suauitate mulceret].[47]

Florentius of Valeránica copied these words on f. 14v of his *Moralia*, perhaps experiencing some contact nourishment himself as he did so. In Chapter 1 we saw that the scribal frame within which Florentius sets his book is in deep dialog with the way that Gregory himself roots that massive commentary in his own body and biography. If Florentius was as devoted a practitioner of *lectio divina* as he certainly was of *scriptio*, then he learned

to live with written language from Gregory, whose works and work passed through the scribe's mind and body to the page as he wrote, on what is now f. 26v of BNE MS 80, that "we must transform what we read into our very selves" [in nobismetipsis . . . debemus transformare quod legimus].[48]

Florentius learned from Jerome, too. On f. 4v of the *Moralia*, he laid out a luminous incipit in red-bordered majuscules on banners of deep yellow and green announcing "the Prologue of St. Jerome in the book of Holy Job" [PROLOGUS BEATI IHERONIMI IN LIBRO SCTI IOB]. If, as he copied, the scribe were reading Jerome's preface as attentively as he read Gregory, he might have seen his own labor described in the words that passed from eye to mind and hand to page:

> If I were to weave a basket from rushes or to plait palm leaves, so that I might eat my bread in the sweat of my brow and work to fill my belly with a troubled mind, no-one would criticize me, no-one would reproach me. But now, since according to the word of the Savior I wish to . . . purge the ancient track of the divine volumes from brambles and brush-wood, . . . it is said that I do not remove errors, but sow them. . . . So, therefore, Paula and Eustochium . . . in place of the straw mat and the little rush baskets, the small presents of the monks, receive these spiritual and enduring gifts.

> [Si aut fiscellam iunco texerem aut palmarum folia conplicarem, ut in sudore uultus mei comederem panem et uentris opus sollicita mente tractarem, nullus morderet, nemo reprehenderet. nunc autem quia iuxta sententiam saluatoris uolo . . . antiquam diuinorum uoluminum uiam sentibus uirgultis que purgare, mihi . . . errores non auferre, sed serere. . . . Quapropter, o Paula et Eustochium . . . pro flauello, calathis sportellis que, munusculo monachorum, spiritualia haec et mansura dona suscipite.][49]

Jerome represents himself toiling over the page to ensure that his readers know that he too earned his bread by manual labor. If my work were more obviously sweaty, Jerome tartly observes, I might not be criticized. But look, language work is just as hard as fieldwork: I'm cutting back the brambles of accumulated error, I've plaited this book-basket, woven these lines to catch your attention.

Similarly, the *Moralia* colophon's great lesson in the somatics of *scriptura* goes to great lengths to show the reader that the bread Florentius ate

was earned by the sweat of his brow. It is not impossible that the scribe understood through Jerome's words his own work of plaiting interlace, weaving text, and driving the pen across the page. Perhaps Florentius saw in the harmonies of the three frames he set around the *Moralia* a similar sort of weaving—in place of Jerome's metaphorical little rush basket, a carefully woven codex.

From Jerome, then, as well as from a life lived with Valeránica's *codex regularum*, Florentius learned to feel the plow in the pen and to think of intellectual and agricultural labor in the same metaphorical terms. The anatomical precision and vivid verbs of the *Moralia* colophon inscribe the burden of writing in the reader's imagination in the most corporeally vivid terms possible:

> One who knows little of writing thinks it no labor at all. For if you want to know I will explain to you in detail how heavy is the burden of writing. It makes the eyes misty. It twists the back. It breaks the ribs and belly. It makes the kidneys ache and fills the whole body with every kind of annoyance.

> [Qua qui nescit scribere laborem nullum extimat esse nam si uelis scire singulatim nuntio tibi quam grabe est scribture pondus oculis caliginem facit, dorsum incurbat, costas et uentrem frangit, renibus dolorem inmittit et omne corpus fastidium nutrit.][50]

This hard labor, Florentius says, is the condition for the reader's refreshment. But if you read your monastic rule carefully, you will see that reading is no vacation either. Thus Isidore:

> If anyone wants time for reading so as not to work, they are in opposition to the same reading because they do not do what they read there. For it is written, "Let those who work eat their own bread" (2 Thess 3:12) and again, "for you know how you ought to imitate us, for we were not disorderly among you, nor did we eat any man's bread for nothing, but in labor and in toil working day and night lest we be a burden to any of you" (2 Thess 3:7–8).

> [Qui sic uolunt uacare lectioni ut non operentur, ipsius lectionis contumaces existunt, quod non faciunt quod ibi legunt. Ibi enim scriptum est: operantes, inquit, suum panem manducent; et iterum: ipsi enim scitis

quomodo opportet imitari nos quia non inquieti fuimus inter uos neque panem gratis ab aliquo manducauimus sed in labore et fatigatione die et nocte operantes ne quem uestrum grauaremus.][51]

If you read, you'll see that you must work. But *lectio* is not only a matter for the eyes and mind, but also for the lips and tongue, hands and fingers, back and neck. Reading is bodily as well as intellectual work.[52] This is what drives the extended development of *opus* and *labor* together with their verb forms in the *Moralia* colophon:

> The labor of the scribe is the refreshment of the reader: one damages the body, the other benefits the mind. Whoever you are, therefore, who benefit from this work, do not neglect to remember the working laborer: and so may God, thus invoked, forget your faults.

> [Labor scribentis refectio est legentis, hic deficit corpore ille proficit mente quisquis ergo in hoc proficis opere operarii laborantis non dedignemini meminisse ut Dominus inuocatus inmemor sit iniquitatibus tuis.][53]

Manual labor and interpretive work are here not two separate realms of activity. And the reader's refreshment? It does not come without some exertion.

Florentius, you'll remember, led us into his *Moralia* through a lettered labyrinth (Plate 3). We stayed with it in Chapter 1 just long enough to see its scattered letters resolve into a prayerful request to "remember unworthy Florentius." If we are the attentive monastic readers that Florentius expects—and to a certain extent trains—us to be, then to turn the page once we have deciphered that message is to be, as Isidore would say, in opposition to our reading (*ipsius lectionis contumaces*).[54]

"Theorists and teachers of *lectio divina* concern themselves more with the process of reading than with its result," observes Duncan Robertson in his recent introduction to the practice.[55] Thus, the process of engaging assiduously with Florentius's labyrinth is, in fact, as much about the engagement itself as with the linguistic meaning of the encoded text.

The apparently random arrangement of letters in Florentius's labyrinth reveals its sense slowly and only if you carefully arrange the letters into sense, then shuttle that sense over and over. FLORENTIUM INDIGNUM MEMORARE: the single phrase makes of itself both warp and woof, and repeats

in every imaginable direction, up and down, side to side, stepwise and in straight lines.

In the colophon, Florentius cautions readers not to use their fingers to trace paths through his pages, but it's hard to resist. When I wanted to make the count myself, I printed out a copy of the image and started marking it up with colored pencils. Letting myself be led by the traces left by Florentius's pen, I was engaging with his *ductus* not only paleographically but also rhetorically. *Ductus* in this latter sense has been defined by Mary Carruthers as "the way by which a work leads someone through itself: that quality in a work's formal patterns which engages an audience and then sets a viewer or auditor or performer in motion within its structures, an experience more like traveling through stages along a route than like perceiving a whole object."[56]

Once I saw that the phrase FLORENTIUM INDIGNUM MEMORARE rolls out stepwise as well as in straight lines, it was clear that reckoning the number of possible repetitions went well beyond my abilities. I stopped making colored lines and hatch marks and referred the problem to a friend with the right skills. He wrote a computer program and set it to trace all possible paths of Florentius's prayer. The result is Borgesian in its vastness: in this grid of 260 letters the phrase is repeated . . . *354,200 times.*[57]

No mortal unassisted by a counting machine could possibly arrive at this total. But what is likely is that a monastic user trained by *lectio divina* to think of reading less as page-turning forward movement than as a recursive, repetitive exploration would have come to feel that the labyrinth's apparently infinite permutations made it an inexhaustible, near-miraculous generator of prayer. Florentius's shuttling prayer can lead the attentive user of this page into something very like *meditatio.*

The labyrinth page is nothing short of a machine for spiritual and intellectual work.[58] Carruthers again: "The interior way of meditation . . . and its dependence on a basic model of thought as a restless, unceasing activity, requir[es] instruments, machines which can lift the mind and channel its movements, however variously, towards its destination."[59] Three bodies are articulated when a meditative reader engages with a bookish *machina* like this—the reader's, of course, but also the writer's, connected by the parchment body of the completed codex. Hands (perhaps) upon the page, lips moving, eyes following the path of the shuttling inscription, readers participate in the manuscript book both intellectually and bodily—just as

the theorists of *lectio divina* would have us do with scripture or authoritative commentary, and just as the meditating writer did during its design and execution.

GRAMMATICA AND THE THEORY OF MANUSCRIPTION

Write in your heart, and like children who learn the first elements of letters, and teach their trembling hand the curved outlines upon a wooden tablet, and become accustomed to writing through skillful meditation . . . write what I say in the tables of your heart and in the wooden tablets of your breast.

[Scribe in corde tuo et quasi paruuli, qui prima elementa accipiunt litterarum, curuos apices et trementem manum in buxo erudiunt et ad recte scribendum meditatione consuescunt, ita tu quoque . . . in tabulis cordis tui et in buxo pectoris scribe quod dico.]

Jerome, *In Abacuc*, I.2

To engage body and mind in the study of this or any other alphabetic labyrinth, of course, a monastic had to know how to read—at least well enough to metaphorically write the word into what Jerome, engaging his own memory of 2 Corinthians 3:3, called the tables of the heart and the wooden tablets of the breast. Ferreolus of Uzès found grammatical study important enough to write it into his monastic rule: "One who wants to claim the title of monastic," he writes, "must not be ignorant of letters" [Omnis qui nomen uult monachi uindicare, litteras ei ignorare non liceat].[60]

Letters, of course, are handwritten for these writers. As students working to shape and sound them, they would have learned much more than a writing system and hand-eye coordination. To write by hand and to read handwritten writing is to move into the habitation of letters and be inhabited by them in a way profoundly different from that generated by print.[61]

Scripts and writing systems, says David Damrosch,

profoundly shape the thought world of those who employ them, not for ontological reasons grounded in the sign system as such but because scripts are never learned in a vacuum. Instead, a writing system is often the centerpiece of a program of education and employment, and in learning a script one absorbs key elements of a broad literary history: its

terms of reference, habits of style, and poetics, often transcending those of any one language or country.[62]

Learning a script, monastics also learned a lettered habitus. The deeper they went in literate study and practice, the more profoundly they were made over in body and imagination. Everything that a highly skilled scribe like Leodegundia or Florentius had learned with and about written language would, by the time they set pen to the first gathering of a great commission like the *Moralia* or a *codex regularum*, be "embodied history, internalized as second nature."[63] The complex articulation of the written artifact with time, place, and the bodies of its makers and users that we see in these great codices is a manifestation of this habitus.

In the grammar classroom, young monastics learned a lettered way of being in their bodies and a thoroughly embodied way of thinking about language. Ivan Illich imagines the class in vivid detail:

> When the father offered his child at the Porter's Lodge to receive instruction, the little one was already acquainted with Latin sounds. . . . [He] learned his words from the traces that the stylus left in the beeswax he had smoothed on his writing tablet before class. . . . As the teacher dictates to the pupil, the pupil dictates to his own hand. The *deogratias* which was a familiar utterance now takes on the shape of two successive words. The single words of Latin impress themselves as a sequence of syllables on the ear of the pupil. They become part of his sense of touch, which remembers how the hand moved to cut them in the wax. They appear as visible traces which impress themselves on the sense of sight. Lips and ears, hands and eyes conspire in shaping the pupil's memory for the Latin words.[64]

The pedagogical scene comes from Illich's imagination, but ancient writers have done much of the descriptive work for him already.[65] In one of his letters, Jerome prescribes an equally embodied grammatical pedagogy for the daughter of his friend Laeta.[66] Little Paula, Jerome says, should learn letters first as sounds, in a singsong rhyme. She learns them too, through touch, as she makes word-houses with letter-shaped blocks of box or ivory.[67]

Paula's hand is not yet strong enough to trace letters and join them into words, so the teacher is advised to "either guide her soft fingers by laying your hand upon hers, or else have simple copies cut upon a tablet; so that her efforts confined within these limits may keep to the lines traced out for

her" [cum uero coeperit trementi manu stilum in cera ducere, uel alterius superposita manu teneri regantur articuli uel in tabella sculpantur elementa, ut per eosdem sulcos inclusa marginibus trahantur uestigia et foras non queant euagari].⁶⁸ Paula's childish *ductus* follows on the trace of other hands, both inhabiting and inhabited by them.

Touch, sight, and hearing, then, made letters not abstract concepts but rather part of grammar students' experience of the world and of their own bodies. Jerome is quite explicit that Paula's lessons assemble *her* even as she assembles written words from their component syllables.

> The very words that she tries bit by bit to put together and to pronounce ought not to be chance ones, but names specially chosen for the purpose. . . . In this way while her tongue will be well-trained, her memory will be likewise developed.

> [Ipsa nomina, per quae consuescet paulatim uerba contexere, non sint fortuita, sed certa et coaceruata de industria . . . ut, dum aliud agit, futurae memoriae praeparetur.]⁶⁹

Learning to letter makes Paula a lettered subject. She has formed her body to letters, and her character (from Greek *kharassein*, to engrave) is likewise inscribed by the words she learns and the process of learning them.⁷⁰

Jerome directs this lettering of character explicitly toward literary spiritual practice in his commentary on the book of Habakkuk. To show us how attentively he wants us to read, he summons our memory of learning to write. When you read, Jerome says, you should

> write in your heart, and like children who learn the first elements of letters, teach their trembling hand the curved outlines upon a wooden tablet, and become accustomed to writing through skillful meditation; even so . . . write what I say in the tables of your heart and in the wooden tablets of your breast.

> [scribe in corde tuo et quasi paruuli, qui prima elementa accipiunt litterarum, curuos apices et trementem manum in buxo erudiunt et ad recte scribendum meditatione consuescunt, ita tu quoque . . . in tabulis cordis tui et in buxo pectoris scribe quod dico.]⁷¹

As grammar and *lectio divina* are merged here, so too they work together in the habitus of attentive monastic writers like Leodegundia and Florentius.

When Florentius writes about making another codex (the Homiliary, now MS 1 in the cathedral archive of Córdoba, studied in Chapter 3), he presents the undertaking through a pedagogical scene in which spiritual and literary formation go hand in hand. "I was prompted in this work," he says, "by my Lord Jesus Christ, choosing very freely to accept as master in this work one whom the learning of writing made my teacher from the first lessons of my earliest youth" [iniungente mici opus domino meo Ihu Xpo eligens presertim liuenter hoc in opere habere dominum quem eruditio huius scriptionis mici ab infantiae meae rudimento extitit pedagogum].[72]

But *grammatica* was not just about learning to write. From their textbooks, once they could read them, monastics would learn how to think about and with letters.[73] Since the letters they wrote were made by hand, the hand is inseparable from both the experience of letters and any ideas the writers had about them. From both grammar books and their own practice they would learn a theory of writing as manuscription. They made that theory material in the books whose gatherings they filled with writing and whose relations with the world they articulated, page by slow page.

VOX IS ARTICULATE

In modern English, the most-ready association of the word *articulation* is with the human voice and "the utterance of the distinct elements of speech."[74] When Leodegundia, Florentius, and their monastic brothers and sisters studied elementary written Latin in the monastery, however, they would have learned that articulation is fundamental not only to the spoken but also to the written word. *Vox*, after all, means "word" as well as "voice." Our young monastics would have been taught that the most articulate voice is in fact heard (as it were) in writing. If the *Artes* of Donatus were used in their grammar classroom as they were in so many monasteries,[75] Leodegundia and Florentius would have learned that "every *vox* is either articulate or confused. If articulate, it can be captured in letters. Confused sound cannot be written" [Omnis vox aut articulata est aut confusa. Articulata est quae litteris comprehendi potest, confusa quae scribi non potest].[76]

An articulate *vox*, says Donatus, is a sound that can be grasped—the Latin says *comprehended*—in letters. "Why is it called articulate?" asks the student in the *Ars grammatica* attributed to Julian of Toledo (c. 680–87). The teacher answers: "The principal members of the human body are called

artus, and the smaller members *articuli*, like for example the fingers. And anything that can be grasped by these writing *articuli* is itself an articulate *vox*" [Quare dicta articulata? artus dicuntur membra maiora hominum, et articuli membra minora, ut sunt digiti, et quidquid per istos articulos scribentis conprehendi potest ipsa est uox articulata].[77]

From the very beginning, the monastic student learned that letters are not just inert marks. Letters join the voice with page and hand; like the hand, they too can be understood as articulate bodies. Priscian explains in his *Institutiones* (also a staple of the grammar classroom) that the ancients "called letters 'elements' with an eye to the similarities with the elements of the world" [literas autem etiam elementorum vocabulo nuncupaverunt ad similitudinem mundi elementorum].[78] As, in the material world, elements combine to form bodies, so voice and trace conjoined in writing "compose sound made up of letters as if it were a body." No, not *as if*, Priscian immediately qualifies, "rather *as a real body*" [coniuncta literalem vocem quasi corpus aliquod componunt *vel magis vere corpus*].[79]

VOX IS A HAND

And sometimes also the very work done by someone's hand is called their hand; as one is said to recognize a hand when they recognize what someone has written.

[Aliquando et ipsum opus hominis, manus hominis dicitur quod fit per manum; sicut dicitur quisque agnoscere manum suam, cum id quod scripsit agnoscit.]

Augustine, *In Iohannis euangelium*, XLVIII.7

If words are bodies, it makes sense that they should be built like bodies. The *Explanationes in arte Donati* attributed to Servius (c. 450 CE) explain that the *literalis vox* ("scriptible language," in Martin Irvine's happy translation)[80] is called articulate because it is "subject to joints, that is, the fingers that write" [subest articulis, id est digitis, qui scribunt].[81] Thus the *vox articulata* is now not so much stricken air[82] as it is a meaning-making *machina* like unto a jointed body. Explains Isidore of Seville:

The joints are so called because being bound to each other by the tendons, they are drawn together, that is, they are bound tight. The diminutive

form of *artus* is *articulus*; we use the word . . . *articulus* in reference to minor limbs like the fingers.

[Artus dicti, quod conligati invicem nervis artentur, id est stringantur; quorum diminutiva sunt articuli. Nam artus dicimus membra maiora . . . articulos minora membra, ut digiti.][83]

What Isidore might call the *vis* or force of the hand comes precisely from the binding and drawing together of the fingers. Articulated into the hand, the digits become a machine that gives material voice to the *vox articulata*.

This manual machination is in fact the dominant trope of a grammatical parable told by Terentianus Maurus (c. 300 CE) in the preface of his verse grammar *De litteris*. Once upon a time, says Terentianus, there was an aged athlete who devised a curious exercise to keep himself in shape. "He connected to each other fine pieces of string" [nervis mollibus invicem / iunctis in teretem struem][84] until together they made a line long enough to drop down into a well. The poet is interested not so much in the bucket of water that can be drawn up by means of that line as he is with the operation of making and extending it, a process that sounds in his description very much like the writer's work. From those bits and pieces of string the old man plaited "such a fine line / that it couldn't be gripped with the full palm of the hand" [tam filo tenui trahens, / quod stringi nequeat vola]; Terentianus Maurus, *De litteris* praefatio, lines 25–26]. Feeding the line into the well isn't easy. It can only be done

by concentrating the efforts from all parts of the body
in the tips of his fingers.
And holding a tight grip

. . .

by the alternate pinching with his thumbs
he struggled to prevent the easy escape
of the weight into the depth.

[nisus undique corporis
summos in digitos agit;
angusto que tenaculo

. . .

alterna vice pollicum
certat vincere ponderis
in praeceps facilem fugam.][85]

In Terentianus's parable of writing, the line of letters is a palpable thing, whose vitality the old man's hands struggle to direct according to his will. This is not an easy task. If you want to know how hard it is, I will tell you: three fingers write, but the whole body labors.

> You may think he did not do anything of importance
> and that the effort was in his fingers only.
> Yet in all the innermost parts of his body
> the hidden effort is aquiver. . . .
> Nothing is left unaffected,
> And yet all these powers have but a small outlet.

> [Nil magnum gerere hunc putes,
> et tantum in digitis opus;
> cunctis visceribus tamen
> occultus trepidat labor . . .
> nil immune relinquitur,
> et parva est via viribus.][86]

Terentianus's little story ties together things that we have noticed about the activity of the articulate codex. Articulation (*invicem/iunctis*, lines 15–16) happens at both ends of the literate relation, though writer and reader do their separate work at different times and on different materials. The writer knots words together and unspools the line—down the well, as in Terentianus's parable, or across the page. Or, as Jerome would have it in his figural meditation on monastic labor, into the stream: "Let nets be also woven for catching fish, and let books be copied so that your hand may earn your meals and your mind be nourished with reading" [Texantur et lina capiendis piscibus, scribantur libri, ut et manus operetur cibos et anima lectione saturetur].[87]

For the mind to be thus satisfied, the reader must first analyze—that is, etymologically, untie—the individual words from the line of letters and collect them anew into a signifying whole. As Servius explains in his commentary on Donatus, "Whatever is read is *vox articulata*. If you unravel that which is joined together in reading, you produce discourse" [praeterea quidquid legitur articulatae uocis est. hoc si resoluas, quod in lectione conligatum est, sermonem facis].[88]

Writing extends one line and then goes back to spool out another; reading loosens, then reweaves, the net. This recursive flirtation with erasure is

an essential characteristic of the grammarians' understanding of lettered practice.[89] It is etymologically (and thus, for the Isidorean Middle Ages, ontologically) built into letters themselves, according to Priscian and everyone who quotes him in the Middle Ages. The letter, they say, "is called *littera* either as a *legitera* ['reading-road'], because it provides a path for reading, or derived from *litura* ['erasure'], as some prefer, because the ancients used to write mostly on wax tablets" [Dicitur autem litera vel quasi legitera, quod legendi iter praebeat, vel a lituris, ut quibusdam placet, quod plerumque in ceratis tabulis antiqui scribere solebant].[90]

Isidore of Seville takes Priscian up and leads him further down the line: "Letters are so called as if the term were *legitera*, because they provide a road for those who are reading, or because they are repeated in reading" [Litterae autem dictae quasi legiterae, quod iter legentibus praestent, vel quod in legendo iterentur].[91] Isidore reiterates: reading is recursive. There the letters are on the page when you come back to read them again, showing you the way. The practice is especially recursive when you read meditatively, rereading, ruminating, memorizing. Moving into the habitation of letters, moving with them along their track, is understood as something fundamentally iterative. If your teacher followed Jerome's advice and guided your little hand with their own, such doubled *ductus* was built into your earliest memory of making letters.

The grammarians' theory of writing is built upon the hand and its activity. Not just in the obvious and necessary sense that before the printing press, letters can't happen without it. For the grammarians, the hand is not only the agent of writing, but also a model for what writing *does*.[92]

The hand is jointed. It is made up of digits—separate units that work together because they are articulated. The *articuli* work together to do something—to reach out, to grasp, to build, to make. The hand is also good for pointing; so too in grammatical theory is manuscription. Articulate *voces* point to things; handwriting points back to the hand that made it. "Sometimes," says Augustine in his *Tractate on John*, "the very work done by someone's hand is called their hand; as one is said to recognize a hand when they recognize what someone has written" [aliquando et ipsum opus hominis, manus hominis dicitur quod fit per manum; sicut dicitur quisque agnoscere manum suam, cum id quod scripsit agnoscit].[93]

Both *vox* and manuscript letter, that is to say, are *indexical*. They point, as with a finger, as smoke points to fire, as footprints point to feet.[94] Isidore

of Seville does not hesitate to borrow from every book in the library, but this part of the definition of letters in the *Etymologies* seems to be from his own hand:

> Indeed, letters are the tokens of things, the signs of words, and they have so much force that the utterances of those who are absent speak to us without a voice, for they present words through the eyes, not through the ears. The use of letters was invented for the sake of remembering things, which are bound by letters lest they slip away into oblivion.

> [Litterae autem sunt indices rerum, signa verborum, quibus tanta vis est, ut nobis dicta absentium sine voce loquantur. Verba enim per oculos non per aures introducunt. Usus litterarum repertus propter memoriam rerum. Nam ne oblivione fugiant, litteris alligantur.][95]

Bookish monastics in tenth-century Iberia would surely have known this definition well. Perhaps repeated schoolroom recitation bound it into their memory. If, like Leodegundia or Florentius, they were particularly skilled with a pen, they might have incorporated this way of thinking about writing through the body-memory of copying.[96] A scribe named Aeximino knew this definition stroke by stroke, and was present in body and mind as it played out in the *Etymologies* he completed for San Millán on August 20, 946 CE. You can see his hand at work right now on f. 22r of the codex now held in Madrid's Real Academia de la Historia as MS 25 (Figure 7), as he writes Isidore's definition. Every time Aeximino makes the "l" of *litterae*, he gives it the extra dignity of height: you can easily pick it out by the tall ascender.

Returning with Aeximino to Isidore's definition of letters, and remembering that *res* means both thing and meaning, we might gloss this page thus: a handwritten letter on the page ties both meaning and things to presence in the present. Like the hand on which it depends, the written word is a body extensible in space; like the human memory so frequently invoked by these colophons, it is extensible through time. Written words are thus also articulate because their spatiotemporal extension joins absence with presence; graphic traces of the *indices rerum*, they weave here to there, now with then.

The lettering hand points back to the scribe himself on f. 160r of Aeximino's *Etymologies*, where a title announcing book IX is surrounded by a

Figure 7. "Letters are the tokens of things, the signs of words." Madrid, RAH, MS 25, f. 22r detail. By permission: Real Academia de la Historia.

circular band bearing, in small red capitals, the inscription + AEXIMINO ARCHIPRESBITER SCRIBSIT OB HONOREM SANCTI EMILIANI DIRCETII (Figure 8). Aeximino was here. Letters point to things, Isidore says; as indexical signs, they have a powerful connection to their things, for presence- and for present-making.

In manuscript culture, letters index the finger that traced them as well as the referent to which they point. How good it is, wrote Seneca the Younger, to get a letter, and see upon its pages "real traces, real evidences, of an absent friend! For that which is sweetest when we meet face to face is afforded by the impress of a friend's hand upon his letter" [iucundiores sunt litterae, quae vera amici absentis vestigia, veras notas adferunt? Nam quod in conspectu dulcissimum est, id amici manus epistulae inpressa praesta].[97]

Figure 8. Archpresbyter Aeximino wrote it. Madrid, RAH, MS 25, f. 160r detail.
By permission: Real Academia de la Historia.

Look again at Aeximino's self-identification on f. 160r (Figure 8). Here
are Seneca's "real traces," left by a living hand that drew the line of ink across
the page. The reader of the handwritten text can be haunted by the sense that
the writer's body is somehow right *here*, hovering just beyond the reader's
sight. Lacking that body, the letter—trace or epistle—must suffice. Isidore
of Seville to his friend Braulio: "When you receive a letter from your friend,
dearest son, you would not hesitate to embrace it in place of your friend.
When friends are separated, the second best consolation, if the beloved
one is not present, is that his letters should be embraced in his stead" [Dum
amici litteras, charissime fili, suscipis, eas pro amico amplecti non moreris.
Ipsa est enim secunda inter absentes consolatio, ut si non est praesens qui
diligitur, pro eo litterae amplexentur].[98]

As the letters are repeated in reading, so too is the gesture of articulating them with the *res*. Both meaning and material things are simultaneously present and absent in the inscription; so too is the writer who sets the encounter in motion. Bound together by syntax, formed by the joints of the hand, spun in lines across the page, handwriting *articulates*. When realized (over and over again) in reading, handwritten letters join the presence entailed in face-to-face speech with a here and now far removed from it: the present moment of reading.

The letters written by these scribes throw out a line to future readers—to us, wherever we might be. Holding that line in our hands as we read, we find ourselves, as Jasper Svenbro wrote of the ideal reader constructed by ancient Greek epitaphs, "before a written word that is present in the absence of the writer." Svenbro continues: "Just as he foresees his own absence, the writer foresees the presence of his writing before the reader. The reading constitutes a meeting between the reader and the written marks of someone who is absent. The writer foresees that meeting, plans it carefully."⁹⁹

Manuscription thus creates its own uncanny temporality: an extensible present that stretches from the *dicta absentium* forward through every encounter of eyes, tongue, and mind with the marked-up page. It is an iterative present: every time the language is undone and redone under a reader's eyes, the writer's *now* begets another: the *now* of reading. And that reading always happens with this very thing: this piece of parchment marked with ink. Aeximino rested his forearm on this page (Figure 8). He sat in front of it just the way you can sit in front of it at the Real Academia de la Historia in Madrid.

Aeximino concludes his work on the *Etymologies* on August 20, 946—that is to say *right now*, if you're attentively engaged with his work—by writing a poem and a colophon at the very bottom of f. 295v (Figure 9). These two texts articulate the page and the laboring body that made it with you and your moment of reading.

A quickly drawn little frame at the very bottom of the page draws your eye first to the poem. A double acrostic laid out in two columns, it is an intricate piece of letter-weaving. The first letter of every line in both columns and the last letter of every line in the second column are picked out in red. Those letters together spell EXIMINO ABBATIS SCRIVAE.

Figure 9. Colophon-poem. Madrid, RAH, MS 25, f. 295v detail. By permission: Real Academia de la Historia.

The beginning of the poem quite literally articulates the laboring body of the abbot's scribe Aeximino, the page he made, and you, sitting bodily before it:

Oh you alertly sitting, behold the face of the page.
And here are my two tired limbs
With all my goods mixed in, I am joined to this.

[EN ORA PAGINIS ALACER INSEDENS

XISTENTESQUE FESSOS BIS MEIS ARTUS SIC

INMIXTIS OMNIBUS BONIS ADIUNGIER][100]

The scribe's tired joints are joined to this—and to you, sitting here, paying attention. (Florentius hopes you're using your own hands thoughtfully.)

The scribe's *now* is named in the colophon, written in alternating black and red letters five lines above the poem:

The Book of Etymologies was completed era DCCCCLXXXIIII, on the XIII of the kalends of September [= August 20, 946], during the XXIII run of the lunar cycle, on the XIX of the moon. Reigning King Ranimirus in León, and Garsea Sanctio in Pamplona, and Gomesano being abbot ruling the monastery of San Millán at Mount Distercio. Pray for the scribe, archpresbyter Eximino, if you have God the protector anywhere in your prayer.

[EXPLICITUS EST LIBER ETHIMOLOGIARUM ERA DCCCCLXXXIIIIA
XIII KALENDAS SEPTEMBRIS LUNE CURSU DISCURRENTE XXIII LUNA
XVIIIIA REGNANTE REGE RANIMIRO IN LEGIONE, ET GARSEA SANCTIO
IN PANPILONA. GOMESANI DENIQUE ABBATI SANCTO EMILIANO DIRCETII
MONASTERII REGENTI. Ora pro scribtore Eximinone archipresbitero, si
deum ubique protectorem habeas tuo in uoto.][101]

The elaborate synchrony of the dating here repeatedly links this page
to a geographical place (the monastery of San Millán de la Cogolla), a
point in time figured doubly by lunar cycles and the Roman calendar
and living persons—two kings (Ramiro of León and García Sancho of
Pamplona), the reigning abbot of San Millán, and the scribe himself. The
final lines of the colophon wrap round the frame enclosing the acrostic.
Like the poem, they articulate us and our work with Aeximino and his.
They *conscript* us. "Read happier, that you may be happier," they say. "Life
to the reader and to the possessor" [LEGE FELICIOR, UT SIS FELICIOR. LEGENTI
AC POSSIDENTI VITA].

As Leodegundia did at Bobatella in the year 912, Aeximino concludes
by throwing a line to the future. Leodegundia imagined the page beneath
her pen bound into a book; so does Aeximino. He sees that book pass
through the hands of owners and readers. If he were able to read twenty-
first-century thing theory, he'd agree that the book he made is not an ob-
ject but a thing, a meeting place for human (and nonhuman) users as it
moves through time.[102] The line he throws out from 946 CE is, happily, a
wish that we live long and happy lives.

Let us return in conclusion to the labyrinth with which Florentius inau-
gurates his copy of the *Moralia* (Plate 3). Here, both grammatical articula-
tion and the interior rumination of *lectio divina* are seamlessly merged. The
indices filling this page point to the hand that laid them out here, line after
line. Through them, the absent scribe speaks to us. The voice isn't audible,
but it is articulate, just as the grammarians taught. It is grasped by the joints
of the writer, then sounded out by our own mouths and (perhaps) fingers, as
we, as Florentius expected, follow the *leg-iter* over and over—thousands of
times if we have the patience—binding unworthy Florentius to our fingers
and our memory, lest he slip away into oblivion.

The carefully designed and executed pages we have studied here were
made for us and for our use; they are what Jerome called "a little monastic

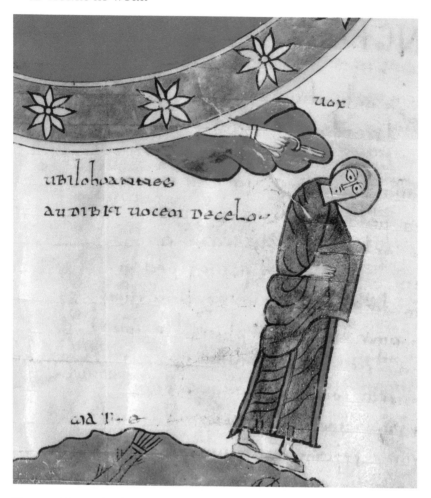

Figure 10. Vox is a hand. La Seu d'Urgell, Museu Diocesà, no shelf no., f. 132v detail. © MDU Museu Diocesà d'Urgell. Used by permission.

gift" [munusculo monachorum][103] in the text that Florentius copied on f. 4v of his *Moralia* with a community of future readers in mind. That present is the fruit of hard manual, intellectual, and spiritual labor—making such gifts, declares Jerome grouchily, is even harder than weaving baskets from rushes or mats from palm leaves. In a monastic context, these are all elaborately woven machines for reading trained on *lectio divina*. What machine, basket, mat, and codex have in common is that they are all artifacts made by people to do things. They are made of conjoined parts that work

together—like the hand, that great anatomical machine whose activity makes these codices possible.

Vox is a hand, and so, for these scribes, is the handmade codex. The tenth-century painter of Apocalypse commentary now at the cathedral of La Seu d'Urgell knew that well. To represent the divine speech to prophets eventually written in the great library that is the Bible, he or she painted a hand emerging from a starry cloud and pointing at the tilted head of a human figure. The hand is labeled with a *titulus* that floats above it on the bare parchment. The hand is labeled *vox* (Figure 10).

Voice and word are both a hand because both are articulate. And, finally, a codex is a hand because it points to its own manufacture in place and time and reaches for its readers in *their* respective place and time. Remember unworthy Florentius. Remember the hand. Remember the index (it points to the scribe). Remember the index (it points to you).

CHAPTER 3

THE GARDEN OF COLOPHONS

Now, having spent some time working alongside early Iberian monastics, we can return to the codices that Florentius made and the lines he spun to articulate them with the circumstances of their production and use. The five codices from Florentius's hand of which we have notice contain significant first-person interventions. Three of them can be read from start to (almost) finish—the *Moralia* (Madrid, BNE, MS 80), which we have already explored; a Homiliary (Córdoba, AC, MS 1); and a Bible (León, San Isidoro, MS 2). Early modern scholars also recorded the colophons from two other books from his hand, now unfortunately lost—another Bible and a copy of Cassiodorus on the Psalms.

Following Florentius at work in these codices, in this chapter we taste the results of monastic reading—not only of the books Florentius was enjoined to copy, but also of the work of scribal colleagues in other Castilian monasteries. We shall see that, if monastic reading and writing are metaphorically forms of agricultural labor, then the best scribes in the monasteries of early medieval Castile understood their work as a common garden and used one another's words to write about their shared work of plowing parchment with a pen.

We begin with Florentius's first-person interventions in the Córdoba Homiliary and the fragmentary Oña Bible. Then the central portion of the chapter will study the complex back-and-forth as Florentius and scribes at other monasteries read and repurpose one another's work. Watching these scribes work in each other's gardens, our concern will not be to determine who is copying whom, but rather simply to observe these writers reading each other, making what they read their own, and writing their codices into the world around them. Then, to conclude, we return to Florentius and one of his students as they articulate a massive illuminated Bible with the world in the year 960 (León, San Isidoro, MS 2).

Let us begin by reading over Florentius's shoulder as he finishes one of the early pages of the *Moralia*. We know him now to be a particularly attentive

writer for whom copying was not simply a mechanical task. In Chapter 2 we watched him weave a little metaphorical basket with Jerome on f. 4v of this very manuscript. Now, on f. 5r, he's writing this:

> Let those who want them have their old books copied on purple parchment with silver and gold, or with uncials, as the people say; these are more burdens inscribed with letters than codices. Just let them leave to me and mine our poor papers and codices—not beautiful but well-emended. Each version [of the text]—that of the Septuagint according to the Greeks and my own according to the Hebrews, has been translated into Latin by my labor. Let everyone choose what they like, and find me to be more studious than spiteful.

> [Habeant qui uolunt ueteres libros uel in membranis purpureis auro argento que descriptos, uel uncialibus, ut uulgo aiunt, litteris onera magis exarata quam codices, dum mihi meis que permittant pauperes habere scidulas et non tam pulchros codices quam emendatos. utraque editio, et septuaginta iuxta graecos et mea iuxta hebraeos, in latinum meo labore translata est. eligat unusquisque quod uult et studiosum me magis quam maliuolum probet.][1]

The glorious peacock that occupies the entire facing page (Plate 4) indicates that Florentius chose to overlook Jerome's scorn for beautiful codices. He did, however, take Jerome's words to heart, for the two writers share a common project. This text has been translated by my labor, they both declare. *Meo labore translata est*, they write; my work moved this from one language, one page, to another. The great lesson in the somatics of *scriptura* with which Florentius's *Moralia* concludes anchors this declaration in the maker's laboring body. Florentius will tell us that, whatever else codices may be, they are certainly, as Jerome would say, "burdens inscribed with letters."

Further evidence of the intimacy of Florentius's relation with Jerome's words can be found in another book that was the product almost entirely of his own hand—the collection of Homilies now MS 1 in the cathedral archive of Córdoba.[2] The Homiliary is sparsely illuminated, but Florentius's hand, as we might now expect, calls attention to its activity in spectacular ways. The scribe's work is explicitly written into the codex from the very first pages, where Florentius reworked the *Moralia* colophon together with

the words of one of his contemporaries to yield four freestanding prologues, each elaborately framed on a full page (ff. 2r, 3r–4r). The *Moralia* colophon was already expansive at 335 words; the four-part scribal preface to the Homiliary, at 747 words, is easily twice as long—so long, in fact, that it can only be surveyed here.[3]

In this inaugural location, Florentius's intervention is in a position to shape reading practice in and responses to the codex as a whole, just as the labyrinth did in his *Moralia*. The Homiliary begins on f. 2r with an incipit framed with a wide border of deep yellow knotwork enclosing blue and red leaves. Text hovers in the center, broken into short lines alternating red and blue and tethered on all sides to the ornamental frame by very fine blue lines punctuated with dots and ending in delicate curled finials. The text titles the book, names the scribe, and draws in the reader:

> In the name of our Lord Jesus Christ begins this book of collects or homilies produced by blessed Smaragdus in honor of all the saints and all the apostles. I beg and beseech you who will read here and you who will draw near to read that you deign to remember me the scribe Florentius. Perhaps I shall be free from sin and go without accusation to the Redeemer of humanity, Amen.

> [In nomine domini nostri Ihesu Christi. Incipit liber collectarum siue homeliarum in honorem scilicet omnium sanctorum et omnium apostolorum a beato Zmaracdo editus. Obsecro atque adclines exposco qui hec legetis uel lecturi accesseritis mi Florentii scribtoris memorare dignetis forsitan deuitis caream et ad hominum redentorem sine reatu perueniam. Amen.][4]

The book begins by introducing itself and its three protagonists: Smaragdus the *auctor*, Florentius the scribe, and "you who will read here and you who will draw near to read." A suitably humble prayer ends as it should with "Amen."

The scribe begins the next line with a new thought and a striking change of tone: "Let each one choose what they like, and find me to be more studious than spiteful" [Eligat unusquisque quod uult et studiosum me magis quam maliuolum probet].[5] The scribe now speaks with the supreme confidence of an accomplished master, identifying himself as *studiosus*—that is, "eager, zealous, assiduous, studious"[6]—and declaring airily that we are free

to choose what we like from what he has so eagerly, zealously, assiduously, and studiously made.

The words are the scribe's—written here by his own hand, connected by the pronoun *me* to Florentius himself as writing subject. But *me* is a deictic, and it's shifty. In fact, it once pointed to another writing subject, one we associate more with auctorial self-assertion than with scribal humility. It referred to Jerome when Florentius wrote these same words onto what is now f. 5r of his *Moralia*; from there they must have lodged in memory until he brought them up onto f. 2r of the Homiliary and pointed them toward his own first person.

The Córdoba Homiliary can thus with some assurance be assigned a later date than the *Moralia*.[7] More important for our purposes, however, is what the reuse of Jerome's prologue to Job shows us about the intimate relation between this scribe's reading and writing habits. As Florentius copied, the Latin words did not pass undigested from exemplar to parchment. It seems too that he read for savor, read meditatively, chewing the words with the teeth of the mind and assimilating them. In this practice of "*lectio divina* with the pen,"[8] Jerome's words became part of his reader. They refer to Florentius's work now as they once did to Jerome's.

The monastic father Cassian, whose *Collationes* survive in multiple codices in Visigothic hand, would recognize and approve of what has happened here:

> If these things [from reading] have been carefully taken in and stored up in the recesses of the soul . . . afterwards . . . they will . . . be brought forth from the jar of your breast with great fragrance . . . and will pour forth copious streams as if from some deep well in your heart.

> [Si itaque haec diligenter excepta et in recessu mentis condita . . . cum magna sui fragrantia de uase tui pectoris proferentur et . . . fluenta que continua uelut de quadam abysso tui cordis effundent.][9]

Florentius clearly unstoppered the jar of his heart as he composed this page of the Homiliary. Here's memory made matter on the page, become Florentius as once it was Jerome. Adopting Jerome's writerly first person as his own, Florentius moves briefly into the rhetorical space carved out by the master's capacious authorial ego. Florentius is indeed studious, assiduous: as he copied, he read; he added what he copied and read to what Cassian

called "the recesses of the soul." The text on this page concludes with another, much warmer, address to his readers: "Oh dearest brothers, I have reached the end. Remember Florentius. Amen and alleluia" [O fratres karissimi, peregi. Florentio Memento! Amen et alleluia].[10]

The only end Florentius has reached—for a sequential reader, at least—is that of the *incipit*. Turn the page and see beginnings and endings together again in the Alpha and Omega dangling from the arms of a full-page Cross of Oviedo (f. 2v), just as they do in the Madrid *Moralia* (Madrid, BNE, MS 80, f. 2v; Figure 3). The beginning continues to roll out over the next three pages, each containing a framed prologue elaborated from that text's colophon. With the expansion in length comes even more insistence on the colophon's key terms: the name "Florentius" (seven times, versus twice in the *Moralia* colophons), the phrase "you who (will) read" (four times, versus once in the *Moralia*), and the word "labor" (six times, versus thrice in the *Moralia*).

Like the *Moralia* colophon, the text here continues the labor of articulating the codex, the person who made it, and its users. It also shows Florentius at work and in deep dialogue with another writer—not an *auctor* like Jerome this time, but another scribe, whose work will occupy us a little later in this chapter.

The long lines of the prologue on f. 3r almost completely fill the interlace frame of the page. It begins thus:

Compelled from heaven by the inspiration of the nourishing divine trinity, I Florentius, although unworthy to bear the rank of monk, skillfully began to write the beginning of this book. I was prompted in this work by my Lord Jesus Christ, choosing very freely to accept as master in this work one whom the learning of writing made my teacher from the first lessons of my earliest youth.

[Alme trinitatis diuine celitus inspiramine conpulsus, ego Florentius, confessionis licet indigne gerens ordinem, libri huius praescribere sollerter cepi initium iniungente mici hoc opus domino meo Ihesu Christo eligens presertim liuenter hoc in opere habere dominum quem mici ab infantie mee rudimento extitit pedagogum.][11]

This language, shared with and probably borrowed from a contemporary Castilian scribe named Endura (whom we shall meet shortly), is all about

beginnings. The first lines of a prologue situated at the very front of a codex, the text performs the beginning of the writing process itself ("I Florentius . . . skillfully began to write the beginning of this book"). The end of the sentence reaches even further back in time to root the beginning of this book in the beginning of the writer's own career—his childhood writing lessons under the aegis of a master who may—the syntax is ambiguous, perhaps intentionally—be a mortal teacher or the *dominus meus Ihesus Christus* evoked in the previous clause.

The remainder of this prologue turns outward to address "all you, the favorably disposed in present and future who might read in this book" [uobis autem presentibus et futuris adclines exposco qui in hoc libro . . . legeritis].[12] Our prayers are requested for "the scribe of this work" [huius operis scriptoris] who now directs the eye of his imagination to the future of the page at hand and prays that he might "be worthy to bring to completion this labor of writing" [hunc quem scribendi lauorem suscepi ad perfectum peruenire merear]. The writer hopes that those prayers, together with "the skill evinced in this labor" [huius tamen lauoris sollertia] might count for something in the afterlife. Labor matters to this maker.

Explicitly invoking readers again in much the same language used in the incipit-prologue on f. 2r, he concludes, "Whoever you are who will draw near to read, vouchsafe to remember me, the scribe Florentius, and my sins" [Quisquis hic lecturus accesseris mi Florentii scriptoris et peccatoris memorare digneris].[13]

Thus written and drawn in to the codex, we turn the page to find an elaborately designed opening laid out like a garden (Plate 5).

These are prologues three (f. 3v) and four (f. 4r), each planted on its own page. The text rolls out in carefully plowed lines alternating red and black and anchored by graceful stylized trees with red and green leaves, four at the corners of 3v and one each at the midpoint of the left and right margins of 4r. Line length is carefully planned so that the text of prologue three is disposed as a Greek cross and prologue four as a column with capital and base. Both page-fields are bounded with interlace borders from which spring, at midpoints and corners, the same fine filigree leaves that spout from the trees within. Florentius plowed and planted this garden of delights. Now it is the reader's turn to work in it and taste its fruits.

On each page the prologues seem to start all over again, repeating the invocation of beginnings, evocation of scribal labor, and address to readers.

Prologue 2 (f. 3v): "In the name of the unbegotten son and of the one God ever proceeding from nature. Here begins the book of collects or homilies. . . . In the glory of his coming a second time or on the future day of judgment I shall enjoy grace and recompense for my labor" [In nomine ingeniti prolisque ac procedentis unius semper natura deitatis. Incipit liber collectarum siue humeliarum . . . in secundo aduentus sui gloria uel futura examinationis die fruar gratia et mercedis pro labore].[14]

The final prologue repeats (f. 4r): "Truly, I, Florentius, inscribed this book, at the command of Lord Jesus Christ and the sacred community of the monastery of Valeránica. I copiously pray and amply request that you who, in the future, might read in this codex direct your frequent prayer to the Lord for me, miserable Florentius, that in this life we might deserve to please Lord Jesus Christ. Amen" [Hic nempe liber ego Florentius exaraui, imperante mici domino Ihesu Christo uel uniuersa congeries sacra monasterii Baleranice copiosissime uobis praecor et affatim rogo qui in hoc codice legeritis ut frequens uestra pro me Florentio misero ad dominum dirigatur oratio, ita ut in hac uita placere mereamini domino Ihesu Christo, amen].[15]

After another paragraph praying for the scribe's salvation, the master class in the somatics of *scriptura* from the *Moralia* returns, set off by placement in the central column of f. 4r, between the two tall seven-leaved trees. The text is repeated word for word.

> One who knows little of writing thinks it no labor at all. For if you want to know I will explain to you in detail how heavy is the burden of writing. It makes the eyes misty. It twists the back. It breaks the ribs and belly. It makes the kidneys ache and fills the whole body with every kind of annoyance.

> [Qui nescit scribere laborem nullum extimat esse nam si uelis scire singulatim nuntio tibi quam grabe est scripture pondus oculis caliginem facit, dorsum incurbat, costas et uentrem frangit, renibus dolorem inmittit, et omne corpus fastidium nutrit.][16]

But the page has a body, too, as recalcitrant as Florentius's—or, for that matter, mine or yours. In the first sentence, the words *nullum* and *extimat* are separated not only by a line break ("One who knows little of writing thinks it/no labor at all") but also by two rough spaces at the end and beginning of the lines in question, where letters have been carefully scraped off (Figure 11).

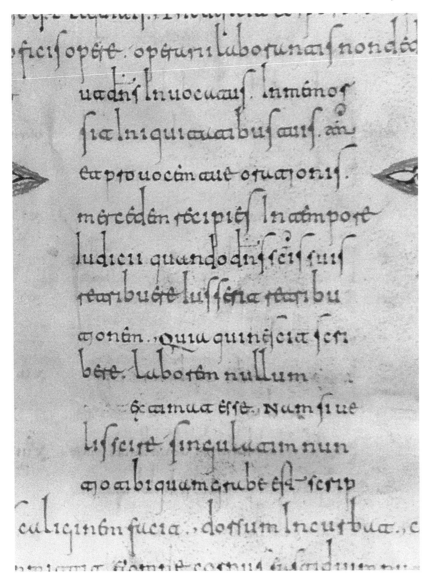

Figure 11. Florentius makes a mistake. Córdoba, AC, MS 1, f. 4r detail. By permission: Archivo Catedralicio de Córdoba.

Just at the point of enumerating the difficulties of writing as manual labor, Florentius made a mistake that had to be corrected by more of the same, the cutting and scraping whose trace can be read next to the scribe's delicate letters.[17] He must have been distracted that day: in the very next sentence, the word *nuntio* (I announce) spreads over a line break. Florentius

forgot to change color from red to black at the new line, and a faint shadow of red is visible under the black of the first two letters of the new line (-*tio*).

The master class is thus conducted not only by the words on the page, but also by the *ductus* itself: the difficult labor of writing is performed in the muddied colors of correction and the rough parchment of erasure. "So, reader, turn the pages slowly, and keep your fingers far away from the letters, for just as hail reduces the fruitfulness of the earth, so a careless reader ruins both writing and book" [Ideo tu, lector, lente folias uersa, longe a litteris digitos tene, quia sicut grando fecunditatem telluris tollit, sic lector inutilis scripturam et librum euertit].[18]

"GATHER GOOD AND SWEET-SMELLING FRUITS!" (FLORENTIUS'S OÑA BIBLE)

We saw in Chapter 1 that readers of the *Moralia* ignored Florentius's carefully lettered command, marking up the very page where he makes this declaration. The Homiliary, too, had its own careless users. At some point it lost its final gathering, together with what was almost certainly a spectacular colophon. Even more brutal treatment was suffered by the first of two Bibles preserved from Florentius's hand, called the Oña Bible after its last known location as a complete book. It survives only in fragments: eleven folios and a scrap of another in Salamanca (Hermandad de Sacerdotes Operarios Diocesanos, no shelf number) and one in the monastery library at Silos (Silos, Archivo del Monasterio, frag. 19).[19]

Fortunately, early modern antiquarians saw the complete codex at the church of San Salvador de Oña (Burgos) and described it in some detail. In his *Crónica General de España*, published in 1586, Ambrosio de Morales calls it "a very big parchment Bible in gothic letters that was finished on the tenth of June nine hundred forty-three" [una biblia muy grande de pergamino y letra gótica que se acabó de escribir a los diez días de junio, año novecientos cuarenta y tres].[20] How did Morales know the date with such specificity? He explains: "Thus was it memorialized at the end of the book by the one who wrote it" [Así lo dejó por memoria al cabo del libro el que lo escribió].[21]

Morales says no more, but a monk living at Oña in the late eighteenth century named Iñigo de Barreda y Lombera knew the codex well and found its colophon interesting enough to include it in a book of his own. Barreda's

book was never printed, and his manuscript, too, was lost. We know about it through a 1960 essay by Constancio Gutiérrez.[22] Photographs included in Gutiérrez's article show that Barreda's scholarly interest was not limited to the colophon's linguistic content: when his transcription reaches Florentius's present moment, Barreda switches from his neat scholarly hand to an imitation of Florentius's "gothic" characters (Figure 12). Thus, not only does Barreda transcribe Florentius's colophon, he *participates* in it. Inhabiting Florentius's *ductus*, he is, imaginatively at least, present to something that happened, as Morales told us, on the tenth of June nine hundred forty-three.

"At the end of the Apocalypse can be seen an inscription in red letters," writes Barreda in neat black letters, "in which the one who wrote it gives the month and year in this manner" [Al fin del Apocalipsis se deja ver una inscripción de letra encarnada que dice el que lo escribió y el mes y era de esta forma].[23] So that you can see the manner in which Barreda wrote it, the boldface type in the following extract indicates the places where he imitates Florentius's hand:

This codex was written by the notary Florentius, **IIII of the Ides of June, era DCCCCLXVIII** [= June 10, 943]. The glorious and most serene Prince Ranimirus of Oviedo and León at the head of the exalted kingdom, and his consul was Ferdinandus Gundesalviz, the exceptional Count for the imperial court reigning in Castile.

[Conscriptus est hic codex a notario Florentio **IIII idus iunias era DCCCCLXXXI**, obtinente glorioso ac serenissimo principe Ranimiro Oueto siue Legione sublimis apicem regni consulque ejus Fredenande Gunesalbiz agregius comes in Castella comitatui gerente.][24]

As a friend of Florentius might expect, that's not all the scribe wrote. Another monastic antiquary, Gregorio de Argaiz, describes one more scribal intervention in the Oña Bible in his *La soledad laureada por San Benito y sus hijos* (1675), and it's a doozy. Unlike Barreda, Argaiz keeps a cool and scholarly distance from Florentius: though he praises the "very small letter" in which the text is written,[25] he does not transcribe the colophon in full because, he says, the quality of the Latin does not merit our attention.

Whatever the merit of its grammar, the Latin colophon Argaiz describes would have been quite a production for a young monk (if he was twenty-two when he finished the *Moralia* in 945, Florentius would have been just twenty

Esta Biblia se compone de Dos Partes, o Cuerpos, en el primero
contiene el testamento Viejo y el segundo el Nuevo, y al fin del Apo=
calipsis se dexa ver una Inscripcion de letra encarnada que dice el que la es=
cribio y el mes, y era en esta forma

Conscriptus est hic Codex a Notario Flo-
rentio. IIII los huius cta. dcccc lxxxi.
Obtinente gloso ac serenissimo principe
Domno Ranimiro Oveto sive Legione sub
Limis apicem regni., Consulg et Frica
nande. Cundesalbiz egregius Comes. In
Castella Comitatu gerenti.

Por cuya Inscripcion se demuestra haber sido escrita la pre=
sente Biblia por el Notario Florencio en IV de los Idus de Ju=
nio en la Era XC.LXXXI. que corresponde al año de Jesu-Xpto
943 siendo Rey de Oviedo y Leon Ranimiro o Ramiro.
y Conde en Castilla Fernando Gundisalbez =

Otro Codigo se halla de folio regular, claveteados y de pergami
no, y en el Canto se intitula Ovidio, pero no es sino sobre los
Psalmos, Himnos de Prudencio cuyo nombre se halla escrito
en varios folios de dicho Codigo y especialmente en la primera
plana alo ultimo della En el principio tiene una Inscripcion
de diverso letra que dice: Este Libro es de los Himnos de Pruden=
cio de grande estimacion por ser con letra y mano escrito

in 943!). For one thing, the colophon included a verbal puzzle not unlike the labyrinth Florentius would later devise for the *Moralia*. Here, it is an acrostic poem. Argaiz tells us that the initial letters of its verses spelled out

To Abbot Silvanus.
Remember the writer Florentius.
In honor of most holy Peter
And, enjoying the life of monks in that same place,
of archpriest Eximino[26]

[Silvano Abbati sanctissimo
Florentio memorare Scriptor
in honorem sanctisimi Petri
Vita Monachorum ibidem fruens
Eximinonis Archisacerdotis.][27]

This is not the full colophon, only the text spelled out by the initial letters of its acrostic verses. Argaiz's somewhat obscure description is illuminated by García Molinos with a diagram representing a poem twenty-five lines long.[28] Each line is broken into four sections, and the initial letters of each section, together with the final letters of the last, when read downward vertically, form the five columns described by Argaiz. Reading down from the first letter of the first line, the initial letters would spell out "SILVANO ABBATI SANCTISSIMO," the first letter of each line in the second section, "FLORENTIO MEMORARE SCRIPTOR." The initial letter of each line in the third section would read "IN HONOREM SANCTISIMI PETRI." And in the last "column" of text, both initial and final letters read downward to invoke Eximino and the life of monks.

Argaiz recognizes the work that went into making such a poem in terms that Florentius would recognize. He paraphrases without acknowledgment the same scribal commonplace that Florentius himself would later develop at such glorious length: "Because there was no such thing as a printing press, it was fortunate that someone was found to copy books, because although three fingers do it, the whole body pays" [Como no auía emprenta, era ventura hallar quien a esta ocupación se dedicasse: porque aunque lo hazen tres dedos lo paga todo el cuerpo].[29]

But, despite his sympathy for scribal labor, Argaiz is still an early modern humanist and does not approve of either Florentius's versifying or his

Latin. After noting that in those five columns Florentius "says what he wants," Argaiz concludes, "and because they [the verses] are barbarous, I will not include more than the explanation" [En cinco órdenes dize lo que quiere, y por ser barbaros, no pondré más de la explicación].[30]

Argaiz does, however, provide a detailed paraphrase of these "barbarous" verses. Even in Spanish prose, it is quite a production. It would have been more complicated for a reader of the Latin, and more complicated still for the acrostic-weaving writer. Florentius probably started his work on the poem with the five vertical verses quoted by Argaiz. Once the letters had been locked vertically into place in the four-column grid, he had to generate Latin text that both used those letters in their established places and made sense appropriate for the context.

This is the sense of the verses, says Argaiz:

> Holy virgin and flower who engendered the Lord who is in Valeriana, where there are monks occupied in continuously reading Holy Scripture together with their Abbot, who is feeding them with the true food of the divine Word. Study, oh monks, with all the attention of your souls the supremely well-ordered work of this Bible, written so beautifully.

> [Virgen santa, y flor que engendraste al Señor que está en lugar de Valeriana, donde ay Monges ocupados en leer continuamente la Sagrada Escritura yuntamente con su Abad, que los está alimentando con el manjar verdadero de la palabra Divina. Estudiad (o Religiosos) con atención de vuestros ánimos la obra también ordenada de esta Biblia escrita tan hermosamente.][31]

This is recognizably Florentian: it's a florid production, reaching out from the page into the surrounding space and into the lives of those who engage with it. It is also a staging of and invitation to *lectio divina*. At Valeránica, the monks read attentively and continuously, just as the Rules advise. Ruminating, they chew on the true food that is found not just in any Bible, but particularly and especially in one like this codex here, beautifully written and so well ordered.

If you want to know, Florentius says (through Argaiz), I will explain to you in detail how to read this poem:

> The name of the one who ordered me to copy this book is in the first letters and verses of the first column. The Writer in the first [letters] of the

second. One of the Saints to whom the Church is dedicated in the first [letters] of the third. The name, Episcopal dignity and monastic profession in the first and last [letters] of the fourth.

[El nombre de él que me la mandó copiar está en las primeras letras y versos de la primera columna. El Escritor en las primeras de la segunda. Uno de los Santos a quien está dedicado la Iglesia en las primeras de la tercera. El nombre, dignidad Episcopal y profesión monástica en las primeras y postreras de la cuarta.][32]

Here, in case we might miss what he is doing, Florentius draws our attention to the web he has woven and teaches us how to engage with it. As in the alphabetic labyrinth of the *Moralia*, we are being led into a puzzle and instructed to suspend our attention in engagement with the page. The writer Florentius must have done the same thing as he made this, weaving words to make sense in multiple directions at once, planting in each horizontal line the seed-letters for the vertical lines at the appropriate places.

Having given us our instructions, the poet sets us loose: "Gather good and sweet-smelling fruits!," the next line of the paraphrase commands [Coged buenos y olorosos frutos].[33] Where the prologues of the Homiliary grew up around ornamental trees of ink, the fruits of the Oña poem are espaliered on the page. All we have to do is hunt them out and pick them, line after line.

Now that we have tasted the sweet fruits of reading, Florentius will write for us about writing. It's like this, he says:

Thus Moses began the writings on the beginning of the world. Thus the prophets sing of it in their mysterious and profound verses, and thus the Evangelists and Apostles in similar style brought forth the mysteries of the faith among the people, giving to Spaniards sweet-smelling and fragrant doctrine, as did Peter to the Gentiles and James to Judea. Then in the same style, John, James, Bartholomew, Andrew, Matthew, Phillip, Simon Zelotes. In this way Florentius wrote it, era nine hundred ninety-one, under obedience to and by the command of Abbot Silvanus, blessed prelate.

[Assi començó Moyses los escritos del principio del mundo. Así los prophetas lo cantan en sus misteriosos versos, y profundos, también los Evangelistas y Apostoles en estilo semejantes, parecieron en las gentes

los misterios de la Fe, dando a los Españoles olorosa y fragrante doctrina, como Pedro a todos los Gentiles, Iacobo a Iudea. Luego con el mesmo estilo Iuan, Iacobo, Thomas, Bartolomé, Andres, Matheo, Philipe, Simon Zelotes. De esta suerte pues lo ha escrito Florencio en la era de novecientos noventa y uno, estando debaxo de la obediencia del Abad Silvano y por mandado suyo, Prelado bien aventurado.][34]

Since this is a paraphrase by someone who did not really enjoy what he was reading, one should be cautious about placing too much importance on particular word choices. That said, this section is striking for its insistent focus on writing as both noun and verb—as both active practice and *modus operandi*. Thus Moses began writing, this is how the prophets sing, thus too in similar style the apostles and Evangelists. The paraphrase does not make clear to what exact manner "thus" refers, but it must be *a way of writing*, a style or manner that produces the "supremely well-ordered work of this Bible."

And then, in a surprising conclusion, the poem leaps from the canonical honor roll to the scribe's own worktable: thus too in this very manner Florentius made "this Bible, written so beautifully." If we trust Argaiz's testimony, this young man has just written his labor into the biblical canon.

It is tempting to conclude from a performance like this, as a recent reader has observed, that Florentius had "a high degree of self-esteem" and "natural artist's vanity."[35] Difficult as it might be to reconcile Florentius's apparently audacious self-presentation with proper monastic humility, I ask readers to pause before assimilating it to patterns and attitudes we know well from our own culture. Two hundred years from Florentius's *now*, when professionals like Master Mateo and Master Nicolaus put their names to their work while praising it in fulsome terms, perhaps it will be time to start cautiously thinking about something like what we might now call artistic pride.[36] For the moment ("era nine hundred ninety-one"), I ask that we let ourselves be conscripted enough into this world of words and ink and parchment simply to observe how those things together construct the scribe and his work.

It is undeniable that in the scribal interventions we have seen so far, writers understand their work as important enough not only to be explicitly represented in their books, but also to be connected to a personal name and precise spatiotemporal coordinates. When presented with the sentence "the scribes write themselves into their books," our post-Romantic tendency

would be to organize the sentence around "themselves"—that is, around the representation of a self-as-identity ("The scribes write their *selves* into their books"). I suggest instead that we take the verb as the organizing principle of the sentence and understand scribal work rather than self as the engine that drives the joint articulation of personal name, time, and place ("the *scribes write* themselves into their books"). From this point of view, what is here being written into the biblical canon is not the personal identity and desires of a twenty-year-old named Florentius, but scribal labor itself, named and particularized so that it can be seen.

FLORENTIUS AND ENDURA

Rich as Florentius's garden might be, many of the fruits and flowers in it are grafts. Some turns of phrase he probably learned from his teachers in "the first lessons of his earliest youth." Other, more elaborate formulations he picked up from his reading and from the books that arrived at his worktable for copying. He studied and absorbed not only the *auctores* he was commissioned to copy—Jerome, Gregory—but also the words of other monastic scribes.

All over Castile and León, scribes were doing the same thing: gathering good and sweet-smelling fruits from the gardens of each other's colophons. Watching the formulations move from book to book reveals what scribes were interested in, what kind of language they found attractive, and—most importantly for our purposes—what they wanted their books to do. Whichever way the sharing went (it can be hard to tell), one thing is clear as day: books and writers moved around, and scribes were readers of each other's work as well as writers of their own. Concerned as they all were with scribal activity as a matter for thought as well as occupation of the hand, they shared among themselves the tastiest representations of manuscript.

One monastic scribe whose work Florentius certainly knew was named Endura; this scribe's generous colophons use language in many places identical to Florentius's. We know little about Endura beyond the fact that he was more or less the same age as Florentius and that he worked at the nearby monastery of San Pedro de Cardeña, about forty kilometers as the crow flies from Valeránica.[37] Judging by the codices and colophons that survive attached to his name, Endura was a skilled writer and enthusiastic thinker about books, words, and work. He was certainly accomplished enough to

come to Florentius's attention as someone whose words were worth incorporating and repurposing under his own first-person pronoun. Alternately, the borrowing might have gone the other way.[38] What can be said with certainty is that, as the most skilled scribes in their respective communities, they cannot but have come to one other's notice.[39]

Endura concludes a copy of Isidore's *Etymologies* with words that will be familiar to friends of Florentius: "I bless the kingdom of heaven that permitted me to arrive safely to the end of this book, Amen" [Benedico celi quoque regem me qui ad istius libri finem venire permisit incolomem, Amen] (Madrid, RAH, MS 76, f. 159v);[40] Florentius wrote the same blessing into the explicit of his *Moralia* (Madrid, BNE, MS 80, f. 499r).[41] The next sentence, spreading out across both columns of the page in red and black majuscules touched with yellow, might show us who learned from whom, if we could but read the date with confidence: "The book of Etymologies was completed by two scribes, namely Ndura the presbyter and Didaco the deacon in era DCCCCLX II" [EXPLICITUS EST LIBER ETHIMOLOGIARUM A DUOBUS VIDELICET SCRIPTORIBUS NDURA PRESBITER ET DIDACO DIACONUS SUB ERA DCCCCLX IIA].[42]

An erasure cuts into the page after the number "DCCCCLX," and two different scenarios of scribal interchange arise from the gap in the date. If Ruiz García is correct to insert an "L" into the erasure,[43] Endura and Didaco finished their work in era 992 (954 CE), nine years after Florentius ended the *Moralia* with the identical burst of gratitude at prime, three days before the Ides of April in 945 CE. In this version of the story, Endura and Didaco, having digested well Florentius's version of this common sentiment, write it here word for word in their own hands and with their own names.

On the other hand, if, like Loewe and Hartel, we see the shadows of two vertical strokes under the erasure and resolve the date to era 962 (924 CE),[44] then it is *Florentius* who has incorporated Endura's and Didaco's words. I cannot resolve the dilemma, and the truth is, for the purposes of this discussion resolution is not necessary. No matter which way we take it, this citation shows us scribes concerned with crafting written language to articulate a codex with its makers and familiar enough with one another's gardens to pluck therefrom the sweetest fruits of scribal self-representation.

In the next case of scribal commensalism between Florentius and Endura, we must rely once again on early modern antiquaries, in this case a 1719 account of the monastery library at San Pedro de Cardeña by Francisco de

Berganza. Berganza describes a mid-tenth-century copy of Cassiodorus's commentary on the Psalms completed by scribes named Endura and Sebastianus in 949 CE. "At the beginning and at the end of the Book," he says, "these Writers placed some notices worthy of our topic" [al principio, como al fin del Libro, pusieron estos Escritores algunas noticias muy dignas de nuestro assumpto].[45]

Worthy indeed is the way the prologue that Berganza is about to transcribe articulates this particular codex with a place, the people who made it, and the people, present and future, who will benefit from it.

> Inspired by God, Munnionus, most faithful worshipper of Christ and most noble of blood, together with his most honorable wife Gugina, offered, in addition to other donations to the monastery, a good sum of money for the writing of the book of the Decades of the Psalms in honor of the apostles saints Peter and Paul. They made this offer to abbot Stephanus, honored father of two hundred monks who live in his company with regular observance at the monastery of Cardeña on the condition that, those in the present having enjoyed the book, those to come might likewise enjoy it, so that thus the Superior as well as his subordinates might benefit from it.

> [Diuino praesertim munere inspirante est Munnioni Christi fidelissimo cultori nobile orto genere simul cum coniuge clarissima Gugina absque aliis muneribus hoc peculiariter munus offerrent et obtulerunt optimum pretium ad conscribendum librum Decadae, uidelicet, omnium Psalmorum ob honorem sanctorum Petri et Pauli apostolorum concessumque iure perenni fruendum Stephano, abbati pastoralis curae digne ferenti ducentorum numero monachorum Caradignae in ascisterio simul regulariter uiuentium; hac enim conditione ut et praesentes eum incunctanter possideant et successoribus seu in regimene seu in subiectione perpetim habendi gratiam reliquant.][46]

The colophon records a donation to the eternal honor of the donors. But that is not all it does: it presents an entire community, past, present, and future, articulated by this book. Made possible by a gift from Munnionus and Gugina and the labor of the writers, this very codex serves not only Abbot Stephanus and his two hundred living monks but also their successors into the future.

Now the scribe writes himself into the codex.

Compelled by the heavenly inspiration of the nourishing divine trinity, I Endura, although unworthy to bear the office of priest, skillfully wrote the beginning of this book, when the thirty-first year of my wretched life was almost accomplished. Then I passed this work on for completion to Sebastianus my own son and beloved student, when he was a deacon, choosing especially to have as a companion in this work the one whom learning to write had offered to me as my dearest student.

[Almae Trinitatis diuinae coelitus inspiramine compulsus ego Endura, Sacerdotij indigne gerens officium, libri huius solerter praescribere feci initium, aerumnose uite peracto statis mee tricesimo et primo anno. Iniunxi tamen hoc opus implendum Sebastiano speciali filio alumnoque dilecto, Leuitico etiam ordine functo, eligens praesertim hoc in opere habere socium, quem eruditio huius scriptionis charissimum mihi prebuerat discipulum.]⁴⁷

Florentius liked the way this was done. Here is the way he opens the second prologue of the Homiliary:

Compelled from heaven by the inspiration of the nourishing divine trinity, I Florentius, although unworthy to bear the rank of *confessus*, skillfully began to write the beginning of this book. I was prompted in this work by my Lord Jesus Christ, choosing very freely to accept as master in this work one whom the learning of writing made my teacher from the first lessons of my earliest youth.

[Almae trinitatis diuinae celitus inspiramine conpulsus ego Florentius confessionis licet indigne gerens ordinem libri huius praescribere sollerter caepi initium iniungente mici opus domino meo Ihu Xpo eligens presertim liuenter hoc in opere habere dominum quem mici ab infantiae meae rudimento extitit pedagogum.]⁴⁸

The words have not passed through Florentius undigested. What is on Endura's page a straightforward narrative becomes in the Homiliary a series of overlaid origins. Beginning to write the beginning of this book, Florentius recalls his own beginning as a writer on the first lessons of his earliest youth. He turns Endura's concluding pedagogical scene inward to show *himself* as the beginner in the writing lesson.

Endura, on the other hand, tells a history of the writer and *his* student, starting in the scribe's thirty-first year with the beginning of the project, moving forward in time to the handing-over to Sebastianus, and from there jumping back to the grammar classroom where Endura initiated his disciple in the way of letters.

In those sessions Endura taught Sebastianus the Greek as well as the Latin alphabet, it seems, for, at the very end of their Cassiodorus is this Latin note, written, says Berganza, in ostentatiously Greek letters:

> This Book was finished by the Notary and Deacon Sebastianus, on the fourteenth of the kalends of February, era DCCCC.LXXX.VII, the most Serene King Ranimirus ruling in León and the exceptional Count Fredinandus Gundesalviz in Castile, Bishop Basilius holding the Episcopate in Muño del Castrillo.

> [Explicitus est Liber iste a Notario Sebastiano Diacono notum praefixionis diem quarto decimo Kalendas februarij. Era DCCCC.LXXX.VII, regnante Serenissimo Rege Ramiro in Legione et egregio Comite Fredinando Gundesalvi in Castella, atque Pontificatum gerente Basilio Episcopo Sedis Munnioni Castelli.][49]

Sebastianus put down his pen on January 19, 949 CE. The parchment on which he and his master wrote has, unfortunately, disappeared. The book they made together has long been associated with another tenth-century Iberian copy of the same text that is, in fact, missing its colophon page (Manchester, Rylands, MS lat. 89 [olim 99]). The association of Berganza's colophon with this codex is not absolutely certain,[50] but it's certainly tempting, as the Rylands Cassiodorus was also written by a scribe named Endura who was fond of Greek letters as well as Latin ones. He shows them off on f. 4r of the Rylands Cassiodorus as his student Sebastianus did in the lost colophon studied by Berganza: "Oh good and dearest reader, remember the miserable presbyter Endura, or rather me the scribe, in your prayer. Amen" (ω βωνη ληχτωρ καρικκιμη μυcηλλω ηνδορα πρηcβυτηρ cηο cχρυβτορυc τωα υν πρηχη μηυ μημηντο αμην).[51]

In whatever manuscript body he encountered it, it is clear that Florentius engaged intensely and intimately with Endura's Cassiodorus, for the fruits of that reading hang all over the Homiliary's prologues. And when it was his turn to copy Cassiodorus on the Psalms for Valeránica in 953, he

plants the lettered seeds again. Florentius's Cassiodorus is also, alas, lost, but once again we are fortunate to have a transcription made before it disappeared. Manuel Risco saw Florentius's Cassiodorus at San Isidoro in León and published a transcription of its colophon in 1792.[52] The language will be familiar. You've read it in the first prologue of the Homiliary, and before that in Endura's Cassiodorus (borrowings are italicized in the Latin).

> I, brother Florentius, although insignificant, began concisely to write the work of this book, when I had completed the thirty-fifth year of this sorrowful life of mine. Furthermore, this was carried out in the monastery of Valeránica, beneath the sanctuary which holds the relics of the Holy Virgin Mary, mother of our Lord Jesus Christ, and the Holy Apostles Peter and Paul, Martyrs, and Saints Vincent and Laetus the most holy witnesses of Christ, when, teaching a great crowd of honorable monastics, the spiritual father Martin held the office of prior in order to rule. Therefore this book was completed, containing in itself a marvelous exposition of all the Psalms, with the aid of the right hand of Christ, in the era DCCCCLXI[53] during the Night Office, on the VII of the Ides of July, in the third year of the rule of King Ordonius.

> [Florentius confrater licet exiguus libri *hujus praescribere* collecter[54] coepi opus *erumnosae vitae hujus peracto aetatis meae* trigesimo quinto *anno. Extat praeterea hoc gestum* Valeranicae *in Arcisterio, sub atrio reliquias ferente* S. Mariae Virginis genitricis Domini nostri Iesu Christi, et SS. Apostolorum Petri et Pauli, Martyrum, SSque. Vicentii et Lethi fidelissimorum testium Xpti. *magna docente caterva, patre spirituali* Martino *gratia regiminis priore in ordine constituto. Perfectus est* igitur *hic liber expositionem in se mirificam continens omnium Psalmorum, Xpti juvante dextera,* sub era DCCCLXIa, diemque temporis nocturni, VII iduum Iuliarum, tertio regnante anno Ordonius Princeps.][55]

Words that once linked a copy of Cassiodorus on the Psalms to Cardeña, Endura, and the year 949 now articulate another token of the same work with Valeránica, Florentius, and 953—in the middle of the night on July 9, to be exact. Endura says he was thirty-one when he wrote; Florentius is now thirty-five.

It was apparent that Florentius had read Endura's colophon well when, in the second Homiliary prologue, he bent its language in a new shape; now

he may even have the text itself before him as his exemplar as he works. Reading well, however, means making a text one's own: you may now recognize Florentius's hand in the way Endura's colophon has been tweaked to make the object of the verb of writing not "the beginning of this book" [*initium* libri huius] as Endura had it, but "the *work* of this book" [*opus* libri huius]. Florentius wants us to see that he's not just writing the book but rather the *opus* of the book. Again, Florentius is focused not only on the book as vessel of significance but also on the book as artifact, the product of labor as intense as that required to break ground in the garden, plow, and tend it.

FLOWERS AT SILOS

Just as Florentius read, absorbed, and repurposed Gregory, Jerome, and Endura, so, after the end of the glory days of Visigothic script,[56] scribes from Santo Domingo de Silos plucked good and sweet-smelling fruit from the colophonic orchard planted a century or so earlier. Their names were Petrus, Dominicus, and Munnius, and from the late 1080s until 1109 they worked on a copy of Beatus of Liébana's great Apocalypse commentary for their monastery library (London, BL, Add MS 11695).[57] They grafted the words of earlier scribes with equal enthusiasm into the introductory and concluding frames of their new book.[58]

After a full-page Cross of Oviedo (5v) and an intricate but sadly incomplete labyrinth (6r), an ample text box framed with leaves and interlace introduces the *auctores* and one of the writers of this codex. The scribe's name is Petrus, and he has gathered flowers from the gardens of both Endura and Florentius.[59] He begins as Florentius began the second of the Homiliary prologues: "In the name of the unbegotten son proceeding from the one God by conjoined nature" [In nomine ingeneti prolisque ac procedentis conexa unius semper natura deitatis].[60] Petrus then names himself in a striking formulation: "He who stood silent before the court, when I, Petrus, began, let him guide me towards liberation" [Ille qui ante presidem stetit silens, mecum Petro incipiente ad liberandum sit regens].[61] Somewhat mysterious now, this phrasing so pleased early medieval scribes in the region that they passed it from book to book, from Cardeña to Valeránica to Silos.[62] The same phrasing appears in the Rylands Cassiodorus (Manchester, Rylands, 89, f. 4r) and Florentius's Homiliary (Córdoba, AC, MS 1, f. 3v).

Mecum points to Petrus here at Silos; it indexed Endura and Florentius before him.

The codex concludes with a double colophon opening clearly inspired by Florentius's work on the Homiliary (ff. 277v–278r). Preceding Petrus's prologue by some twenty years, it is the work of scribes named Dominicus and Munnius. Together, this pair of colophons evokes and expects a fully embodied understanding of writing and reading anchored in the writerly first person. "Compelled from heaven by the inspiration of the nourishing divine trinity" [Alme Trinitatis divine caelitus inspiramine compulsus . . .], Dominicus the presbyter and the presbyter Munnius his kinsman began to write the work of this book, the colophon on the left announces [". . . ego Dominico presbiter et consanguinei mei Munnio presbiter exigui libri huius prescribere solerter cepimus opus"].[63] Here too the scribal pronoun once pointed elsewhere—both to *ego Endura* (in the orphan Cassiodorus colophon)[64] and to *ego Florentius* (Córdoba, AC, MS 1, f. 3r).

Dominicus and Munnius completed their work on Thursday, April 18, 1091, at midday [Perfectus est igitur hic liver . . . diemque temporis XIIII kalendas maii, hora VI, die V feria, sub era TCXXVIIII^a],[65] and as they finish, right then at noon, they imagine their readers and write us into the book, too. They see us "in the present and in the future"; we are reading avidly [presentibus et futuris, qui in hoc libro fulgidam sacre explanationem Apocalipsis avide legeritis].[66] Addressing themselves to the present and the future, Dominicus and Munnius pray for attentive reading. On the facing page, they will speak with Florentius and ask us not to read with our fingers (f. 278r). Here, though, it's clear that they want more of us than our eyes and minds:

> Dearest brothers, whosoever of you—present and future—might read this codex, may he read with a sharp mind, and may he understand well what he reads with the ears, eyes, and mouth of the heart. May he give heed to these works unceasingly for the Lord God; and may he pour out prayers so that in eternal life—with the producers and authors and defenders and makers of this book and with all the saints—he may find a place to dwell, amen. Pray for us scribes, if you rule with God the redeemer, amen.

> [Fratres karissimi, quisquis hunc codicem legerit ex vobis, presentibus et futuris, prespicaci mente legat, aures, oculos, os cordis quod legerit discrete intellegat et intelligenda opera Domino Deo indesinenter teneat;

et infundat preces ut in vitam eternam cum editoribus et auctoribus vel abtutoribus atque facientibus libri huius, vel cum omnibus sanctis locum inveniat habitationis, amen. Orate pro nos scriptores, si regnatis cum Domino redemtore, amen.][67]

The Silos scribes imagine a reading involving not only the reader's mind, but also ears, eyes, mouth, and heart. The intellectual understanding that follows on this bodily activity is thus as somatic as it is mental, like the gathering of good fruits that Argaiz transcribed from Florentius's now-lost Cassiodorus. And, as the scribal, editorial, and authorial frames of BNE MS 80 wrote the labor involved in making the *Moralia* into the codex itself, so here do the Silos scribes, promising that our prayers for them will be rewarded with celestial company—not just of the saints, but most particularly of "the producers [editoribus] and authors [auctoribus] or guardians [abtutoribus] and makers [facientibus] of this book."[68]

On the facing recto, framed in airy knots of yellow, red, and blue, is Florentius's lesson on the somatics of writing, referring now of course to Munnius's and Dominicus's laboring bodies and to the leaf of parchment we now call f. 278r of the Silos Beatus. In the ten-line blank space below the admonition to keep our fingers far from the fertile ground of their pages, the scribes have made a little topiary orchard with the help of compass and straightedge (Plate 6). Three slender stems rise from the knotted border of the page, each crowned with a pinwheel rosette with petals alternating red and yellow. The yellow petals on two of the flowers are marked with little letters, in red on the outer edge of the petal and in black toward the center. The letters M, N, I, N, S, R, B, N are readily legible, but it is not clear what we are to make of them. John Williams explains:

> Reading alternatively, starting with the upper letter (M) in the section at one o'clock in the righthand flower and reading the upper letters in the yellow sections alternately from the center flower, the name MUNNIO is spelled. Reading the lower letters in the red sections in the same way produces SCRIBANO, an Hispanicized form of *scribanus*, or scribe. Read serially clockwise, the lower letters in both flowers also produce SCRIBANO and the name DOMINICO may be present, but there is no D visible.[69]

Wheeling around the edge of the rosettes and jumping from flower to flower, we can, with Williams's help, unscramble MUNNIO SCRIBANO and DOMINICO. The writers seeded their names on the page so that the contemplative labor

of making sense from apparently random letters would plant Munnius and Dominicus in your memory.

"THOSE WHO BOTH READ AND WRITE": FLORENTIUS AND SANCTIUS (LEÓN, SAN ISIDORO, MS 2)

On July 20, 960, Florentius and his student Sanctius completed a richly il-luminated Bible that, happily, still survives (León, San Isidoro, MS 2).[70] As Florentius learned from his *pedagogus* (Córdoba, AC, MS 1, f. 3r), and Se-bastianus from Endura,[71] so Sanctius learned from Florentius. After a full-page image of Christ in Majesty (f. 2r) comes an incipit written in luxurious display capitals and spread over three elaborately bordered pages (ff. 3r–4r). The same layout returns on ff. 11v–12r, two framed pages filled with monu-mental interlaced display capitals on intensely colored banners. On the left (f. 11v) are verses from the poem that Theodulf of Orléans (d. 821) composed for his edition of the Bible.[72] Across the gutter on the facing page (f. 12r), another quotation receives the same flashy layout. The source, however, is a little less authoritative.

> Whoever you are who will have eagerly approached this book to read it, vouchsafe to pray for me, Sanctius the presbyter: Perhaps I shall be free from sin and go without confusion to the Redeemer of men, Amen.
>
> [QUIS QUIS ANELANTER HIC LECTURUS ACCESERIS PRO ME SANTIO PRSBRO ORARE DIGNES FORSAN DIVITIS CAREAM ET AD OMNIUM REDENTOREM SINE CONFUSIONE PERVENIAM. AMEN.][73]

Sanctius is quoting, of course, from his master Florentius: both the vivid evocation of the reader's physical approach to the codex and the character-istic hypothetical turn to the scribe's possible salvation are drawn directly from Florentius's Homiliary prologues, where the master uses similar lan-guage (Córdoba, AC, MS 1, ff. 2r and 3r). Sanctius gives these words the same visual dignity that he bestowed on Theodulf's verses on the facing page. You have to read closely to know which words were composed by a great bishop and which by a mere scribe.

This Bible ends on f. 514r with a full-page Omega (Figure 13).

Like the Omega at the end of the *Moralia* (BNE MS 80, f. 501r), this mon-umental letter is supported by two little figures. Here, however, they hold

Figure 13. Apocalyptic Omega and scribal toast. León, San Isidoro, MS 2, f. 514r. Photo from facsimile, Rare Book and Special Collections Division of the Library of Congress, Washington, DC. Used by permission.

out goblets, presumably of wine. Tituli above their heads tell us who they are: on the right, "Sanctius presbiter" and on the left, "Florentius confessus." They are toasting, and the text beneath their goblets tells us what they say. Florentius: "O my dearest disciple, the presbyter Sanctius, whose name fills me with joy. Let us bless the king of heaven who allowed us to come safely to the end of this book" [O Karissimo micique dilecti discipulo atque gaudio retaxando Sanctioni presbitero. Benedicamus celi quoque regem nos qui ad istius libri finem venire permisit incolumnes. Amen].[74] Sanctius replies, "And I say, Master: Let us praise our God Jesus Christ, that he might lead us to the kingdom of heaven. Amen" [Et iterum dico magister benedicamus Dominum nostrum Iesu Christum in secula seculorum que nos perducat ad regna celorum. Amen].

Sanctius speaks for himself, however, on the facing page (f. 513v). His colophon occupies the lower two-thirds of the left column, framed by alternating blocks of red and green bordered in a deep yellow. The first paragraph repeats the prologue's Florentian gesture of evoking the passage of the codex from scribe's to reader's hands (f. 12r); now, however, the gesture is anchored in a precise time and place.

This codex was written by the presbyter and notary Sanctius, on the XIII of the kalends of July, era DCCCCLX.VIII. The glorious and most serene Prince Ordonius of Oviedo was head of the exalted kingdom, and his consul was Fredenandus Gundesalviz, the exceptional Count for the imperial court reigning in Castile. I beg you, reader, whoever you are, that when reviewing the battles of the combatants in this volume, you arrive here at the end, that you be a suppliant for these same men, and also for me, most pitiable Sanctius. And may you obtain the garments of holy recompense for your labor from the Lord, since one who prays on behalf of another commends themselves to God.

[Conscriptus est Codex a Notario Sanctioni Presbytero XIII. Kal. Julias. Era DCCCCLX.VIIIª. Obtinente glorioso ac serenissimo Principe Ordonio Oveto sublimis apicem Regni, Consulque ejus Fredenando Gundesalviz egregius Comes in Castella comitatui gerenti. Obsecro te, quisquis es lector, ut dum horum praelia agonistarum hujus recensendo voluminis hucusque adtigeris portum, mei quoque Sanctii miserrimi apud hoc eosdem supplex sis intercessor, et ipse sancte manipulos retributionis tua a Dno. consequaris laboris, quia qui pro quemlibet orat, seipsum Deo commendat.][75]

Sanctius finished, then, on June 18, 960. But he's not done yet: after a diplomatic *item* ["furthermore"], he adds his own prayer on behalf, not just of anyone, but of three very special groups of those who, as he says, quoting his master Florentius, "eagerly approach this book to read it."

> May Christ crown the scribe while you all are certainly praying. May he fill those who are reading with the good sweetness of discourse. May he likewise enrich with eternal life both reader and writer, rewarding his servant the scribe with help upon on his last day. May Christ present him guiltless on the final day, and may he join him at the same time with the saints. Amen.

> [Scribentis Christus uos nempe orantes coronam inplodat, legentibusque bone sermonis dulcedine farciat, simulque scribenti et legenti eterne uite ditet, remunerando sue extremi die aminiculo suo iuuante sine culpa exibeat, simulque sanctis coniungat, amen.][76]

Sanctius wishes for a scene of letters and their rewards: we the readers filled with sweet discourse and he the scribe crowned by Christ as we prayerfully look on, witnesses now as well as readers. And all of us together, reader and writer alike, filled with good things.[77] Sanctius's colophon prays for the users of books: those who write them and those who read them. If we choose to read the *simul* in the third clause [simulque scribenti et legenti eterne uite ditet] as an adverb expressing simultaneity ("at the same time") rather than similarity ("likewise") then, Sanctius prays especially for those who, like his master Florentius and himself, "write and read at the same time" [simulque scribenti et legenti].

CHAPTER 4

MANU MEA: CHARTERS, PRESENCE, AND
THE AUTHORITY OF INSCRIPTION

> To seal a testament is "to put a distinguishing mark" on it so that
> what is written may be recognized.
>
> [Testamentum autem signare notare est, id est ut notum sit quod
> scriptum est.]
>
> —Isidore of Seville, *Etymologies* V.24

Writing and reading at the same time, these monastic writers craft elaborate colophons that draw attention to the intellectual and corporeal agency of the scribe and connect both quite explicitly to the scribe's name and the time and place of his or her labor. The result is a virtual library of monastic books driven by a striking degree of scribal protagonism. Viewed from the perspective of proper monastic humility, this would seem to be pure presumption. Why, then, did monastics like Leodegundia, Endura, Florentius, and Sanctius explicitly write their scribal activity into the books that they made?

They did so because skilled scribal activity mattered. And not just for the practical reason that Christianity is a religion of the book and people who are masters of bookmaking have an important skill. As we saw in Chapter 2, from their very earliest grammatical instruction these monastics learned to conceive of written language as an articulation of here and there, now and then, presence and absence, writer and reader. As scribes, they are practitioners and in a sense masters of this powerful medium of articulation. There is, in fact, an authority of inscription.

The authority of inscription is especially clear in the other genre of writing that these skilled monastics were called upon to practice: the charter. In this chapter, we examine the way authority and making are inscribed into and performed by such legal documents. The charter, written record of a gift, depends for its validity on the assurance that the donors were and in a

sense still *are* present, continuously affirming "I give" in the letters written on the page. Isidore of Seville says that what creates such presence-in-absence is the *vis* or force of the letter itself.[1]

While in legal terminology it is the donor who is called *auctor*,[2] the scribe, too, has authority, for it is by his or her hand that presence is lettered into the page with such *vis* that it continues to speak even when copied by another hand on another piece of parchment. A donor might confirm a document by laying hands upon it, but the hand that makes that document a *charter* and names itself in the act of writing belongs to the scribe.

The practices of subscription particular to the legal document will enrich our understanding of what monastic scribes are doing when they write their names onto the pages of their codices. It is, as we shall see, not at all like "signing" in the modern sense.

Until the establishment of a professional notariate in the thirteenth century, the task of formalizing private legal documents fell to the nearest person able to produce written Latin in the appropriate forms.[3] In tenth-century Iberia, the best place to find such a person would have been the nearest monastery. Florentius called himself *notarius* in the now-lost colophon to the Oña Bible of 943; his student Sanctius does the same in the Bible that they completed together in 960. At Cardeña, Sebastianus learned from his teacher Endura the *elongata* hand used to write charters as well as minuscule for books and the Greek alphabet. Writing Latin in proudly Greek letters, Sebastianus, too, calls himself a notary in the now-lost colophon of the Cassiodorus that they made together.[4]

Handwork stocks the memory, which in turn guides the hand in future labors. In Chapter 3, we saw Florentius appropriate for his own first person in the Córdoba Homiliary words of the holy *auctor* Jerome that he, Florentius, had faithfully written into a copy of the *Moralia* several years before. Since composing and writing out legal documents was an integral part of the labor of these book-workers, it would make sense that the language and thought-forms of charters would be as important an element of their lettered *habitus* as the language and thought-forms of *auctores* like Jerome, Gregory, or Isidore. It should not, then, be surprising to find—as we shall in this chapter—that monastic colophons owe much to both the language and the articulative practices characteristic of the legal document.

Different as charter and colophon are functionally—secular versus sacred—and visually—*elongata* hand inscribed on a single sheet versus

minuscule copied into a gathering—both genres explicitly project the written text from a present of writing into an imagined future of repeated use. Both genres authorize the act of writing and its result by working proper names, dates, and represented acts of inscription into the very tissue of the written artifact itself. Thus, although codex and charter are to a modern reader very different materially and literarily, from a scribe's-eye view, the boundaries between them are fluid. Both are quarries from which scribes stocked their memories with efficacious language; both are fields of activity for the articulative *vis* of the Isidorean letter.

An inquiry into the lettered habitus of notary-scribes like Florentius and others like him will be enriched by study of the legal document not only as a source of historical information or quarry for formulaic language, but also as a rhetorical situation and site of manual labor.[5] This chapter will thus begin by discussing the early medieval charter with an eye toward the connections to articulation as practiced by the great Iberian bookmakers of the tenth century; we shall then look closely at a few examples from Florentius's own practice to make the connections clear.

THE ARTICULATE CHARTER

First and most importantly, the charter is both documentary and performative—it both records and *does* things.[6] As a legal document, the charter is writing that has force, or *vis*, whether dispositive (the document makes the act happen) or probative (the document proves the act happened).[7] The flexible period terminology for these documents is telling: their Latin names associate them simultaneously with things done (*acta*), the tools by which things are done (*instrumenta*), the material support on which those things done are written (*chartae*), and even the writing itself (*titulus, apices*).[8] This is writing that, when properly executed, efficaciously reaches into the world beyond the page, authorizing a human action and extending that action into future time. It doesn't just record things done; it records the doing of things in ways that give that "doing" and that "done" continuing validity and activity in a present extended until further notice.

A charter, in other words, can reach into the extra-text as vigorously as the codices and colophons we have been reading. It activates the same elements of the act of writing: names, dates, bodies, memorable actions. Handwriting's capacity to make the absent present was exploited in our scribes'

first-person colophons and direct appeals to future readers. In the charter, the infusion of presence through inscription is actually the guarantor of the document's legal efficacy.

The charter is a languaged artifact that uses the material presence of writing to instrumentalize a person's desires for what is to be done in her or his absence. In her study of medieval technologies of individuation, Brigitte Bedos-Rezak observes that the human subject in early medieval charters is "an autonomous, voluntary, and empirically present agent, situated within a set of social relationships arising out of consent and contract."[9] In legal documents, that *empirical presence* is bound neither to the individual's lifetime nor even to the original document; it extends out from the originating time and place and originating set of social relationships.

Imagine a noblewoman named Urraca who wants to make a donation to a neighboring monastery. Facing the perfect finitude of human life (knowing that at some point it will be said that Urraca died), she manifests her desire in a charter that instrumentalizes her intention in an ongoing present progressive, so that (ideally) even now, Urraca's desires are still being fulfilled. Setting the desires down in writing is a first step, Isidore of Seville would say, because letters "have so much force that the utterances of those who are absent speak to us without a voice" [quibus tanta vis est, ut nobis dicta absentium sine voce loquantur].[10] But how to articulate that voice legally and unequivocally with its speaker, "to make the discourse survive its subject *as if he or she were still speaking it*"?[11]

Mere marks on a surface do not evoke presence strongly enough to stand up in court; they must be supported. The charter responds to this challenge with rhetorical structures and bodily rituals whose goal is to make empirically and continuously present not only the deed, but also when, where, by, for, and before whom it was done. That is, the charter aims to give *vis* to a particular constellation of people as agents in space and time and projects that *vis* into the future. It aims to ensure that the first-person discourse it records survives its subject as if he or she were still speaking it.

One discursive survival mechanism is, of course, what we now call the signature—the autograph trace of the writing subject. Modern autographs gain their authority from the fact that we now see them as "idiosyncratic signs of selves, intimately tied to the hand that produced them."[12] But the autograph signature did not become the obligatory legal authentication mechanism in the West until well into the early modern period.[13] In early

medieval law, validity springs not from the "signature" but from authoritative allograph: the subscription, by an authorized hand, of the names of the document's human agents—the donors, the witnesses, the scribe—beneath the formal exposition of the agreement.[14]

Executed by an authoritative scribal hand, subscriptions ensure the ongoing presence of the charter's human agents symbolically—by standing in for the giving, witnessing, and writing subjects—and grammatically, by articulating those subjects with the action of the crucial verbs "I give," "I witness," and "I subscribe." First among these agents is the charter's speaking subject, the donor. The donor is also the legal *auctor*,[15] the agent whose first-person desires are served by the charter: "I give" and "I subscribe." But that authorship is legal, not material; the legal *auctor* need not subscribe by her or his own hand.[16] In fact, autograph subscriptions, though not unknown, are very rare in early medieval León-Castile.[17]

Absent a donor's autograph, the enactment of the document was supported by ritual aiming to articulate the subscriptions to their living human referents and to connect the will of those people to the document as a linguistic and material artifact.[18] Rogelio Pacheco Sampedro reconstructs the early medieval Iberian ritual thus: the first step is the *recognitio*, in which the document is read aloud in public before donors and witnesses. Then the hands get busy: in the *manufirmatio* or *impositio manuum*, the donor lays hands upon the document itself, an action often recorded with phraseology like this: "I Veremudus Suerii have validated in this charter with my hands and have confirmed the deed" [Ego Ueremudus Suerii, in hac carta manus meas roboraui, et hoc factum confirmaui].[19] The scribe him- or herself subscribes at the end of the document. Scribal subscription gives the document legal efficacy; it articulates the performative text with the act of inscription. The material *charta*—the sheet of parchment itself—becomes a legal *instrumentum* as a result of the subscriptions and the rituals of its production and enactment, all of which are designed to make the document speak in the voice of its absent legal *auctor* and say, in effect, "I was here. I willed this."

However, for all its authoritative *vis*, the subscription is shifty. Even the most apparently direct of statements does not signify as an uninitiated modern would expect it to do. Let us look again at the formula of validation adduced earlier as an example of *impositio manuum*. It comes from a charter dated 1086 CE. The donor Veremudus speaks: "I, Veremudus Suerii, have

validated in this charter with my hands and have confirmed the deed" [Ego Ueremudus Suerii, in hac carta manus meas roboraui, et hoc factum confirmaui].[20] My translation is intentionally literal and awkward. Veremudus is validating the charter, and his hands are helping him do that. But, on the face of the Latin at least, his hands do not validate the charter (*cartam roborare*) so much as *perform validation within it* (*in hac carta roborare*),[21] as if by an injection of manual presence into the charter's very parchment. Once ritually bestowed upon the *carta*, the validating presence of Veremudus's auctorial hands passes from the "material support" into the language of the agreement itself.[22]

Just as autograph and authorized subscription are legally—and, in a sense, ontologically—equivalent, so Veremudus's manual presence continues to validate the charter from within the language itself, regardless of where or how many times it is copied. I have, in fact, been quoting from just such a copy: a cartulary written in the mid-thirteenth century at the monastery of S. Xoán de Caaveiro in Galicia (Madrid, AHN, Códices, L.1439). In that cartulary, Veremudus's validation and that date of 1086 CE are copied on f. 90r in a neat thirteenth-century script (Figure 14).

It does not matter that the subscription is not in Veremudus's hand, nor that his hands could never possibly have lain upon this piece of parchment made from an animal that lived more than a century after Veremudus himself. Remember what Isidore says about letters, "so called as if the term were *legitera*, because they provide a road for those who are reading, or because they are repeated in reading" [dictae quasi legiterae, quod iter legentibus praestent, vel quod in legendo iterentur].[23] Iteration is built into the manuscript letter both in theory and in the lived practices of copying and reading. "Medieval documentary truths," writes Brigitte Bedos-Rezak, "are in a sense the truths of action done double, of action re-produced."[24]

Veremudus's validation in the thirteenth-century cartulary is accompanied by the image of a hand clutching a scroll marked with a cross (Figure 14). This image visually reenacts the linguistic declaration *manus meas*, which itself reenacts the ritual laying on of hands. In other words, Veremudus Suerii is still in this copy, his presence activated by the ritual *impositio* of his hands upon the parchment surface by the authorized scribal handwork that documents it.[25] This little picture is not just a representation of presence; it is also presence's very *performance*. The hand of Veremudus Suerii is here, still validating, even though the text before us was copied long after his

Figure 14. Veremudus's hand. Madrid, AHN, MS L.1439, f. 90r detail. By permission: Ministerio de Cultura y Deporte. Archivo Histórico Nacional.

death. The validation is performed from the inside of the agreement itself by the written text and the *signum* that accompanies it.[26]

This charter-holding hand is the most explicit form of the *signum manus*, a symbolic representation of the hand's presence on the page that is, in fact, a representation of a hand upon the page.[27] A *signum* can also be made from letters—condensed, for example, from the three S's of the verb *subscripsi*.[28] It can be symbolic, like the ever-ready cross or X. It can also take its hand literally, as does Veremudus's *signum* in the Caaveiro cartulary. Ostolaza notes that such manual representations are woven into *signa* beginning in the late tenth century, "begun by the scribes themselves, who in their signatures begin to express in a palpable manner that their labor is executed manually and with the right hand, which is drawn in a perfectly recognizable manner."[29]

Palpable is a good word: these semiotic strategies aim to maintain— etymologically, to hold in the hand—a durable, graphic relation between *auctor*, actors, act, and page. *Subscripsi*: I, the subscriber, was here, here

in two places at once: in attendance both corporeal and symbolic at the charter's enactment. "I, Veremudus Suerii, have validated in this charter with my hands and have confirmed the deed."

The hands prove it, but as we have seen, they need not have written the texts that say they prove it. If the donor is the *auctor* of the document, the hand that makes that document authoritative belongs to the scribe. These deictic indices point to multiple *ego*s, multiple *nunc*s, multiple *hic*s. Just as the donor's formulaic *subscripsi* both records and creates presence both corporeal and symbolic, the pronoun in *manu mea* articulates the authorizing hand with two subjects at once, pointing simultaneously to *auctor* and writer, subscriber and scribe. *Auctor* and writer can speak through the same *ego*. They have, as it were, the same hands.[30]

Puzzling as it might be to a modern reader, the deictic multiplicity characteristic of the early medieval subscription is constitutive of the charter *qua* charter. I Veremudus subscribe, and I the scribe write the subscription. Two hundred years later, another "I the scribe" will inhabit both subject positions—donor and scribe—and write the date 1086 as if it were *now*. Rather than weakening the *vis* of the document, the charter's slippery deictics articulate it with the circumstances of its production and reception— and continue to do so every time the document is copied.

The charter's deictic articulation is temporal as well as pronominal. Written after the agreement it perpetuates, and often after the date of the enactment that it explicitly records, the charter is as multiply rooted in time as it is in first-person actors. One root sinks into the represented time, the "time in which those things were done in reference to which the charter is given" [*tempus in quo ea facta sunt super quibus datur littera*]; the other into the time of performance, the "time in which the charter is given" [*tempus in quo datur littera*].[31] Thus the characteristic phrase "I give" speaks from two different *now*s at once: the represented time of donation and the time of representation itself. From this double present the charter reaches out into the extra-documental world. And when that reach is taken up and recopied—into the mid-thirteenth-century Caaveiro cartulary, for example—we must add a new *tempus in quo datur littera* inhabiting the date of the subscriptions, just as we must articulate a new subject—the cartulary copyist—with the verb *subscripsi*.

All of this articulate machinery is quite literally in the hands of an agent who, while not a legal *auctor*, is a material writer—call him or her *ego scriptor*—who composes the document from the storehouse of fitting

formulas in memory, writes it in the appropriate hand and mise-en-page, provides the date of the act, writes below the text of the agreement the names of the donors and witnesses, and, finally, concludes the document by sub-scribing.[32] While not technically authorial, the scribe's is an authorized hand;[33] its activity, properly executed, ensures the text's continuing viability.

FLORENTIUS THE NOTARY

Florentius's was one such authorized hand. Seven surviving legal documents name him as scribe or notary: four are identifiably in his hand, and three are later copies.[34] The documents track a remarkably long forty-one-year career: the earliest is dated eight years before the *Moralia* in 937 CE; the lat-est, 978 CE, eighteen years after the León Bible, when the scribe would have been in his mid- to late fifties.

To get a sense of how charters articulate human subjects with the times and places of human activity, let us look at a charter surviving in Floren-tius's hand, this one quite recently identified in the collection of the British Library, Add.Ch.71356. Dated March 1, 937 CE, it solemnizes the donation of Santa María de Cárdaba to the monastery of San Pedro de Arlanza by Fernán González, Count of Castile (d. 970 CE).

It is a fine piece of work, carefully laid out and lettered by the young scribe in a minuscule much like the one that he would use for the *Moralia* eight years later. The charter proceeds in the proper formulaic fashion: it opens under the aegis of "the power of the Holy Trinity" [sub imperio be-ate Trinitatis],[35] names the *auctor* of the charter and its addressees, describes the gift and the penalties for violation of the agreement. Finally, the con-clusion instrumentalizes the charter with date of enactment and the sub-scriptions of agents and witnesses.

> This charter of donations or confirmations was made on the very kalends of March, era DCCCCLXXVa [= March 1, 937], in the reign of our Lord Jesus Christ and the most glorious prince Ramiro in Oviedo. I, Fredi-nando Gundisaluiz count of Castile and my wife Santia, who desire to have this written testament made, confirmed this sign from our own hands before witnesses + + and deliver it to witnesses for confirmation.

> [Facta cartula donationes uel confirmationes ipsas kalendas marcias, era DCCCCLXXVa, Regnante Domino nostro Ihsu Christo et principe

gloriosissimo Ranimiro in Obeto. Ego Fredinando Gundisaluiz comite in Castella, et uxor mea Santia, qui istum scriptum testamenti fieri uolumus, de manibus nostris coram testibus signum roborauimus + + et testibus ad roborandum tradimus.][36]

The subscriptions are ranked in four columns below this text. Each name is followed by the bearer's office, the abbreviation of the word *confirmans* or *testis*, and, in some cases, a *signum*. These names and the *signa* that accompany them indicate their bearers' presence to—and in a sense *in*—the document, but they are written too consistently and regularly to have been traced by the hands of whose presence they are the signs. Such, too, is the case with the elaborate donor monograms standing tall in the central column of subscriptions.

But what about those two crosses separating the confirmation and the delivery of the charter for further confirmation [*roborauimus + + et testibus ad roborandum tradimus*]? The count and countess's hands were here, but their continuing presence is most likely symbolic (through crosses standing in for their *impositio manuum*) rather than indexical (through autograph marks). But it is *Florentius*'s hand that articulates their auctorial presence with the page, both in this passage and in the two monograms made for the donors below, each evoking with its three arches the s's of the verb *subscripsi*, I have subscribed.

The hand that wrote for the subscribers identifies itself at the end of the last column of subscriptions inside a text box with a crenelated top that looks for all the world like a castle tower (Figure 15). The crenelations frame the letters S P S, an abbreviated *scripsi(t)*, I or he wrote.[37]

The letters of the *signum* thus gloss the subscription in the text box below, which reads *Florentius scriba depinxit hoc*.

I have left the subscription in Latin because the verb needs to be explored rather than simply translated. Recognizable through its English cognate *depict*, the verb is built on *pingo*, to paint. So, etymologically at least, *Florentius the scribe depicted this*. Díaz y Díaz took this verb as an audacious appropriation of a term of art and imagined the talented teenage scribe styling himself already a painter and not just an executor of instruments.[38] While Florentius's use of *depingo* is not in fact as unusual as Díaz y Díaz thought it was,[39] the word choice still deserves attention. Looking with this verb, we see the document as a graphic assemblage and are led to consider

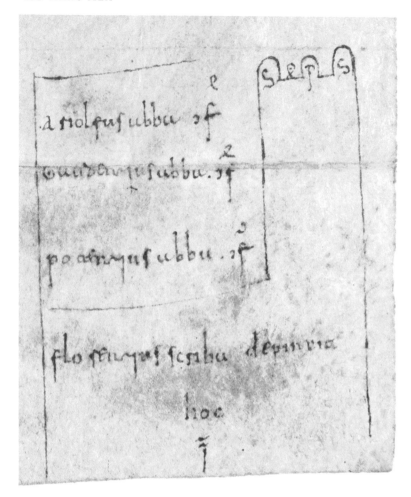

Figure 15. "Florentius scriba depinxit hoc." London, BL, Add. Ch. 71356, recto detail. © British Library Board. Used by permission.

it materially as well as semiotically—not only as writing but also as ink on a page.

MEMORIA: THE AUTHORITY OF INSCRIPTION

An equally material writing verb subscribes to another document surviving in Florentius's hand, the foundational deed of the Infantado de Covarrubias (Covarrubias, Colegiata de San Cosme y San Damián, leg. I no. 4).[40]

This document, written in alternating red and black lines of ornamental *elongata* script, was completed "on the VIII of the kalends of December, during the era TXVI" [diem VIII kalendas decembris, era discurrente certa TXVI][41]—that is, November 24, 978 CE, when Florentius would have been in his mid- to late fifties.

The subscription here reads *Florentius scriba licet indignus exarabit*.[42] The verb points not to painting but to plowing, evoking the physical labor of driving the pen across the parchment ground. We have read these words before: they cross the sweaty verb from the Homilies prologues (*Hic nempe liber ego Florentius exaraui*, Córdoba, AC, MS 1, f. 4r) with the ostentatious humility of the *Moralia* labyrinth (*Florentium indignum memorare*, Madrid, BNE, MS 80, f. 3r). And what of the words that formally open the Covarrubias charter with a cross and an invocation? "+ In the name of the unbegotten son and of the one God ever proceeding from nature, namely, of the Father and of the Son, the Holy Spirit binding the conjoined Trinity in unity" [+ In nomine ingeniti prolisque ac procedentis unius semper natura deitatis, videlicet, Patris et Filii, adnectens Spiritus Sanctus simulque conexa Trinitas in unitate].[43] This opening phrase should be familiar, too. The Córdoba Homiliary also begins under the sign of the cross—a full-page Cross of Oviedo on f. 3r—and the identical invocation "In the name of the unbegotten son and of the one God ever proceeding from nature" [In nomine ingeniti prolisque ac procedentis unius semper natura deitatis"; Córdoba, AC, MS 1, f. 3v].

The rhetorical situation of solemn framing provides the point of contact between charter and colophon over which this language can be shared. What is missing from the charter subscription, of course, is the colophon's direct address to the reader. The charter simply states that "Florentius, scribe though unworthy, wrote" [Florentius scriba licet indignus exarabit]; the *Moralia* labyrinth couches that same information in a request, conscripting future readers into the activity of the writing: "Remember unworthy Florentius" (Madrid, BNE, MS 80, f. 3r). It's not unknown, however, for notaries to subscribe to a charter as if they were writing a colophon. A legal document from 992 preserved in the Cathedral Archive of León, for example, declares: "Ruderigus the deacon wrote. In memory" [Ruderigus diagonus noduit memoria].[44] Ruderigus can do this not only because his memory is filled with useful Latin phrases and because the rhetorical situations of subscription and colophon are similar. Both of these are true, of course. But

it's also true that the authority of inscription puts the Ruderigus the dea-con in a position analogous, while not equal to, that of the document's aris-tocratic *auctor* and thus, by extension, deserving of memorialization.

The subscription of a charter from 918 (now in the Cathedral Archive of Lugo), behaves even more like a colophon. Tight dark cursive along the bottom margin of the document projects the charter itself in its very ma-teriality into the equally material hands of an imagined future reader. It begins, "Remember me all you who will have read this charter and who shall carry it in hand" [Memento mei qui hunc testamentum legerit et in manibus portauerit].⁴⁵ Having evoked you as embodied reader with this very charter between your hands, the text turns back to the scribal body in a move familiar from Florentius's writing-lesson: "Let [the reader] see and understand, because now my eyes grow cloudy and I cannot see well; I have reached old age" [Videat et intelligat quia iam hocculi mei calligant et uidere bene non possum; ad senectute deuenio]. The encroaching right margin cramps the scribe's hand, as the text concludes "and you, brother Veremu-dus [illegible] good honor in me. Sisvertus the priest wrote" [Et tu frater Ueremudu [illegible] in me bono honore. Sisuertus presbiter notuit]. Sisver-tus, first-person subject of the verb *scribo*, anchors writing in a thoroughly embodied present, from which, again like the colophons we've seen so far, he imagines future embodied readings. Sisvertus has thrown his line out to you, you who hold this in your hands.

We saw in Chapter 3 that if, in their colophons, scribes can be said to write themselves into their books, to understand their activity as they did, we should stress not the reflexive pronoun but the subject and verb in that sentence: not "the scribes write *themselves* into their books," but "*the scribes write* themselves into their books." This is what happens in the notarial subscription as well. "When [the notary] writes the word *ego* with their hand," observes Béatrice Fraenkel, "the term refers to their capacity as officer—their fictive persona—just as the 'I' of the writing refers only to a linguistic category."⁴⁶

These writers include their names in their work not so much because of the importance of the "self" that the names point to, but because of that activity of that subject: *ego scriptor*, not *ego-self-behind-my-eyes*. And because subscriptions are executed by an authoritative scribal hand, they ensure the ongoing presence of the charter's human agents in the document. They ensure presence symbolically, by standing in for the agents, and

grammatically, by articulating them with the action of the crucial verbs "I give" and "I subscribe." The experience of the writing subject matters not because it's theirs, but because it's *scribal*.

The scribe's hand has its own authority, for it is by that hand that presence is lettered into the page. No mere surface to be skimmed by the eye; the page is understood as an inscribed environment, as much a space one can enter as a surface on which one lays one's hand. The scribes we studied in Chapter 3 imagine us not as reading the books they made, but reading *in* them,[47] you'll remember: Florentius sees us reading *in this codex* [in hoc codice (Córdoba, AC, MS 1, f. 4r)]. Similarly, Veremudus Suerii did not validate that charter in 1086 but rather validated *in* it, and with his hands confirmed the deed [in hac carta manus meas roboraui, et hoc factum confirmaui].[48] In Chapter 5 we shall see that early medieval monastics did not just read in codices; they also, in a sense, lived in them. What they read on the walls demonstrated to them, over and over, the presence-making *vis* of inscription and the authority of making.

CHAPTER 5

MAKERS AND THE INSCRIBED ENVIRONMENT

There is no need to seek a book: may the room itself be your book.

[Non opus est ut quaeratur codex: camera illa codex uester sit.]

—Augustine, Sermon 319

True to its etymology (from Greek *kharassein*, to engrave), the character of both individual and community in a textual community is shaped by letters.[1] We have seen in previous chapters how you might have learned about what writing does if you were an early medieval monastic: in the grammar classroom, you would have been taught that letters had the power to make the absent present; in your devotional reading, you would be accustomed to letting scripture remake whatever it was you thought you were. If you were skilled in the way of letters, the scriptorium would be your field of manual labor. There, you would draft and solemnize legal documents with the power to make continuously present the intentions of their *auctores*.

Viewed this way, monastic character is a habitus ingrained by intimacy with inscription. In addition, text was not just made by your hand and performed by your voice; the spaces you lived in and moved through every day were themselves richly inscribed. The "epigraphic habit"[2] was still strong in early medieval Iberia, and much public space was vocal with inscription ranging from monumental texts carved and painted on walls to epitaphs set at eye level and informal graffiti made by the users of the built environment.

The monastery was no exception. Thus, monastic scribes learned to think about written language not only from the explicit training received in the schoolroom and put to use in the scriptorium, but also simply by living in monastic space itself, which, like the codex and charter, surrounded them with inscribed calls to remember deeds, names, dates, and places. When they made books, engaging intimately with the words of the thinkers most important to the community, their practice on those pages would be shaped as much by what they learned on the walls of the buildings themselves as by what they learned and did in the schoolroom and the choir.

Thus, this chapter turns from texts inscribed within the walls of the monastery to the inscriptions on the walls themselves. We will engage with the early medieval Iberian epigraphic record to see how living amid inscription might have taught workers in the scriptorium to think about and represent their labor. We focus on inscriptions that, like colophons and charters, articulate acts of making with the names of makers and the times and places of their activity. We begin by studying monumental inscriptions that, like colophons, record the construction and dedication of monastic churches. Here the making memorialized is auctorial, architectural, and artisanal. We then turn to the epitaph, an inscription that, also like the colophon, commemorates the end of a labor-intensive process—in this case, a single human life. And, at the end of the chapter, early medieval Iberian church graffiti will show us that the inhabitants of these buildings, like the users of the books stored within them, responded to their inscribed environment with some writing of their own.

A sermon delivered by Augustine helps us to imagine the silent rhetoric of these inscribed monastic environments. He stops mid-speech to situate his audience with respect to language, himself, and the space they all inhabit.

> What more shall I say to you? Shall I go on speaking? Read the four verses that we have written on the chapel wall: read, understand, and hold them in your heart. For that is why we wrote them there: so that all who choose to read might read, and read when they choose. So that all might understand, the verses are few; that all might read, they are publicly written. There is no need to seek a book: may the room itself be your book.

> [Quid uobis plus dicam et multum loquar? legite quatuor uersus quos in cella scripsimus, legite, tenete, in corde habete. propterea enim eos ibi scribere uoluimus, ut qui uult legat, quando uult legat. ut omnes teneant, ideo pauci sunt: ut omnes legant, ideo publice scripti sunt. non opus est ut quaeratur codex: camera illa codex uester sit].[3]

The speaker here calls on his listeners to stop and pay attention to *sermo* in its various material and symbolic forms. I don't need to make more sermon here, he says; inscription on the walls will do it for me. Fixed in space there in those carved characters, the discourse stretches forward in time; you can read it whenever you want. And when you read it, Augustine says,

take it up (*tenete*), take it in (*in corde habete*). Transform what you read, Gregory the Great might later add, into your very self (*Moralia* I.24). The efficacy of this discourse depends on your will and on your willingness to let the inscription inhabit you even as you inhabit the space that it articulates. "All who choose to read," says Augustine, may read, "and read when they choose." No need to go to the library for a book: Augustine has written you into one.

A monastery's inscriptions would have behaved much like the colophons we have been studying: they reach out to passersby and incorporate them into the activity of inscription, bringing precisely dated acts of making into the present moment of reading. Like colophons and charters, the monastic inscribed environment summons the Isidorean authority of inscription to make the absent present. It memorializes things that human beings made and did by articulating what they made (a donation, a building, an inscription) and did (lived, gave, and died) with the particularities of personal names, dates, and places.

"CAMERA CODEX VESTRA": INSCRIBED CHURCHES

Little remains today of the buildings at Valeránica that Florentius would have known so intimately beyond a few carved fragments.[4] Elaborate epigraphic programs do, however, survive in monastic churches like San Miguel de Escalada (León, consecrated 913 CE, restored 1088), and, later, Santo Domingo de Silos and Santiago de Compostela.[5]

The epigraphic grouping from San Martín de Salas (Asturias, restored 951 CE) allows us to imagine such an inscribed environment more concretely. The little church there was renovated and rededicated at roughly the same time that Florentius bent over the pages of the Homiliary at Valeránica some 260 kilometers to the south. We know when the work was done at Salas from nine richly worked stone fragments that document the renovation: three sets of triple-arched windows framed by decorative friezes and crowned with hortatory inscriptions, three inscribed crosses, two dedication plaques, and an elaborate epitaph.[6]

Six of the inscriptions articulate the building with the name and times of the person they present as the agent responsible for its construction. One inscription, originally on the exterior wall, fills a square lined-out text block

with beautifully rendered Visigothic capitals. It commemorates the activity of one "Adefonsus":[7]

> This church being for a long time in ruins, the monk Adefonsus ordered that it be renovated and rise again. For such labor may God be his helper and protector, that he might before God have reward for this gift that he made.
>
> [EX MULTIS TEMPORIBUS DESTRUCTAM ADEFONSUS CONFESSUS IN MELIUS EAM IUSSIT RENOVARI ATQUE RESURGERI ET PRO TALI LABORE SIT ILLI DNS ADIUTOREM ET PROTECTOREM UT ANTE DEUM HAVEAT PRO TALI FACTO DONARE MUNERATIONEM.][8]

This inscription presents Adefonsus as an *auctor*, an authoritative agent like the donor in a charter. A similar inscription formerly on an interior wall names Adefonsus again and gives the date of the building's restoration as "the IIII of the Ides of October, era DCCCCLXXXVIIII" (=October 12, 951 CE) [DIE IIII IDUS OCTOBRIS IN ERA DCCCCLXXXVIIIIa].[9] On the outer wall, a cross of Oviedo half a meter high bears the usual inscription in the upper register [HOC SIGNO TUETUR PIUS / HOC SIGNO VINCITUR INIMICUS]; and in the lower, "Adefonsus made it and save him, God" [ADEFONSUS FECIT ET SALVA EUM, DEUS].[10]

The *auctor* himself speaks in the inscriptions above the windows on the north and south exterior walls: "Give me Adefonsus eternal rest" [DA MICI ADEFONSUS REQUIEM SEMPITERNAM] (north side)].[11] The inscription on the south wall echoes, "Give me Adefonsus confidence that you will lead my soul without confusion into your company" [DA MICI ADEFONSUS FIDUCIAM UT ANIMA MEA ANTE TUORUM CONSORTIUM SINE CONFUSIONE PERDUCAS].[12] He turns to readers directly in his epitaph, writing us into his presence in striking language:

> +I beg you servants of God who will have come in to this tomb, do not fail to pray for me Adefonsus, if you wish to possess the kingdom of Christ eternally.[13] Here rests the servant of God Adefonsus the monk, who died the III day of the week, the VI of the kalends of August, era MVII. [=Tuesday, July 27, 969 CE].
>
> [+DEPRECO VOS SERVI DEI QUI AD HUNC SEPULCRU[M] INTRAVERITIS PRO ME ADEFONSO ORARE NON PIGEATIS SI REGNUM XPI SINE FINE

POSSIDEATIS. HIC REQUIESCIT FAMULUS DEI ADEFONSUS CONFESSUS QUI OBIIT DIE III FERIA VI KLS AUGUSTAS IN ERA MVIIa.][14]

The text here evokes us not, as we might expect, as standing before an engraved stone, but as actually having "come into" the tomb that it marks (*qui ad hunc sepulcrum intraveritis*). We have, that is to say, been drawn in, conscripted into the writing's project—just as Florentius imagined us not reading his book, but reading *in* it, and as blind old Sisvertus saw us holding the charter he wrote in our own future hands.[15] Sharing that space with Adefonsus, who rests here, we in our time are articulated with him and his time—specifically, the moment it stopped for him: Tuesday, July 27, 969 CE. We inhabit the space made possible by this person named Adefonsus, whose activity, anchored in a very specific moment in time, is made present in the moment of reading. These inscriptions, Isidore would say, "have so much force that the utterances of those who are absent speak to us without a voice" [tanta vis est, ut nobis dicta absentium sine voce loquantur].[16]

If, as Augustine suggested, the sanctuary room is a codex for the faithful, then it should not come as a surprise that the writing on the wall should be understood to function much as the writing in a book does. A rather awkwardly lettered plaque over a window at the church of San Martín de Argüelles (Asturias) reads much like a colophon. "In the name of our Lord Jesus Christ in era DCCCCLXXXVIIII (= 951 CE), Dominigus the presbyter restored this basilica. O you priests and all people, pray for me" [IN NOMINE DNI NOSTRI IHESU XPI IN ERA DCCCCLXXXVIIIIA RESTAURABIT DOMINIGUS PRESBITER BASELICAM ISTAM O VOS SACERDOTES VELUT OMNES HOMINES ORATE PRO ME].[17]

Much as a colophon links book, scribe, and reader, this inscription articulates the building on the one hand with its maker and the time of the making, and on the other with its readers and the moment of reading. To be interpellated by such an inscription is to be addressed in one's own present from a moment in the past whose particularity is made clear not only by the precise date with which the inscription is articulated but also by the singular constellation of persons and events that it records. Particularly elaborate in this sense is an inscription on the west portico of the church of San Martín de Castañeda in Zamora, which leads us to encounter the building not just as a finished structure, but as a process precisely represented in time and space.[18]

This place was a sanctuary of small size dedicated anciently to St Martin. Fallen into ruins, it remained thus for some time until Abbot Iohannes came from Córdoba and consecrated a temple here, raised the ruins of the shrine from their foundation and worked it up with finished stones. Not by imperial order, but by diligence of the monks, these works were completed in two plus three months. In the reign of King Ordonius, in the era nine and half a hundred plus nine [= 921 CE].

[HIC LOCUS ANTIQUITUS MARTINUS SANCTUS HONORE DICATUS, BREVI OPERE INSTRUCTUS, DIU MANSIT DIRUTUS, DONEC IOHANNES ABBA A CORDOBA UENIT ET HIC TEMPLUM LITAUIT, EDIS RUGINAM A FUNDAMINE EREXIT ET ACTE SAXE EXARABIT. NON IMPERIALIBUS IUSSUS ET FRATRUM UIGILANTIA INSTANTIBUS. DUO ET TRIBUS MENSIS PERACTI SUNT HEC OPERIBUS. HORDONIUS PERAGENS SCEPTRA, ERA NOBI ET SEMIS CENTENA NONA.][19]

Auctor, architecture, and activity are here mutually articulated in relation to space (*hic locus, hic templum*) and time (five months in the year 921 CE). Between these points, the inscription weaves a wide temporal web. The first sentence, couched in three parallel clauses ending in adjectival past participles (*dicatus . . . instructus . . . dirutus*), describes the long stretch of the building's history. This period is interrupted by the arrival of Abbot Iohannes and the subsequent renovations made under his authority, set in four parallel clauses ending in verbs in the perfect tense (*uenit . . . litauit . . . erexit . . . exarabit*). The last two sentences continue this pattern of juxtaposing temporal point (*uenit*) with temporal extension (*diu*), concluding a stretch of labor that lasted for "two plus three months" in "the era nine and half a hundred plus nine."[20]

Though the composers of a text like this were writing for a wall, they were most certainly thinking in the scriptorium, using language and rhetorical structures known to them through their work on parchment. At Castañeda, the phrase linking the building to the brothers' labor ("Not by imperial order, but by diligence of the monks") is drawn directly from the legal formulaic storehouse and makes frequent appearances in contemporary charters.[21] Like a charter's *auctor*, Abbot Iohannes does not need to do the work with his own hand. As a donor uses the scribe's hand to subscribe *manu mea* to a charter, so here Iohannes's activity is indicated by a verb borrowed from scribal handwork. My translation says that Abbot

Iohannes "worked up" his renovated building with finished stones. The Latin, however, is even more explicit about the nature of his work: *acte saxe exarabit*, it declares. With *exaro*,[22] the scribal laborer's verb par excellence, who-ever composed this inscription referred to Iohannes's activity with the word most often used for his own labor in the scriptorium. The inscrip-tion thus figurally incorporates handwork into the abbot's expansive auc-torial agency.

As a scribe like Florentius might make a sermon collection or copy a legal document, Abbot Iohannes plowed this building, wrote it, worked it up with finished stone. Thus, San Martín de Castañeda is written in its stones and crowned with this inscription, which has been aptly called an "epigraphic colophon."[23] Like a colophon, the inscription guides visitors to attend not only to the finished building but to the process by which it was made and the human labor that made it. The date on which the reconstruction was completed gives us the finished building; the evocation of its ruined state and those "two plus three months" of monastic labor in its renovation lead us to imagine it as a building-in-process. Like the self-narrating frame of Florentius's *Moralia*, the inscription presents the building as both product and process, explicitly articulated both with time and with human labor.

This colophonic memorialization is not peculiar to Castañeda. Contem-poraneous inscriptions at the nearby monasteries of San Miguel de Esca-lada (914 CE, now lost) and San Pedro de Montes (919 CE)[24] lay out the laborious process of making in almost identical terms. Most elaborate is the story told almost two hundred years later at San Esteban de Corullón (León). The church, this inscription declares, was consecrated on December 16, 1086 CE, torn down in 1093, rebuilt and rededicated in 1100.[25]

In the name of our Lord Jesus Christ and in honor of St. Stephen this place was consecrated by bishop Osmundus of Astorga in era ten times one hundred plus twice fifty plus twice ten plus IIII the XVII of the ka-lends of January by the hand of Petrus Monincus and the presbyter who was its founder VII years later tore it down and built it up from the foun-dation and in VII more it was complete.[26]

[IN NOMINE DOMINI NOSTRI IESHV XHRISTI ET IN HONORE SANCTI STEPHANI SACRATVS EST LOCVS ISTE AB EPISCOPO ASTORICENSE NO-MINE OSMVNDO IN ERA CENTIES DENA ET BIS QVINQVAGENA ATQVE DVO DENA ET IIII QVOTVM XVII KALENDAS IANVARII PER MANVS DE PETRO

MONINCI ET PRESBITER CVIS ORIGO ERAT POSTEA AD ANNOS VII EIECIT
EAM ET A FVNDAMENTO CONSTRVXIT ET IN ALIOS VII FVIT PERFECTA.][27]

At Corullón, the precise date of consecration is followed by two seven-year periods: one in which the building was used, then torn down, and the other encompassing the rebuilding process. Expressions of time are rendered in the same distributive way as in Florentius's colophons, here made all the more time- and labor-intensive by the resistance of stone to the chisel.[28] The labored engraving of letters on the wall requires a parallel intellectual exertion from the reader, who must mentally assemble the date of the building from the spelled-out sum. All these labored dates converge on "the hand of Petrus Monincus," who is probably, but not certainly, the same person as the presbyter identified as originator of the foundation.[29] Like Abbot Iohannes of Castañeda or the monk Adefonsus of Salas, Petrus has an auctorial hand. Although his involvement came more from mandate than from manual labor, he is as much a maker as a stonecutter or a scribe.

Petrus's status was made even clearer in a relief seen beneath the inscription in the mid-nineteenth century that represented "the figure of a priest with a book in hand, and on the book is written: 'Petrus Munniocus, then presbyter, ordered this work to be made'" [Petrus Munnioci quo tempore presbiter jussit hoc opus facere].[30] Petrus has made a building that, like the codices made in the scriptorium, is a machine for living and for prayer.[31] The relief has since vanished, but we can get an idea of what it might have looked like from the church of San Miguel at San Esteban de Gormaz (Soria). The central corbel above a galleried portico bears the image of a hooded figure looking up, wide-eyed, from a codex on his lap (Figure 16).

On the pages open before him is written " + Master Iulianus made it era MXVIIII" (=1081 CE) [+ IVLIANUS MAGISTER FECIT ERA MCXVIIII].[32] The letters are small and look improvised, so it is hard to be certain about the date.[33] But this much is clear: Master Iulianus made it, and someone wanted you to know when he made it. However we understand the verb *fecit* here (more on that important word shortly), what matters now is this: an inscribed declaration of making is represented as a sculpted colophon, as if the church were a book and Iulianus its scribe. *Camera codex vester sit*, as Augustine would say: let the building be your book.

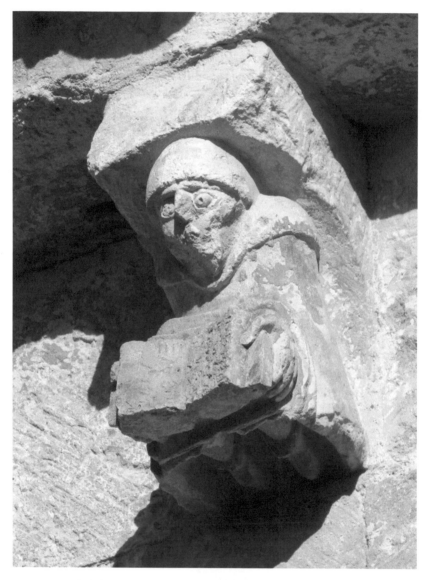

Figure 16. Corbel: "Master Iulianus made it." San Esteban de Gormaz (Soria), church of San Miguel. Photo courtesy of Josemi Lorenzo. Used by permission.

"EXEGI MANOMENTUM": MAKERS AND INSCRIPTION

The hand (*manus*) is so called because it is in the service (*munus*) of the whole body, for it serves food to the mouth and it operates everything and manages it; with its help we receive and we give. With strained usage, *manus* also means either a craft or a craftsman.

[Manus dicta, quod sit totius corporis munus. Ipsa enim cibum ori ministrat; ipsa operatur omnia atque dispensat; per eam accipimus et damus. Abusive autem manus etiam ars vel artifex.]

—Isidore of Seville, *Etymologies* XI.1

Facio is a many-handed verb in medieval Latin, as complex and revealing in its multiple meanings as the conceptually related noun *auctor*.[34] Recent work by Emilie Mineo and Therese Martin suggests that there is much to be gained by not trying to disambiguate the verb in inscriptions like these. Mineo suggests that, instead of trying to determine if the subject of *facio* in an inscription is a patron or an artist, we should think about them together as agents of artistic creation. This, she says, "has the advantage of emptying out, at least provisionally, anachronistic labels like 'artist' or 'patron.'"[35]

In the inscriptions we have been studying, clean-handed auctorial work borrows the language of manual labor to represent itself as a making. The Castañeda inscription appropriates the scribal verb *exaro* for Abbot Iohannes's foundational activity; at Corullón the hand of the presbyter Petrus Monincus is given full agency for the entire process of construction, demolition, and rebuilding of the church. Petrus at Corullón and Master Iulianus at Gormaz are sculpted bookishly writing colophons for the buildings they established. The *opus* is theirs, if not the manual labor. The only details we are given about these people beyond their names and, if available, ranks, are those associated with the making. What mattered, then, is that, whatever they did and however they did it, these people were makers, and their making *matters*. Inscriptions like these—in the early Middle Ages at least—memorialize the making more than the personal identity of the maker.[36]

Many forms of the merit of making are made present in the ninth-century foundation plaque at the church of San Vicente at Serrapio in Asturias (Figure 17).

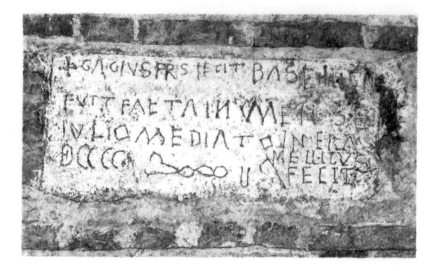

Figure 17. Foundation plaque. Serrapio (Asturias), church of San Vicente. Line drawing © Sophia Linden. Used by permission.

Like a charter or a colophon, it begins under a cross. Scraggling capitals then declare that " + Gagius the presbyter made the basilica. It was made in the middle of July in era DCCCC XXXII (= 894 CE)" [+ GAGIUS PRESBITER FECIT BASELIGAM FUIT FACTA IN MENSE IVLIO MEDIATO IN ERA DCCCCa XXXII].[37] But the making isn't over. Crammed somewhat awkwardly in the lower right corner of the stone in half-size capitals, an addition: "Mellitus made it" [MELLITUS FECIT].[38] Three times the verb *facio*: once with Gagius the presbyter, once with the basilica itself, and once with a certain Mellitus as its subject. Gagius's making is most likely auctorial: the basilica was probably his idea, his commission. And Mellitus? The sentence gives no details on his activity, but the literally subordinate position (etymologically under-the-row) in the layout suggests that the object of his making may be the text we're reading—that is, the inscription itself.

Mellitus's hand, in the act of inscribing his name to the act of inscription, points our attention toward what we might at first glance want to call "artist's signatures" on the walls of early medieval Iberian buildings.[39] These are the closest epigraphic analogues to the colophons that scribes like Endura and Florentius lettered with such labor at the crown-points of their books. From inscriptions like these, workers in the scriptorium learned to

think about their labor—as the makers of buildings learned to think about theirs from the books they saw and used to think about their labor.

Explicitly and literally manual is the making recorded in an inscription over the main portico of the church of Santa María de Iguácel (Aragón). It begins by naming Count Sanctius and his wife, Urraca, by whose command the church was founded "in era T one hundred X" [IN ERA T CENTESIMA Xᵃ].[40] So far so good: this is the year the building was completed, 1072 CE, and here are the nobles who made its construction possible. After this, however, come more words about making. The agency could not be any clearer: "The writer of these letters is named Azena, the master of these pictures Galindo Garces" [SCRIPTOR HARUM LIBTERARUM NOMINE AZENA. MAGISTER HARUM PICTURARAM GALINDO GARCES].[41] Faint traces of paint on fragments of stucco remaining on the portico were visible in the 1920s,[42] but any paintings in the church were lost when it was redecorated in the fifteenth century. The words are still here, though: still tied to the *scriptor*'s hand, still pointing toward invisible paint.

Most scribally assertive of all is the dedication stone of the shrine of San Miguel at Villatuerta (Navarra), now in the Museo de Navarra in Pamplona, dated by language and letterforms to the 970s CE (Figure 18).[43]

A rectangular tablet bears an inscription laid out in four sizes of Visigothic capitals. Horizontal ruling divides the tablet into three broad bands. Letters that rise to the full height of the ruled space occupy the upper two bands; the third contains two rows of capitals half the size of those in the upper two registers. The whole is framed by a thin decorative border interrupted by text in still smaller capitals at top and bottom. The text at the top of the border has been damaged; in Robert Favreau's reconstruction, it reads, "In the name of God. By the Lord Sanctius, servant of Lord St Michael" [IN DEI NOMINE. FAMULO DOMINI SANCTI MIKAELI DOMINO SANCIO].[44] Here then is one maker, most likely the noble by whose authority this building was constructed. The agency grows more specific in the three main bands of the inscription that read thus:

In the name of our Lord Jesus Christ and St Michael by Lord Blascio Lord Sanctius Acto is the name of the master who made [it]. Belengeres.

[IN NOMINE DOMINI NOSTRI IHESV CHRISTI SANCTI MIKAELIS DOMINO BLASCIO DOMINO SANCIO ACTO NOMEN MAGESTRI QUI FECIT. BELENGERES.][45]

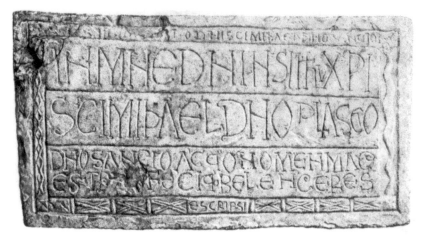

Figure 18. Dedication plaque. Villatuerta (Navarra), church of San Miguel. Line drawing © Sophia Linden. Used by permission.

It is clear that we are being given the proper names of persons associated with the making of the building in ways deemed worthy of memory. Two nobles, Blascius and Sancius, are named in ablatives indicating patronage. Somewhere here is "the name of the master who made it" [nomen magestri qui fecit], though lack of punctuation makes it hard to see exactly where. Both Favreau and Silva associate this phrase with the word ACTO, which they take to be a proper name. This leaves BELENGERES hanging orphaned at the end of the line. He will get a verb, too: it is written below his name in half-size capitals in the exact center of the bottom frame of the plaque. ESCRIPSI, it says, *I wrote.*

Now to the maker Acto we can add the first person of a writer named Belengeres.[46] Acto may well be the architect.[47] The other, Belengeres, seems to speak—or rather to write—for himself, and with what I cannot help but call a Spanish accent: ESCRIPSI. He has laid out his subscription so that it is visually all but independent of the proper name that indicates its subject: it hangs on the bottom center of the border like the identifying tag on a picture frame in a modern museum. But instead of telling us the artist's name, all this "tag" explains is his activity: ESCRIPSI. As if that were the most important thing, as if any proper name attached to it were secondary, supplemental. The first-person verb of writing anchors a monument of making, the epigraphic analogue of a notarial subscription.

Most emphatic of all is the testimony of the late eleventh-century plaques from a church dedicated to Saint Andrew and now set into the exterior walls of the church of San Cipriano in the city of Zamora.[48] Like the inscription at Iguácel, they record the building of a church and provide the names of important figures associated with its construction. There is, however, a striking difference: no noble or ecclesiastical makers are mentioned. Instead, the protagonists are the artisans.

Two of the inscriptions are explicitly dated and record the construction of a church. One announces the building's dedication on "the IIII of the nones of February, era MC XXXI" [IN QUOTUM DIE QUOD ERIT IIII NONAS FEBRUARII, IN ERA MC XXXI],[49] that is, February 2, 1093. Immediately after the date follow the names of the artisans, presented in a narrative sequence that mimics the construction process of the building. They are led by a master whose handiness modifies his name like an epithet: "At first Master Sancius through his sure hand, [then] Ildifonsus before the whole council, and Master Raimundus raised the roof. Brothers, pray for their souls" [IN PRIMO SANCIUS MAGISTER PER MANU CERTA. ILDIFONSE ANTE TOTUM CONCILIUM ET INCIMAVIT RAIMUNDUS MAGISTER. FRATRES, ORATE PRO ANIMIS ILLIS].[50]

These same makers—Ildifonsus, Sancius, Raimundus—are protagonists of another inscription dated a year later, which surrounds a relief of three figures representing the masters themselves.[51] In this relief the makers stand still for their close-up, but the other two surviving reliefs show them hard at work. A small figure now set in the exterior wall near a door holds a hammer in his right hand, in his left a set of tongs; the text beside him, in letters part Visigothic, part Carolingian, reads, "Vermudo the blacksmith, who made a memorial of his making" (Figure 19) [VERMUDO FERARIO QUI FECIT MEMORIA DE SUA FRAVICA].[52]

A smaller relief in a harder, whiter stone, now positioned above and to the right of the blacksmith, has been much damaged, but clearly shows three human figures (Figure 20). One, standing and truncated at the waist, seems to be walking away to the right. The other two are at work on a rectangular object in the center of the composition. One bends down over it; the other kneels beside it, arms bent, tools in both hands. The object they are working on is helpfully labeled: this is a MANOMENTUM.[53]

There is no way of knowing what other inscriptions from that church of St. Andrew in Zamora might have said, but the ones that survive at San

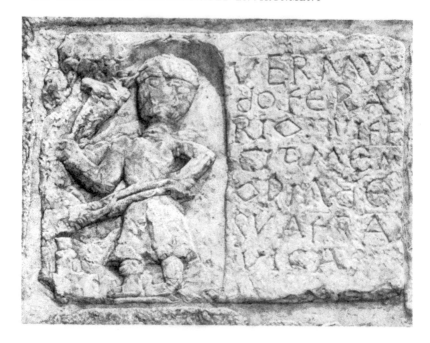

Figure 19. Vermudo the blacksmith. Zamora (Zamora) church of San Cipriano. Line drawing © Sophia Linden. Used by permission.

Cipriano are remarkable in their linguistic and visual assertion of artisanal protagonism. They are, you could say, monuments to the *manus certae*, the skilled hands whose labor raised the building from its foundations and carved the texts in stone. The informal spelling of early medieval Latin allows for handy wordplay. Handwriting on a wall commemorates its own inscription: a *manu-ment* to manual work.

The monastic inscribed environment was designed to be read, understood, and held in the memory. The inscriptions examined so far give a sense of what a building was meant to "say" by its designers; we now turn to eavesdrop on a church as its inhabitants themselves talked to it and made it speak. As readers of codices responded to their conscription in the book by adding commentary of their own, so did users of monastic space annotate the rooms that Augustine called their codices. Recovered early medieval graffiti show us the epigraphic habit on an informal, individual level, articulating a shared space with individual memories and unreconstructible desires.[54]

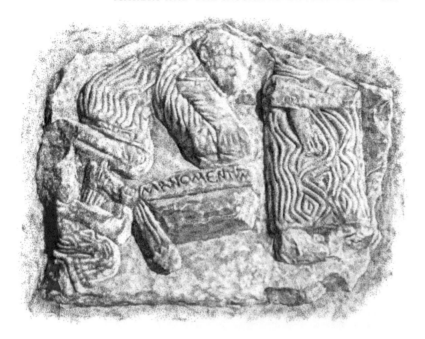

Figure 20. MANOMENTUM. Zamora (Zamora) church of San Cipriano. Line drawing © Sophia Linden. Used by permission.

The church of San Miguel at San Esteban de Gormaz—whose maker Master Iulianus we met earlier in this chapter, displaying a book inscribed with the date 1081 (Figure 16)—was also, it turns out, itself taken as a codex by many of the early medieval people who met in its space. In 2009, an archaeological team began an exploratory removal of plaster to reveal the original interior walls of Master Iulianus's church. Their work revealed hundreds of incised and painted graffiti that vividly show the church in the hands of ordinary people between the late eleventh and the early thirteenth centuries.[55]

The inscriptions are concentrated in a band running some four meters off the floor around the north, west, and south interior walls. The people who put them there must have been standing in a gallery that no longer exists. Graffiti are also clustered at floor level on the south wall, around a door in the north wall, and behind the altar. The textual inscriptions are mostly dates and isolated numbers. The many fields of parallel hatchmarks served once to count something, perhaps prayers. There are drawings, too:

a tower, a hunting scene in charcoal, and a spectacular striding warrior a meter high, a sword in one outstretched hand and a shield in the other. On the shield is helpfully written the word *dominus*.[56]

At the southwest corner of the building, a painted cross was revealed when the post-medieval plaster was removed.[57] It has a black smear up its vertical shaft—this is the holy oil with which the priest's fingers would ritually anoint it on every anniversary of the church's consecration. Here we must imagine the hand to remember it. In other spots we don't need to imagine anything: groups of four parallel smooth channels two to three inches long appear together in many areas of the newly uncovered underwall. Here workers are applying the plaster. They are using their hands.[58]

Also using their hands are three incised figures that stand facing each other across the window in the apse, two on one side and one on the other.[59] Measuring from 50 to 80 centimeters in height, they are represented in profile, wearing long gowns and tight-fitting caps. They are pointing at each other, their extended indices urgent with purpose (Figure 21).[60] There is a conversation going on here, perhaps an argument, but we can never know what it is because its object always slides away from us at the other end of the deixis: Look there, see here, pay attention to this. Meet me here a week from now with a stick this big.[61]

And in manuscript that deictic catches you. Yes, *you*: the formal epigraphic inscriptions address the reader directly, as viewer, as monastic, as future inhabitant of this place. Drawn in, you might leave your mark: count some prayers, draw what's on your mind, scratch in a word or a date as a hook for memory. Other viewers might see your mark and be moved to respond.

Viewers and writers alike are thus present in these handwritten inscriptions. The writers left behind a *ductus* whose lead we follow into a beautiful unknowability more familiar perhaps to poets than to scholars: someone whose name began with "E" died on the 23rd of March, and someone else recorded the death on the wall at San Esteban [x k APRILIS: OBIT E].[62] No year is recorded; perhaps the writer didn't know it. What matters is the day, so that it can be remembered year after year. The day was so important that the person wrote it twice—a tentative, smaller beginning of the inscription scraggles beneath the 23rd of March. A first draft. The writer didn't like the way it turned out and tried again right above it.

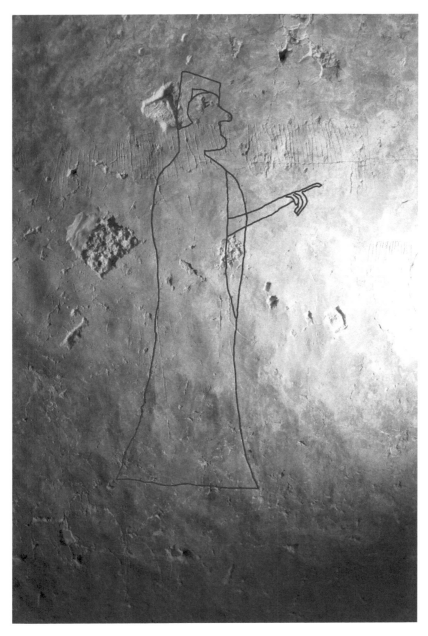

Figure 21. Gesturing figure (graffito). San Esteban de Gormaz (Soria), church of San Miguel. Outline added. Photo courtesy of Josemi Lorenzo. Used by permission.

STATE, VIATOR: THE ARTICULATE EPITAPH

We can date the graffiti at Gormaz because many of them are themselves dates. Some are bare years, scratched into the wall for irrecuperable reasons: *era MC, MCIII* (= 1062 and 1065 CE, both probably inscribed in the early stages of construction), *era mcci* (= 1163 CE). Others, like the memorial for "E," articulate a date with someone's death—"MES died: era MCCIIII" [OBIT MES: ERA MCCIIII] (= 1166 CE).[63] We'll never know who these people were, but someone wanted to record their passing.

The people who scratched those private obits on the wall were responding to the inscribed environment itself, which was also skinned with names and dates. Dedications and epitaphs, both of which we saw in the fragments surviving from Salas, mark the completion of an arduous undertaking (a human life, the construction of a church). So does the colophon. Dates are prominent in all these genres, but they are especially crucial to the Christian funeral inscription, founded as it is on the notion that death is a second birth and its date thus worthy of commemoration.[64]

Also like colophons, many epitaphs explicitly address their imagined readers and conscript them into the process of memorialization.[65] A striking version of such an apostrophe may be seen in an early Christian epitaph from the second century CE found at Beja (now southern Portugal), which uses the act of reading to articulate the passerby with the deceased, and both with the inevitable passage of time. Through the letters carved in stone, the deceased speaks in the first person. Her name is Nice. She speaks to you, passerby, her reader.

> Whoever you are, passerby, who pass in front of me, buried here, when you have read in the boundary stone that I died in the twentieth year of my life, you will pity me, and if I am still aware of my repose, I will quietly pray for you, so that you may live for more years and grow older.

> [QUISQUIS PRAETERIS HIC
> SITAM VIATOR POSTQUAM
> TERMINE LEGERIS MORI
> ME AETATIS UICESIMO
> DOLEBIS ETSI SENSUS ERIT
> MEAE QUIETISQUE LASSO
> TIBI DULCIUS PRECABOR
> UIUAS PLURIBUS ET DIU SE-

NESCAS QUA MIHI NON
LICUIT FRUERE UITA.]⁶⁶

As Ludwig Lieb and Ricarda Wagner observe, inscription on a tomb slab "is charged with the function of initiating . . . communication. It wants to do something with its onlookers by turning them into readers; it possesses agency."⁶⁷ This epitaph reaches for you, reader, from beneath or behind the stone before which you stand. You and the dead person are connected, first by the "boundary stone" that opens communication between you and then, as you read further, by an extratombal emotional reciprocity: the living pities the dead, the dead prays for the living. You will, the inscription says, have more in common with the dead Nice than you now think. "Go, and hurry," her epitaph concludes, "since you who are reading will also be read, go" [I, POTIUS PROPERA NAM/ TU LEGIS IPSE LEGERIS, I]. Someday, Reader, she reminds you, you'll be where I am. Someday you will be read, not reading.

Other ancient epitaphs riddle their way into your attention. One common form of puzzle epitaph hides the most important part of the inscription— the deceased's name—in the first letters of each line of an acrostic poem that sometimes includes instructions for its own decryption.⁶⁸ Such inscriptions request not only the affective, but also the intellectual participation of those who engage with them. Stop, traveler, and get to work. You are not just a reader, but an interpreter.

To learn what an eleventh-century epitaph in the cloister of San Miguel de Bárcena (Asturias) wants you to remember, you must really slow down.⁶⁹ Within a wide foliate border, the inscription begins with a cross at the upper left. Great care has been taken in the disposition of the text, which proceeds not in the usual left-to-right horizontal lines, but in a rectangular spiral of equally sized letters ending at the center in a geometrically patterned cross of St. Andrew. You must pay attention to learn the name of the deceased, and the inscription wants to make sure that you do. It gives you directions, in fact:

In the name of the Lord. Read what is on this stone from the top: here rests the servant of the Lord Arogontina, monastic, and she died on IIII feria on the kalends of September, era MXLI (= Wednesday, September 1, 1003 CE).

[HIN NOMINE DNI. HAEC LAPIDE POSITE A KAPITE CORPORE LEGITE REQUIESCIT HIC FAMULA DEI AROGONTINE CONFESSA ET OBIIT IIII FERIA DIE KLDS SEPTEMBRIS ERA MLA XLIA.]⁷⁰

Though the Latin here is improvisational,[71] whichever way you take it, you are certainly being commanded to read: LEGITE. If Diego Santos's rendering of the second clause (which I have followed here) is correct, the inscription is offering instructions on how it should be read: start at the top, and spiral inward toward the central cross. Read the body of this inscription from the head down (*a kapite corpore*) and find the body of Arogontina. Locate her in space (here) and time (her last day, Wednesday, September 1, 1003). This is the epigraphic equivalent of the lettered labyrinth that opens Florentius's *Moralia* (Madrid, BNE, MS 80, f. 3r; Plate 3), not only because it is an elaborately designed visual puzzle, but also in its rhetorical function: Remember unworthy Florentius; remember Arogontina. The puzzle suspends you in contemplative arrest, following Isidore of Seville's "road for reading," remembering.[72]

Equally eager to puzzle and engage its imagined reader is the epitaph of an abbot named Stephanus, carved in Visigothic capitals into a jamb of the north door into the monastic church at Peñalba de Santiago (León).[73] The inscription begins by declaring that the deceased "enclosed in Christ beneath this marble" [CLAUDITUR IN CHRISTO / SUB MARMORE . . . ISTO] was "a man of great piety for as long as that was possible for him—for as long as he was permitted to live" [MAGNE / QUOQUE VIR PIETATIS DUM SIBI / POSSE FUIT, VIVERE DUM LICUIT].[74] And when did he die? The inscription is at first forthcoming: on St. Gervasius's Day [GERVASI FESTE], it tells us. If we want to know *which* St. Gervasius's day, however, we will have to do some work.

Arogontina's epitaph set its inscription in a labyrinthine spiral and gave us directions for reading it; Stephanus's, too, encrypts his death date in a puzzle, and then offers a clue: "Take one hundred years, add seven times six and one thousand to them [and] you will know the era" [ANNUM CEN / TENUM DUC, SEPCIES ADITO / SENUM MILLE QUIBUS SOCIES / QUE FUIT ERA SCIES]. Have your answer? Good. So that you can check your work, the epitaph gives the solution: "Abbot Stephanus died on the IIIX of the kalends of July, era CLXX" [IIIX KALENDAS / IULII OBIIT STEPHANUS ABBAS ERA CLXX].[75]

That's June 19, 1132. The text, however, presents the date not as a simple point of reference, but as something to be figured—a process that itself takes time, both in the production and reception. More letters to carve equals more time at work, and if you, reader, go back over the puzzle and its proffered solution, you will need more than a moment to figure out that something is not right here. The thousand has been left off the date in the solution

(*era* CLXX), but that's not the problem: posterity-minded though they were, the writers probably did not imagine a reading public extending into multiple millennia and so could take that thousand for granted. It takes a little longer to think through the mismatch between the dates yielded by puzzle and solution. The epitaph's "solution" triumphantly tells us that Stephanus died in era 1170, but do the sum—$100 + (7 \times 6) + 1,000$—and you get era 1142.

What happened? Someone's mind wandered. The puzzle wants us to work with seven times six [SEPCIES SENUM], which brings us up short. Plug seven times *ten* [SEPCIES DENUM] into the equation, however, and you get a match: era 1170. The composer or engraver had just written the offending *senum* in its other meaning (Stephanus was *dogma decusque senum*, the model and glory of old men), and from memory *senum* misled the hand into repetition, whence the mistake. We may even know whom to blame for the time we have just spent absorbed in this inscription, for, like a charter, the epitaph concludes by identifying its makers: "Pelagius Fernandez ordered this to be made. Petrus wrote it" [PELAGIUS FERNANDIZ / JUSSIT FIERI PETRUS QUI / NOTUIT].[76]

Imagine yourself once again an inhabitant of one of these early medieval monasteries, and you will not forget that Petrus's hand did the dirty work. You would have learned in the grammar classroom that letters give voice to the absent, that they bind fugitive things to memory.[77] The very walls thus would have spoken silently to you. They would have spoken about people who made the space you lived in. They'd have tied your home to the activity of those makers, and to the very dates when they did their work. Some inscriptions named people gone long before your time. Others called up memories of people you knew well. You might have remembered those lost people to the wall yourself, taking your penknife or a nail to the plaster to cut their initial and a date. That small, inscribed act of making answered and carried on the labors that make the very stones of your monastery an articulate library.

May this room be your codex, said Augustine. The reverse is also true: may this codex be a room—an inscribed environment inhabited simultaneously by author, scribe, and reader. In Chapter 6 we return to the scriptorium and move into another book that was articulated there, to inhabit and be inhabited by it. It is a book that is, as we shall see, itself both a library and a tomb.

REMEMBER MAIUS: THE LIBRARY
AND THE TOMB

> Alas! Woe to those who now refuse to examine the books, and to those
> who foolishly despise what will in the future be done in books.
>
> [Eu et uae, qui nunc libros requirere nolunt, et quid in eos gestum erit
> in futuro inerte despiciunt!]
>
> —Beatus of Liébana, *In Apocalypsin* XII.1.5

The elegant little Mozarabic basilica of San Miguel de Escalada still sits quietly atop a lonely hill some twenty-five kilometers east of the city of León. It once served a monastery likewise dedicated to St. Michael, the foundations of which are still visible around the outside walls of the church.[1] For many centuries this monastery was home to a remarkable codex that is, the book itself declares, "the container and key for all books" [Omnium tamen librorum tecam hunc librum . . . et claviculam].[2] This codex, a veritable library of books and bookishness, is now in the collection of the Morgan Library in New York City as MS M644. It contains a commentary on the Apocalypse designed, written, and painted in the mid-940s by a monastic named Maius.

As a maker of books, Maius is in every way the equal of his contemporary and possible acquaintance Florentius (their home monasteries of Tábara and Valeránica were around five days' journey apart).[3] Nothing is known about Maius beyond the testimony of his interventions in the Escalada Apocalypse and what one of his students says about him. We do, however, know where he is buried. This chapter will remember Maius in both his book of books and the bookish tomb made for him by his disciple Emeterius.

Before we enter Maius's library, though, let's visit in imagination the inscribed environment for which he made it.[4] Escalada's foundation in 913 CE was recorded in a monumental inscription. You will recognize the gestures of this dedication, which articulates the space you are (presumably) standing in with the people who made it, their labor, and their times.

This place was a sanctuary of small size dedicated anciently to St. Michael. Fallen into ruins, it remained thus for some time until Abbot Adefonsus, who had arrived from Córdoba with his followers, raised these ruins with the efficacious aid of Prince Adefonsus. With the growth of the number of monks, this beautiful sanctuary was raised anew with admirable work, amplified in all parts from its foundations. These works were completed in twelve months, neither by authoritarian fiat nor popular pressure, but by the insistent vigilance of Abbot Adefonsus and the monks, when Garsea held the scepter with Queen Mumadomna, in the era DCCCLI. It was consecrated by Bishop Jenadius on the XII of the kalends of December [=November 20, 913 CE].

[HIC LOCUS ANTIQUITUS MICHAELIS ARCHANGELI HONORE DICATUS, BREVI OPERE INSTRUCTUS, POST RUINIS ABOLITUS DIU MANSIT DIRUTUS, DONEC ADEFONSUS ABBA CUM SOCIIS ADVENIENS A CORDUUENSI PATRIA EDIS RUINAM EREXIT SUB VALENTE SERENO ADEFONSO PRINCIPE. MONACHORUM NUMERO CRESCENTE, DEMUM HOC TEMPLUM DECORUM MIRO OPERE A FUNDAMINE EXUNDIQUE AMPLIFICATUM ERIGITUR. NON JUSSU IMPERIALI, UEL OPPRESIONE VULGI, SED ABBATIS ADEFONSI, & FRATRUM INSTANTE VIGILANTIA DUODENIS MENSIBUS PERACTA SUNT HAEC OPERA, GARSEA SCEPTRA REGNI PERAGENS MUMADOMNA CUM REGINA, ERA DCCCLI. SACRATUMQUE TEMPLUM AB EPISCOPUM JENADIUM XII. KAL. DECEMBRIUM.][5]

Although the stone on which these words were carved has unfortunately disappeared, the surviving church building is richly inscribed.[6] You could even say that the stones themselves are pages: space above a column capital on the arcaded portico was lined out to receive an inscription that was never written—like a lined blank sheet of parchment.[7] Other spaces not formally prepared for inscription were written on anyway by people who took literally Augustine's reminder that the chamber was their book[8] and treated the walls as a stone codex in which they read—and occasionally wrote—their own lives.

They scratched stars, birds, horses, and human figures through the plastered surface of the walls and into the stone beneath. They wrote, too. Most evocative are the inscriptions high above the arches that line the nave: on the eastern side, over two rough baselines, is a jumble of Visigothic letters from which are clearly legible "+ PPS MONIONI MNO" [+Remember Monionus,

presbyter] and "FRUCTO:SO MONACHO:" [Fructuosus, monk].⁹ Similarly placed on the other side of the nave, another MONIONI MNO, a scraggly Greek cross, and the votive inscription of the angelic patron's name: MICAEL. The "I" receives special emphasis: it has a wide central shaft and a trailing descender like a display initial in a luxury manuscript. Whoever wrote this name thought it worth practicing, for this entire zone is filled with these emphatic display I's and capital M's—as if someone were using the wall as scrap for pentrials.

These inscriptions face into the nave many meters above the church floor. Vanessa Jimeno Guerra, who has studied them most closely, suggests that they were executed as the church was under construction.¹⁰ This construction, as the dedication plaque made sure to remind us, was undertaken "neither by authoritarian fiat nor popular pressure, but by the insistent vigilance of Abbot Adefonsus and the monks." Perhaps Monionus and Fructuosus were two of those zealous brothers, who stood on the scaffolding of a building under construction and subscribed to their monastery as a scribe might put his name to a codex. In like manner, the painter and calligrapher Maius subscribes to the book that he made for these vigilant readers and writers with the words MAIUS MEMENTO (New York, Morgan Library, MS M644, f. 233v). He wants his work to be remembered.

You will remember that Florentius's beautiful copy of Gregory the Great's commentary on Job (Madrid, BNE, MS 80) is also a book about the *Moralia* in general and this copy in particular—its prehistory, its making, and its future in your hands. Florentius's book calls attention to writing as a verb as well as a noun, insistently linking the *Moralia* to the pen by which the letters were traced and to the hands that traced them and those that follow those traces in reading.

Maius's Apocalypse, too, is explicitly anchored in its own artifactuality and in the bodies of its maker and imagined users. It is also an even more explicitly bookish book than Florentius's *Moralia*. Maius's Apocalypse is driven by the book on many registers, allegorical and material, textual and visual. The maker of this one very particular codex has much to say about his work—what he expects us to do with it, and it to do to us. Written almost entirely by Maius and—by his own account—illuminated and perhaps even designed by him as well,¹¹ Morgan M644 is an articulate bookishness machine.

This chapter studies how that machine works, visually and textually. We begin by reading a little in the Commentary itself to see how the work Maius

was copying might have taught him to embody it on parchment. From there, we pass to the work of Maius the painter and watch over his shoulder as he fills the pages of his Apocalypse with brilliantly colored images of books. We then turn to Maius's memorialization of his activity as a scribe to study the three times he writes his name into the book and what they can tell us about how he understood his work. Finally, Maius's student Emeterius will take us inside another inscribed environment to visit his master's tomb.

THE LIBRARY AND THE KEY

A library [*bibliotheca*] takes its name from Greek, because books are deposited there, for βιβλίων [*biblion*] means "of books" and θήκη [*theka*] means repository.

[Bibliotheca a Graeco nomen accepit, eo quod ibi recondantur libri. Nam βιβλίων librorum, θήκη repositio interpretatur.]
—Isidore of Seville, *Etymologies* VI.3

In the late eighth century, the Asturian monastic Beatus of Liébana compiled a commentary on the Apocalypse; in the centuries following his death it was copied all over northern Iberia. In print, Beatus's book is a rather dull study.[12] In manuscript, however, its remarkable design leaps from the parchment into the user's imagination.[13] When you engage with Beatus in manuscript, you are not just reading *about* the apocalypse, you are also, as Florentius would say, reading *in* it, inhabiting its words and images as you might inhabit the inscribed spaces of your monastery.

Beatus divided the biblical text into sixty-six short extracts called *storiae*. Each extract is followed by a large and brilliant illumination and then by an exegesis assembled from a rich library of ecclesiastical authorities.[14] Readers are given a *storia* to chew over meditatively, along with vivid, beautiful, and terrifying images to support their incorporation of the text. Finally, the text in mind and the image in imagination, they are guided to interpret under the rubric "here begins the explanation of the *storia* written above" [incipit explanatio suprascriptae storiae].[15]

The Beatus commentary is thus what we might now call a multimedia workbook for *lectio divina*,[16] designed, as Dominicus and Munnius said in the copy they made of it at Silos in 1091, to engage "the mind, ears, eyes, and mouth of the heart" [mente . . . aures, oculos, os cordis].[17] It is built to

draw users' attention to the very processes of their engagement with the biblical text—that is, to writing and to reading as productive activities of mind and body.

Beatus clearly had access both to a good library and to a good memory. He declares in his preface that this is a book of books. The things explained here, he writes, "are not by me; rather, I found them in the holy fathers, in books signed by Jerome, Augustine, Ambrose, Fulgentius, Gregory, Apringius, and Isidore" [quae tamen non a me, sed a sanctis patribus quae explanata repperi, in hoc libello indita sunt et firmata his auctoribus, id est, Iheronimo Agustino Ambrosio Fulgentio Gregorio Abringio et Ysidoro].[18] Then he tells us what he has made from his reading: "Believe that this book is the container and key of all books" [Omnium tamen librorum tecam hunc librum credas esse et claviculam].[19]

Beatus has wrapped the biblical text of the Apocalypse in commentary and then enclosed it all between two covers. His book is a container, a metaphorical *armarium* where all the books are kept. It is also the key that opens it all up. Thus by its own explicit declaration, this codex is also a library—a *bibliotheca*—for, as Isidore says, "*biblion* means 'of books' and *theka* means repository" [nam βιβλίων librorum, θήκη repositio interpretatur].[20] In this Beatus's commentary is like, of course, the Bible itself, which shared the word *bibliotheca* with the library in early medieval Latin.[21]

Stuffed full of quotations, Beatus's commentary is a book of books in its very superlativeness (like the biblical Song of Songs). The codex now known as Morgan M644 begins by announcing visually that it, too, will be a book of books. Maius's introductory frame leads us right into the *bibliotheca*. The first lettered page of the book, in fact, tells us about the library the book was designed to occupy and to reflect. On f. 1r, a large rhombus floats just above center, taking up much of the page (Figure 22). Its outer border and pointed corners are decorated with interlace and foliate ornament. Within its frame, the rhombus is composed of tiny squares, each containing a letter of the alphabet in yellow, red, or blue. At the very center sit the letters SCI in red capitals, framed by a rhombus of blue M's, which is contained in a rhombus of yellow I's, within a rhombus of red C's, within a rhombus of blue A's . . . all the way out to the outermost layer of red B's.

This is another lettered labyrinth, calling you to stop, pay attention, and engage with what the scribe has made. Start at the center—SCI—and read through the nested diamonds in sequence from center to border. Even

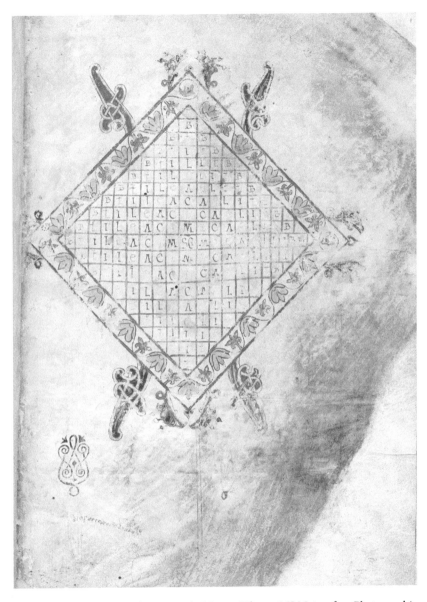

Figure 22. Ex-libris labyrinth. New York: Morgan Library, MS M 644, f. 1r. Photographic credit: The Morgan Library & Museum, New York. Used by permission.

though the page is worn from water and hard use, the legend is clear: sci|m|i|c|a|e|l|i|l|i|b. Resolve the abbreviations and you won't forget what you're reading: LIBER LIBER LIBER. You now know where this BOOK BOOK BOOK belongs: at St. Michael's.[22]

That St. Michael's was for a long time the rural monastery of San Miguel de Escalada, where someone wrote the patron's holy name on the wall as ornately as he could, where Monionus and Fructuosus wanted to be remembered. The codex may have been made for Escalada or for another St. Michael's much closer to Maius's home at San Salvador de Tábara, but we don't have to know for certain which monastery commissioned it for this labyrinth to do its work of articulation.[23] Even now, in New York, it links Maius's book to that monastic library, and the labor of making meaning from its letters connects it to you, the reader—and to your present moment, wherever it and you might be.

The series of full-page illuminations that begins on the verso of the ex libris (ff. 1v–4r) expands the frame to place this book in the wider library of Christian Scripture (Plate 7).

Though pages have been lost from this sequence, it was clearly designed as a set of four openings devoted to the evangelists and their books.[24] In page after page, scrolls and codices are handed over—from evangelist to human witness, from angel to angel, and from evangelist-beasts to humans and angels alike. The ex libris articulated the book with earthly places: the monastery of St. Michael and your reading room. The evangelist pages lay out another bookish space, encompassing both the historical writers of the gospels and their symbolic manifestations, abstracted now from the mundane.

The bookish framing of Maius's codex is appropriate for a commentary on the Apocalypse, a work that makes representations of writing work hard on all levels of its argument.[25] Books direct the apocalyptic narrative in pragmatically literal commands: at the beginning, the visionary is instructed to write down what he sees "in a book" [in libro] and publish it (Apoc. 1:11); at the end, he imagines the resulting volume and warns readers not to alter the words on its pages (Apoc. 22:19). The narrative of the vision is itself full of represented writing (Apoc. 2:17, 17:5, 19:6, 22:4). Divine judgment is figured as inscription in a "Book of Life" (Apoc. 3:5); paying close attention to a message as eating a book (Apoc. 10:9); and the end of time as the rolling up of a scroll (Apoc. 6:14). Beatus was thus thinking with

his target text when, in his preface, he promised us that his work, compiled from a library of patristic exegesis, would be an accessible meta-commentary, the key and container for all books.

Maius's Apocalypse follows the lead of both biblical book and Beatus's commentary, presenting in the pages between the opening sequence and the concluding scribal subscriptions a veritable library of represented books for our contemplation. Maius represents books in his Apocalypse using six basic forms.[26] Only two of them are recognizably mimetic: the scroll (e.g., f. 1v, Plate 7) and the open codex with ruled or gently arched pages (e.g., ff. 4v and 154v, respectively). The other book forms are resolutely schematic, even in a visual style notable for its abstraction.[27] Three of them are variations on the rectangle. One is simply a block of a solid color, often an intense mustardy yellow (e.g., f. 149r). Another surrounds the solid-color rectangle with a substantial border of a contrasting color (e.g., f. 26r). The third rectangular form is bisected vertically and evokes wax tablets or a Roman consular diptych (e.g., f. 23r, Plate 8).

Finally, the most unusual and, on the face of it anyway, least book-like of Maius's codices: a pentagon of solid color, sometimes framed with a thick contrasting border (e.g., f. 1v, Plate 7).

Rarely do any of these book-forms bear any interior marking to indicate text. The vast majority are blank slates—not so much representations of codices as representations of what "codex" means. Or better yet, *icons* of codex-icality. And here I mean "icon" not in the Byzantine, but in the twenty-first-century sense. Like those little images that point to the apps on your phone, these book icons condense the idea of what their referent does into an abstract and instantly recognizable form.

So what is the libresque activity represented in Maius's codex icons? Let's begin the answer by examining two of these book icons, the diptych and the pentagon. The diptych form is used to represent codices in illuminated manuscripts both before and after Maius. The earliest Beatus commentary to survive more or less intact represents the codex this way (Madrid, BNE, VITR 14/1, c. 930–45; see, e.g., f. 23r and f. 126r, Plate 9). Maius's contemporary Florentius does, too, in the great *Maiestas* that introduces his *Moralia*, where Jesus ceremonially holds a red-framed diptych while, below, the beasts of the Tetramorph animatedly discuss the diptychs they each hold (Madrid, BNE, MS 80, f. 2r, Plate 2). So does the presentation page of the León Antiphoner (León, AC, MS 8, f. 1v; frontispiece), made a few decades earlier.

The diptych icon is the focus of Maius's image of the great and weird scene of prophetic *lectio divina* that occurs at Apoc. 10:9. The visionary has been about to write down what he has seen. A thunderous voice from heaven stops him, and an angel hands him a book, saying, "Take the book, and eat it up: and it shall make thy belly bitter, but in thy mouth it shall be sweet as honey" [Accipe librum, et devora illum: et faciet amaricari ventrem tuum, sed in ore tuo erit dulce tamquam mel; Apoc. 10:9]. In the upper register of f. 146r, under the titulus "John takes the book" [ubi Iohannes librum accepit], an angel in a swirl of blue cloud holds out a red-framed green diptych (Plate 10). The visionary takes hold of the other side. The codex held by these two figures is helpfully labeled in large capital letters that occupy much of the two green pages of the represented opening. LI-BRUM, the letters say: this is a meta-book whose self-referential text is nothing but "book."[28] Maius's visionary is receiving *an idea of the book*, the book abstracted to its very book-ness.

This diptych form, minus the label, occurs again and again in Maius's apocalypse. What is instantly striking about these represented books is their prominent margins and gutters, picked out in thick lines of contrasting color that make the thing look, if you will pardon another anachronism, less like a diptych than an empty double picture frame. In fact, the figures in these illuminations often hold their books as if that's exactly what they were—*frames*. On f. 57v of Maius's Apocalypse, for example, when John delivers his letter to the church at Pergamum, the visionary (on the left) grasps the diptych by wrapping his fingers from behind around its red marginal border (Plate 11). On f. 207r, the enthroned Christ has a blue diptych on his left knee. He holds it with his left hand by the red column that bisects it vertically (Plate 12). That is: *he holds the codex by its gutter.*

A generation later, the painters of the Girona Beatus (Girona, AC, MS 7; 975 CE), who include Maius's disciple Emeterius and the female illuminator Ende, seem to dispense with the idea of content altogether: on f. 31v of that manuscript, an angel carries a diptych slung over the right arm like a purse (Plate 13).[29]

The diptych icon reflects an understanding of the codex based not on what it contains, but on the bare fact that it is a *container*. This notion shapes the most unusual book icon in the early medieval Iberian visual vocabulary: the pentagon (e.g., f. 1v, Plate 7). While the diptych form appears in

many genres of Iberian illuminated manuscripts, as far as I can tell, the pentagonal icon is unique to the Beatus tradition in the tenth and eleventh centuries. It appears first in the work of Maius: of the two earlier illuminated Beatuses, neither the Silos fragment (Archivo del Monasterio, frag. 4; late ninth century) nor the Vitrina 14/1 Beatus (Madrid, BNE, VITR 14/1; c. 930–40) uses it to represent books. After Maius, however, the pentagonal book icon was adopted by every Iberian Beatus illuminator, fading away only when the more naturalistic Romanesque style takes over.[30]

The pentagon is everywhere in Maius's design program: Evangelists and angels present pentagonal codices in the introductory sequence of the codex (ff. 1v–4r); pentagons alternate with tablets and diptychs in representations of the letters to the Seven Churches (e.g., ff. 27r, 231v, 52v). Context makes it clear what these pentagons represent, but they don't look anything like books. They look, instead, like reliquaries—like, for example, the great agate coffer in the cathedral of Oviedo, dated in an inscription on its underside to 910 CE (Figure 23).[31]

Books and boxes go together in the early Middle Ages. Books were stored in box-like *armaria*, and particularly precious volumes had their own specially designed ornamental coffers.[32] Armando Petrucci argues that, in the early medieval period, the principal mode of representing the book in the West shifts from an open codex to a boxed book. By the seventh century, he writes, "the book itself had been transformed from an instrument of writing and reading, to be used and thus open, into an object of adoration and a jewel-box of mysteries, not to be used directly and thus closed."[33] Such images resemble nothing so much, he says, as a "closed reliquary, glowing with gems, rigidly presented for the veneration but not the comprehension of the faithful."[34]

Much as Maius's book icon looks like a reliquary, its primary function in these images is not, *pace* Petrucci, to be an object of adoration. Maius uses the same form to represent other artifacts: a thurible (f. 133v), the fiery furnace of Daniel 3:20 (f. 248v), the arks of Noah (f. 79r) and the Covenant (f. 156v), and, tellingly, a coffin (the three sarcophagi on f. 238v, Plate 14).[35] These pentagonal forms are not sealed for uncomprehending veneration. They can be opened—as on f. 133v, when an angel turns one upside-down and pulls back the lid, releasing catastrophic arrows all over the earth. We see inside them in cross section, as in Noah's ark, the fiery furnace, and the three sarcophagi with their wispy little souls inside.

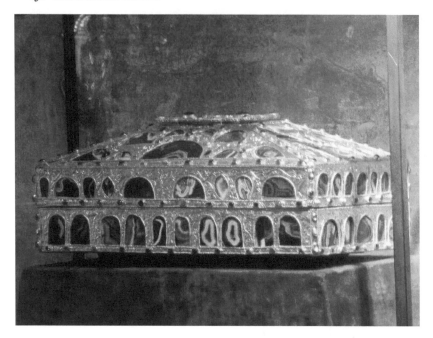

Figure 23. Arqueta de las Ágatas. Oviedo: Cathedral. Photo by Zarateman (https://commons.wikimedia.org/wiki/User:Zarateman). Creative Commons CC 3.0.

Maius's books are more like arks and coffins than they are like cult objects. They don't glow with gems; they are unadorned abstractions whose austerity points the mind's eye not toward what they look like but toward what they *do*. And what they do is *contain*—the tablets of the Law, Noah's family and the animals, the bodies of the saints, the words of the Fathers.[36] Their intense colors and their borders mark out not only the capacity for containing but also the space where one engages with their contents. They are, in a sense, blank slates full of potential, awaiting readerly engagement.

Nowadays we tend to think of "book" as referring to the *contents* of that material or digital artifact. Unless it's accompanied by a deictic gesture, the question "Have you read that book?" doesn't usually refer to that book there, but rather to its contents. For Maius and other Iberian illuminators of the tenth and eleventh centuries, however, it is not content but *containing* that shapes the representation of the book.

Florentius insisted that we understand his handwriting as a verb as well as a noun; here, Maius helps us to see the book not so much as a table of

contents, but as a box that contains. Enabling contemplation of containing itself, the book icon is what Mary Carruthers would call a meditative "shape pun."[37] Maius might have called this shape an *arca*. He might also have called it *theca*, "so named," as he surely knew that Isidore of Seville said, "because it covers [*tegere*] whatever is held in it." "*Theca*," Isidore continues, "is from a Greek word, because something is stored there—whence a storage place for books is called a *bibliotheca*" [Teca ab eo quod aliquid receptum tegat. . . . Alii Graeco nomine thecam vocari adserunt, quod ibi reponatur aliquid. Inde et bibliotheca librorum repositio dicitur].[38] Beatus would approve: these abstract book icons are truly the "container and key for all books." Thus, the frames and coffers repeatedly proffered in Maius's design are compact *mises-en-abyme* for the commentary in which they appear and, by extension, for the codex that contains it.[39]

A CODICOLOGY LESSON

The scribe's tools are the reed-pen and the quill, for by these the words are fixed to the page. A reed-pen is from a tree; the quill is from a bird.

[Instrumenta scribae calamus et pinna. Ex his enim verba paginis infiguntur; sed calamus arboris est, pinna avis.]

—Isidore of Seville, *Etymologies* VI.14

Maius's book icons think abstractly about the codex as *bibliotheca*. But the scribe's daily work was no abstraction: his table was stocked with leaves of parchment, quills, ink, brushes, and paint, and his fingers were cramped at the end of a workday. It may not then be altogether unexpected that Maius concludes Beatus's commentary by turning his (and our) attention to the codex as a material container and by extension to the person who made it.

The Apocalypse commentary ends on f. 233v, two-thirds of the way down the left column (Figure 24). These concluding words, however, are not the most noticeable thing about the page. That would be the name MAIUS at the bottom of the right text column, in heavy black capitals twice the size of the usual display text. Below it, in smaller capitals, is the command MEMENTO, Remember. But Maius is not—or not only—signing off on the Apocalypse. He is, as we shall see, subscribing to a library and offering a codicology lesson.

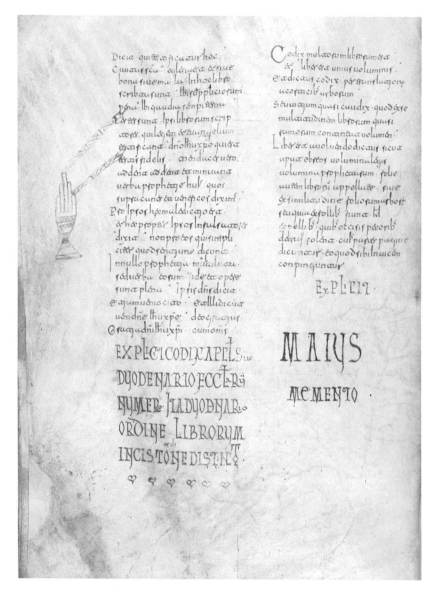

Figure 24. "Here ends the codex of the Apocalypse." New York, Morgan Library, MS M644, f. 233v. Photographic credit: The Morgan Library & Museum, New York. Used by permission.

The page is laid out in two columns, the subscription anchoring the composition at the bottom right. After the commentary ends two-thirds of the way down the left column, alternating rows of red and green capitals lay out the *explicit*: "Here ends the codex of the Apocalypse in the number twelve of the churches. It too is divided into a sequence of twelve books" [EXPLICIT CODIX APOCALPSIN DUODENARIO ECCLESIARUM NUMERO. ITA DUODENARIO ORDINE LIBRORUM INCISTO ORDINE DISTINCTO].[40]

The *explicit* makes programmatic the correspondence that we've so far observed between commentary and commented, between the Apocalypse of John and "the codex of the Apocalypse," declaring that both are constructed on "the number twelve of the churches." Taken alone, the statement is puzzling—there are of course *seven* churches in the Apocalypse of John, not twelve.[41] On the page, however, the motivating logic is unmistakable: we are being led to see the codex as a mimetic outgrowth of the biblical book on which it depends. The work, the commentary upon it, and the physical structure of this particular codex are inextricably interlinked by structural analogy. So powerful is this analogical drive that it reduces the accuracy of the correspondence to a matter of mere detail.

The "codex of the Apocalypse" in its twelve books may be over, but Maius's work is not. What he is about to do, however, grows directly from those words. After the line of heart-shaped leaves concluding the *explicit* at the bottom of the left column of f. 233v, Maius's book hand starts all over again at the top of the right column with a red capital C. Surprisingly, the passage set off by this red initial has nothing whatever to do with the end of the world, the second coming, or the Last Judgment. It is, however, very much about the "codex of the Apocalypse" and its parts. Maius will not write his name into the book until the text that begins here is complete. It reads thus:

The codex is composed of many books and a book from a single volume. It is called a codex by metaphor from tree bark or, erroneously, from tree trunk, because within itself it contains a multitude of books like tree branches. A book is called a *volumen* from rolling, just as the Jews say "the volumes of the Law" and the "volumes of the Prophets." The leaves of books, however, are so called either because of their resemblance to the leaves of trees or because they are made from leathers, that is from leathers that are usually taken from slaughtered sheep. Their parts are called pages, from the fact that they are joined together among themselves.

[Codix multorum librorum est, et liber est unius uoluminis. Et dictus codix per translationum a corticibus arborum, seu uitium quasi caudix, quod ex se multitudinem librorum quasi ramorum contineat. Volumen liber est ad uoluendo dictus, sicut apud Hebreos uolumina legis, uolumina prophetarum. Foliae autem librorum appellatae siue ex similitudine foliorum arborum, seu qui ex follibus fiunt, id est ex pellibus, qui occisis pecoribus detrai solent. Cuius partes paginae dicuntur, eo quod sibi inuicem compinguntur.][42]

No revelation: this is a quote. Not, however, from Revelation: it has been condensed from the *Etymologies* of Isidore of Seville—specifically from chapters on "the terminology of books" [de librorum vocabulis] and "bookmakers and their tools" [de librariis et eorum instrumentis] (*Etymologies* VI.13–14). However this passage got into the commentary,[43] it is pretty clearly an associative gloss on the word codex that features so prominently in the *explicit* that immediately precedes it. Since it appears here in every surviving complete manuscript of the Beatus commentary,[44] the scribes who copied it must have thought its activity was important. Let's follow their lead and think about what this definition does and how what it does might be connected to the work of the very codex that (imaginatively, anyway) lies open before us.

We have seen how important books are in the Apocalypse, in Beatus's commentary, and in the images that Maius painted to accompany it. This Isidorean codicology lesson is thus a fitting coda to a book that is insistent about representing its own bookishness. Supplementing both the commentary and the codex, Isidore's definition here comments not on the work that the codex contains, but on the codex that contains the work. It understands the codex as a composite of its material parts and of the labor that joins them together.

The codex is once again container. The containing is not, however, in the passive way of box or bottle. The book "is called a codex by metaphor from tree bark . . . because within itself it contains a multitude of books like tree branches" [Dictus codix per translationum a corticibus arborum . . . quod ex se multitudinem librorum quasi ramorum contineat]. Isidore's codex is both surrounding bark and extending branch, both enclosure and articulation. *Foliae* branch out to both leaves and leather; even pages are articulate not just in their assembly but in their etymological being, named as they

are "from the fact that they are joined together among themselves" [sibi in-uicem compinguntur].

The scribe and painter Facundus, working a century later in the tradition of Maius's apocalypse, includes the Isidorean codex-coda on f. 264r of the Beatus commentary that he made for the king and queen of Castile-León in 1047 (Madrid, BNE, VITR 14/2). Facundus read his Isidore carefully. He had absorbed enough of the *Etymologies*—beyond the definition of the co-dex—to know that for Isidore the pun is the very path to knowledge of a thing.[45] In the evangelist pages at the beginning of the commentary (e.g., 7v, 10r, Plate 15), Facundus paints the books handled by people and angels. He has inscribed on each page of the represented opening the outline of a large acanthus leaf. Facundus's books really are made up of leaves, a pun-ning *mise-en-abyme* as striking as Maius's book icon whose represented text is simply LIBRUM (New York, Morgan Library, MS M644, f. 146r, Plate 10). Once again, the book is its material before it can be anything else.

With the addition of Isidore's codicology lesson, Beatus's "container and key to all books" now fully lives up to its name: the commentary now con-tains not only the last book of the Christian Bible but the very definition of codex, and thus all the codices that are and ever will be found in any *bib-liotheca*. The interpolation from the *Etymologies* gives us the keys to that library—the terms we need to use and analyze the things we read. By ex-panding our thinking from "the codex of the Apocalypse" to the codex in general, the Isidorean graft leads readers to think both abstractly and ma-terially about the literate enterprise in which we participate by engaging with this book.

Illuminators like Maius and Facundus follow suit. Both the Isidorean graft and the early medieval illumination program lead us to think not only about the text, but about literate activity itself. We're being led to think about the codex as both material artifact and, container that it is, an *activity*. The abstraction of the images gives us the idea of the book; the Isidorean gloss inseparably articulates that idea with material form of this very book in front of us.

In the *Moralia* preface copied by Florentius at the beginning of BNE MS 80, Gregory the Great wanted readerly attention to slide through the let-ters on the page, past the pen that put them there to the meaning they com-municate.[46] In contrast, these Iberian book artists direct our attention to the page itself and to the visible labor there that articulates letters with the

world. Maius's Apocalypse commentary goes out of its way to remind us that we cannot get at meaning without the dead sheep, the page, the pen, and the scribe.

Meaning (*res*) is also a thing (*res*): moving from the finished book to the codex and its parts, the last page of Maius's Apocalypse reminds us of the materiality of meaning.[47] Now, this being accomplished, the maker can sign off. He centers his hand on the following line and writes, "EXPLICIT." Now that Isidore has primed us to think etymologically, we know that someone has just finished rolling out (*ex + plico*) this volume. With no further explanation, the scribe drops down five lines, names the holder of the pen, and conscribes readers on (and in) the page and its activity. He writes, "MAIUS MEMENTO" [Maius Remember].[48]

Prompted by Isidore, we are unlikely to forget that this is a codex, that it has pages, that those pages come from a world of living beings who live no more. Now, remembering that, we can best remember Maius—so he reminds us. At least one early reader of Maius's codex felt that the best way to remember was with the work of his own hand. Finding something on f. 233v that was worthy of memory, this reader marked it out by drawing a stylized hand seven lines tall reaching vertically up the left margin of the page (Figure 24). From its index and middle fingers, two slender cross-hatched diagonal bars extend toward the text to bracket a sentence in Beatus's final peroration. The ends closest to the text are sharpened into little points: *these are pens.* The sentence they indicate reads, "The writers of the books are themselves witnesses, who through the Law and the Gospels testify to the Lord Jesus Christ, who is the faithful witness" [Testes sunt ipsi librorum scriptores, qui per legem et euangelium testificant Domino Iesu Christo, qui est testis fidelis].[49] A reader is participating in this codex and answers its call using their pen to draw pens that point out a passage about the writers of the books themselves. Someone wants to remember the testimony of the hand.

REMEMBER THE END

Maius has signed off, but the work is not yet finished. He will subscribe again, and for the last time, some seventy folios deeper into the codex, but to really understand what he does there, we need to have some idea of what comes between the first subscription and the final one. So now, knowing

as you do that Maius is thinking with Isidore, and remembering that both author and scribe have just defined the codex as "composed of many books," it should not be too surprising to see another work in Maius's hand starting up right away on the recto facing the *explicit* of the Apocalypse commentary. The scribe has once again turned to Isidore, copying the master's little kinship treatise *De adfinitatibus et gradibus* and translating it into full-page summary diagrams.[50] This text concluded, the work is still not done. Much more obviously germane to the apocalyptic topic is the text Maius copies after the *De adfinitatibus*: Jerome's commentary on the visionary book of Daniel, accompanied by yet more spectacular images, possibly of Maius's own design (ff. 239r–92v).[51]

When the Daniel commentary too reaches its conclusion (f. 292v), the time has come for Maius's final intervention: a poem that takes up fully half of the recto of what would have been for him the last leaf of the codex (f. 293r, Figure 25).[52] Like the ex-libris frontispiece (f. 1r, Figure 22), this too is a puzzle; also like that introductory labyrinth, it articulates this codex with the world outside its pages. The ex libris linked the codex to a place and, implicitly, to puzzle-solving readers, wherever or whoever they might be. The poem that ends Maius's Apocalypse again reaches for readers, linking them not to a place this time but to the scribe's own person and to the making of this "container and key to all books."

The poem begins as its letters call for sound: "+Let the faithful voice resound, let it resound and re-echo" [+Resonet uox fidelis. Resonet et concrepet].[53] And whose voice might this be? We learn before the first line is over: "Let Maius, insignificant / but eager, rejoice and sing, resound and cry out!" [Maius quippe pusillus. / Exobtansque iubilet et modulet. Resonet et clamitet]. The poem sounds out a *vox articulata*. This is the kind of voice, Julian of Toledo taught us in the grammar classroom, "that can be grasped by the joint of a writer" [articulo scribentis conprehendi potest].[54]

"Insignificant" Maius is not above using those joints to display his skill as composer as well as writer of text. That humble pun on his name in the first line, for example.[55] He turns his hand to another game when, in alternating lines of the poem, he picks out the first letters in bold red ink. A red capital begins the next line: *Mementote enim mihi*, "Remember me." Reading downward now, jump to the next red capital. *Ad paboremque patroni arcisummi scribens ego*: "I, writing this in awe of the exalted patron." The grammar is emphatic, ending the sentence with the personal pronoun. Read

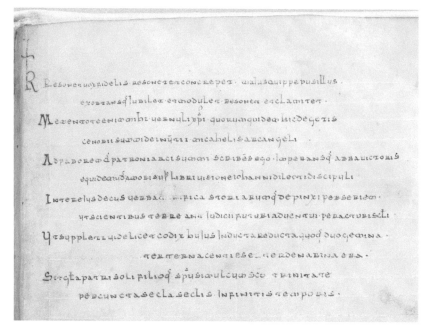

Figure 25. Colophon. New York, Morgan Library, MS M644, f. 293r detail. Photographic credit: The Morgan Library & Museum, New York. Used by permission.

out the rest of those red letters down the page and you have remembered that *ego scribens*: M-A-I-U-S.[56] Insignificant indeed.

Maius wants to be remembered. He made this clear when he finished Beatus's commentary and paired his prayer with an authoritative reminder of the materiality of the thing he is making. Now he tells us about the making itself.

> Let the faithful voice resound,
> let it resound and re-echo!
> Let Maius, insignificant but eager,
> rejoice and sing, resound and cry out.
> Remember me, servants of Christ,
> you who will now dwell here[57]
> in the monastery of the supreme messenger,
> the Archangel Michael.
> I am writing this in awe of the exalted patron,
> at the command of the abbot of the Victorious One,[58]

truly imbued with love for the book
with the vision of John the beloved disciple.
As part of its adornment
I have painted a series of pictures
for the wonderful words of its *storiae*
so that those who know about the last judgement
might fear the coming of the end of time.

[RESONET UOX FIDELIS. RESONET ET CONCREPET. MAIUS QUIPPE PUSILLUS.
EXOBTANSQUE IUBILET ET MODULET. RESONET ET CLAMITET.
MEMENTOTE ENIM MIHI. UERNULI CHRISTI. QUORUM QUIDEM HIC DEGETIS
CENOBII SUMMI DEI NUNTII MICAHELIS ARCANGELI.
AD PABOREMQUE PATRONI ARCISUMMI SCRIBENS EGO. IMPERANSQUE
 ABBA UICTORIS
EQUIDEM UDUS AMORIS UIUS LIBRI UISIONE IOHANNI DILECTI DISCIPULI
INTER EIUS DECUS UERBA MIRIFICA STORIARUMQUE DEPINXI PER SERIEM.
UT SCIENTIBUS TERREANT IUDICII FUTURI ADUENTUI. PERACTURI
 SECULI.][59]

In words copied by Maius's contemporary Florentius, Gregory the Great
declared that "the writer is the one who inspires the book and recounts
through the voice of the scribe the deeds we are to imitate" [Ipse scripsit,
qui et in illius opere inspirator extitit, et per scribentis vocem imitanda ad
nos ejus facta transmisit].[60] Here in Maius's colophon, in contrast, it's the
scribe whose inspiration is discussed, whose resounding and re-echoing
voice we hear. The emotion that motivates it is quite literally bibliophilic:
Maius has painted these pictures and written these words, he tells us, "truly
imbued with love" not only for the vision of John, but also for *the book* that
contains it (*libri uisione Iohanni*). And he wants us—we who dwell here,
now—to respond in the same way to this book he has made. He thus writes
us into the project. Remember me, he says; while I made this book I thought
of you; I wrote these words and painted these images to remind you of the
end of time.

This double protagonism of artifact and maker is not the work of Maius's
artistic ego; he learned to think this way from the work he's copying and
from the work of copying it. Beatus's book *about* the book of the vision of
John, with which Maius has lived for all these many months, has taught
the scribe that here in his hands is the "container and key" of the entire

bibliotheca, "the book of life" (Apoc. 20:12), the book of books. So that is what he makes.

Ambiguous syntax and an inconvenient erasure make the next part of the colophon hard to interpret. Maurilio Pérez González reads the next line thus: "Ut suppleti uidelicet codix huius inducta reducta quoque duo gemina" [In order truly to complete this codex, two similar works have been added]. The "two similar works" referenced here might well be Jerome's commentary on Daniel (ff. 239r–93r) and the selections from Isidore's *De adfinitatibus et gradibus* (ff. 234r–37r), both, as we have seen, similar works added to Beatus's commentary in the manuscript family of which M644 is the oldest witness.[61] If this is true,[62] Maius is here claiming responsibility not only for this very codex, but for the "programmatic expansion"[63] of the third recension itself, both textual ("two similar works") and visual ("I have painted a series of pictures"). José Manuel García Lobo suggests that Maius was inspired to make this editorial addition by the codicology lesson that he had copied earlier on f. 233v—for if "a codex is composed of many books," to be fully a codex, Maius's manuscript must contain more than Beatus and his paratexts.[64] In this scenario, the extraordinarily sophisticated expansion of the Beatus program that is the third recension grows from a quotation that itself grew associatively from the target text.[65]

Whether or not this passage proves Maius's hand in the third recension of the Beatus commentary, it is clear that his colophon is doing some very strenuous articulative work, linking this codex to people—himself, the abbot, us—and to both place and time (the adverb *hic* in line 3 can indicate both). Maius imagines us living here now, reading the codex that he made and praising God all the way through "the infinite ages of time" [per cuncta secula seculis infinitis temporis]. He looks down that long corridor of future from a very particular human moment. Unfortunately, erasures make that moment hard to place.

> [*erasure*] three times three hundred and three times twice ten [was the] era.
> Glory be to the Father and to his only Son, to the Holy Spirit and the
> Trinity
> through every age in the infinite ages of time.
>
> [*erasure*] [TER TERNA CENTIES ET TER DENA BINA ERA.
> SIT GLORIA PATRI SOLI FILIOQUE SPIRITU SIMUL CUM SANCTO TRINITATE
> PER CUNCTA SECULA SECULIS INFINITIS TEMPORIS.][66]

Although it is clear that Maius is expending significant extra effort to tell us when exactly his work was finished, it is hard to be certain what date he actually means—and the erasure shows that someone, possibly Maius himself, was not certain either.

Satisfying as it would be to know exactly when Maius completed the codex, what really matters for our purposes here is not the precise date, but rather the *will* to provide it and the form in which it is provided. The distributive reckoning, while subject to imprecision, has the benefit of engaging both scribe and reader in a shared exercise of sustained arithmetical attention. The concluding lines of the colophon draw us back through the composition process and remind us both of the oncoming end of the time of writing and the oncoming end of time itself.

Maius's colophon thus performs a complex articulation of this codex and its production with respect to affect (awe, love, fear), persons (the commissioning abbot, Maius the maker, the community of readers), place ("here"), and time. From his "now" (whenever it was) Maius looks both back and forward and weaves his just-completed work into the labyrinthine time laid out in the introductory diagrammatic chronicle (ff. 4v–9v). Writing this (*scribens*, present participle) in awe of St. Michael, in obedience to the abbot, and in the love of the book, "I have painted this" (*ego . . . depinxi*, perfect tense), he says, "for you, who will dwell here" (*hic degetis*, future tense); read it and remember me. I have painted these pictures, he says, in anticipation of apocalypse, "so that those who know about the last judgement might fear the coming of the end of time" [Ut scientibus terreant iudicii futuri aduentui. Peracturi seculi].[67]

"CODEX CAMERA VESTRA":
THE CODEX AS INSCRIBED ENVIRONMENT

Maius's book of books has been articulating codices, makers, and users since its very beginning. The alphabetic and temporal labyrinths of the ex libris and the genealogy diagrams that follow it work readers into the codex by making us work. The bookish illumination program shows us countless examples of the codex inviting and containing our labor. Maius crowns the commentary with a codicology lesson that articulates the book-in-general with the material book-in-particular and gives us the keywords with which to think about this complexly signifying thing. Maius himself

can be seen to follow that lesson to the letter by articulating Beatus's apocalypse commentary with Isidore's kinship treatise and Jerome's commentary on Daniel. Lest we miss the point, he explains it to us in his colophon and reminds us who has done this work and why he has pitched it toward the memory of the impending end of time.

These interventions—all attributable to Maius's choices if not to his original design—tell us that if we want to understand the activity of a book in the early Middle Ages, we need to think beyond the auctorial Work and think about the work that goes into articulating it in codex form. If, like Maius, we love "the book of the vision of the disciple John," we love not so much a book in the modern sense as an inscribed environment.

As in the monastic inscribed environment, the writing is not all from one person's hand. We have already seen one example of such work: the attentive reader who, on f. 233v, draws a pen-holding hand to underline the Apocalypse's praise of writers (Figure 24). Later reader-writers are equally bookish. On f. 95v, in a Carolingian hand, is a milestone left generations after Maius's death as another scribe labored over these pages: *usque huc habemus scriptum.* "We have written up until this point," someone writes, perhaps recording in the copy-text the progress of its reproduction. Other notes in Romance and in a later hand seem to record a user's concern at the state of the codex itself: on f. 5v, the word "pagella" [page] is barely legible; the same hand observes later on f. 26v that "estas dos pagelas non caesçen . . . fallesçen lecturas" [these two pages do not fit . . . readings are missing] and, on 30r, "non caescen . . . fallesçen" [do not fit . . . are missing]. Most striking of all, on the verso of Maius's colophon (f. 293v, Figure 26), yet another user of the book, also writing in Romance in a fourteenth-century hand, takes the appeal to future readers quite personally.

His name is Johan Lopes, and he uses the parchment space to make a public proclamation:

> Let all who see this document know that I, Johan Lopes, am in great tribulation with the Jews for the money that I owe them. I pray to God the Father that he might be pleased to protect me from them by his mercy, amen. And I pray to these Mozarabic letters that they assist me.
>
> [Sepan quantos esta carta vieren como yo Johan Lopes esto en gran tribulacion con judyos por dyneros que les devo. Ruego a Dyos padre que

Figure 26. Readers use a blank page. New York, Morgan Library, MS M644, f. 293v detail. Photographic credit: The Morgan Library & Museum, New York. Used by permission.

me quiera guardar delos por su merced amen y riego destas letras moçar-rabas que me quieran acorrer.][68]

Like Maius, Johan Lopes intervenes to speak in the first person and to conscript future users of the codex into his bookish project. Like Maius in the Isidorean codex-coda, he enlists the support of the material support: the very letters themselves, which by his time, through age, have themselves acquired near-magical authority. (For Maius, the codex has the power; in the later, more secular concerns of Johan Lopes, it's the very letters.) Although it is unlikely that Lopes could read those letters, he still takes advantage of script's projection into the future to make his requests—of us for our attention, of God for his protection, of the "Mozarabic" letters for their help. Like the people who scratched prayers and drawings into the church walls at Escalada and San Esteban de Gormaz, Lopes also takes advantage of the holy location, enshrining his announcement and his prayer in a space presumably with direct connection to the divine.[69]

THE BOOK AND THE TOMB

The master of those "letras moçarrabas," too, inscribed a prayer in this place of power: "Remember me" (f. 233v). A completed codex "becomes a monument to the scribe's memory," observes Elizabeth Sears.[70] Isidore of Seville would agree: "Both 'monument' and 'memory,'" he writes, "are so called from 'the admonition of the mind'" [monumenta itaque et memoriae pro mentis admonitione dictae].[71]

Maius would, I think, approve of the pun made, perhaps unconsciously, by the stonecutters at San Cipriano, who carved themselves at work on an object that they called a *manomentum* (Figure 20). So would Florentius and Endura: their codices, too, are *manomenta*, so called, Isidore might say, from the labor of both hand and mind. At about the same time that Master Raimundus raised the roof at San Cipriano, a scribe working at Santo Domingo de Silos embodied this pun in an extraordinary double colophon-epitaph that makes explicit the mutually reflective articulation of memory, monument, and bookwork in early medieval Iberian book culture. It is appropriate that the book in question is yet another copy of Isidore's *Etymologies* (Paris, BnF, nal 2169). Looking at the way this book manomentalizes making will prepare us for what is about to happen to Maius and his body of work.

The scribe of this copy of the *Etymologies* tells us his name on what is now f. 21v of his book in a lettered labyrinth that looks like a cross between Florentius's name-puzzle in the *Moralia* and the ex libris Maius made for his Apocalypse (Plate 16). Within a rich frame of interlace, a grid of colored squares is arranged in nested diamonds, each of different color. As in the Escalada ex libris, sense-making starts at the central diamond composed of little E's in yellow squares. Collect the letter from each successive nested diamond, and the message emerges: ERICONI PRESVITERI INDIGNI MEMENTO: "Remember Ericonus, unworthy presbyter."

Like the spiraling epitaph of Arogontina (discussed in Chapter 5), this page addresses us and presents its buried subject. Judging from the similarities of *mise-en-page* and phrasing, Ericonus is likely himself to be remembering Florentius here.[72] The echoes are even clearer, when, the *Etymologies* complete, Ericonus composes his colophon on August 24, 1072. Writing in red at the bottom on the left column of f. 385r, the scribe declares:

Explicit. Thanks be to God. I bless the king of heaven who has permitted me to reach the end of this book safe and sound, amen. Here concludes the Book of Etymologies, era TCX, the VIIII of the kalends of September, during the VII run of the lunar cycle, Sancio being King in Castile, León, and Galicia, and Sebastianus being abbot of the monastery of St. Dominic at Silos. Life to the reader and the possessor. Amen. Amen.

[EXPLICIT DEO GRATIAS. Benedico celi quoque regem me qui ad istius libri finem uenire permisit incolomen, amen. Explicitus est liber Ethimologiarum sub era TACAXA, UIIII kalendas septembris, lune cursu UIIA, regnante rex Sancio in Castella et in Legione et in Gallecia, Dominico denique abbati monasterii sancti Sebastiani de Silus regenti. Legenti et possidenti vita, amen, amen.][73]

As in the great colophons of Florentius, with which he shares some formulaic phrasing,[74] Ericonus anchors his labor in space and time. Then, in a gesture that is now familiar, he reaches out beyond the page into the reader's time and place. Having asked you to remember him, he, prospectively, remembers you. He conscripts you concretely as reader of this book, its owner, or both. In either case, he wishes you well: *Legenti et possidenti vita.*[75]

This scribe's articulation of his book with the world is not, however, yet complete. He moves his hand over to the top of the right column of the same page and begins another memorial. This one is not for himself in the present, nor for his reader in the future, but for the *auctor* in whose company he has labored through all these many leaves of parchment. "Item," begins the red-letter text at the top of the right-hand column, "verses about Leander and Isidore, bishops of the Church of Seville, composed by Blessed Braulio, bishop" [Item uersi de Leandri et Isidori episcopis sedis spalensis ecclesie a beato Braulioni episcopo editum].[76] The verses about Isidore are, in fact, his epitaph.[77]

This cross bears the nurturing bodies of brothers
Leander and Isidore, both in sacred orders.
A third, Florentina their sister, forever consecrated to God,
here rests beside them, a worthy companion.
Isidore in the middle separates the members of the other two.
To learn what they were like inquire in books, oh reader.
Know that they were well-spoken of in all things,

sure in hope, full of faith, beloved beyond all things.
See how they brought forth the faithful by those teachings,
so that those held back by impious laws were restored to the Lord.
That you might believe they live forever on high,
look again at the pictures and try to see.

[Crux hec alma gerit corpora fratrum
Leandri Isidorique parum ex ordine uatum
Tercia Florentina soror et deo uota perennis
Eo posita consors hic digna quiescit
Esidorus in medium disiungit menbra duorum
hi quales fuerint libris inquirito lector
ut cognosces eos bene cuncta fuisse locuutus
Spe certos fide plenos super omnia caros
Docmatibus istis cerne creuisse fideles
hac reddi Domino quos impia iura tenebant
Utque uiros credas sublimis uiuere semper
Aspicitis rursum pictos contende uidere.][78]

"This cross bears the nurturing bodies" of Isidore and his siblings, the manuscript says, but Ericonus has drawn no cross. The deictic x-marks-the-spot function of the epitaph is fulfilled by the poem itself, pointing toward these very bookish bodies in their very bookish representations ("What they were like inquire in books, oh reader"). The letters, as Isidore himself would say, speak in the voices of the absent.

The characters and bodies of the three siblings thus made present, Ericonus now tells us the dates on which their labors ended.

> Bishop Leander of blessed memory died on the II of the Ides of March, era DCXL [March 14, 602 CE].
> Bishop Isidore of holy memory died on the Nones of April, era DCLXXIIII [April 5, 636 CE].
> Florentina, consecrated to God, of pious memory died on the V of the kalends of September, era DCLXXI [633 CE]. It is finished.

[Obiit felicis memorie Leander episcopus die II idus marcias era DCXLa.
Obiit sancte memorie Esidorus episcopus die nonas aprilis era DCLXXIIIIa.
Obiit pie memorie Florentina Deo deuota V kalendas septembris era DCLXXIa. Finit.][79]

In Maius's Apocalypse, textual *explicit*, codicology lesson, and scribal sub-scription respond to each other across the two columns of a single page. So too in Ericonus's *Etymologies*, colophon and epitaph share the same page and, together, unpack the Latin pun that analogizes the body of the writer and the body of his writings. *Finit* like a codex; *explicit*.[80] Rolled out, rolled up, stored in a box: book and body end the same way.

The well-wishing colophon and apostrophic epitaph both call readers to participate affectively in Ericonus's codex. And participate they did. On f. 21v, the labyrinth where the scribe's name is buried, the lettered paths that spell out the inscription are worn by the tracks of many fingers, especially at the center where the message begins. On the colophon-epitaph page (f. 385r), blank parchment toward the bottom has been used to ink memorials for members of the community at Silos: "Martinus died on the VII of the ides of July, era TCXLI" [Obiit Martinus VII idus iulii era TCXLI] (= July 9, 1103) and, faintly, "Dominicus died on the kalends of May, era TCXLVI" (= May 1, 1108) [kalendas maii obiit Dominicus, era TCXLVI].[81]

A monastic codex was clearly holy ground and holy space, and inscriptions in it like these obits for Martinus and Dominicus constitute a memorial akin to burial near a saint's tomb. In one case, the holy corpse of the saint shares its aura with the deceased; in the other, it's the textual corpus.[82] In Ericonus's *Etymologies*, the epitaph provides a truly authorizing subscription by underwriting the textual corpus of the *Etymologies* with reference to Isidore's own body, crowning this copy of the *Etymologies* with parallel memorials to the scribe who wrote this book and the *auctor* who composed it.

Both writers are in a sense interred in the codex, which points to their bodies—in both the inked traces of the scribe's hand and the deictic gesture of the "here lies" epitaph. Here is Isidore's body; here is Ericonus's hand at work. They made this book. Remember them.

MAIUS: IN MEMORY

Returning now to Maius's Apocalypse, you will remember that the verso of his colophon page was used centuries later by one Johan Lopes, who wrote on it an appeal to its *letras moçarrabas*. Equally, if more piously, attuned to the power of inscription is an older response, heavily inked lower down on the same page: *obiit petrus leuita CSR* (f. 293v, Figure 26). Petrus the deacon

died: now the manuscript that is a reminder of the end of the world and a monument to the memory of the scribe becomes a monument also to this Petrus, who, as the abbreviation CSR after his name indicates, was dwelling here at San Miguel de Escalada when it was under the governance of the canons of St. Ruf of Avignon.[83] The body of Petrus the deacon was probably also interred in the consecrated ground of the cloister at Escalada;[84] here his name and the fact of his death are articulated with the holy activity of this codex.

Although Maius has also attempted to write himself into our memory as clearly as any epitaph would, he is not, of course, entombed in the *bibliotheca* that is the Escalada Apocalypse. We do, however, know where he is buried. There is no physical monument at the site, which has been razed and rebuilt many times over the years. But a manuscript points to it, as Ericonus's *Etymologies* points to the tomb of Isidore of Seville. This manuscript was made by a student of Maius who follows the master's instructions to commemorate his labor, well, to the letter. We know this person's name, too; we know the place where he worked and when he finished his job.[85]

The project was another copy of Beatus's Apocalypse commentary; it was made at the monastery of San Salvador de Tábara (Zamora), about 100 kilometers to the southwest of Escalada as the crow flies. The maker of the book crowns his labor with a spectacular two-page colophon that records in both text and image Maius's death as well as the birth, process, and conclusion of the codex that contains it.

The Tábara Beatus is now kept at the Archivo Histórico Nacional in Madrid with the shelf number L.1097. The manuscript has been sadly mistreated, so be especially careful when you open it to folio 171r. (There is no digital facsimile, so you will have to do this in your imagination unless you are in Madrid and lucky.) A giant Omega takes up half the page (Plate 17).

Beneath that great apocalyptic letter, the carefully written colophon rolls out. It begins in capitals:

> O truly blessed man, who, coffined, now is buried in the cloister:
> he wanted the book to be brought to completion and sewn together.
> Magius, priest and monk, the worthy master-painter, gave up the work
> he had begun
> when he went eternally to Christ on St. Faustus's day, the III of the Ides.
> The kalends of November had their third day before he departed out of
> time, era one thousand VI.

[O BIRUM VERE BEATUM QUEM EBUSTARI CLAUSTRA SARCOFOGATUM.
ILLE ERAT DESIDERATUM VOLUMINI VIVS AD PORTVM ITEM CONSVTVM.
ARCIPICTORE ONESTUM, MAGII PRESBITERII ET CONVERSI EMITTIT
 LAVORE INQUOATVM.
E QVO PERENNE PERREXIT AD CHRISTVM DIEM SANCTI FAUSTI, IIIO
 IDUS, KALENDAS NOVEMBRIS DIEM ABVIT TERTIV, ET
 DISCESSIT AB EVO, ERA MILLESIMA VIa.][86]

In spite of the different spelling of the name, the details here line up closely enough with those provided in Morgan M644 to make it very unlikely that this "worthy master-painter" is anyone other than our Maius, who, we are told, began this book but did not live to finish it. His final illness began when he collapsed on October 10, 968 CE, and ended with his death three weeks later, on November 3. What he was like, oh Reader, inquire in books: the colophon points to his body bound up in its coffin (*sarcofoga-tum*) just as the book he began is now, as he wished, bound between its covers (*consutum*).

Though the colophon tells us that Maius was buried in the Tábara cloister, this parchment Omega marks his grave, just as Isidore's tomb is both sited and cited in the *Etymologies* manuscript into which Ericonus copied the author's epitaph on August 24, 1072.

An actual epitaph that survives at Escalada similarly links the body of the maker with the made thing. The inscription is crammed somewhat inelegantly onto the springer stone at the base of an arch at the church door. "Abbot Sabaricus," it says, "died feria II, the VIIIth of the kalends of November, era LXL plus VII after the thousandth [= Monday, October 25, 1059 CE]. He himself made this arch; he lies beneath it" [OBIT SABARICUS ABBA, DIE IIª FERIA VIII° KALENDAS NOVEMBRIS, ERA LXL CUM VIIª POST MILLESIMA. IPSE FECIT ISTE ARCUM; A SUO CABO IACE].[87] If Abbot Sabaricus literally lies interred beneath his own work, we might well say that Isidore and Maius are likewise *impaginated* in theirs,[88] metaphorically contained between the covers of the books in which their names are inscribed.

We have not finished with the Tábara colophon. Maius's student continues, in neat minuscule now, and in a spatially and temporally precise first person:

Then I, Emeterius the presbyter, formed by my master Magius the presbyter, was called to the monastery under the protection of the Savior during the time in which they wanted him to make the book for their

Lord. From them I received the already-begun work. From the kalends of May to the VI of the kalends of August I completed this book. May my master with all his mastery deserve to be crowned with Christ. Amen.

[Ego uero Emeterius presuiter et a magister meus Magi presbiteri nu-tritvs, dum Domino suorum librum construere eum uoluerunt, uocauerunt me in Tauarense arcisteri sub umbraculo Sancti Salbatoris, et de quos inueni inquoatum. De kalendas magias, usque VI° kalendas agustas inueni portum ad librum, cum omni suo magisterio magistrum meum sic eum mereat coronari cum Christo. Amen.][89]

Here's whose hand this is: his name was Emeterius, he was a student of Maius, and he worked on this book from May 1 to July 27. As Florentius paid tribute to his writing-master in the Córdoba Homiliary (discussed in Chapter 3), so here Emeterius commemorates his teacher. The book we hold is in part the work of Maius's hands and in full a memorial to their labor.

More details are forthcoming; they articulate names and times with a particular place and to a particular corporeal experience. The colophon continues: "O tall stone tower of Tábara! Up there is the first chamber, where Emeterius sat for three months . . . bent over and with all his limbs maneuvered the pen" [O turre Tauarense, alta et lapidea! Insuper prima teca, ubi Emeterius tribusque mensis . . . curuior sedit, et cum omni membra calamum conquassatus fuit].[90] Florentius asked, "Do you want to know what it's like to write a book?" Emeterius doesn't bother asking. He just tells us: up there is where he sat. He sat bent over, and for three long months used all his limbs to push the pen. At last, "the book was finished on the VI of the kalends of August, era one thousand VIII" [Explicit librum VI kalendas agustas, era millesima VIIIa]: July 27, 970 CE.[91]

But Emeterius doesn't just tell us what making a book is like—he shows us, too. Turn the page over (to f. 171v, Plate 18), to see what you've just been reading about.

That tall stone tower takes up the full height of the page.[92] A figure on the ground floor reaches for the cables that operate the bells; three others scramble up the ladders. The workroom is into the side of the tower. In the outer room, right under the tiled roof, an apprentice prepares parchment. Up there in the first chamber, two scribes bend over their labor, their pens and books still visible in spite of the sorry state of the page.

The codex is an inscribed environment; this page from a codex in turn represents the environment of inscription. And that environment is itself inscribed. The shadowy text above the writers' heads explains: "Here is the presbyter Emeterius, exhausted and ill . . ." [ubi emeterius presbiter fatigatus sine salus]. "Here Senior stays awake with him" [ubi senior velat pariter cum]. The assistant cutting parchment by himself in the room on the right is labeled with text that is not legible now.

In the *explicit* to his Apocalypse, Maius made sure to give us the keywords we need to understand the book as a particular and material product of manual labor; later, in the colophon, he emphasized his own affective involvement in its construction. Here, his student Emeterius similarly represents the codex *he* is finishing through the discussion of the process of its manufacture and the life of the hands that made it. Maker and made are closely inter-implicated—from the verb *plico*, to fold together. Folded together like the pages of a gathering: the pages of a codex are so called, Isidore reminds us through Maius, "from the fact that they are joined together among themselves" [eo quod sibi inuicem compinguntur].[93]

Maius imagined and painted the book as a container for precious material—as reliquary, as ark, as coffin. In the Tábara colophon-epitaph, *sarcofogatum* (coffined) and *consutum* (sewn together) echo each other at the end of their respective lines, book and body analogized in parallel past participles of containment. Bind a book when your work is finished; coffin a body when its work is done. Paint one or the other with the same shorthand shape because they're both containers, each one a *theca*.

To the opus goes the corpus, the body of the worker to the body of work. Paleographers tell us that that Maius's hand is at work in the early gatherings of the Tábara Beatus.[94] The book thus indicates the master's body in double deixis: graphic traces point to his living hand, the words "this was Magius, priest and archpainter" to his dead body. Remember Maius; his tomb is in this book of books, this *biblio-theca*.

THE STRANGE TIME OF HANDWRITING

> Time is not perceived on its own account, but by way of human activities.
>
> [Tempus per se non intellegitur, nisi per actus humanos.]
>
> —Isidore, *Etymologies* V.31

Handwritten words throw a line into the future to be caught by readers who can only be imagined by the scribe at the moment of writing. For those readers, however, that moment is always right there on the page in the traces left by the scribe's moving hand. I remember Maius when I engage with his subscription on f. 233v of the Escalada Beatus (New York, Morgan Library, MS M644; Figure 24). If I pay close attention, I can move into the writing, in my own time, of course, but somehow, strangely, in his as well. Attending to Maius's *ductus*, I follow his lead into an experience of writing encountered not only as an artifact, but also as an event.

MAIUS MEMENTO. The moment Maius made these letters is long gone, but I can see it, as Isidore would say, by way of the human activity that moved the ink across the page. Maius's letters are elegant, but there seems to be a little tremor in their execution (Figure 27). There is a faint wobble in the vertical strokes, especially of those important capital M's. Maybe Maius was tired that day from other handwork. Maybe the pen was badly cut. Either way, there's a long-gone instant right there, right beneath my fingers.

The page before our eyes, writes classicist Shane Butler, "has two main tenses: reading and writing."[1] Maius's colophon is interested in the former—that is, *our* time, yours and mine. "Remember me," the scribe writes, "you who will now dwell here / in the monastery of the supreme messenger, / the Archangel Michael" [MEMENTOTE ENIM MIHI. UERNULI CHRISTI. QUORUM QUIDEM HIC DEGETIS / CENOBII SUMMI DEI NUNTII MICAHELIS ARCANGELI].[2] From his inky present, Maius aims these lines toward a very concretely imagined future, articulating the temporal dimensions of lettered activity

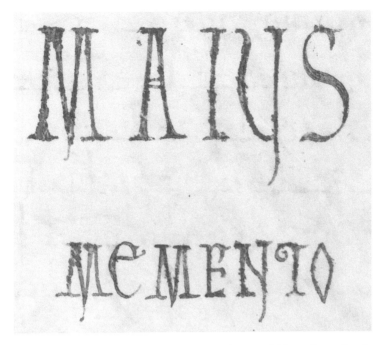

Figure 27. Remember Maius. New York, Morgan Library, MS M644, f. 233v detail. Photographic credit: The Morgan Library & Museum, New York. Used by permission.

with these very letters on this very page. Because the Latin adverb *hic* can mean *now* as well as *here*, when we engage attentively with the line, something strange happens: the inhabiting that Maius imagines has a double of a present sitting right next to its future tense. Just as you occupy both his future and your *now*, the moment of Maius's writing is simultaneously many hundreds of years distant and right here at hand. The manuscript *hic* is a window into the utter strangeness of handwritten time: both linguistically and materially indexical, it thus simultaneously points out to its referent and back to the hand that has always, it seems, just finished making it.

This is manuscript time, and it is a strange place to be. In this chapter we'll move into handwritten time, look around, and feel what it's like to be *hic*, here now, in the handwritten page. The visit begins by exploring how the uncanny deictics of reading manuscript shaped late ancient and early medieval theories of writing and presence. We then spend some time with a copy of Augustine's *City of God* made at the Riojan monastery of San Millán

de la Cogolla between 977 and 978 to see how the strange time of handwriting is integral to the way the codex functions. We conclude with a return to the life and times of Beatus's Apocalypse commentary and see what happened when a scribe working for the convent at Las Huelgas in September of 1220 made sense of Emeterius's parchment monument to the memory of Maius.

THIS THING I WRITE IS SUBTRACTED FROM MY LIFE

> Other portions of the body merely help the speaker, whereas the hands may almost be said to speak. . . . Do they not take the place of adverbs and pronouns when we point at places and things?
>
> [Nam ceterae partes loquentem adiuvant, hae [sc. manus], prope est ut dicam, ipsae loquuntur . . . non in demonstrandis locis atque personis adverbiorum atque pronominum obtinent vicem?]
>
> —Quintilian, *Institutio oratoria* XI.3.87

Isidore of Seville taught us that letters, too, do what hands and adverbs do. When they're handwritten, these indices of things point in two directions at once: toward their meanings and toward their making. A manuscript, then, can explain what it's doing in a way that a pointing hand cannot. And, in the Western metaphysics of script, that is exactly what handwriting does, over and over again. Here, for example, is St. Jerome. A friend has died, so time is on Jerome's mind. He is writing a letter to another friend, thinking time through the time making letters takes.

> Every day we die, every day we are changed, yet still we think ourselves eternal. This very thing that I am dictating, that is written down, that I reread and correct, is subtracted from my life. As many punctuation marks as my secretary makes, so many are the forfeitures of my time. We write, we write back: the letters cross the seas, and as the keel of the ship cuts furrows in one wave after another, the moments of our lives slip away.
>
> [Cotidie morimur, cotidie commutamur et tamen aeternos esse nos credimus. hoc ipsum, quod dicto, quod scribitur, quod relego, quod emendo, de uita mea trahitur. quot puncta notarii, tot meorum damna sunt temporum. scribimus atque rescribimus, transeunt maria epistulae

et findente sulcos carina per singulos fluctus aetatis nostrae momenta minuuntur.][3]

Jerome uses the way handwriting makes thought into matter as a way into putting his hands on time. As if following the wake of that ship in the water, this trace on the page wants somehow to explain the perennial puzzle *that was then; this is now.* Jerome and his secretary are, quite literally, marking time. We write, and we write back: here, for thought, is the movement of thought from mind to voice to letter to friend to new letter of the friend's response. And then, as the keel of the letter-bearing ship cuts furrows in the waves, the sequence dissolves in that ancient trope of impermanence, writing on water.

Impermanent though they may be, here are the letters on the page, and here, at least for an instant, is the presence that was lost. The passage concludes, "May our page sing [our dead friend's] praise; let all its letters sound him out. He whom we may not possess in body, let us hold in memory, and since we cannot speak with him, let us never cease speaking of him" [Illum nostra pagella decantet, illum cunctae litterae sonent. Quem corpore non ualemus, recordatione teneamus, et cum quo loqui non possumus, de eo nunquam loqui desinamus]. Isidore of Seville knew how this worked (*Etymologies* I.3); so did Maius's student Emeterius (Madrid, AHN, MS L.1097, f. 171r).

In print, as we have so far been studying this passage, Jerome's epistle might inspire admiration as an ingenious fusion of medium (the irreversible sequence of time-bound human language) and message (the inevitability of death), but that would be an admiration, as it were, from the outside. In manuscript, in contrast, there is no position outside the inky performance of mortality: to copy Jerome's letter is to rehearse one's own passing.

Anyone who copies this passage occupies a subject position first and continuously inhabited by Jerome himself, but there is room for many in this *ego.* Each successive writer will simultaneously occupy both Jerome's "I" and the moving hand of his secretary, laying his or her own time over the times of author and scribe. Jerome looks forward through time to the moment of his death; the scribe ticks off a sequence of present moments with his *puncta;* finally, so would you, if, writing this now by hand, you looked back at Jerome looking forward.

John Keats extends this living-yet-dead-yet-living hand to his readers in a poem that, appropriately enough, survives only in manuscript. "See here it is," he says, "I hold it towards you."[4] In her 1998 essay "The Strange Time of Reading," Karen Swann steps into this uncanny poem and finds herself implicated in its "strange effects of retrospectively activated prolepsis."[5] In an entirely handwritten world, what Carolyn Dinshaw has recently called the "multitemporality of the now" is strange indeed.[6] "The material text and the reader are not fully distinct entities," Dinshaw observes:

> They are not solid and unitary, founded in a self-identical present, but are rather part of a heterogeneous now in which the divide between the living and the dead, material and immaterial, reality and fiction, text and spirit, present and past is unsettled, where traces of signs, on the one hand, and tracks of the living, on the other, function differentially in displacing final meaning or a transcendent guarantee of meaning.[7]

You might call this the strange time of handwriting.

Take, for example, the eleventh-century Iberian scribe who copied Jerome's punctilious meditation for an epistle collection now in the BNE in Madrid (MS 6126; f. 53v, Figure 28).[8] Subtracting moments from the life of an author long dead, this writer fills space with some uncertainty. The script's left margin sways ever so slightly inward toward the gutter as Jerome's text proceeds, and, though the page is ruled, the first line sags a bit in the middle like a thread weighted by the *punctum* at its midpoint.

I see this, but I can't tell you what it means. If there is a connection between the script's irregularities and the scribe's bodily responses to the "intimate strangeness"[9] of the scene he or she is in the process of reproducing, we have no way of knowing. I can't tell you what it means, yet there it is. Circulated and read in manuscript, the letters of Jerome's epistle continue to do their asynchronous work every time the scenes of copying, revision, publication, reading, and response are repeated. "The *punctum* is Time," wrote Roland Barthes.[10] But unlike the photographs that so moved Barthes, the handwritten letter grows new spikes of indexical *puncta* with every act of copying and reading.

There's nothing especially beautiful or historically important about BNE 6126's instantiation of Jerome's Letter 60. Any manuscript at all would do for my purposes—even one written yesterday. In the strange time of handwriting,

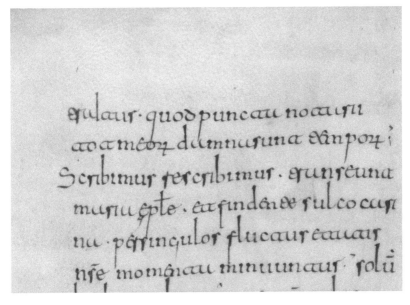

Figure 28. "As many punctuation marks as my secretary makes, so many are the forfeitures of my time." Madrid, BNE, MS 6126, f. 53v detail. By permission: Biblioteca Nacional de España.

what matters is not so much whose hand made these marks, or even when they were made, but the simple fact that *a hand made them*, made them in time, and made them in time for reading at the hands of others.

Those reading hands leave traces (visible and virtual) of their participation and intervention in the scene of reading. Johan Lopes wrote his request for divine help repaying his loan on the ancient page of Maius's Apocalypse, close to the *letras moçarrabas* whose power he hoped to harness (New York, Morgan Library, MS M644, f. 293v; Figure 26). At San Esteban de Gormaz, someone drew tall figures arguing with extended index fingers on the wall; another writer scratched into the wall a reminder of the death of someone whose name began with "E."[11]

In reading attentive to the strange time of handwriting, such marks are not vulgar defacements to be lamented and edited out; they are voices in an ongoing conversation, in a sense invited onto available surface by the gesturing deixis of the writing *ego*. Written by hand, *I write* and *you read* are capaciously reversible positions, at once precisely individual and endlessly iterable.

MAKING TIME (MADRID, RAH, MS 29)

In this place I rested

[in histo loco requiesci]

> —Marginal inscription in late tenth-century cursive
> in a *Passionarium* offered to a monastery in Valdeavellano
> (Soria) in 992 (Paris, BnF, nal 2180, f. 118v)

The people best positioned to theorize the strange time of handwriting are those inked most deeply into its web: the scribes themselves. They were, after all, experts, with intimate experience both experiential and theoretical. Experiential: practitioners of a slow craft, they were intimately familiar with what time looked like on the page (a column of text, a morning's work) and what it felt like in the body.[12] Theoretical: if their manual work taught them what time feels like, the works they copied taught them how to think about it.

One book from which medieval monastic readers and writers learned how to think about, with, and in time is Augustine's *City of God*, a universal history that places human civilization under the aegis of the titular divine city and, thus, parenthetically, under the shadow of that same end of time of which Maius so wanted his Apocalypse commentary to remind us. *City of God* is also one of the more formidable copying tasks that a handwriter could assume. In the preface, Augustine himself says that composing it was a "great and arduous work" [magnum opus et arduum].[13] Since Augustine, like his contemporary (and grumpy quondam correspondent) Jerome, relied primarily on dictation to embody thought in writing,[14] the hard work he refers to here is more intellectual and vocal than manual.

But now imagine a scribe preparing for work, an exemplar of *City of God* and blank gatherings of parchment before her or him. Leaving the first recto blank against the wear and tear of use, on the verso the scribe letters out an incipit in red, yellow, black, and green: "In the name of our Lord Jesus Christ. Here begins the book of the *City of God* of St Augustine the Bishop, marvelously disputed against pagan demons and their gods, from the beginning of the world up until the end of the age" [IN NOMINE DOMINI NOSTRI IESU CHRISTI. INCIPIT LIBER DE CIUITATE DEI SANCTI AGUSTINI EPISCOPI MIRIFICE DISPUTATUS ADUERSUS PAGANOS DEMONES ET HEORUM DEOS AB EXORDIO MUNDI USQUE IN FINEM SECULI].[15] "Suscepi magnum opus et

arduum," says Augustine from his work's beginning. And so says the writer who takes dictation—whether from the living man himself or from the *voces paginarum*. This scribe, too, has taken on a great and arduous work.

We are entering *City of God* through MS 29 at the Real Academia de la Historia in Madrid (f. 1v). It is one of that institution's rich collection of codices from the monastery of San Millán de la Cogolla, an important center of early medieval Iberian Latin culture. RAH 29 is one of two manuscripts of *City of God* in Visigothic hand and is thus an important witness to the diffusion of Augustine in the early medieval peninsula.[16] Internal evidence (about which more shortly) allows us to date it quite precisely to 977–78 CE.

Although Augustine understood *City of God* to be, as he said in a letter, "too bulky to bind into one corpus" [in unum corpus redigere multum est],[17] this particular instantiation of the work occupies one closely written volume, fitting all twenty-two books of the work within some three hundred folios.[18] The people who made it wrote in fine Visigothic minuscule, on good-quality parchment, evenly cut and ruled. There are no illuminations, though the codex begins with some very fine display lettering, and new books start with graceful interlace initials.[19] Because chapter headings appear irregularly, navigation within books is not easy, but it's smooth sailing if you're reading the book from beginning to end.[20] Especially noticeable in an attentive reading is the abundance of careful marginal notes, most of them in the same hands that copied the body text. These annotations articulate readers, writers, and author in complex multitemporal webs of reading and writing—webs that, though slippery and abstract as the indexical word "now," are also as concrete and material as the parchment itself and the ink that marks it.[21]

On f. 1v of RAH 29, both Augustine and his Iberian copyist declare that they have taken on "a great and arduous work." The *incipit* that the scribe has just carefully lettered declares that the undertaking extends "from the beginning of the world up until the end of the age" [ab exordio mundi usque in finem seculi]. Here at the beginning, their work is pointed toward its end. As religious, both writers would agree that that *telos* is the inscription of their names in the heavenly Book that opens at the end of time (Apoc. 20:12). As *writers*, though, the goal is the more mundane end of the book they are working on.

Augustine tells us right away that the result of his hard compositional labor is carefully constructed. Since the two cities (human and divine) "are

interwoven and intermixed in this era, and await separation at the last judg-ment" [sunt istae duae civitates in hoc saeculo invicemque permixtae, do-nec ultimo iudicio dirimantur],[22] so too in *City of God*, whose argument focuses sometimes on one city, sometimes on the other, and sometimes on both at once, *invicemque permixtae.*

So too in the book before us, Work (*City of God*) and codex (RAH 29) are interwoven and intermixed. Each can teach us about the other. To explore the City of Augustine and the City of Scribes simultaneously is to engage in a profound meditation on time perceived not on its own account, as Isidore will later write, but "by way of human activities" [tempus per se non intel-legitur, nisi per actus humanos].[23]

The universal history in *City of God* follows the interwoven development of the two cities from Genesis into what is for Augustine the recent past. A great chronology unspools, pushing inexorably toward the perfection of time in the apocalypse. To this argumentative teleology the scribes at San Millán add their own codicological one, for among the copious annotations of RAH 29 are marginal milestones that record the book's construction, col-umn by column, day by day. They track the movement of this particular codex toward its own material *telos*, the perfection of scribal time in the production of the finished book. Time of Work and time of labor, interwo-ven and intermixed.[24]

The first of these codico-chronological milestones appears on f. 63v, tak-ing the outer edge of the page as its baseline. It is "Sunday, the beginning of Lent, era 1015" [Dominico in introytum quadragesime, era MXVa] (=Feb-ruary 18, 977); the last one occurs 219 folios later, in Chapter 18 of Book XXII, which is marked "on the day of St. Felix" [In diem sancti Felicis, f. 283r]—that is, January 14, almost certainly of the following year. A year rolls by as we turn the pages: Saturday after the octave of Easter [sabbato post octabas pasce] (f. 88v), Sunday after Ascension [in dominico post ascensio] (f. 106r), Wednesday after Pentecost [IIIIa feria post pentacosten] (f. 109v), Sunday after Pentecost [dominico post pentacosten] (f. 112r). It is a year un-derstood through movable feasts, the local sanctoral (St. Hadrian, Sts. Justa and Rufina, St. Ciprian), and once, the Roman calendar (IIa feria, II idus junii).

It is also a year understood through labor—not only the labor of writing but also, as a user of the book encounters these annotations, the labor of reading. Though the records of scribal labor are carefully written, they are not

Color plates

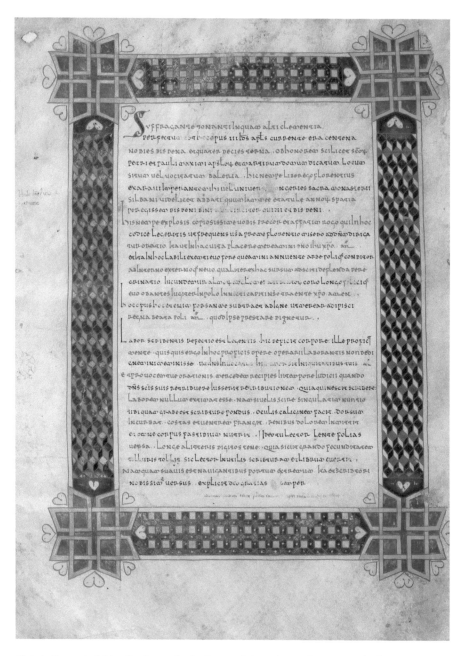

Plate 1. Florentius' *Moralia*, Second colophon and Apocalyptic Omega. Madrid, BNE, MS 80, ff. 500v-501r. by permission: Biblioteca Nacional de España

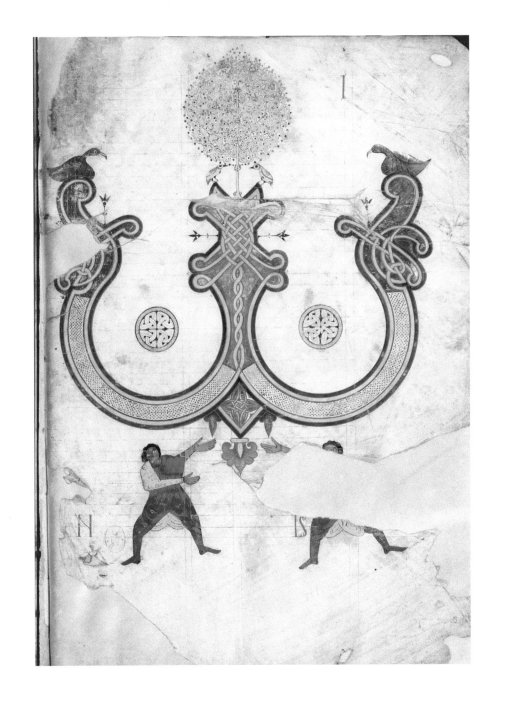

Plate 2. Apocalyptic Alpha and *Maiestas Domini*. Madrid, BNE, MS 80, ff. 1v -2r. by permission: Biblioteca Nacional de España

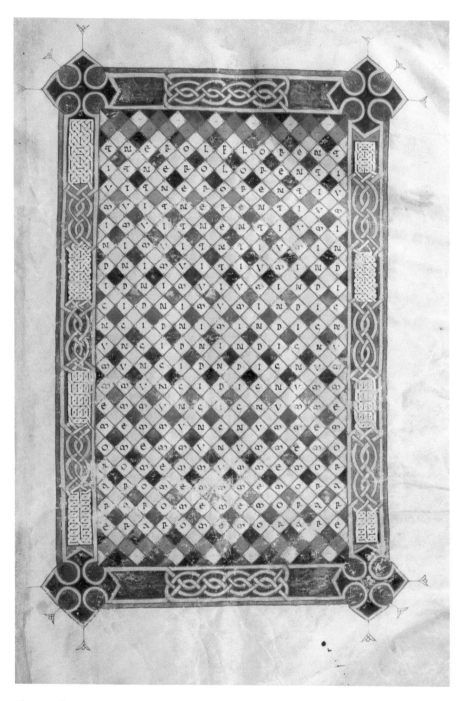

Plate 3. Labyrinth: "Remember unworthy Florentius." Madrid, BNE, MS 80, f. 3r. by permission: Biblioteca Nacional de España

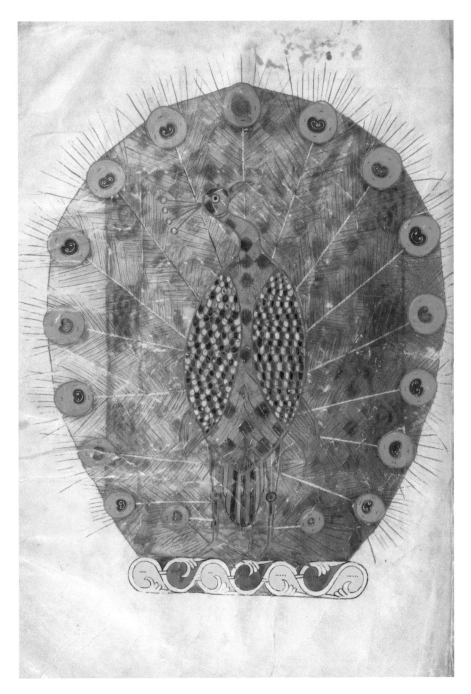

Plate 4. Peacock. Madrid, BNE, MS 80, f. 3v. by permission: Biblioteca Nacional de España

Plate 5. The scribe plants a garden. Córdoba, AC, MS 1, ff. 3v -4r. by permission: Archivo
Catedralicio de Córdoba

Bene nempe liber ego florthaqus & caruui imperauerat mici dno ihuxero ut uniuersa
congenti fuerat monastirii bullgance copiosissime nobis trede & unfiruum rogo
qui lithoe codices legenteris uac sequaris usu promeflorthago missro uadintii direquar
omnato lea uel inhuc mea placere mereumini domino ihsu xpo. am
Et aiaulmhos lubilicionem euo fore queumini un nuciet urce polis condicaurubin
axmo ceaerno q neuo qunliceir deauc fussum coferct deflandu percermuato, incundamus
almorum uaglomerian beuaors coro longo felici q euo obunacis luqiceir inpolo liinoc
ct cupiratno aruanct ihpo. am. hoc opus hoc cenim forsumne subauier ubiqui uermetius
udipisier regnu beuau pols. am. quod ipse presaure diqneaur.

Lubor scribentis refecrato est legentum. hic deficeit corpore ille proficit mene
quis quis creo in hoc proficis oper. operanti liborurais non dedicnonimini meminisse
uradis in uocuaus. in manor
sic in iqui euebus caus. am
ta puo uocemcaue q ruaroris.
mere caan recipes in aen por
ludiciii quando dns scit cuis
rearibuere lussera rearibu
acociun. quia euineseia sci
beret. Luboran nullum
chaanuue essct. Nam siue
li scire singulam ennum
cxo mbraua maerube est scrip
cure pondus. oculis cealigi non sucia. dorsum incurbua. cosaus & uenaroin frun
cia raintbus dolorem inrinuita. domine corpus exardium uarie spo auloeuos
Lenae solius uestra. Longe uliratis diqicaos aeac. quia sicut cqrundo fecundi
auctm aellurrs ccollict. sic leenor lauuilis fere eurum aclifrum euerara.
Num quam suuuisc esta nauiqunatibus poreum ceaeronum. laua scripto ri
nobissimus uersus. ceplicia deo cruuaus sonter. Amen.
Sancac murie puerperum uirqo. macnorum uaposcolorum pereris & pauli.
suncta aciome uere ii chsci subueniuun. hoc munus uecepice. id hoc librum
quod inaula usa uaboqulebu presbiceir offerc
reo enim ad dominum imhereidiat. am. am.

Plate 6. Subscribing in flowers. London, BL, Add MS 11695, f. 278r detail. © British Library Board. Used by permission.

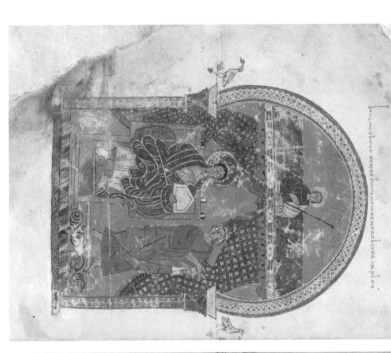
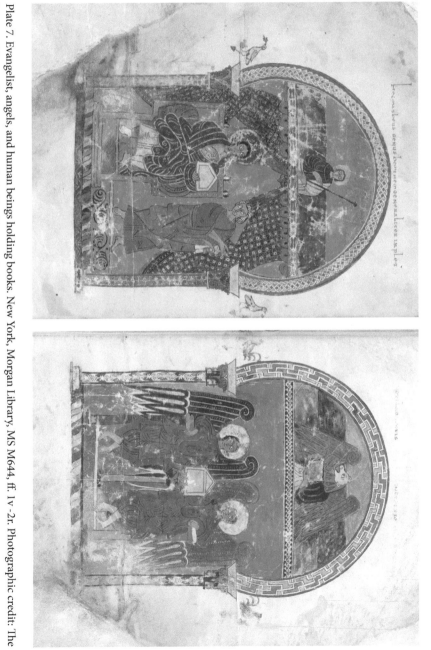

Plate 7. Evangelist, angels, and human beings holding books. New York, Morgan Library, MS M644, ff. 1v -2r. Photographic credit: The Morgan Library & Museum, New York. Used by permission.

Plate 8. The codex as diptych. New York, Morgan Library, MS M644, f. 23r detail. Photographic credit: The Morgan Library & Museum, New York

Plate 9. The codex as diptych. Madrid, BNE, MS VITR 14/1, f. 126r detail. by permission: Biblioteca Nacional de España

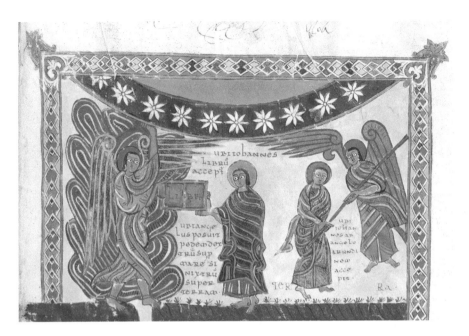

Plate 10. John receives the book. New York, Morgan Library, MS M644, f. 146r detail. Photographic credit: The Morgan Library & Museum, New York. Used by permission.

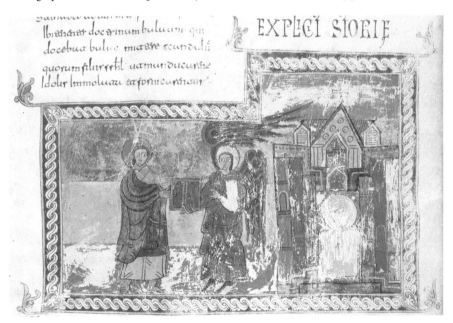

Plate 11. Write to the church in Pergamum. New York, Morgan Library, MS M644, f. 57v detail. Photographic credit: The Morgan Library & Museum, New York. Used by permission.

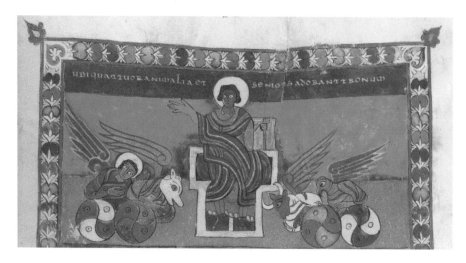

Plate 12. Holding the book by its gutter. New York, Morgan Library, MS M644, f. 207r detail. Photographic credit: The Morgan Library & Museum, New York. Used by permission.

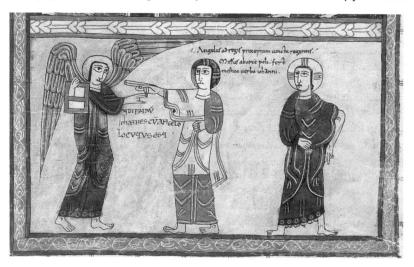

Plate 13. Holding the book by its margin. Girona, Arxiu Capitular, MS 7, f. 31v detail. By permission: Arxiu Capitular, Catedral de Girona.

Plate 14. Sarcophagi. New York, Morgan Library, MS M644, f. 238v detail. Photographic credit: The Morgan Library & Museum, New York. Used by permission.

Plate 15. Foliate folios. Madrid, BNE, MS VITR 14/2, f. 10r detail. by permission: Biblioteca Nacional de España

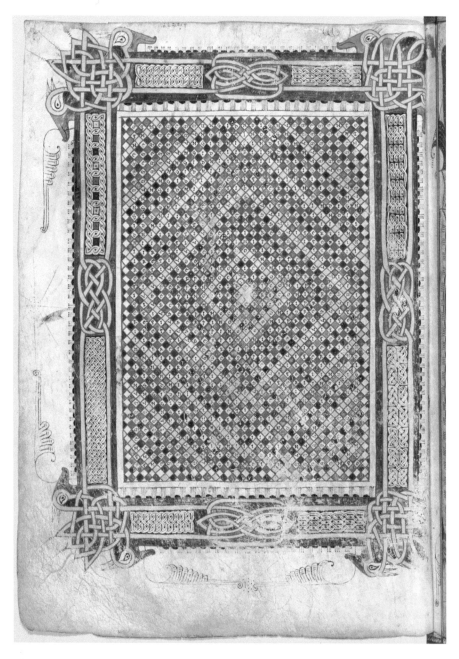

Plate 16. Labyrinth: "Remember Ericonus, unworthy presbyter." Paris, BnF, nal 2169, f. 21v.
By permission: Bibliothèque nationale de France.

Plate 17. Apocalyptic Omega and colophon. Madrid, AHN, MS L.1097, f. 171r. By permission: Ministerio de Cultura y Deporte. Archivo Histórico Nacional.

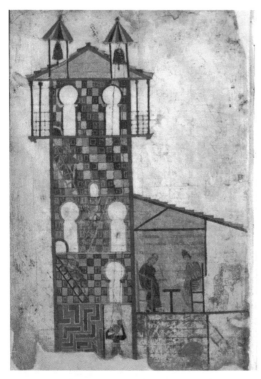

Plate 18. Scriptorium. Madrid, AHN, MS L.1097, f. 171v. By permission: Ministerio de Cultura y Deporte. Archivo Histórico Nacional.

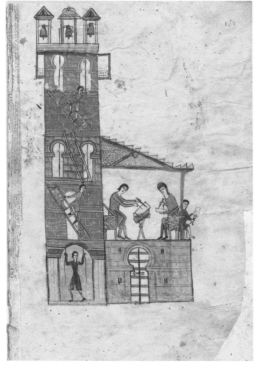

Plate 19. Scriptorium. New York, Morgan Library, MS M429, f. 183r. Photographic credit: The Morgan Library & Museum, New York.

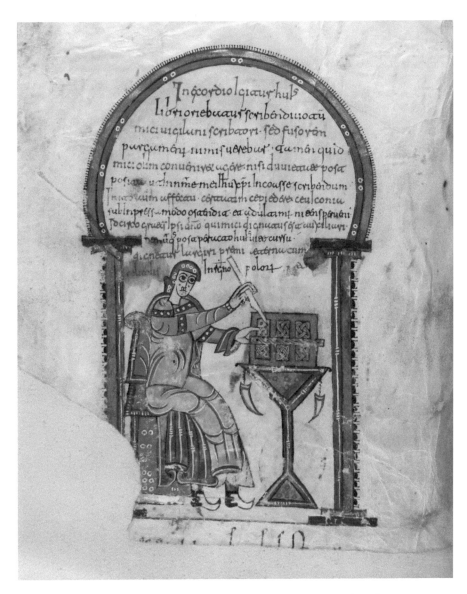

Plate 20. The scribe at work. El Escorial, Biblioteca del Monasterio, MS d.I.2, f. XXIIv.
By permission: Patrimonio Nacional, Biblioteca del Real Monasterio de San Lorenzo del
Escorial.

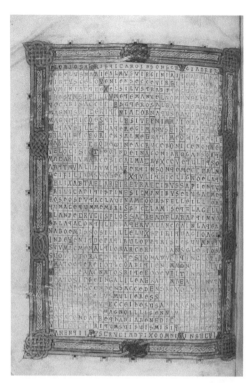

Plate 21. Acrostic and figured poem: "Gloriosa Christi caro" El Escorial, Biblioteca del Monasterio, MS d.I.2, f. 1v. By permission: Patrimonio Nacional, Biblioteca del Real Monasterio de San Lorenzo del Escorial.

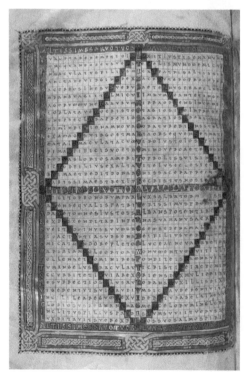

Plate 22. Acrostic and figured poem: "Altissime, seruo tuo salua" El Escorial, Biblioteca del Monasterio, MS d.I.2, f. 3v. By permission: Patrimonio Nacional, Biblioteca del Real Monasterio de San Lorenzo del Escorial.

Plate 23. Portrait gallery: monarchs and scribes. El Escorial, Biblioteca del Monasterio, MS d.I.2, f. 428r. By permission: Patrimonio Nacional, Biblioteca del Real Monasterio de San Lorenzo del Escorial.

Plate 24. Reading as conversation. El Escorial, Biblioteca del Monasterio, MS d.I.2, f. 20v. By permission: Patrimonio Nacional, Biblioteca del Real Monasterio de San Lorenzo del Escorial.

Plate 25. Reading as conversation. El Escorial, Biblioteca del Monasterio, MS d.I.2, f. 35r detail. By permission: Patrimonio Nacional, Biblioteca del Real Monasterio de San Lorenzo del Escorial.

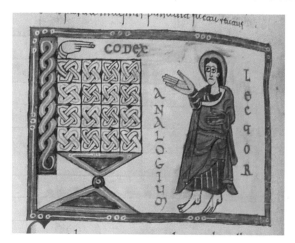

Plate 26. Reading as conversation. El Escorial, Biblioteca del Monasterio, MS d.I.2, f. 37v detail. By permission: Patrimonio Nacional, Biblioteca del Real Monasterio de San Lorenzo del Escorial.

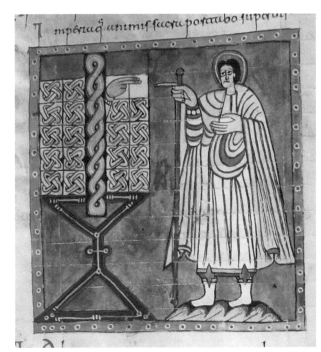

Plate 27. Reading as conversation. El Escorial, Biblioteca del Monasterio, MS d.I.2, f. 43v detail. By permission: Patrimonio Nacional, Biblioteca del Real Monasterio de San Lorenzo del Escorial.

Plate 28. Reading as conversation. El Escorial, Biblioteca del Monasterio, MS d.I.2, f.47v detail. By permission: Patrimonio Nacional, Biblioteca del Real Monasterio de San Lorenzo del Escorial.

Plate 29. The Feast of Belshazzar. New York, Morgan Library MS M644, f. 255v. Photographic credit: The Morgan Library & Museum, New York. Used by permission.

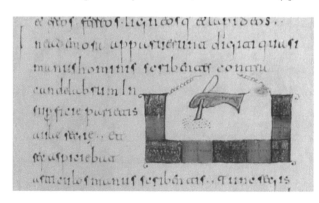

Plate 30. "There appeared fingers, as it were a human hand" León, San Isidoro, MS 2, f. 320r detail. Photo from facsimile, Rare Book and Special Collections Division of the Library of Congress, Washington, DC. Used by permission.

easily deciphered. The scribes mark their time very small, sometimes in cursive (ff. 134v, 141r, 155r, 162v) and sometimes in code—in puzzles, that is to say, that beg to be solved by the reader (ff. 170v, 176v, 184r, 189r, 195v, 273v).

Stop reading Augustine for a minute or two and engage with this puzzle, *permixtus* with the argument of Book XV, Chapter 23 in the lower outside margin of f. 170v (Figure 29).

Here are two columns of tiny letters. They don't make any sense read horizontally or vertically. But rotate the page 90 degrees counterclockwise. Begin with the capital E, bottom row, far left. Above it, F. Diagonally down to the right, bottom row: A. Above it, R. Continue to zigzag the two rows of letters together and you produce more apparent nonsense: EFARRTOM MUNOCAID AIROMEM. Read it backward, though, and you will never forget who made this puzzle and this page. MEMORIA DIACONUM MOTERRAFE: "In memory of Moterrafe the deacon."

On f. 196r, the hand changes; eighty folios later, we get a name for the new hand and another reminder, this time laid out in the kind of monogram one might use to subscribe to a document. ALOITII PRESBITERI MEMORIA: "Remember the presbyter Aloysius" (f. 273v, Figure 30). And on f. 276v (Figure 31), we are told "Here Aloysius the presbyter stopped writing" [Hic cessavit Aloitius presbiter de scribere], and another hand takes over.[25] In sum: sixteen dates and perhaps as many as five scribes, two of whom—Moterrafe and Aloysius—record their names.[26]

The San Millán *City of God* is not the only early medieval manuscript to track the activity of multiple scribes. Jean Vezin has shown that there is in fact a body—small but significant—of codices that, like RAH 29, marginally identify the hands that made them.[27] In most of Vezin's cases, the name-glosses, though contemporary with the text hand, are not written in it; they come often at the beginning or end of gatherings, in formulations like *pars Genadii*, Genadius's section. The hand, Vezin speculates, is likely that of the workshop's head, who is keeping track of the copyists assigned to each gathering.[28] The milestones in RAH 29, however, are more about the dates than about the names: the dates are *sequential*, and the glosses are not *about* but rather *by* the scribes themselves. Instead of managing simultaneous transcription of the book's components,[29] these annotations track the making of the codex conceived as a whole, in a series of *ego-hic-et-nunc* interventions.

The scribes make themselves known in RAH 29, establishing their presence through a sequence of precisely located presents of manuscription:

Figure 29. "In memory of Moterrafe the deacon." Madrid, RAH, MS 29, f.170v detail. By permission: Real Academia de la Historia.

Figure 30. "Remember the presbyter Aloysius." Madrid, RAH, MS 29, f. 273v detail. By permission: Real Academia de la Historia.

Figure 31. "Here Aloysius the presbyter stopped writing." Madrid, RAH, MS 29, f. 276v detail. By permission: Real Academia de la Historia.

Sunday, the beginning of Lent, era 1015; Saturday after the octave of Easter; Sunday after Ascension; Monday two days before the Ides of June; the Eve of St. Hadrian; and so on until the day of St. Felix. They are documenting their contributions to building *City of God*. One of them reminds us, in the outer margin of f. 106r, that this contribution was material as well as intellectual: "I wrote here on the Sunday after Ascension," he says, "and the pen was bad" [Hic scripsi in dominico post ascensio et fuit illa pinna mala] (Figure 32).[30] Writing here represents itself in the quality of the very instrument by which the scribe marks time. It is assessed in an unequivocal first person, articulated with this particular page—*hic scripsi*—and this particular Sunday.[31]

Again and again, as the scribal milestones are interwoven and intermixed with Augustine's developing argument, the scribal present intervenes in the present of reading. In this, the San Millán scribes are brothers to Florentius, whose copy of the *Moralia* was fitted out with a self-narrating frame that presented the codex as both product and process, and Maius, who programmatically articulated his great Apocalypse with his own first person and the codicological applications of his own manual labor. The Apocalypse commentary, too, rolls forward to an end whose date, while imminent, is constantly shifting forward. As apocalypse is always *soon*, manuscription is always *hic*, both here and now, and reading hovers strangely in between.

It is not surprising that no modern edition of *City of God* mentions these annotations, particular as they are to one single manuscript. But marginal as these scribal interventions may seem to Augustine's great argument, they are in fact in sustained dialogue with the work's intense preoccupation with time. For Augustinian readers (which these monks were by force of copying,

Figure 32. "I wrote here on the Sunday after Ascension, and the pen was bad." Madrid, RAH, MS 29, 106r detail. By permission: Real Academia de la Historia.

if nothing else), the present is a vanishing construct, no sooner noted than lost. Thus the *Confessions* famously declares:

> But then if the present, in becoming time, comes into being in such a way that it passes into the past, how can we say that the present exists, either? The reason for its being is actually that it *won't* be. I guess, then, that we couldn't truly say that time exists, unless through its existence it aims at nonexistence?

> [Si ergo praesens, ut tempus sit, ideo fit, quia in praeteritum transit, quomodo et hoc esse dicimus, cui causa, ut sit, illa est, quia non erit, ut scilicet non vere dicamus tempus esse, nisi quia tendit non esse?][32]

What we see in RAH 29's process glosses is nothing less than the present's impending state of not-being, repeated over and over, each iteration of *now* no sooner recorded than lost, over and over again as the book is built. As many punctuation marks as my secretary makes, Jerome said, so many are the forfeitures of my time.

It would be lovely at this point to offer a tenth- or eleventh-century Iberian copy of the *Confessions* to show how our scribes handled Augustine's great meditation on time. Alas, no exemplar of the work survives in Iberian manuscripts of this period. Its existence, however, was known—as was the fact that it contains an authoritative discussion of time.[33] Thus, when *City of God* broaches the subject in its discussions of the Creation (Book XI) and death (Book XIII), the glosses in RAH 29 supply marginal cross-references to the *Confessions*.[34] Someone, it seems, was paying very close attention.

In Book XIII, *City of God*'s relentless forward movement and its equally relentless insistence on seeing the macro- (salvation history) in the micro- (human history) shave down to a disappearing instant much as the present moment disappears into Xeno's paradox in Book XI of the *Confessions*. That instant is the very breath that separates life from death.[35]

> Thus between these two situations [before death and being dead] the period in which a man is dying or "in death" disappears. For if he is still alive, he is "before death"; if he has stopped living, he is by now "after death." Therefore he is never detected in the situation of dying, or "in death." The same thing happens in the passage of time; we try to find the present moment, but without success, because the future changes into the past without interval.

> [Perit igitur inter utrumque, quo moriens vel in morte sit; quoniam si adhuc vivit, ante mortem est; si vivere destitit, iam post mortem est. Numquam ergo moriens, id est in morte, esse conprehenditur. Ita etiam in transcursu temporum quaeritur praesens, nec invenitur, quia sine ullo spatio est, per quod transitur ex futuro in praeteritum.][36]

A gloss written by a scribe at San Millán draws attention to this passage, marking the interior margin of the page on which it occurs (RAH 29, f. 138v; bottom margin, interior) with a cross-reference to *libri confessionum*.

We know, of course, that we are passing time with Augustine, and that, as Jerome might say, we forfeit moments with every page we turn. But the instantiation of *City of God* in RAH 29 materializes this simple fact for all time. In both the City of Augustine and the City of Scribes, time explicitly moves forward with every turn of a page. The difference, of course, is that Augustine's *now* (like Jerome's) is always vanishing, and the scribe's *hic* is right (t)here under our fingertips. The moment of writing is undeniably present in the inky gesture and equally irrecuperable therefrom.

Pace Augustine, the period in which the scribe is writing or is "in writing" doesn't disappear, but rather extends, suspended between going and gone, for as long as the written trace itself survives. Manuscription is always in the present tense, a present linked with multiple and infinitely iterable presents in asynchronous simultaneity: the *now* of reading. The Eve of Sts. Justa and Rufina in July (f. 134v, outer margin) inevitably gives place to the Eve of St. Bartholomew, Apostle in August (f. 141r). But turn back to

f. 134v and, whatever your calendar may tell you, here are Justa and Rufina, and it's still July.

The scribal present is capacious and embraces both the inevitably future reader and the ostensibly past figure of the author. Augustine himself, for example, is addressed in the glosses of RAH 29 in the present tense, as if he were in the room: "You discourse so mystically, O Doctor" [Tam mistice disseris o doctor] (f. 122r, inner margin, center). The reader, too, is addressed as if she or he were present—which, of course, you are, and corporeally too, sitting before the open book in the precise position once occupied by the scribe. A note on f. 92r (outer margin) addresses you with an affectionate vocative: *karissime*.[37] To a passage at *City of God* X.13.2, the note praises "a useful comparison and a notable similitude" and advises, "but proceed, reader, and consume sweet food" [Utilis comparatio et egregia similitudo, set perge lector et dulces cibos sume" (f. 105r, inner margin, center)].

When the discussion of time and Creation gets technical, a gloss on *City of God* XI.5 advises in the inner margin of f. 116r, "Note this, and pay attention not only with your eyes but also with all of your mind" [Nota et non solum oculis set mente tota intende]. Our presence, both corporeal and intellectual, is requested. Not just requested, but *conscripted*: our eyes and our minds are part of what's happening here, written into the page as event. And, appropriately enough, what's happening on the page where this scribal injunction to pay full attention appears is the collapse of time periods *sub specie divinitatis*:

> It does not follow that we conceive anything gratuitous in God's action in creating the world at that particular time rather than earlier, since the previous ages had passed without any difference which might make one time preferable to any other.

> [Non est consequens ut deo aliquid existimemus accidisse fortuitum, quod illo potius quam anteriore tempore condidit mundum, cum aequaliter anteriora tempora per infinitum retro spatium praeterissent nec fuisset aliqua differentia, unde tempus tempori eligendo praeponeretur.][38]

The apparatus of RAH 29 thus explicitly articulates the codex with the temporalities of writing and reading; the glosses reach out from the page and into time. Interpellations of a reader (Pay attention here, dear; Remember Moterrafe the deacon) articulate the Work (*City of God*) with the text

(RAH 29); the temporal glosses articulate the text (RAH 29) with specific dates in the time-bound process—and even, in the case of f. 106r, with the particular *instrument*—of its manufacture.

More intricately still, the glosses sometimes articulate their own present with Augustine's. At the discussion of the good and evil angels in Book XII, the gloss conflates Augustine's "pagans" with contemporary Iberian Muslims: "a marvelous assertion," it comments, "against the gentiles of our time" [mirauilem adsertionem contra nostri temporis gentiles] (f. 127r, inner margin, center). Even more striking is the observation on f. 156v. This one is occasioned by and in dialogue with a moment in which Augustine textualizes details even more mundane than a scribe's bad pen, and works them into his titanic argument:

> A number of people produce at will such musical sounds from their behind (without any stink) that they seem to be singing from that region. I know from my own experience of a man who used to sweat whenever he chose; and it is a well-known fact that some people can weep at will and shed floods of tears.

> [Nonnulli ab imo sine paedore ullo ita numerosos pro arbitrio sonitus edunt, ut ex illa etiam parte cantare videantur. Ipse sum expertus sudare hominem solere, cum uellet. Notum est quosdam flere, cum volunt, atque ubertim lacrimas fundere.][39]

To this the glossator responds in kind, speaking in his own first person about what he says that he himself has seen in his own recent experience: "And *today in our time*, many people shamelessly do this or all that is described above. Truly, I have not seen people sweat and weep [in this way], but I have seen them laugh openly and have been much amazed" [Et hoc *odie nostri in tempore* multi impudice faciunt uel omnia que superius dicta sunt, sudare uero et flere non uidimus set plane ridere uidi et multum miratus sum"; f. 156v; emphasis added].

But who is "I," and which "today," which "our times" is this? What do these indexical fingers point to? Since most of the many marginalia in the codex (and all of those cited here) are in the handwriting of Moterrafe, the scribe who so punctiliously critiques his pen on the Sunday after Ascension, it is tempting to identify their "I" with him. Not so fast, says Manuel Díaz y Díaz, the scholar who has to date made the closest study of this codex's

marginal apparatus. Historical references in some of the annotations place the glossator not in San Millán in Rioja, but among the restive Christians of mid-ninth-century al Andalus. One gloss, for example, invokes the Córdoban firebrand Paulus Alvarus (d. 861 CE) as a recent contemporary—"Note the Catholic faith, oh reader—Long live your memory, Alvarus" [nota catholicam fidem, o lector—uiuat memoria tua, Albare] (f. 117v);[40] another (on f. 100v) invokes Alvarus together with a reference to a *Cordubensis concilium*, most likely the one that took place in 864 CE.[41] Although, judging by his name, Moterrafe may well have been an Andalusian emigré, he would have to have been preternaturally long-lived for these glosses to be of his own composition. Instead, it is more likely that he found them in the exemplar provided him for copying. So the "I" that marveled at shameless laughter pointed to another writer before it pointed to Moterrafe.

And what about that *tempora nostra*? Augustine says that we try to find the present moment, but without success. It is both everywhere and nowhere in the scribal interventions of RAH 29, evoked in the ninth-century Córdoban annotations whose words and, by extension, times, the monastic scribes of San Millán made their own and activated in the time-tracking notes that they added to the codex.

MANUSCRIPT ESCHATOLOGY

The Apocalypse now combines the present, the past, and the future.

[Miscet nunc Apocalypsis praesens, praeteritum, et futurum.]
 —Beatus of Liébana, *Tractatus de Apocalypsin* IX.2

We have followed the argument of *City of God* from gathering to gathering, the saints' days observed at San Millán in the years 977–78 CE running parallel to Augustine's universal history. The book that has walked us through the six ages of history now approaches the end. Augustine writes that those ages are like a week in the eyes of God, ending in Eternity, "the greatest of Sabbaths, a Sabbath that has no evening, the Sabbath that the Lord approved from the beginning of Creation" [maximum sabbatum ñon habens vesperam, quod commendavit dominus in primis operibus mundi].[42]

Eternity crowns the work of Creation as the colophon crowns a book. Thus the ecstatic conclusion of *City of God*: "Behold what will be, in the end, without end! For what is our end but to reach that kingdom which has no

end?" [Ecce quod erit in fine sine fine. Nam quis alius noster est finis nisi pervenire ad regnum, cuius nullus est finis?].[43] Augustine's virtuosic play on *finis* (repeated four times in the twenty-one words of this passage) evokes a collective joy in the end of the *opus arduum* of human history and directs it outside and beyond his book's temporal binding. Both ends—*echaton* and *telos*—are here accomplished: the *eschaton* in our imagination and the material *telos* beneath our fingertips.

Augustine is too eschatologically focused to allow *finis* to settle on its material, secular meaning. However, to a scribal sympathizer, his final sentences sound a great deal like a colophon.

> And now, as I think, I have discharged my debt, with the completion, by God's help, of this huge work. It will be too much for some; too little for others. Of both these groups I ask forgiveness. But of those for whom it is enough I make this request: that they do not thank me, but join with me in rendering thanks to God. Amen.

> [Videor mihi debitum ingentis huius operis adiuuante domino reddidisse. Quibus parum vel quibus nimium est, mihi ignoscant; quibus autem satis est, non mihi, sed Deo mecum gratias congratulantes agant. Amen.][44]

The scribes of RAH 29 were so engaged with the process of copying this massive work, and so experienced with reading, copying, and composing colophons, that they would surely have recognized in this rhapsodic conclusion the tropes of the colophon as a rhetorical genre. We'll never know what they made of Augustine's conclusion, though, for RAH 29 lost its last gathering somewhere along its travels. However, the colophon's eschatological overtones were not lost on other Iberian scribes. "What is our end but to reach that kingdom which has no end?" asks Augustine [Quis alius noster est finis nisi pervenire ad regnum].[45] What is the scribe's end but to finish the book? The scribe of a tenth-century patristic miscellany uses the same language to mark the conclusion of his work: *ad finem perveni*, he writes. I have reached the end. His name was Isidorus, and he is quite specific about the date on which this happened: Monday, November 1, 938 CE, at nine A.M.[46]

Dating a manuscript, as Michael Clanchy observed, was in itself an eschatological exercise for a scribe. To record the year of writing in a document, Clanchy says, "was to give it a place in the chronology of Christian

salvation in past, present, and future time, as expounded by St. Augustine in the *City of God*."[47] That is certainly what the scribes of RAH 29 are doing, over and over and over: they are writing into universal history, not so much their *selves*, but their scribal *activity*. The scribe who dates the manuscript writes his or her activity into world history, *sub specie apocalipsis*.

Particularly striking is the apocalyptic analogy made in the León Bible of 1162 (León, San Isidoro, MS 3), whose colophon, after grounding the book in the very particular and laborious conditions of its production, explicitly assimilates its manufacture with both the divine week of Creation and the cosmic week of human history.

> This work was begun in the time and during the noble reign of the most serene king Alfonso, son of the emperor. It was brought forth complete when abbot Menendus prudently governed the monastery of St. Isidore. A certain person from among the canons of St. Isidore brought the parchments of this most precious work back to this country from the regions of Gaul with much laborious road travel and a difficult sea voyage. That you might be so greatly amazed, this book was written in the space of six months and in the seventh composed with the beauty of colors in era MCC on the VII of the kalends of April [May 26, 1162].

> [Tempore serenissimi fredenandi Regis adefonsi imperatoris filii hoc opus ceptum, ipsoque nobiliter regnante; extitit consumatum Reverendissimo domino Menendo abbate prudenti monasterii sancti ysidori regimen gubernante. huius etiam preciosissimi operis pergamena: quidam e sancti ysidori canonicis ex gallicis partibus itineris labore nimio ac maris asperrimo navigio: hanc ad patriam reportavit. Adeoque maxime mireris: in sex mensium spacio scriptus, septimoque colorum pulcritudine iste fuit liber compositus. Sub era MCC VII Kal. Aprilis.][48]

It is certainly amazing that the production of so large a book should be completed in so little time. Perhaps by now, however, you might be less amazed that human labor should be made so perfectly to mirror the work that it contains: six months of bookwork, six days of creation, six ages of human history from Genesis to Apocalypse.

Beatus of Liébana does something similar when he laboriously calculates his place in time with reference to the most important dates in Christian world history: creation, Incarnation, and apocalypse.

Add up all the time from Adam to Christ: 5227 years. And from the birth of our Lord Jesus Christ to the present era 822, there are 784 years. Add, then, from the first man, Adam, until the present era 822, and you will have in total 5987. Fourteen years thus remain until the sixth millennium. The sixth age will end in era 838 [800 CE].

[Colligitur omne tempus ab Adam usque ad Christum anni V milia CCXXVII; et ab adventu Domini nostri Iesu Christi usque in praesentem eram, DCCCXXIV, sunt anni DCCLXXXVI. computa ergo a primo homine Adam usque in praesentem eram DCCCXXIV, et invenies annos sub uno V milia DCCCCLXXXVI. . . . supersunt ergo anni de sexto miliario XIIII. Finiebit quoque sexta aetas in era DCCCXXXVIII.][49]

Beatus writes his own moment of composition (and, later, revision) into both his book and human history.[50] How, then, will a scribe orient his or her lettered activity in relation to this temporal articulation?

When Maius copied this passage into the Escalada Beatus, he repeated the *now* of his exemplar and wrote that there were 784 years from the birth of Christ to the present. At the very same moment that Maius wrote that it was the year 784, of course, it was another year altogether. Beatus's *hic* is still here even as Maius bends over his worktable to date his work to "era three times three hundred and three times twice ten" and to remind his readers of the coming of the end (New York, Morgan Library, MS M644, f. 293r).

This happens across the surviving manuscripts of the commentary: Beatus's authoritative pre-Apocalyptic *now* continues being present even as the scribes add colophons dated to their own time of writing. There is neither contradiction nor inattentiveness in the scribal failure to update the commentary's calculations.[51] Every time a manuscript is copied, the scribal *now* overlaps the *now* of the previous copying, all the way back to the writing or dictating author. A manuscript has room for future writers and readers, even when it is articulated with a specific date. Rather than "correcting" the manuscript present to match the moment of manuscription, scribes simply add another present to the pile.

Manuscript time gives us presents: the present of the author in the act of composition, the present of the copy text, and the scribe's *now*, slipping away moment by moment under the strokes of the pen. Copied by another hand, a scribal *scripsi* is oddly imperfect in its perfection, both over and done and still underway. And when that manuscript is read, the scribal

interventions are still happening: they inter-vene. They arrive on the scene and come into the reading, a continuing intervention that is reactivated (*leg-iterated*, in Isidore's terms) in each and every reading encounter. There is something uncanny about such time-bound simultaneity: both now and then, here and there. You're relating not so much to the writer as to the codex that she or he made, and the codex is always present, no matter where the writer is.

WHEN NOW ISN'T NOW AND I IS SOMEONE ELSE

Your now is not my now; and again, your then is not my then; but my now may be your then, and vice versa. Whose head is competent to these things?

—Charles Lamb, letter to Barron Field, August 31, 1817

Return for a moment, if you will, to the Tábara Beatus with which we concluded Chapter 6 (Madrid, AHN, MS L.1097). Its elaborate colophon illustrates the scene of writing and explains how Emeterius inherited the book project on the death of his master Maius. There (say, on ff. 2r–68r) is the trace of Maius's hand; here is his codex-memorial, the binder for his body. And here, on f. 171r, is Emeterius telling us how he made it, and telling us exactly when *now* is: July 27, 970 (Plate 17).

A scribe who copied these words helps us imagine that July 27 even more precisely than Emeterius does. This scribe worked for (or at) the Cistercian convent of Las Huelgas near Burgos, two hundred and fifty years after Emeterius. What is now an illegible smudge after the year 970 on Emeterius's page is, in the copy, a time of the day, reckoned by the monastic liturgy: *ora viiiia*. Nones.

It is thus three in the afternoon on July 27, 970, on f. 182v of the Las Huelgas Beatus (New York, Morgan Library, MS M429) (Figure 33). The colophon that tells us this is copied carefully at the bottom of the inner column in red ink that contrasts brightly with the rusty black of the commentary text. Some seventeen lines of empty space separate it from the commentary, whose end at the top of the same column is marked by these words: *Explicit liber mense septembris era MCCLVIII.*

Seventeen blank lines and a change of ink from black to red separate September 1220 from Emeterius's colophon at the bottom of the column,

Figure 33. Emeterius's colophon recopied in 1220. New York, Morgan Library, M429, f. 182v. Photographic credit: The Morgan Library & Museum, New York. Used by permission.

where it's still July of the year 970. Names, dates, places, and time are here just as Emeterius wrote them on f. 171r of the Tábara Beatus, copied word for word and stroke for stroke. Emeterius still speaks in the Las Huelgas Beatus—still speaks in the first person (*ego uero Emeterius*), still tells us that he wrote this book, that he "with all his body maneuvered the pen" to make these letters. There he is, on the following page (f. 183r, Plate 19), still bent over his writing, two hundred and fifty years after following his master Maius out of time.

On the recto of the very next page comes another colophon, unique to the Las Huelgas manuscript (Figure 34). It too is quite long and detailed (my citation condenses it).

> Here ends this book in the month of September, era M.CC.L.VIII [1220 CE]. I the writer with my colleagues will always give thanks that we have reached the end of this noble volume. . . . I, the writer, ask all readers that you treat this volume gently and softly, lest the leaves and writing be damaged; and for us and for you living readers may this prayer be said. . . .

> [Explicit liber mense septembris era M.CC.L.VIII. Ego scriptor cum meis collegis gratias inmensis domino semper agamus quod ad finem hiuus nobilissimi uoluminis peruenimus. . . . Ego scriptor rogo uos omnes legentes ut suauiter et leniter hoc uolumen tractetis ne folia et scripta dampnenter. Et pro nobis et uobis uiuis legentibus dicatur Oratio. . . .][52]

Here speaks *ego scriptor*, I the writer; he or she speaks from 1220 to us, the living, with an eye toward the safety of souls—the writer's, the commissioning abbess's, and ours.

The writer also, it seems, spoke to a mid-twentieth-century curator at the Morgan Library, who responded in the blank column facing the colophon. The curator took up a pencil and began translating: "Here endeth this book, the month of September era 1258 (1220 A.D.). I, the scribe with my colleagues will always give immense thanks to God that we have reached the end of this most noble volume."[53]

"I the scribe" now speaks English. As on f. 182v of the Las Huelgas Beatus, where September 1220 and July 970 both lay claim to *now* across seventeen blank lines of parchment, this page has one foot in 1220 and the other in the mid-twentieth century. Even the text of the English translation there speaks from multiple times at once. When the curator picked up the pencil, the

Figure 34. Colophon, 1220, with penciled English translation. New York, Morgan Library, MS M429, f. 184r. detail. Photographic credit: The Morgan Library & Museum, New York. Used by permission.

final column of 184r was not entirely blank. Three phrases in what looks like the text hand hovered on the blank parchment: *novitatem* at line 8, nine lines further down, *domine audivi*, and a few lines below that and a little to the right, *domine audivi* again. The curator penciled the translation in around them. The result is calligraphically, linguistically, and temporally hybrid:

> I, the scribe, ask all (you) readers that you treat this volume gently, lest the leaves and **domine audivi** and writing be damaged; and for us and? (*sic*) you living readers, let it be said, "Oh who justifieth the wicked and desireth not the death of the sinner, we prayerfully beseech Thy Majesty that you protect thy servant N. and (all) (male) thy servants with thy confident **domine audivi** mercy . . ."[54]

At least from a postmedieval point of view, there's some wacky deixis going on here. The writing *ego* that tells us on f. 182v of the Las Huelgas codex that the codex was finished on "the sixth of the kalends of August era 1008, in the ninth hour" is revealed two folios later to be the *ego scriptor* who finished the (same?!) book in "the month of September era 1258." That very book is finished yet again some eight centuries later when *ego scriptor*'s words pass hesitantly through another hand, in an English in which someone else's Latin hovers like a ghost. The Las Huelgas Beatus thus articulates the first-person pronoun simultaneously with the activity of three writing hands, separated by almost a thousand years. And with one indefinitely timed reading body—yours, especially if, like a good medieval, you're reading aloud or copying this passage for your own later use.

Thus, the colophons so concerned with the *now* of writing are also proleptically concerned with an almost endlessly iterable future *now* that is repeatedly redated with every act of reading and, just as repeatedly, articulated with the small, fixed point at the intersection of scribal name and date. "Bound by letters lest they slip away into oblivion" (Isidore of Seville, *Etymologies* I.3), all these things reach out to you and to me and to *now*.

In these interventions, the scribes make their presence known. Yes, in the colophons, they are signing off on a completed project, indicating that their work on the codex is finally done. We could call this the "perfect" mode of scribal interventions—that is to say, the codex is *perfectus*, it's complete, finished, all done. Remember Maius: Writing this now [*scribens*] in awe of St. Michael, "I have painted this" [*ego . . . depinxi*], he says, "for you, who will dwell here" in the future [*hic degetis*]; read it and remember me. "I have painted this" [*depinxi*], he says, in anticipation of the End of Time, so that readers might consider its extinction.[55]

Remember Emeterius, *fatigatus sine salus. Ego scriptor,* here in Las Huelgas. No name to lessen the deixis of the pronoun, just *ego*. I ask you, the living, to turn the pages with care.

The apocalypse is always soon; manuscription is always *now*, and from a reader's position, now, both are oddly evasive, both here and not-here, always impending, right under our fingertips, but impossible to get a handle on.

THE WEAVERS OF ALBELDA

At the monastery of St. Martin at Albelda, in Rioja, sometime in the third quarter of the tenth century, a monk named Vigila contemplated a project that felt to him as "great and arduous" as Augustine's *City of God* must have seemed, around the same time, to scribes assigned to copy it at San Millán. Vigila's task was to make a book: not a single work like *City of God*, but a compendium of law and related topics. Although he was not composing the book from scratch, we can infer from evidence in the book itself that he was responsible for its design, and the design was complicated. He had to identify the works to be included and arrange them suitably. He needed to design the illuminations and plan where they would fall in relation to the text they accompanied and in relation to the parchment leaves on which they would be positioned. The work grew in his mind's eye as it shortly would under his hands, a weft of letters across a page, text wrapped to text, and text to images.

This gentle speculation has been guided by information provided by Vigila himself,[1] in an illuminated preface that introduces the book I have asked you to imagine Vigila thinking about. You will find it in the collection of the library at El Escorial with the shelf number d.I.2. Vigila would be happy to know that this book is often called the Codex Albeldensis after his home monastery. It might also please him to learn that some people also name it, in his memory, the Codex Vigilanus. I will do that here myself, not only to honor the hand that made it, but also because this title highlights the protagonists whose activity we will explore in this chapter: the book and its maker.

This double focus—on scribal agency and on the codex as artifact—has been characteristic of all the codices we have studied so far. Like Florentius's *Moralia* and Maius's Apocalypse, the Codex Vigilanus is carefully framed to guide the user's encounter with the book and its contents. Indeed, it is the most insistent about foregrounding the craft of its manufacture. Vigila and his coworkers have planned the reading of this codex as an encounter with their skilled manual labor.

Florentius understood his work as plowing—driving a line across a page and planting inky seeds to grow into meaning under a reader's cultivation. The bookmakers of Albelda work a different metaphor: they are weavers of text. Moderns taught to read by European post-structuralism (as I was) might know text(ile) as a winking set of parentheses and a seductively metaphorical etymology. "Text means Tissue," Roland Barthes reminded us in *The Pleasure of the Text*. He urged us to shift our understanding of the metaphor from the nominal veil over hidden meaning to something more verbal, more "generative": the text, he says, "is made, is worked out in a perpetual interweaving."[2] The weaving buried in text is no dead metaphor in the etymological epistemology of the Iberian early Middle Ages. It is labor both manual and intellectual. The weavers of Albelda have no doubts about its importance: they understand it through and with the work of kings.[3]

"INTERWOVEN AND INTERMIXED": THE ARTICULATE *CODEX VIGILANUS*

Because the Vigilanus is perhaps the most elaborately structured of all the codices we study here, a few words about its contents are in order before we move into its pages. The Codex Vigilanus is a richly illuminated legal encyclopedia that articulates jurisprudence sacred and secular with a sweeping view of political and religious history. Its own pages tell us that it was designed, written, and illuminated at the monastery of Albelda in the kingdom of Pamplona by members of the community named Vigila and Sarracinus, assisted by their student Garsea, and that it was completed on May 1, 976 CE. At its core are the two principal bodies of law in early medieval Christian Iberia: the canons of church councils[4] and the Visigothic legal code (known variously as the *Liber Iudicum*, *Liber Iudiciorum*, and *Forum Iudicum*). These two bodies of ecclesiastical and secular law are conjoined by carefully chosen texts that illuminate their quotidian use and ideological functions.

Multiple codices survive in Visigothic hand of both the Council Collection (in its various recensions) and the *Liber Iudicum*.[5] Only, however, in the Codex Vigilanus and the copy made of it seventeen years later at San Millán (the Codex Emilianensis: El Escorial, Biblioteca del Monasterio, d.I.1) are the two codes conjoined in a single volume. The ambitions of such a project are great. Here, as in *City of God*, realms secular and sacred "are interwoven and intermixed" [invicemque permixtae][6] and history written

sub specie aeternitatis.[7] Since Council Collection and Visigothic code are found together only in the Vigilanus and its copy, it is likely that their assembly into a legal pandect[8] happened in the Albelda scriptorium. Internal evidence suggests that Vigila was primarily responsible for this articulation.[9] The association is loud and clear in codex's remarkable frontispiece, which introduces the codex through the experience of the worker who made it.

Open the codex. The first leaf, now numbered f. XXII,[10] has been cropped and damaged, having done its job of taking wear and tear as the book was used. The recto is blank. Turn the leaf over gently.

On a first glance, you might take what you see on the verso (Plate 20) to be an evangelist portrait of the type that often introduces early medieval Bibles.[11] Here, framed by a horseshoe arch, is a writer, pen in hand, inkwells at the ready, a page on the worktable. There is, however, no symbolic animal to identify the writer, no halo to indicate sanctity, no angel or dove to represent a divine Author speaking to him. Just a person, a pen, a desk, and the page.

Above the image, lines of alternating red and black text gloss the represented scene. Before we even learn what book we will be reading, we are told who made it, how he felt about making it, and his hopes for the future.

> So, in the beginning of this book, when I, Vigila the scribe, received the commission to write, I greatly feared being a waster of parchment.[12] However, casting such appropriate concern aside, I began writing in the name of my Jesus Christ. In this state of mind I earnestly began to write, as the picture below shows. Laboring, I arrived at the end. Therefore thanks be to God who deigned to help me. At last, the course of this life being run, may He deign to give the eternal prize with the saints in the kingdom of heaven. Amen.

> [In exordio igitur huius libri oriebatur scribendi uotum mici Vigilani scribtori, sed fusorem pargamentum nimis uerebar. Tamen quid mici olim conueniret agere nisi duuietate postposita ut in nomine mei Ihesu Xristi incoasse scribendum. Inito autem affectu certatim cepi edere ceu iconia subinpressa modo ostendit et ad ultimum nitens perueni. Idcirco grates ipsi domino qui mici dignatus est auxiliari. Demumque post peracto huius uite cursu dignetur largiri premia eterna cum celicolis in regno polorum. Amen.][13]

The strange time of this manuscript page begins "in the beginning of this book," when Vigila received his commission.[14] By the second sentence, we are in the middle of the writing, in an act of making that takes place before our very eyes, in the brilliantly colored image below the text we are reading. Soon, the codex is complete, the work done: "Laboring, I arrived at the end" [ad ultimum nitens perueni]. Writing this, the scribe is now past that end, looking back on the process of making. The final sentence turns toward what for him is future: "the course of this life being run" [peracto huius uite cursu], the scribe will exist only in the memory of readers. As he does now, right now, when you think about him.

This book, he reminds us, was made by an individual human being who was prey, as all humans are, to doubt and fear. Writing requires effort both physical (the verb *nitor*, to strive) and affective (away with doubt and fear!) and involves real expenditures of real material (don't waste that parchment!).[15]

The writer has laid out the text in which he names himself so that the keyword *scribtori* is perfectly centered in the middle of the third line; verbs for writing are repeated four times in the first three sentences. He is thus thinking at least as much—if not more—about Vigila the writer as he is about Vigila the individual. What he thinks about the noun "writing" is deeply shaped by the verb—that is, the corporeal activity of putting hand to pen and pen to parchment. He is teaching us to regard the book with a scribal eye.

It is a bold stroke for a scribe to begin a book by representing the scribe beginning the book.[16] The promised "image below" [iconia subinpressa] shows us the scribe's view of the page. Here is what it looks like: three columns of interlace, held flat by a braided band. In a glorious visual pun, about which we shall have much to say in this chapter, Vigila represents text as textile and himself as the agent responsible for directing its interlaced activity. Text means tissue, and the scribe is a weaver.

THE LETTERED LOOM

If Vigila's frontispiece represents text as interlace, in the eight full-page poems that compose the volume's frame—six at the beginning (ff. 1v–3v) and two at the end (ff. 428v–29r)—we see for ourselves why text is textile (Plates 21 and 22).[17] Marginal knots and braid like the represented text of

the frontispiece enclose the introductory and concluding poems, compositions that in the reading show you how to weave. Your eyes and fingers habitually move left to right, but visual clues lead them down as well: letters in red drop vertically to make more words woven with common letters around the horizontal. These pattern-poems are Vigila's practice distilled; they are what text is in its making: vertical warp, horizontal weft.

The late ancient and early medieval poets who cultivated this abstruse art form understood what they made through the work of the weaver.[18] The fourth-century poetic experimenter Optatian thought of these additional lines of his poems as verses woven in: *versus intexti*, he called them.[19] Two centuries later, Venantius Fortunatus (d. c. 600) developed the image further in an explanation of one of his compound acrostics: "Any letter which is tinted in a descending verse is both contained in the one and runs crosswise with the other: it both stands upright, so to speak, as the warp, and runs crosswise as the weft—so far as may be on the page, *a literary looming*" [Littera vero quae tinguitur in descendenti versiculo, et tenetur in uno et currit in altero et, ut ita dicatur, et stat pro stamine et pro trama currit in tramite, ut esse potest in pagina: licia litterata].[20]

In the framing poems of the Codex Vigilanus, lines of letters have been woven to produce meaning in as many as five directions. They all read left to right as one would expect. Vertical lines of text descend from letters at the beginnings, ends, and middles of verses or run diagonally from corner to corner. In their most demanding form, these compositions are laid out on a gridded field whose colored squares form both images and additional lines of verse (see Plates 21 and 22).

These pages are sisters to the lettered labyrinths over which we have already labored together in this book.[21] Florentius's memorial maze is, of course, a spectacular example (Madrid, BNE, MS 80, f. 3r), but such texts have called out to us from gravestones and colophons and from the ex libris of Maius's Apocalypse. Each of these labyrinths is a meticulous exercise in calligraphic design; each is also, as we saw in Chapter 2, an exercise of contemplative suspension for both the monastic scribes who designed and made it and the viewers they imagined engaging with it.

The eight acrostics that frame the Codex Vigilanus—composed, laid out, and lettered by Vigila and his associate Sarracinus—work this contemplative engagement with inscription into verbal and visual artifacts of mind-bending, hand-cramping complexity. Since these poems were composed by

the people who lettered them and lettered by the people who composed them, poem and page together speak with some authority about bookwork. The weaving required in their construction calls attention to the compositional labor of the poet, and their beautiful layout calls attention to the labor of the scribe.[22]

Each of the six acrostics that together form the introductory frame of the codex occupies a full page bordered by knotwork and interlace. Their ground poems praise God, Christ, and the Virgin, while their *versus intexti* spell out prayers for individual human beings whose names will become familiar to us: Ranimirus, Sancio, Garsea, Urraca, Vigila, Sarracinus. The first four are royalty.[23] The last two are scribes. The scribes talk about their labor and weave it by association with the law-giving work of kings, line after line, page after page.

The first poem, "Diuina uirtus, Christe," the work of Vigila, is written in alternating lines of red and blue capitals. Scansion marks over each letter announce right away that this is a poem; the marginal note in Vigila's hand provides a little lecture on the meter and its origin.[24] The disposition on the page is not perfect: Vigila does not lay the poem out on a grid, so the final letters of each line are a little lonely at the right edge of the text box, separated from the previous letter by empty spaces of varying width. Red ink and deep yellow shading call attention to the first and last letters of each line, silently instructing us to read those letters together, vertically. Proceeding down the column from the initial D in the poem's first word (*Divina*), the acrostic spells out an invocation: "Only [son] of God the Father" [DEI PATRIS UNICE]. The column of final letters—the telestic, as Vigila would have known it—responds by reminding us where we are: "Oh Christ, the beginning" [O CRISTE INITIUM].

So we begin once more. The entire poem reads:

Divine strength, Christ, light of light, behold your servant.
Show me favor; be righteous and gentle to me now.
Now, righteous father, as I begin this work,
I entreat you so to extend your merciful comfort,
high-thundering God, that I, little Vigila, might be able
to complete this book, arranging it in parts
so that many might receive the fragrance
of the noble book of the canons of the Fathers,

illumined and divine with the signs of prophets and evangelists,
brilliant with the acts of the apostles,
and flowering where the ever-living words of Old and New Testament
imprint holy dogma in the body of the single nourishing book.
In the light of this Alpha and assisted by your hand
may I arrive through my efforts at home port.[25]

[DIUINA UIRTUS, CHRISTE, LUX LUMINIS, FABE TUO

EN FAMULO, PIUS ATQUE MITIS MICI ESTO NUNC:

INCIPIENS OPUS NUNC PRECOR TE, O PIE PATER,

PORRIGAS SOLAMEN SIC CLEMENS, UT MISERO MICI

ALTITONANS EXIGUOQUE VIGILANI, DEUS

TOGILLATIM EDIGERENS EDERE UALEAM UT TOT

REDOLENTES LIBRI CANONUM PATRUM PRECLARIQUE,

INFOLA UATUMUE EUANGELISTARUM DIUINI

SIC RADIANS ACTA APOSTOLORUM ALIOQUIN

VERNANTIA FLORENS SUABISSIMA UERBA UBI

NOBI AC UETERIS ET SACRATUM DOGMAQUE ILLUT

IMPRIMENS ALMI UNIUSUE IN CORPORE LIBRI

CORUSCANS HEC ALFA ATQUE TUA IUBATUS MANV

ENIXE ACTUM MEREAR PERUENIRE AD PORTUM][26]

Like the frontispiece, this poem puts Vigila and the beginning of his labor under the gaze of God.[27] Here too we find the stress upon the present moment (in the repeated adverb *nunc* of lines 2 and 3). Here, too, the scribe looks forward from this *now* into the future, toward the moment of completion that he might commemorate in a colophon.

Here, though, the speaker is not just copying and illuminating this book: he speaks as the *designer* of the compilation whose task it is to skillfully arrange its parts (*togillatim edigerens edere*). The frontispiece showed us the scene of inscription; the first acrostic poem describes assembly of the codex itself.[28] When the "words of Old and New Testament / imprint holy dogma in the body of the single nourishing book" [SUABISSIMA UERBA . . . / NOBI AC UETERIS ET SACRATUM DOGMAQUE ILLUT / IMPRIMENS ALMI UNIUSUE IN CORPORE LIBRI], it is as if the holy words themselves held the pen to inscribe the body of the book. In this divine letterpress *avant la lettre*, the work of the scribe is understood by way of analogy with the highest form of writing its audience could imagine.

The second poem ("Gloriosa Cristi caro," f. 1v, Plate 21), most likely the work of Sarracinus, combines compound acrostic with a figured poem. The text is woven on a grid of thirty-five squares in each direction. Deep yellow boxes containing red capital letters outline a schematic Cross of Oviedo in a rectangular border. The ground poem's first line speaks to the figure: "Glorious, innocent flesh of Christ, fixed on the cross" [GLORIOSA CRISTI CARO INSONS CRUCI ADFIXA].[29] While the ground poem recapitulates the life story of that flesh, the *versus intexti* weave scribes, readers, and royalty into the devout practice of that memorial retelling. The cross's vertical shaft is outlined by two files of descending letters that spell out, on the left, "Venerable cross bearing the body of the Savior" [CRUX UENERANDA FERENS SALBATORIS MEMBRA] and on the right, "O holy cross, protect Vigilanus Gracila" [VIGILANEM GRACILAM O CRUX PROTEGE SANCTA].[30] These two *versus intexti* are semantically as well as visually parallel: the left side tells us that the cross bears the Savior, the right entreats the cross to protect the scribe. The verses that make up the crossbar offer prayers for the reigning kings of Pamplona and Viguera, the brothers Sancho and Ramiro.[31]

From these king-bearing lines dangle the alpha and omega characteristic of the Cross of Oviedo (itself given spectacular full-page treatment on f. 18v), composed, like the rest of the figure, of red capitals on a yellow ground. Here the apocalyptic Greek letters have been doubled to two schematic omegas hovering above the crossbar and two alphas hanging below it. Above the crossbar, the figured omegas call on us: O LECTORES, says the left-hand omega; the omega on the right completes the thought: MEMORIOSI. *O mindful readers.* Below, the letters forming the dangling alphas continue: SARRACINI (left); MEMENTOTE (right). *Remember Sarracinus.* These lettered Letters and the labor of deciphering them articulate us with the book we're reading. Just as the cross carries the body of Jesus, so the text that evokes and represents it carries the names of scribes and kings—and an appeal to mindful readers, whose labor is required for the poem to do its prayerful work.

The next three poems, all gridded compound acrostics, are written in Sarracinus's first person. In poem 3 ("Salbatoris mater," f. 2r), the *versus intexti* form the trunk and upward-reaching branches of a tree; they spell out prayers for the reigning monarchs.[32] The ground poem appeals to "Mary, mother of the Savior" and weaves names together in prayer: "May I, Sarracinus, shine with your support/together with mother Urraca and your Ranimirus" [LUCEAM EGO EN ADIUTORIO TUO, SARRACINUS, / UNA CUM VRRACA MATRE

EN ET RANIMIRO TUO].[33] Following lines similarly weave the poet-scribes Sarracinus and Vigila together with the kings Ramiro and Sancho.

> May the honor of life be unto your servant Vigila.
> O Redeemer, give the palm of victory to Sanctio;
> oh Victor, help Ranimirus, and help me Sarracinus.
>
> [SERUULO SIT ET HONOR TUO UITAE VIGILANI.
> REDEMTOR SANCIONI DA UICTORIAE PALMAM,
> AC RANIMIRO UICTOR IUBA, ET ME, SARRACINO.][34]

The fabric of poems 4 ("Ortus virginis," f. 2v) and 5 ("O alfa et ω," f. 3r), both composed by Sarracinus, is likewise shot through with the names of makers and monarchs in both ground poems and *versus intexti*. In poem 5, the scribe writes his own first person into his work with an emphatic seventeen uses of the personal pronoun, four in the first six lines alone.[35]

Similar insistence upon the scribal first person drives the last of the introductory poems (poem 6, "Altissime, seruo tuo salua," f. 3v, Plate 22), the work of Vigila. Though most of the ground poem devoutly recounts the life of Christ from conception to resurrection, the last word of its first line reveals the poem's mortal protagonist: "Oh most high, Redeemer, save your servant Vigila" [ALTISSIME, SERUO TUO SALUA, REDEMPTOR, VIGILA].[36] This verse is repeated verbatim five times on the page—thrice in the ground poem at introduction, midpoint, and conclusion (lines 1, 19, and 37), and twice vertically, descending from the first and middle letter of every horizontal line. Prayers for Sarracinus appear both vertically and diagonally: "Most high Christ, save your servant Sarracinus" [ALTISSIME, SERUO TUO SARRACINO, christe, SALUA] (telestic), "Look kindly on Sarracinus, nourishing God, and give him your grace. / Author of life, grant your servant indulgence" [ANNUE SARRACINO ET TUA, ALME DEUS, DONA GRATIA / AUCTOR UITAE, SERUO PRAESTA TUO INDULGENTIA] (diagonal *versus intexti*). Whatever the "content" of its ground poem, poem 6 is woven from the names of its makers. Engaging with it on the page is to participate in the performance of that naming in capitals of gold (VIGILA) and silver (SARRACINUS).

These poems are cast as prayers, and as such, they carry the names of the scribes and royalty alike on a lettered ladder up to heaven. And, of course, to the eyes of the *lectores memoriosi* addressed in the apocalyptic letters alpha and omega in poem 2, and invoked in the final lines of Sarracinus's

poem 3: "Reader, as you read, I beg that you remember Vigila and me amply and often in your pious prayers" [LEGENS, LECTOR, ROGO, HIC AFFATIM MEMENTO / VIGILANI ET MEI PIA IN TUA ORATIONE SEPE].[37]

THE WEAVER'S WORK

These poems—artifacts of studied craftsmanship—set the rulers of kingdoms and the makers of books on an equal footing before audiences both earthly and celestial. We are likely to remember Vigila and Sarracinus not just because they tell us that they merit remembrance, and not only because they have impressed us, but also because we have had to work so hard to figure out what they're saying. To engage thoughtfully with such a poem, observes William Levitan, is to become inescapably aware of "how much time, how much intellectual labor, how many discarded versions, how much paper, how much ink has been so conspicuously consumed for this gigantic enterprise."[38]

Reading, you follow threads through a labyrinth; now imagine *composing*. You'd be building the maze itself and laying down thread in five different directions at once. Now think about doing it in a foreign language, or—as likely was the case for Vigila and Sarracinus—an archaic version of your own vernacular.[39]

Fiendish difficulty, of course, is what pattern poetry is about, no matter the ostensible topic of any individual composition. Lest his audience mistake one of his texts for a mere poem, Venantius Fortunatus prefaced it with an explanatory letter explaining the process of its construction.[40] We encountered this letter briefly earlier in this chapter: it gave us the term "literary looming" [licia litterata] for the poet's work. Loomed on the grid of letter boxes with a weft of ground-poem and warp of *versus intexti*, the poem is, he says, "made foursquare in one weaving" [Habes igitur opus sic uno textu quadratum].[41]

Fortunatus takes Optatian's etymological analogy between text and textile and runs with it. But neither one of these poets is just punning: the "literary looming" of these *versus intexti* is equally and inescapably material. For this is not the kind of poetry you can compose in your head or easily read aloud: it is an inky thing, dependent on parchment for its very existence.

No wonder, then, that writers like Fortunatus, Vigila, and Sarracinus don't just want readers to notice the weaving; they want us to contemplate

the materiality of the writer-weaver's *work*. "As impressive as the poems are as finished products," writes Levitan, "they are irresistibly more impressive as *activities*."[42] A poem, for Vigila and Sarracinus, is not just an artifact of writing, not a *noun*; it's a process and a kind of labor, the enactment of a *verb* that involves, even *shapes* their bodies and minds. They thus design their pages and the text upon them so that readers see their letters not just as traces of manual work but as its record and memorial. If Vigila and Sarracinus were, in addition to formidably skilled book-artists, contemplatives like the ones with whom we studied in Chapter 2, they would have understood that labor as meritorious in itself, and all the more so if readers or viewers were so impressed with its results that they remember the hand that made it.

The more fully we inhabit these poems, the more likely we are to feel the labor of composition even in our own flesh. Florentius crafted his lesson on the somatics of *scriptura* to fill our reading bodies, as writing filled his, with "every kind of annoyance" [omne corpus fastidium nutrit] (Madrid, BNE, MS 80, f. 500v), at least in empathy and imagination. Fortunatus writes similarly:

> I was repelled by the difficulty of this task, or—what was more difficult— hemmed in, both by the requirements of meter and the limitation on letters. What was I to do? How was I to advance? . . . Nor did the weaving permit me to roam, since the descending verses served as a bridle and a restraint. In fact, in this web it was not possible to untie or loosen the strands by a single superfluous letter, lest a wandering thread exceed the measure and become tangled. . . . Accordingly, when I had gathered up all the strands of this web in measure and begun to weave them, the threads burst both themselves and me.

> [Hac protenus operis difficultate repulsus aut magis difficulter inclusus tam metri necessitate quam litterarum epitome quid facerem, quo prodirem? . . . in quo quippe exordio supercrescente apice non licuit vel solvere vel fila laxare, ne numerum transiliens erratica se tela turbaret. . . . Igitur huius telae cum licia numero collegissem, ut texere coeperam, et se et me fila rumpebant.][43]

Fortunatus does not just want his readers to notice the "literary looming"; he wants us to engage with writing as *activity* as well as artifact. He

wants us to follow the threads woven through his text, wants us to feel the labor of interlace in our own bodies and to see it happen in our imaginations as well as on the page. So do Vigila and Sarracinus, and so do Florentius, Maius, and Emeterius. So, too, does that scribe from San Millán who wrote with a bad pen on the Sunday after Ascension (Madrid, RAH, MS 29, f. 106r).

What we see when we contemplate a pattern-poem is thus mind-work inseparable from the work of the body. "It is a marvelous task for the mind," wrote Optatian, "to weave a poem in verse along various paths" [mentis opus mirum metris intexere carmen / ad varios cursus].[44] Elsewhere he turned toward agriculture to describe this same mental *mirum opus*: "It is an amazing work to produce all the verses and of such a kind, and to arrange them thus [like a trellis] for vines" [Mirum opus est cunctos et tales edere versus sicque locare hederis].[45]

A monastic writer and reader of Jerome—like, for example, our friend Florentius—having absorbed and made the old scholar's words his or her own, might add that it is also amazing work to "weave lines for catching fish, and [to] copy books" [texantur et lina capiendis piscibus, scribantur libri].[46] In the grammar classroom, a literate monastic might have learned with Terentianus to see a sentence growing under the hand "by concentrating the efforts from all parts of the body / in the tips of his fingers" [nisus undique corporis / Summos in digitos agit].[47]

We can see this intimate articulation of mental and manual labor in a final acrostic by Vigila, preserved not in the Codex Vigilanus but in a contemporary miscellany from San Millán. This codex (Madrid, AHN, MS 1007B) contains various works useful in a monastery—the *Contra Jovinianum* of Jerome and the *Via Regia* of Smaragdus, among others. Perhaps in a nod to the literary ambitions of the monks of San Millán (a rising monastery that would soon make its own copy of the Codex Vigilanus), it concludes with two compound acrostic poems by Iberian masters of the form.[48]

The poets name themselves in the acrostics. One is Aeximino, probably the same scribe whose acrostic colophon for Isidore's *Etymologies* we encountered in Chapter 2 (Madrid, RAH, MS 25, f. 295v).[49] The other poet in this pocket anthology is our Vigila. His poem dates itself, in a bonus arithmetical puzzle, to era 1018 (980 CE), four years after the Codex Vigilanus was completed.[50]

On the somewhat ragged pages of AHN 1007B, Vigila's text is copied as prose sprinkled with red capitals.[51] As it weaves across the manuscript folios 74v and 75r and rolls down the pages of the printed edition, the red-lettered acrostic spells out this self-referential designation: "Parchments sent to Montanus by Vigila" [MEMBRANA MISSA A VIGILANE MONTANO].[52] Since this is not Vigila's handwriting, these letters may point to parchment, but not toward these pages. The ground poem in which they appear, like the first poem of the Codex Vigilanus, seems to have been written to present a completed codex. It reads like a little monastic rule,[53] with instructions on proper diet, clothing, prayer, and Psalm recitation. Its punning praise of manual labor reveals a certain identification of the writer with his work:

> Vigilantly the monk should seek to complete
> the burden undertaken: alone on his little plot of land,
> he should use all that is his. He should do his work,
> whatever it is, with his own hand.

> [Vigilanter pondus ceptum perficere sequatur,
> solus manens in agello cunctis suis utatur,
> oposculum quantumquumque manu sua agatur.][54]

Like "insignificant Maius" [Maius quippe pusillus] (New York, Morgan Library, MS M644, f. 293r), Vigilant Vigila is not above wordplay. Florid Florentius, too, knew well the weight borne by the laborers of the scriptorium. He called it the "burden of writing" [scripture pondus]. In his Homiliary, Florentius designed the detailed description of this undertaking as if the opening on which it is inscribed were indeed what Vigila here calls "a little plot of land," with neat rows of letters growing beneath and around a little grove of flowering trees (Córdoba, AC, MS 1, ff. 3v–4r, Plate 5). Perhaps the same agricultural metaphor is on Vigila's mind as he arranges verses like Optatian's "trellis for vines," praises manual labor, and recommends a vigilance like his own to his laboring reader.

In the codex we now name after him, it was Vigila who performed due vigilance, mapping out his plot of book-land, doing his work with his own hand (and some help from Sarracinus), painting and writing about shouldering a great burden. Vigila's burden included the task of designing and laying out the codex as a whole. This would have been work as demanding

as the composition of multiple compound acrostics and, like composing acrostics, a taxing labor of word-joinery.

Accustomed as we now are to typesetting executed in a digital cloud, modern readers need to make an effort of the imagination to fully understand the mental labor required when word processing was *corporeally* digital. For a luxury illuminated codex like the Madrid *Moralia*, Maius's Apocalypse, or the Codex Vigilanus, the copying process had to be carefully planned so that chapter headings appeared in the right places and images were appropriately positioned on the page with the text. This means that the number of words on a page, and even the number of words in a line, had to be calculated in advance, making allowance for the different sizes of lettering necessary for text, headings, and initials. Making sure that the text and illuminations flowed coherently in the assembled gatherings required a degree of spatial imagination that is far beyond my skills as I move letters around on this glowing screen. No wonder, then, that the scribe, poet, and designer of the Codex Vigilanus should fear being a waster of parchment.

Now we can look again and perhaps with more empathic understanding at the volume's frontispiece (f. XXIIv, Plate 20). Vigila is at work, the page laid out before him. His text is represented by three vertical bands of knotwork, held open by a horizontal bar of braid. Here the weaving—the *textura*—of the acrostic poems is generalized to represent the codex itself.[55] Text is tissue for Vigila, and in a move of remarkable imagination, he has made an abstract icon for writing unimaginable apart from scribal activity and scribal experience.[56] Interlace, that is, isn't just a quality of the acrostic poems: it's a defining quality of the book itself, distilled here into an icon every bit as theoretically powerful as Maius's codex-coffers in the Morgan apocalypse. *Mentis opus mirum*, Vigila might say, *atramento membranaque intexere codicem*: it is indeed a marvelous task for mind and hand, to weave a codex from ink on a page.

THE MAKERS OF BOOKS

The introductory acrostics of the Codex Vigilanus honor the scribes by weaving their names together with the names of kings. The concluding sequence of the codex, too, is constructed to make clear how very worthy of respect is this marvelous task of bookmaking. On f. 428r, a full-page illumination breaks the relative visual silence of the last hundred folios (Plate 23).

Within a broad foliate frame stand three rows of three human figures of identical size, laid out like a deck of colorful cards in play. Identified by *tituli* above their heads, the figures gesture emphatically with one hand and present the attributes of their stations in the other. The figures on the top row wear elaborate crowns and hold a codex or a scroll in one hand. They are CINDASVINCTUS REX, RECESVINCTUS REX, and EGICA REX. In the middle stand URRACA REGINA, SANCIO REX, and RANIMIRUS REX, each holding a staff or scepter and crowned with distinctive golden headgear. Finally, in the bottom row, stand three tonsured figures, each holding a scroll or codex. The two on the outside are turned slightly toward the center, gesturing animatedly with outsize hands. They direct their attention—and ours—toward the figure looking straight out from the center of the bottom row. Of all the people on the page, this one makes no gesture. Instead, he uses his hands to hold a scroll close to his chest. This is VIGILA SCRIBA. To his right, SARRACINUS SOCIUS [Sarracinus the associate]; to his left, GARSEA DISCIPULUS [Garsea the disciple].

Elizabeth Sears reminds us that an illuminator creating any form of group portrait "was faced with the delicate task of conveying the relative stature and status of all the various individuals implicated in its production: these included author, editor, secretary, continuator, translator, commentator, scribe and original and subsequent patrons and dedicatees."[57] Now, monastic scribes and their assistants cannot possibly be the equals of Iberian royalty, but here they are, lower on the page perhaps but still exactly the same size.

The glosses in Visigothic hand in the right margin will help us understand what this page is doing. Next to the first row of kings (Cindasvinctus, Recesvinctus, and Egica), the gloss explains: "These are the kings who wanted the *Liber Iudicum* to be made" [Hii sunt reges qui abtauerunt librum ivdicum].[58] In the middle, Urraca, Sancio, and Ranimirus, the reigning monarchs of Pamplona and Viguera, for whom so many acrostic prayers were woven into the framing poems. The gloss tells us why they are here: "In the time of these kings and this queen the work of this book was completed during the era TXIIII" (era 1014 = 976 CE) [In tempore horum regum atque regine perfectum est opus libri huius discurrente era TXIIIIA]. And the figures in the bottom row? You know who they are, but the gloss explains: "Vigila the scribe with his colleague Sarracinus the presbyter with Garsea his disciple made this book. Remember their memory always, with blessing"

[Vigila scriba cum sodale Sarracino presbitero pariterque com Garsea discipulo suo editit hunc librum. Mementote memoria eorum semper in benedictione].[59]

The reigning monarchs in the middle row bear scepters to indicate their authority. Their Visigothic forebears Cindasvinctus, Recesvinctus, and Egica carry scrolls and codices because they commissioned the *Liber Iudicum*. So do the pen-pushers Sarracinus, Garsea, and Vigila, who wrote that law code into this codex. They made the book that contains the laws made by those kings. The book and the pen that letters it are here thus equally authorized.

Gregory the Great confidently declared at the beginning of the *Moralia* that when one knows who the true Author of a book is, "it would be foolish indeed to inquire" who might have physically written it [quis haec scripserit, ualde superuacue quaeritur, cum tamen auctor libri spiritus sanctus fideliter credatur].[60] We saw in Chapter 1 that Florentius, even as he copied these words, made sure that the voice and body of the scribe were as present to us as the voice and body of the sainted *auctor*. This page presents with equal honor the scribes of Albelda and regal lawgivers: look, here are images of their bodies, just as worthy of our attention as the pictures of those monarchs.

In fact, the royals are here because of the book, not the other way round, for, as the gloss explains, the living monarchs in the middle row are represented because their regnal dates help situate this book in time and place.[61] The monks in the third row are the ones who made this codex, the Visigothic kings at the top are the ones who made the Code contained therein, and the monarchs in the middle are there to tell us when the making happened.[62]

The three rows of figures are all linked together by analogy, and the energy of that analogy focuses on the principal agents of the Codex Vigilanus: weavers and text, the scribes and the book. The codex began with an unusual joint portrait of these two protagonists that gave the scribe the dignity—and authority—of an evangelist. The equally remarkable portrait gallery that is its final image makes the team of book workers analogical monarchs of its pages. This final image of the Codex Vigilanus articulates Code with codex, *auctores* with amanuenses, and bookwork with the lawgiving labor of monarchs.

Vigila is silent in the final image, though he stares out from the page directly at the user of the book he made. In the two concluding poems of the

codex, he speaks again, and brings the codex back to where it started. In the frontispiece, he told us that "laboring, I arrived at the end" (f. XXIIv). We've arrived at the end now, too, and Vigila is still not finished.

On the verso of the portrait gallery page (f. 428v), the first of the two concluding poems shuttles out within a wide leafy border. The letters are carefully spaced but not laid out in a grid; the scansion is notated above the lines as Vigila likes to do. The poem begins thus: "The virtue of Christ often comforting me, humble Vigila, / having begun the work of this book of holy canons, I have—behold!—diligently brought it to its conclusion" [VIRTUS NEMPE CRISTI MICI SOLACIUM VIGILANI PREBENS HUMILLIMO SEPE / INCEPTA CANONIS SACRI HUIUS LIBRI AD CALCEM OPERA PERDUXI].[63] This is a verse colophon, and it is as particular and precise in its way as the one Florentius wrote into both his *Moralia* and Homiliary.

Bold capitals at the beginning and end of each line indicate that, in addition to reading the lines of the ground poem, we should also look for the verses woven vertically into the text. Reading down from the initial v in the first word (VIRTUS), we learn that "Vigila and Sarracinus made it" [VIGILA SARRACINUSQUE EDIDERUNT]; descending from the final E of the first verse, the thought is completed: "era one thousand and fourteen" [ERA MILLESIMA SIUE QUARTA DECIMA]. The ground poem embroiders further, situating this point in time on the knotted threads of five different chronologies.

In the course of era ten times one hundred
and once ten plus four, on the kalends of May,
in the twenty-fifth run of the lunar cycle.
in the reign of the orthodox king Sancio brother of Ranimirus,
together with the noble queen Urraca,
in the sixth year after the death of King Garsea
this book was written.

[DECIES CENTENA AC UNUM DECIES QUARTA ERA LABENS PER NOTA
 QUE ABID
ET NOTATUM TEMPUS KALENDARUM MAII QUINTUS UICESIMUS SEU
 CURSUS LUNE
RANIMIRI FRATRE REGNANTE SANCIO REGE ORTODOXO SCRIBTUS EST
 LIBER HIC
VNA CUM REGINA URRACA PRECLARA SEXTO ANNO OBITUS REGIS
 GARSEANI.][64]

Together, in their different ways, the *era hispana*, the Roman calendar, the lunar cycle, and the lives of the monarchs whose images we just saw all tell us that it is May 1, 976 CE.

The rest of the poem is devoted to what makes this date worth remembering. Unlike Florentius, Vigila is concerned not so much with the somatics of *scriptura* as he is with the intellectual work of designing the codex and articulating its contexts. The first four lines show Vigila, like Taio the bishop, whose story is told in the editorial frame of Florentius's *Moralia*, at work assembling a book from scattered parts into a single corpus.

> The virtue of Christ often comforting me, humble Vigila,
> having begun the work of this book of holy canons, I have—behold!
> diligently brought it to its conclusion, assembling
> the vigorous, florid, famous Councils of the blessed Eastern fathers,
> then binding in the great and blessed Councils of kings and Western
> bishops.

> [VIRTUS NEMPE CRISTI MICI SOLACIUM VIGILANI PREBENS HUMILLIMO
> SEPE
> INCEPTA CANONIS SACRI HUIUS LIBRI AD CALCEM OPERA PERDUXI
> NABITER,
> GLOBANS EN UIUIDA ALMORUM FLORIDA PATRUM ORIENTUM CLARA
> CONCILIA,
> INGENTIA DEHINC NECTENS ALMIFICA REGUM AC PRESULUM
> OCCIDENTALIUM.][65]

Vigila wove the body of this colophon on the page from the warp and weft of ground poem and *versus intexti*. And now behold! See how the contents of this book, too, have been assembled into this parchment body, this corpus of law. That has been his work—his and Sarracinus's: "May we, Sarracinus and I myself Vigila (assisted by the prayers of our master Salvus) / enjoy the pure, green, and flowering goods of the living / whose now famous names this book holds / and which we, twin scribes, have arranged" [VERNANTIA PURA ATQUE FLORIGERA UIBORUM FRUENTES CUMULATO FRUCTU / SARRACINUS SALBI IPSEQUE VIGILA MAGISTRI OBTIMI ADIUBATI PRECE / QUORUM DIGESSIMUS CLARA NUNC NOMINA SCRIBTORES GEMINIQUE TENET LIBER HIC].[66]

The poem prays that the *scribtores geminique* together might enjoy the same rewards as the authorities whose names and words they have so carefully written into this book. And the reward Vigila imagines is appropriately bookish: he prays to see their "names inscribed in the book of life" [NOSTRORUM NOMINA LIBRO UITE SCRIBTA].[67] We ourselves, you and I, are inscribed in a book too—this very codex: "Now on our knees we beg all of you who are reading that you commend us in our humility to the most holy Trinity" [NUNC OMNES CERNUI LEGENTES PRECAMUR NOS UT EXIGUOS APUD SANCTISSIMAM / TRINITATEM SIMPLAM CONMENDETIS] (lines 27–28).

The final poem is laid out in two columns, with acrostic and telestic framing each column vertically (f. 429r). As the frontispiece and first poem both brought us in imagination to the end of the project, this poem returns to its beginning. You'll remember that the *versus intexti* of the first poem (f. 1r; also by Vigila) read, "Only [son] of God the Father / O Christ, the beginning." The double acrostic of the final poem joins alpha to omega: "Oh begotten King, beginning and end" [O REX GENITE, INITIUM FINISQUE] (left column); "Christ, light of the unbegotten father!" [CRISTE, INGENITI PATRIS LUMEN] (right column).[68]

At the end of this codex as in the beginning, we are held in a lettered loom of scribal making, our labor of interpretation articulated with the writer's work of inscription and with the contingent particularities of the maker's time and place. The ground poem and the telestics of both columns invoke divine protection on the community of monks at Albelda.[69] And as for time, the poem concludes by repeating the year it was completed, figuring the date this time from the Incarnation instead of the *era hispana* (lines 41–45).

Elsewhere, too, the makers of this book insist on articulating their own present of writing with the larger sweep of human history. Like the protagonist of Terentianus's grammatical fable (discussed in Chapter 2), they braid their lines of writing and drop them down the well of time. On f. 72r, a marginal note next to the canons of the Council of Nicaea does the math: "From the time of this great council until the present era TXII there are DCL years" [A tempore concilii huius magni usque presentem era TXII fiunt anno DCL].[70] So here on f. 72r, it's 974 CE; the Council of Nicaea took place 650 years ago. A callout framed in a horseshoe arch on f. 4r sets the moment of writing

(now 976 CE) in relation to an even more ancient event: "from Adam until era TXIIII in which the work of this codex was completed there are [illegible] years" [Ab Adam usque era TXIIII[a] in qua est editum opus huius codicis fiunt anni (illegible)].[71] Bookwork is important enough to be on the same page with kings and to articulate itself with the great narrative of world history.

Page after page, line after line, codices like the ones studied here represent and understand bookwork—both production and use—as braiding, weaving, trellising. These are all forms of joining one thing to another, and joining one thing to another is what these remarkably detailed colophons do. Specifically, they join the Work of the *auctor* with the work of copying it and the labor of reading both Work and copy; they join the work of copying with the bodies of both copyist and reader, and with their separate yet conjoined activities in space and time.

These monastic manuscripts thus are designed to encourage what Mary Carruthers called the "cognitive pattern-making" of medieval meditative rhetoric. Such articulative thinking, she suggests, locates the production of meaning "within and in relation to other 'things.'"[72] At all levels—structure, the layout of individual pages, and colophons alike— these handmade codices encourage the production of what she calls "locational networks" between and among represented and remembered things. Such networks, Carruthers continues, "finer even than the filaments of a spider's web—are rich devices of thinking, constructing patterns or 'scenes' within which 'things' are caught and into which they are 'gathered' and re-gathered, in innumerable ways, by individual human minds."[73] Textual theorist D. C. Greetham comes to a similar conclusion: "Each end-user [of a medieval manuscript] would construct a labyrinth or web of reading negotiations that might never be replicated exactly by another user."[74]

Spiders, says Isidore of Seville, "spin out a long thread from their little body and, constantly attentive to their webs, never leave off working on them, maintaining a perpetual suspension in their own piece of craftsmanship" [Exiguo corpore longa fila deducit, et telae semper intenta numquam desinit laborare, perpetuum sustinens in sua arte suspendium].[75] For Isidore, the hanging spiders are captured, done in like Arachne by their art. In contrast, the suspension practiced by the contemplative makers of these books is vitally productive. Readers willing to participate in the craft of these books

as their makers expect will find the experience to be more like living in and with a page than being hung up in it.[76]

The acrostic labyrinths and interlaced book icons of the Codex Vigilanus bear out Tim Ingold's insight that the medieval manuscript pages were understood by their makers and users as "regions to be inhabited, and which one can get to know not through one single, totalizing gaze, but through the laborious process of moving around."[77] Engaging medievally with a book, and continually negotiating the articulation of our reading with embodied experience, we, too are weavers, assembling and collecting meaning from the surface of the page.

CONCLUSION: THE HANDY MANUSCRIPT

This has been a book about reading and writing, things that its readers already know a great deal about. You know about writing with a pen or on a keyboard; you know all about reading on a screen, on printed pages bound in stiff paper. If you are my age, you have filed away a library of photocopies; maybe you mark up pdfs on one of those little tablets with sensitive black glass faces.

I have done all these things myself, of course, and I was doing them long before this book began. The makers and users of written text that I met while researching and writing it were readers and writers, too, but their experience of intellectual labor was very different from the one I learned from print, from school, from my colleagues, from the internet. The Iberian scribes studied in this book understood intellectual labor through the work of the body. But, as we have seen, not only in the necessary sense that, before the printing press, writing couldn't happen without the hand. For the scribes, the hand was not only the agent of writing, but also a model for what writing *did*. They wrote and thought by hand.

And reading? Reading a book, of course, requires hands to turn the pages, and hands, too, perhaps to gloss or write a marginal memo or memorial. The handmade book shapes thought and reading, too, for when you engage attentively with manuscript, the bodies of those who made it still shadow every letter, estranging the time you read in. On f. 106r of RAH 29 (Figure 32), it is forever the Sunday after Ascension in the year 977, and the pen is always bad.

The handwritten word always points in at least two directions: toward its referential meaning and toward the hand that made it. Letters, says Isidore of Seville, "are the tokens of things, the signs of words, and they have so much force that the utterances of those who are absent speak to us without a voice, for they present words through the eyes, not through the ears" [Litterae autem sunt indices rerum, signa verborum, quibus tanta vis est, ut nobis dicta absentium sine voce loquantur. Verba enim per oculos non per aures introducunt].[1]

The handwritten book makes absence present: now and then, here and there, all at once. Without a voice, it speaks of the one who made the page you read, and of the one who made the copy that the one who made that page copied from, and so on back to the person we call the author. The handmade book speaks in articulate silence through the work of the scribe's jointed fingers. "Oh you alertly sitting, behold the face of the page," writes the scribe Aeximino on f. 295v of the copy he is finishing of Isidore's *Etymologies* (Madrid, RAH, MS 25, Figure 9). It is August 20, 946. "Here," he shows us, "are my two tired limbs," driving the letters we still can see right here across this page. "With all my goods mixed in, I am joined to this"— to this page, to this work [en ora paginis alacer insedens / xistentesque fessos bis meis artus sic / inmixtis omnibus bonis adiungier].[2]

In Chapter 8, the writing joints of Vigila's fingers joined us, too, to books. Here, in conclusion, their work will help us see the handy book of early medieval manuscript culture and help us grasp its activity. For in a remarkable series of five illuminated poems, the Codex Vigilanus stages the scene of reading, showing the body of the book, the body of the reader, and how they work on one another. It will show us the *vox paginarum*, and that voice is . . . a hand.

You will remember that Vigila and Sarracinus metaphorically bound their book in a frame of tightly woven acrostic text, six poems at the opening (El Escorial, Biblioteca del Monasterio, MS d.I.2, ff. 1v–3v) and two in conclusion (ff. 428v–29r). Enclosed by that frame is the Council Collection, itself prefaced by a reader's digest of its contents, the ten books of *excerpta canonum*.[3] This condensed summary of the Council Collection was so important that short poems were composed to serve as introductions to its first five books.[4] Vigila made them easy to find with a series of spectacular illuminations.[5] Both poems and illuminations represent reading quite literally as a conversation between a single human being and a very singular codex.

The first of the five poems begins on f. 20v. INCIPIT VERSIFICATIO INTERROGATIOQUE LECTORIS AD CODICEM, the title reads: the reader asks questions and the codex answers. Above the poem's title, the illumination encloses the scene of reading in a pair of horseshoe arches (Plate 24).

On the right sits the Reader (helpfully identified by name, LECTOR); on the left, on an elaborate lectern (ANOLOGIUM), sits CODEX. In the frontispiece (f. XXIIv, Plate 20), we saw Vigila at work on this very book, his pen

poised over a page whose golden borders enclosed neither text nor blank parchment, but three columns of knotwork. In the illumination for the first *excerpta* poem, the knots and braid composing the represented text stack up above the florid interlace of the great capital "C" that begins the text. The visual rhyme—woven letter and woven text—occupies almost the entire left column of the composition.

The painted Codex of the *excerpta* poems is designed to inspire awe. Open on its lectern on f. 20v, the codex is almost as wide as its reader is tall. In subsequent illuminations (ff. 35r, 37v, and 43v; Plate 25, Plate 26, Plate 27), the codex grows to human size. On f. 37v (Plate 26), each of the knotty blocks in the gridded codex is fully as big as the Reader's head.

I have not yet mentioned the most astonishing thing about these painted books. They are not just human sized—they are endowed with human hands. The books extend their fingers like a Roman emperor haranguing his troops or like God speaking manually from a cloud in the Urgell Beatus (Figure 10).[6] The books speak. Their *vox*, like that of the scribe who made them, is a hand.

The gigantic and garrulous codices of the *excerpta* illuminations could be taken to illustrate literally Jan-Dirk Müller's observation that, in medieval manuscript culture, "books are the teachers, not their authors. The conversation is held with books, not their authors. In them the author is present."[7] Marshall McLuhan observed that "manuscript culture is conversational . . . because the writer and his audience are physically related by the form of publication as performance."[8] Here, in the Codex Vigilanus, we see publication performed: in the frontispiece, as scribal monologue; here, as an encounter between the reader and the finished book.

For Lector, encounter with Codex is an immersive experience. In the image accompanying the fifth and final poem (f. 47v, Plate 28) the codex, stretched out on the five round arches of its lectern, looks more like a building than a book. It is like a palace; you could move into it. Once inside, you follow the trail of first one knotty problem and then another.[9]

Ask, and the book will answer. You will have to answer its questions, too. "If you wish to know me," the Codex declares in the first poem, "slide me eagerly into your heart of hearts" [si vis me nosse . . . / Arcanisque tuis promptus me inlabere totum].[10] The Codex has been reading Jerome, who wanted his reader to "write what I say in the tables of your heart" [in tabulis cordis tui . . . scribe quod dico].[11] Or maybe it has been studying Gregory

the Great, who advised in the *Moralia* that "we should transform what we read into our very selves" [in nobismetipsis namque debemus transformare quod legimus].[12] This is what books do. They speak, and their hands, like the pen of a ready writer (Ps 45:2), write upon your heart of hearts. They inscribe themselves upon you in a sort of divine remediation, book on parchment to book in heart.

In the Codex Vigilanus, however, Lector is not just passive material support written on by the hand of the scribal codex. The *excerpta* poems are noisy with readerly as well as bookish hands. The whole series charts the push-and-pull of conversation: reading the images left to right, three times the codex, on the left, starts the conversation, and the reader responds (ff. 20v, 37v, 43v), but twice Lector takes the lead (ff. 35r, 47v). This dialogue was important enough that a cursive note reminds the illuminator on f. 34v, "Here the reader speaks to a responding codex" [ubi loquitur codici respondenti lector].

Lector's participation in the codex is material as well as intellectual, for, as the first poem makes clear, the reader is himself a maker of books. "I greatly desire to turn over your commands fully within me," he says to the Codex.

> Should God grant me the ability
> to know and investigate the depths,
> and thus to gather into my breast
> the seeds of your words scattered over the earth,
> then, having approached you with sharpness of mind,
> I might bind you up, spread out as you are,
> in a great body.

> [Appeto plane satis tua mecum volvere iussa.
> Et si scire Deus dederit scutare profunda,
> Sicque per orbem te semina sparsum
> Sinibus aggregare meis, ut acumine mentis
> Te aggressus stringam distentum corpore multo.][13]

Lector promises to serve Codex by joining up its elements into a new form. True to the etymology of his name, he wants to collect "the scattered and not-already-commented-on things into one" [Dispersaque trahens nec iam commenta sub uno][14] and bind them together anew, "filling a new body

with late-added youthful joints" [novum corpus primaevis artubus implens].[15] Vigila, who copies Lector's words and paints his portrait here, says much the same about his own task as architect of this codex, which consists of "assembling the vigorous, florid, famous Councils of the blessed Eastern fathers,/then binding in the great and blessed Councils of kings and Western bishops" [GLOBANS EN UIUIDA ALMORUM FLORIDA PATRUM ORIENTUM CLARA CONCILIA,/INGENTIA DEHINC NECTENS ALMIFICA REGUM AC PRESULUM OCCIDENTALIUM];[16] Both Lector and Vigila want, in short, to rearticulate those old bones to help them speak.

Lector is a book-worker, like his real-life avatars Vigila, scribe and designer of the Codex Vigilanus, and Taio, editor-scribe of the *Moralia*. Like them, Lector is also an agent of articulation. He gathers dispersed texts together, binds up what is scattered, and gives new joints to an old body. He reassembles the knotwork boxes of the gridded codex before him into a new work of lettered looming.

The result of his labor, the poems imply, is nothing other than the *excerpta canonum* themselves, which collect, summarize, and reconstitute the many and various members of the Council Collection. The poems thus, in a bit of bookish self-reflexiveness that should by now be familiar, represent the genesis of the very work that they illustrate, just as the frontispiece showed Vigila at work on the very codex we're reading. Similarly self-theorizing is the illumination for the second poem (f. 35r, Plate 25). The talking hand of the codex rises here not from knotwork but from a ruled page on which text has been written in alternating lines of red and blue. The text on the represented page of the represented Codex reads, "LOCUTIO CODICIS APUD LECTOREM IN EXCERPTIS CANONUM." The title of the poem is also the represented text of the represented codex: "The Speech of the Codex to the Reader about the *Excerpta* of the Canons."[17] In the image before us, the codex speaks those very words in both handwriting and extended hand.

The iconography of the codex is rich ground for the imagination of early medieval Iberian painter-scribes. The people who made these books— Florentius, Maius, Emeterius, Vigila, Sarracinus—represent written language and its privileged vehicle, the codex, in ways that show them actively and theoretically thinking with and about the very object that they are in the process of making.

From Vigila's scribal-eye view, this is what "codex" is: a speaking hand rising from a tissue of interlace. Its conjoined parts "are called pages, from

the fact that they are joined together among themselves" [Cuius partes paginae dicuntur, eo quod sibi inuicem compinguntur] said the codicology lesson that Maius copied from Isidore of Seville, just before he wrote his own name in neat capitals (New York, Morgan Library, MS M644, f. 233v, Figure 24). The painter-scribe Facundus punned those folia into the acanthus-leaved books held by the figures in the Beatus commentary he made for King Fernando I in 1047 (Madrid, BNE, VITR 14/2, f. 10r, Plate 15).

Vigila makes his pages rich with conceptual interlace, yes, but also with the manual labor of word-joinery. Behind the brilliant visual pun that represents text as textile lies the slow and labored weaving of one line of letters with another in poem and on page. The labor of designing and making these pages has come to stand for the codex itself, process for product, making for meaning. Similarly, the *excerpta* poems and illuminations represent reading as interlaced voices interwoven in question and answer, reader to codex and codex to reader. Each of the acrostic poems of the frame is a gridded maze in which the scribe's hand and reader's eyes (and perhaps our fingers too, if we are gloved or medieval) weave back and forth, up and down upon what Isidore of Seville would call the lettered paths of reading, the *leg-itinera*.[18] When we use a book in this manuscript-modeled way, we engage with it bodily, imaginatively, intellectually, maybe even spiritually.

THE WRITING ON THE WALL

Vox is a hand, and Vigila's codex has one. It rises from the book's knotted text like the mysterious hand that breaks up a dinner party in the fifth book of Daniel.

> There appeared fingers, as it were of the hand of a man, writing over against the candlestick upon the surface of the wall of the king's palace: and the king beheld the joints of the hand that wrote. Then was the king's countenance changed, and his thoughts troubled him: and the joints of his loins were loosed, and his knees struck one against the other

> [In eadem hora apparuerunt digiti, quasi manus hominis scribentis contra candelabrum in superficie parietis aulae regiae: et rex aspiciebat articulos manus scribentis. Tunc facies regis commutata est, et cogitationes ejus conturbabant eum: et compages renum ejus solvebantur, et genua ejus ad se invicem collidebantur].[19]

Maius represents this scene in a full-page illumination in his copy of Beatus's Apocalypse commentary (New York, Morgan Library, MS M644, f. 255v, Plate 29).

At the top of the page, the first verse of the story is written in red: "Belshazzar the king made a great feast for a thousand of his nobles: and every one drank according to his age" [Baltassar rex fecit grande convivium optimatibus suis mille: et unusquisque secundum suam bibebat aetatem].[20] Below, a striped horseshoe arch on a bare parchment ground lays out the inscribed environment. *Tituli* in brownish ink show us that three different moments are suspended here simultaneously: at bottom center, the king and his large-eyed guests recline, wine, and dine, as the text on the left explains: "Belshazzar at dinner with his thousand guests" [Baltassar in conuibium cum obtinatibus suis mille]. Above them, a few moments later, disembodied fingers and, as it were, a human hand sprout from the candelabrum (also helpfully labeled, to the left of the flames), pointing with a pen toward the mysterious words it has written on the bricks of the arch. Those words, the figure of Daniel contemplating them [Daniel contrascripturam respiciens], and the interpretation that he makes of them are still further into the diners' future.

In the commentary Maius copies here, Jerome approaches this uncanny scene with a scholar's eye, focused on the writing hand, the text, and the material support. With the staunch practicality of one used to working in the dark, he comments, "The fingers seemed to be writing on the wall over against the candlestick, so that the hand and what it was writing would not be too far from the light" [Videntur autem digiti in pariete scribere contra candelabrum, ne et manus et id quod scribebatur, longius a lumine, non parerent].[21]

Maius has left the ground those fingers write on unpainted, so the divine hand writes on the same parchment as the scribe. And of course, since it is Maius who makes this, it writes in his hand: MANE, TEHCEL, FARES. Back at the dinner party, Belshazzar cannot read the writing on the wall, but he knows who it's for: "The king beheld the joints of the hand that wrote. Then was the king's countenance changed, and his thoughts troubled him: and the joints of his loins were loosed, and his knees struck one against the other" [Et rex aspiciebat articulos manus scribentis. Tunc facies regis commutata est, et cogitationes ejus conturbabant eum: et compages renum ejus solvebantur, et genua ejus ad se invicem collidebantur].[22] Maius, too, reaches

urgently toward his audience. "I have painted a series of pictures," he writes in his poem-colophon, "so that those who know . . . may fear the coming of the end of time" [Ut scientibus terreant . . . futuri aduentui. Peracturi seculi].[23]

Augustine advised his congregation that the painted and inscribed walls surrounding them could well serve as a book.[24] Maius would have wanted this represented room to serve us in the same fashion. The same, I suggest, goes for the makers of the other articulate codices we have studied here. Inhabiting the codex (that's us around Belshazzar's table), we, too, are enjoined to read the writing on the wall.

Florentius and his student Sanctius knew this biblical story well, and they manifest a similar understanding of it in the great Bible they made together in 960 (León, San Isidoro, MS 2). They condense the entire narrative into a single enigmatic figure. On f. 320r, exactly at the words "in superficie parietis aulae regiae," a small image floats as the text wraps around it (Plate 30).

A rectangle, open at the top and made of alternating blocks of red and green, sets off a figure as it were of a human hand, holding a deep yellow pen. The hand hovers within the open box of its frame, barely contained by two delicate spirals that angle inward from the vertical bars enclosing it. It is at work—making not recognizable characters, but tiny black dots that cover a zone the size of four or five letters of the surrounding minuscule. Like the divine hand in Maius's version of the scene, this one makes its marks upon the same parchment the scribe writes on. This is not so much as representation of a hand holding a pen as a representation of the idea of (a) hand, writing. It's an icon for handwriting, just as Maius's *biblio-theca* and Vigila's text(ile) are for handwritten books, and as Vigila's handy manuscript is for the practice of reading.

This page of the 960 Bible is as uncanny as the biblical scene to which it responds. When one reads with the kind of attention I have been advocating here, at certain moments—a slip of the pen, an errant color change—the scribe's hand and its activity become intensely, uncannily *present*. The joints of one's loins may not be loosed, but there is a kind of a chill, or maybe a kind of a thrill. If you have put your gloved or naked hands upon medieval manuscript, you know the feeling. I can't tell you what to think about it because it's hard to think about. I can, however, tell you that both the feeling and why it is so hard to think about are well worth thinking about.

Seamlessly joining the abstract idea of manuscript, a story about the manu-festation of meaning, and the particular signifying labor of a

particular human hand, this page from Florentius and Sanctius's Bible strikingly represents the conjoined writing-and-reading practice that we have been attending to in this book. As a tenth-century codex from St. Gall puts it, "Reading is established by seven foundations: sight, hearing, pen, hand, ink, wax, and parchment . . . *lectio* is so called as if it were *litterarum statio*, the station of letters" [Fundamenta quibus lectio plantatur VII sunt: visus auditus penna manus atramentum caera cartha . . . Lectio dicta est quasi litterarum statio].[25] Reading cannot be separated here from the material of writing; it is defined by an epistemo-ontological pun that assembles the word *lectio* from the words *litterarum* and *statio*, which is to say, it is the station of letters.

That's how this works on the punning surface of the Latin letter. To see it conceptually in English, we have to lose the puns and translate. Reading is compounded from the residence of letters. Which is to say, reading is the habitation of letters, where letters live. To read is thus to move in with the letters as if into new rooms, installing yourself there in body and bodily sense. Thus Florentius addresses not "you who might read this codex" but "you who might read *in* this codex" [qui in hoc codice legeritis] (Madrid, BNE, MS 80, f. 500v). Thus, the St. Gall manuscript's seven elements of reading: "sight, hearing, pen, hand, ink, wax, and parchment" [visus auditus penna manus atramentum caera cartha]. These are, the handwriting says, the foundations. There is plenty of room for hermeneutics in this model—*ille proficit mente*, says Florentius—but the foundation is made of matter and the human senses. Before interpretation, there is simply attention.

Reading where letters live allows us to see not only the intimate connection here between the activities of reading and writing but also between the "meaning" of the letters and the way they stand on the page. When we read like this, we move into the *statio* of letters as if into new living quarters. The manuscripts we have attended to here agree. You could say that when we follow their lead, we are reading manuscription as well as reading a manuscript. And when we read a handwritten book, we are always doing both.

ACKNOWLEDGMENTS

This book has been an amateur undertaking in the most intimate sense of the word: a labor of love. Of love for the material studied, but also for language, for color, for bodies, and for attentive craft. In the dozen years of its gestation and growth, many people have nourished it. Some of them know this, some don't. I am grateful to have this space to name and thank them.

John Dagenais's radical attention to manuscripts, especially those of the beloved *Libro de buen amor,* showed me that loving literature means loving its body, too. Carolyn Dinshaw's warm and fearless exploration of queer time, amateurism, and medieval studies made space for thought and breathing. Reading Jonathan Goldberg's *Writing Matter* shortly after its appearance in 1990 planted seeds whose fruit nourished me for years. A beautiful paper on the hands of the *Liber Testamentorum* delivered by Flora Ward at Kalamazoo in 2008 helped me articulate an inchoate curiosity about the scribal culture of early medieval Iberia into the hand and its activity.

Friends have supported and loved both work and worker through what often seemed like a never-ending story. Jim Cogswell is a painter and lover of words, but above all he is a maker. I can't thank him enough for giving me a copy of Tim Ingold's *Making.* Cary Howie, dear little brother of the heart, invited me out of anchoritic claustrophilia to be part of a community of like-minded writer-medievalists. Peggy McCracken is an indefatigably generous reader who knows how to say things so that they can be truly heard. Christi Merrill has the best laugh in the world and offered writing trips to the lake, even when this project was stalled and its maker felt writing was impossible. Ryan Szpiech, beloved brother of the fermentation lab, devoured both culinary and scholarly experiments with nourishing enthusiasm.

The quirky ways of working that eventually produced this book started to take shape in a fellowship year at the Newberry Library in 1999–2000. I regret that I did not use the Newberry's resources as fully as I might have, but the year was nonetheless rich with reading, thinking, and theater and was not wasted. Audiences at Barnard, Bryn Mawr, Cornell, Princeton, UCLA, the University of Michigan, the University of Tennessee, the University of Toronto, and the University of Warwick thought through these

texts and images with me. Portions of Chapters 1, 3, and 7 and a paragraph or two from the Introduction and Conclusion have appeared elsewhere; thanks to all who commented on their previous incarnations.

Thanks to the Department of Comparative Literature and the Residential College at the University of Michigan for supporting a manuscript workshop that helped me see that this really was a book, and that improved it hugely. The University's ADVANCE program and Sally Schmall supported the project in a dark period, and the University of Michigan Library's purchase of a gorgeous facsimile of the *Codex Vigilanus* made Chapter 8 possible.

When software caused one problem while solving another, Amanda Kubic patiently recoded every single footnote, for which labor I am deeply grateful. Ellen Cole and Harriet Fertig spent many hours with the ostentatious Latin in which these scribes composed their colophons and provided the foundations upon which many of the translations offered here are built. The hardest and most incomprehensible passages ended up in Donka Markus's hands. She patiently and skillfully helped me make sense of them. Any errors are mine. Sophie Linden made gorgeous line drawings of bas-reliefs that, due to pandemic travel restrictions, were only accessible to me through photographs on the internet.

The final stages of revision were supported by thoughtful suggestions from readers for the Press and from Mary C. Erler, departing editor of the Fordham Series in Medieval Studies. Will Cerbone let air into some clotted paragraphs in later chapters and loosened a writer's tangled spirits with good wit.

This book is freely available in an open-access edition thanks to TOME (Toward an Open Monograph Ecosystem)—a collaboration of the Association of American Universities, the Association of University Presses, and the Association of Research Libraries—and the generous support of the University of Michigan's College of Literature, Science & the Arts and the Provost Office. Learn more at the TOME website, available at: open-monographs.org.

It is nourishing beyond words to thank the precious people who have given so much to this project, and to imagine them with this book in their hands. Some of those people, however, will never hold or see it. I am sorry that I never had the chance to tell them how deeply grateful I am for their lives, thought, and actions. The work of Michael Camille, encountered both

in writing and occasionally in person, taught me how to look at a medieval page and think of a book as a body. Helen Tartar edited my first book and believed in this one even when I didn't. I thank her for that, and for Chinese poetry and knitting. John Williams was extraordinarily generous and supportive of an enthusiastic total stranger who wanted to study what he studied.

Finally, the two most important shapers of this book and its author. The Venerable Haju Sunim's earthy wisdom reminds me always to work with my hands when things get too heady. Her guidance has helped me hear that these scribes are speaking directly to me.

Laura Creagh did not sign up to share her life with *Remember the Hand* for a dozen or more years, but share it she did, and did so with generosity and patience. Thank you, Laura, for supporting my need to make this book and for making possible a life of both work and love. As Haju says: Words fall short. Thank you.

Legenti et possidenti vita.

NOTES

PREFACE

1. León, AC, MS 8, f. 1v. Latin in Benedictines of Silos, *Antiphonarium mozarabicum de la catedral de León* (Burgos: Aldecoa, 1928), xxviii, corrected to the manuscript; my translation.

2. Madrid, BNE MS 80, f. 500v. Latin in Manuel C. Díaz y Díaz, "Los prólogos y colofones de los códices de Florencio," in *Códices visigóticos en la monarquía leonesa* (León: Centro de Estudios de Investigación "San Isidoro," 1983), 517; my translation.

3. Madrid, BNE, MS 80, f. 500v. Latin in Díaz y Díaz, "Prólogos," 517; my translation.

4. Madrid, BNE, MS 80, f. 500v. Latin in Díaz y Díaz, "Prólogos," 517; my translation.

5. Ben C. Tilghman makes a similar argument about the way the Lindisfarne Gospels work; Tilghman, "Pattern, Process, and the Creation of Meaning in the Lindisfarne Gospels," *West 86th* 24, no. 1 (2017).

6. "Three fingers write, the whole body labors" [Tres digiti scribunt totumque corporis laborat] is a widespread colophon trope in the early Middle Ages and is given particular life by these scribes. For studies of this formula, see Lucien Reynhout, *Formules latines de colophons*, Bibliologia 25 (Turnhout: Brepols, 2006), 1:95–100, and Kurt Otto Seidel, "'Tres digiti scribunt totumque corpus laborat': Kolophone als Quelle für das Selbstverständnis mittelalterlicher Schreiber," *Das Mittelalter* 7, no. 2 (2002).

7. The typographical manipulations advocated by John Dagenais in his groundbreaking book on the *Libro de buen amor* are an admirably radical approach to the problem; Dagenais, *The Ethics of Reading in Manuscript Culture: Glossing the "Libro de buen amor"* (Princeton: Princeton University Press, 1994), xx–xxii. My own practice aims for the middle way between a Dagenaisian radicalism that makes reading the typeset text almost as attention-intense as reading the manuscript and a total makeover that allows us to pretend that medieval words have always been as stable and unambiguous as print makes them seem.

8. Up until the late Middle Ages, Iberian Christian scribes render dates according to the *era hispana*, which is thirty-eight years ahead of dates figured by the Common Era. Thus, "era MXVa" = era 1015 = 977 CE.

9. Madrid, BNE, MS 80, f. 499r. Latin from Díaz y Díaz, "Prólogos," 516 (corrected to the manuscript); my translation.

INTRODUCTION: THE ARTICULATE CODEX, MANUSCRIPTION, AND EMPATHIC CODICOLOGY

1. Annotations in Latin, proto-Romance, and Arabic show us the languages in which users were thinking as they read. Most famous of the proto-Romance annotations are the "glosas emilianenses" (Madrid, RAH, MS 60). Many Latin codices produced in northern monasteries contain Arabic annotations, including two studied here: the Tábara Apocalypse (Madrid, AHN, MS L.1097) and the Bible of 960 (León, San Isidoro, MS 2). The work of Cyrille Aillet is especially helpful for such plurilingual manuscripts. For example: "Recherches sur le christianisme arabisé (IX^e–XII^e siècles): Les manuscrits hispaniques annotés en arabe," in *¿Existe una identidad mozárabe?: Historia, lengua y cultura de los cristianos de al-Andalus (siglos IX–XII)*, ed. Cyrille Aillet, María Teresa Penelas, and Philippe Roisse (Madrid: Casa de Velánquez, 2008); "Quelques repères pour l'étude des gloses arabes dans les manuscrits ibériques latins (IX^e–XIII^e siècles)," in *Von Mozarabern zu Mozarabismen*, ed. Matthias Maser and Klaus Herbers (Münster: Aschendorff, 2014). On Arabic in the Christian communities of medieval Iberia, see Sidney Harrison Griffith, *The Bible in Arabic: The Scriptures of the "People of the Book" in the Language of Islam* (Princeton: Princeton University Press, 2013); Juan Pedro Monferrer Sala, "Unas notas sobre los 'textos árabes cristianos andalusíes,'" *Asociación Española de Orientalistas* 38 (2002); P. S. van Koningsveld, "La literatura cristiana-árabe de la España medieval y el significado de la transmisión textual en árabe de la Collectio Conciliorum," in *Concilio III de Toledo: XIV centenario, 589–1989* (Toledo: Arzobispado de Toledo, 1991), and van Koningsveld, "Christian-Arabic Manuscripts from the Iberian Peninsula and North Africa," *Al-Qantara* 15 (1994).

2. Otto Werckmeister certainly thought so; Werckmeister, "Art of the Frontier: Mozarabic Monasticism," in *The Art of Medieval Spain, A. D. 500–1200*, ed. John P. O'Neill, Kathleen Howard, and Ann M. Lucke (New York: Metropolitan Museum of Art, 1993), 123. On Arabic colophons, see Ramazan Şeşen, "Esquisse d'un histoire du développement des colophons dans les manuscrits musulmans," in *Scribes et manuscrits du Moyen-Orient*, ed. François Déroche and Francis Richard (Paris: Bibliothèque Nationale de France, 1997), and, in the same volume, Gérard Troupeau, "Les colophons des manuscrits arabes chrétiens."

3. Werckmeister, "Art of the Frontier," 122. The rich field of Mozarabic studies beckons beyond the pages of this book. From that vast and growing bibliography, good orientation in English: Thomas E. Burman, *Religious Polemic and the Intellectual History of the Mozarabs, c. 1050–1200* (Leiden: Brill, 1994), and Richard Hitchcock, *Mozarabs in Medieval and Early Modern Spain* (Burlington, Vt.: Ashgate, 2008). See also the essays collected in Cyrille Aillet, María Teresa Penelas, and Philippe Roisse, eds., *¿Existe una identidad mozárabe?: Historia, lengua y cultura de los cristianos de al-Andalus (siglos IX–XII)* (Madrid: Casa de Velázquez, 2008), and Matthias Maser and Klaus Herbers, eds., *Die Mozaraber: Definitionen und Perspektiven der Forschung* (Berlin: Lit Verlag, 2011). So powerful

is the imprint of Arabic culture on the Christian arts of this period that "Mozarabic" is shorthand for the Iberian pre-Romanesque, even in the Christian regions. Representative studies for manuscript illumination: Otto K. Werckmeister, "The Islamic Rider in the Beatus of Girona," *Gesta* 36, no. 2 (1997) ; E. Rodriguez Díaz, "Los manuscritos mozárabes: Una encrucijada de culturas," in *Die Mozaraber: Definitionen und Perspektiven der Forschung*, ed. Klaus Herbers and Matthias Maser (Munich: Lit Verlag, 2011); and Emily Baldwin Goetsch, "Extra-Apocalyptic Iconography in the Tenth-Century Beatus Commentaries on the Apocalypse as Indicators of Christian-Muslim Relations in Medieval Iberia" (Ph.D., University of Edinburgh, 2014).

4. The Latin of early medieval Iberian book-workers can be very creative indeed. Helpful for getting a handle on it: Manuel C. Díaz y Díaz, "El cultivo del latín en el siglo X," *Anuario de estudios filológicos* 4 (1981). Essential is Maurilio Pérez González, *Lexicon latinitatis medii regni Legionis*, Corpus Christianorum, Lexica Latina Medii Aevi (Turnhout: Brepols, 2010); see also Pérez González, "El latín del siglo X leonés a la luz de las inscripciones," in *Actas. III Congreso hispánico de latín medieval (León, 26–29 de Septiembre de 2001)*, ed. Maurilio Pérez González (León: Universidad de León, 2002), and Pérez González, "El latín medieval diplomático," *Bulletin du Cange* 66 (2008); and Pérez González, "La escritura y los escritos durante el siglo X," in *"In principio erat verbum": El Reino de León y sus Beatos*, ed. Maurilio Pérez González, Carlos M. Reglero de la Fuente, and Margarita Torres (Madrid: Sociedad Estatal de Conmemoraciones Culturales, 2010). On the emergence of Romance in this period, see the work of Roger Wright, especially *Late Latin and Early Romance in Spain and Carolingian France* (Liverpool: F. Cairns, 1982).

5. Catalonia, in the Carolingian sphere of influence, adopted the Caroline minuscule. Although early medieval Catalan book culture is beyond the scope of this project, it is being studied in exciting ways; see, for example, A. M. Mundó, "El jutge Bonsom de Barcelona, cal.lígraf i copista del 979 al 1024," in *Scribi e colofoni: Le sottoscrizioni di copisti dalle origini all'avvento della stampa*, ed. Emma Condello and Giuseppe De Gregorio (Spoleto: Centro italiano di studi sull'alto Medioevo, 1995), and Mundó, "Le Statut du scripteur en Catalogne du IXᵉ au XIᵉ siècle," in *Le statut du scripteur au Moyen Age: Actes du XIIᵉ colloque scientifique du Comité International de Paléographie Latine (Cluny, 17–20 juillet 1998)*, ed. Marie-Clotilde Hubert, Emmanuel Poulle, and Marc H. Smith (Paris: École des Chartes, 2000); Michel Zimmermann, *Écrire et lire en Catalogne: IXᵉ–XIIᵉ siècles*, 2 vols. (Madrid: Casa de Velázquez, 2003); and Domènec Miquel Serra, "El llibre al monestir de Sant Cugat: La biblioteca, l'escriptori, l'escola," *Gausac* 25 (2004).

6. "Visigothic" is a paleographical and not a cultural term, referring not to the people who made the manuscripts but rather to the hand in which they are written. Manuscripts in the "Visigothic" hand were produced well after the fall of the Visigothic kingdom in 711 CE. Ainoa Castro Correa offers generous resources

on the web on both her website ("VisigothicPal," accessed June 8, 2021, http:// visigothicpal.com/) and her blog ("Littera visigothica," accessed June 8, 2020, http://www.litteravisigothica.com/); see also Jesús Alturo i Perucho, "La escritura visigótica: Estado de la cuestión," *Archiv für Diplomatik* 50 (2004), and Alturo i Perucho, Ainoa Castro Correa, and Miquel Torras i Cortina, eds., *La escritura visigótica en la Península Ibérica: Nuevas aportaciones* (Bellaterra: Universitat Autònoma de Barcelona, 2012).

7. Agustín Millares Carlo, *Corpus de códices visigóticos*, 2 vols. (Las Palmas: Universidad de Educación a Distancia, 1999).

8. Use of the Visigothic hand did not, of course, end overnight. For the transition between the Visigothic and Caroline hands, see especially the important work of Ainoa Castro Correa: "Visigothic Script versus Caroline Minuscule: The Collision of Two Cultural Worlds in Twelfth-Century Galicia," *Mediaeval Studies* 78 (2016); "The Scribes of the Silos Apocalypse (London, British Library Add. MS 11695) and the Scriptorium of Silos in the Late 11th Century," *Speculum* 95, no. 2 (2020); and "Dejando el pasado atrás, adaptándose al futuro: Escribas de transición y escribas poligráficos visigótica-carolina," *Anuario de estudios medievales* 50, no. 2 (2020).

9. Mireille Mentré, *Illuminated Manuscripts of Medieval Spain* (London: Thames and Hudson, 1996), 102.

10. John Dagenais, "Decolonizing the Medieval Page," in *The Future of the Page*, ed. Peter Stoicheff and Andrew Taylor (Toronto: University of Toronto Press, 2004), 40.

11. Peter Mark Roget et al., *Thesaurus of Words and Phrases* (New York: Grosset & Dunlap, 1947), I.iii.3.43; p. 17.

12. Isidore of Seville, *Etymologies* XI.1.84: *Etymologiarum sive Originvm libri XX*, ed. W. M. Lindsay (Oxford: Clarendon, 1911); *The Etymologies of Isidore of Seville*, trans. Stephen A. Barney et al. (Cambridge: Cambridge University Press, 2006), 236. Because the second volume of Lindsay's edition is unpaginated, I will cite references to it by standard text division only.

13. There was ample communication between north Iberian monastic scriptoria and the great Caroline book-center of Tours; see Jacques Fontaine, "Mozarabe hispanique et monde carolingien: Les échanges culturels entre la France et l'Espagne du VIIIᵉ au Xᵉ siècle," *Anuario de estudios medievales* 13 (1983); Junco Kume, "Aspectos de la influencia iconográfica carolingia en la miniatura hispánica de los siglos X y XI," in *El arte foráneo en España: Presencia e influencia*, ed. Miguel Cabañas Bravo (Madrid: Departamento de Historia del Arte, Instituto de Historia, 2005); John Williams, "Tours and the Early Medieval Art of Spain," in *Florilegium in honorem Carl Nordenfalk octogenarii contextum*, ed. Per Bjurström, Nils Göran Hökby, and Florentine Mütherich (Stockholm: Nationalmuseum, 1987). The great First Bible of Charles the Bald (Paris, BnF, MS lat. 1) makes an excellent comparison with an articulate Iberian codex like, for example, Florentius's *Moralia*, completed a century later. In the presentation scene of the Frankish

book (f. 423r), the finished Bible is reverently offered to the emperor by its noble patron. In Florentius's *Moralia*, in contrast, the scribe himself presents the book to monastic readers in language of remarkable intimacy.

14. As the concept *orality* is an artifact of literacy, the noun *manuscript* is an artifact of print culture. Its first attestation in English dates from 1600: "Hither are brought diuers manuscripts or written books out of Barbarie" (OED, s.v. *manuscript*).

15. The word created by adding the suffix *-tion* to an English verb is, in the OED's words, "a noun of action" (s.v.—*tion*).

16. Cf. Jennifer Baird and Claire Taylor, writing on ancient Roman graffiti: "If writing is an event which becomes an object, the interpretation of graffiti turns the objects into an event again"; Baird and Taylor, "Ancient Graffiti in Context: Introduction," in *Ancient Graffiti in Context*, ed. Jennifer A. Baird and Claire Taylor (New York: Routledge, 2011), 6. Similarly, Isaac Fellman's novel *Dead Collections* begins with this declaration by its vampire-archivist narrator: "When I was training to be an archivist, my mentor told me, 'A thing is just a slow event'"; Fellman, *Dead Collections* (New York: Penguin Random House, 2022), 1.

17. Most inspiring for the making-focused orientation of this book has been the work of Tim Ingold: *Lines: A Brief History* (London: Routledge, 2007), and *Making: Anthropology, Archaeology, Art and Architecture* (London: Routledge, 2013). Ben Tilghman and Francis Newton have discussed Insular manuscripts with similar interest in making; Tilghman, "Pattern, Process, and the Creation of Meaning in the Lindisfarne Gospels," *West 86th* 24, no. 1 (2017); Newton, "A Giant among Scribes: Colophon and Iconographical Programme in the Eadui Gospels," in *Writing in Context: Insular Manuscript Culture, 500–1200*, ed. Erik Kwakkel (Leiden: Leiden University Press, 2013); and Francis L. Newton, Francis L. Newton Jr., and Christopher R. J. Scheirer, "Domiciling the Evangelists in Anglo-Saxon England: A Fresh Reading of Aldred's Colophon in the 'Lindisfarne Gospels,'" *Anglo-Saxon England* 41 (2012); see also Jeffrey F. Hamburger, "The Hand of God and the Hand of the Scribe: Craft and Collaboration at Arnstein," in *Die Bibliothek des Mittelalters als dynamischer Prozess*, ed. Michael Embach, Claudine Moulin, and Andrea Rapp (Wiesbaden: Reichert, 2012), and Therese Martin, "The Margin to Act: A Framework of Investigation for Women's (and Men's) Medieval Art-Making," *Journal of Medieval History* 42, no. 1 (2016).

18. I borrow here C. S. Peirce's distinction between *type* and *token*. For Peirce, a type—like, for example, the idea you get when someone refers to *Wuthering Heights*—is "a definitely significant Form" that "does not exist; it only determines things that do exist." Such a thing he calls a "token": "a Single event which happens once and whose identity is limited to that one happening or a Single object or thing which is in some single place at any one instant of time"; Charles Sanders Peirce, *Collected Papers*, vol. 4, *The Simplest Mathematics*, ed. Charles Hartshorne and Paul Weiss (Cambridge, Mass.: Harvard University Press, 1933), 423.

19. "Most, if not all, of the ideas we bring to our appreciation of the medieval page are shaped, almost unavoidably, by our prior familiarity with the printed

page. And so, as with much else having to do with the so-called Middle Ages, the announced chronology is, in fact, reversed: the printed page comes before the manuscript page for us. We inevitably see the medieval page as a set of deviations from and similarities with the printed page"; Dagenais, "Decolonizing the Medieval Page," 38.

20. For the historical emergence of the idea of "text" separate from its material instantiation, see Ivan Illich, *In the Vineyard of the Text: A Commentary to Hugh's "Didascalicon"* (Chicago: University of Chicago Press, 1993), and Jan-Dirk Müller, "The Body of the Book: The Media Transition from Manuscript to Print," in *The Book History Reader*, ed. David Finkelstein and Alistair McCleery (London: Routledge, 2002).

21. Beatus of Liébana, *Adversus Elipandum* I.97: ed. Bengt Löfstedt, CCCM 59 (Turnhout: Brepols, 1984), 73.

22. Cassian and Jerome, writers well represented in early medieval Iberian libraries, both regularly used the word in the sense of speculation, contemplation, meditation; Albert Blaise, *Dictionnaire latin-français des auteurs chrétiens*, ed. Paul Tombeur (Turnhout: Brepols, 1954), s.v. *theoria*.

23. Cassian, *Collationes* I.8: ed. M. Petschenig, CSEL 13 (Vienna: Gerold, 1886), 15.

24. Madrid, BNE, MS 80, f. 500v; Latin in Manuel C. Díaz y Díaz, "Los prólogos y colofones de los códices de Florencio," in *Códices visigóticos en la monarquía leonesa* (León: Centro de Estudios de Investigación "San Isidoro," 1983), 516–17.

25. Quintilian, *Institutio Oratoria* X.1.16, ed. and trans. H. E. Butler, Loeb Classical Library (Cambridge, Mass: Harvard University Press, 1996), vol. 4, 114.

26. Ingold, *Making*, 85.

27. Before it became a synonym for "object," the word "thing" in Old English (*þing*) meant a meeting or assembly (OED, s.v. *thing*). "Thing theory" is laid out most programmatically in Bill Brown, "Thing Theory," *Critical Inquiry* 28, no. 1 (2001), and beautifully developed for medieval studies in Andrew Cole, "The Call of Things: A Critique of Object-Oriented Ontologies," *Minnesota Review* 80 (2013). Also relevant for this approach to manuscript studies: Ingold, *Making*, 75–89.

28. Ingold, *Making*, 85.

29. Illich, *In the Vineyard of the Text*, 43.

30. Isidore of Seville, *Sententiae* III.6, ed. Pierre Cazier, CCSL 111 (Turnhout: Brepols, 1998), 229; translation after Duncan Robertson, *"Lectio divina": The Medieval Experience of Reading* (Collegeville, Minn.: Liturgical Press, 2011), 109.

31. Charlton Lewis and Charles Short, *A Latin Dictionary* (Oxford: Clarendon, 1993), s.v. *studium*.

32. Imagining research not as a pairing of scholarly subject and object of study, but rather as a dialogue in which subject and object positions are more fluid, I here follow the lead of Mary Carruthers, Ivan Illich, and Jean Leclercq, all of whom have allowed their prodigious scholarship to hold hands with sympathetic participation in distant thought-worlds; Mary Carruthers, *The Book of Memory: A Study of Memory in Medieval Culture* (Cambridge: Cambridge University

Press, 1990); Carruthers, *The Craft of Thought: Meditation, Rhetoric, and the Making of Images, 400–1200* (Cambridge: Cambridge University Press, 1998); Illich, *In the Vineyard of the Text*; Jean Leclercq, *The Love of Learning and the Desire for God* (New York: Fordham University Press, 1961). Also inspiring is the more experimental work collected in Maggie M. Williams and Karen Eileen Overbey, eds., *Transparent Things: A Cabinet* (Brooklyn: punctum, 2013).

33. For lovely work on the affective and haptic qualities of monastic reading, see especially Aden Kumler, "Handling the Letter," in *St. Albans and the Markyate Psalter: Seeing and Reading in Twelfth-Century England*, ed. Kristen M. Collins and Matthew Fisher (Kalamazoo, Mich.: Medieval Institute Publications, 2017); Kathryn M. Rudy, "Kissing Images, Unfurling Rolls, Measuring Wounds, Sewing Badges and Carrying Talismans: Considering Some Harley Manuscripts through the Physical Rituals They Reveal," *Electronic British Library Journal* (2011), Rudy, *Piety in Pieces: How Medieval Readers Customized Their Manuscripts* (Cambridge: Open Book Publishers, 2016); and Corine Schleif, "Haptic Communities: Hands Joined in and on Manuscripts," in *Manuscripts Changing Hands*, ed. Corine Schleif and Volker Schier (Wiesbaden: Harrassowitz Verlag in Kommission, 2016).

34. In advocating this kind of codicological participant observation, I am not urging readers to write in the margins of ancient codices because medieval readers did. The status of medieval manuscripts has changed: they are no longer ritual participants in a world of use but rather archived treasures. See, for starters, Jacques Derrida, *Archive Fever: A Freudian Impression* (Chicago: University of Chicago Press, 1996); Siân Echard, "House Arrest: Modern Archives, Medieval Manuscripts," *Journal of Medieval and Early Modern Studies* 30, no. 2 (2000).

35. Ingold, *Making*, 8. This distinction between learning *with* and learning *about* is much like Hugh of St. Victor's distinction between working *per artem* and *de arte*; Hugh of St. Victor, *Didascalicon* III.5, ed. H. C. Buttimer (Washington, D.C.: The Catholic University of America Press, 1939), 56.

36. Paraphrasing the *Speculum Monachorum* of twelfth-century Cistercian Arnoul of Bohériss, who writes that in reading, the monastic "should not seek science so much as savor" [non tam quaerat scientia, quam saporem] (PL 184: 1175B).

37. Schleif, "Haptic Communities," 75.

38. "Keep me in mind, the scribe who suffered this for your name" [Me scriptori in mente abete qui hoc pati pro uestro nomine]; León, AC MS 8, f. 1v. Latin in Benedictines of Silos, *Antiphonarium mozarabicum de la catedral de León* (Burgos: Aldecoa, 1928), xxviii.

39. A similarly holistic approach to manuscript study was announced by the "New Philology" in 1990; Stephen G. Nichols, "Introduction: Philology in Manuscript Culture," *Speculum* 65, no. 1 (1990), and, twenty-five years later, Nichols, "Dynamic Reading of Medieval Manuscripts," *Florilegium: The Journal of the Canadian Society of Medievalists / La revue de la Société canadienne des médiévistes* 32 (2015). The approach had been, however, beautifully suggested in 1967, when Leon Delaissé proposed to "study manuscripts as a whole, with a

feeling for their life"; Delaissé, "Towards a History of the Medieval Book," *Divinitas* 11 (1967): 433.

40. Augustine, *Confessions* XI.28: ed. James J. O'Donnell (Oxford: Clarendon, 1992), vol. 1:162; trans. Sarah Ruden (New York: Modern Library, 2017), 379.

41. Clifford Geertz once compared his anthropological method of "thick description" with trying to read a manuscript "written not in conventionalized graphs of sound but in transient examples of shaped behavior"; Geertz, "Thick Description: Toward an Interpretive Theory of Culture," in *The Interpretation of Cultures: Selected Essays* (New York: Basic Books, 1973), 10.

1. FLORENTIUS'S BODY

1. Ben Tilghman has pointed out a similar focus on making in another early medieval manuscript: "By drawing our attention to its making, the Lindisfarne Gospels reminds us that it cannot mean but through the process by which it was made"; Tilghman, "Pattern, Process, and the Creation of Meaning in the Lindisfarne Gospels," *West 86th* 24, no. 1 (2017): 21.

2. Gregory the Great, *Moralia* Praef. I.1, ed. Marc Adriaen, CCCM 143 (Turnhout: Brepols, 1979–81), 8; my trans.

3. Gregory the Great, *Moralia* Praef. I.1: ed. Adriaen, vol. 143: 8; my trans.

4. Gregory the Great, *Moralia* Praef. I.1: ed. Adriaen, vol. 143: 8; my trans.

5. Gregory the Great, *Moralia* Praef. I.1: ed. Adriaen, vol. 143: 8; my trans. The bibliography on Gregory, writing and images, is vast—for orientation, see Lawrence Duggan, "Was Art Really 'The Book of the Illiterate?,'" *Word & Image* 5 (1989); Celia Chazelle, "Pictures, Books and the Illiterate: Pope Gregory I's Letters to Serenus of Marseilles," *Word & Image* 6 (1990); Michel Banniard, *Viva voce: Communication écrite et communication orale du IVᵉ au IXᵉ siècle en occident latin* (Paris: Institut des Études Augustiniennes, 1992), 148–56; Michael Camille, "The Gregorian Definition Revised: Writing and the Medieval Image," in *L'image: Fonctions et usages des images dans l'occident médiévale* (Paris: Le Léopard d'Or, 1996).

6. Gregory the Great, *Moralia* Ep. ad Leandrum: ed. Adriaen, vol. 143: 6; trans. Brian Kerns in *Moral Reflections on the Book of Job*, vol. 1, *Preface and Books 1–5* (Collegeville, Minn.: Liturgical Press, 2014), 54.

7. Attributed to Rabanus Maurus, Letter 10; in Ernst Dümmler and Adolf von Hirsch-Gereuth, eds., *Epistolae Karolini Aevi*, vol. 5 (Berlin: Weidmann, 1898), 633.

8. For the most up-to-date and thorough survey of Florentius's work as scribe and notary, see Elena García Molinos, "Florencio de Valeránica: Calígrafo castellano del siglo X," in *El Reino de León en la Edad Media, XI* (León: Centro de Estudios e Investigación "San Isidoro," 2004). Also important are Manuel C. Díaz y Díaz, "El escriptorio de Valeránica," in *Codex biblicus legionensis: Veinte estudios* (León: Real Colegiata de San Isidoro, 1999); John Williams, "A Contribution to the History of the Castilian Monastery of Valeránica and the Scribe Florentius," *Madrider Mitteilungen* 11 (1970).

9. What remains of Valeránica is studied in Williams, "A Contribution."

10. For monasteries in the territorial agenda of León and Castile in the ninth and tenth centuries, see Juan Ignacio Ruiz de la Peña Solar, "'Ecclesia crescit et regnum ampliatur': Teoría y práctica del programa político de la monarquía astur-leonesa en torno al 900," in *San Miguel de Escalada (913–2013)*, ed. Vicente García Lobo and Gregoria Cavero Domínguez (León: Universidad de León Instituto de Estudios Medievales, 2014), and Carlos M. Reglero de la Fuente, "Iglesia y monasterios en el reino de León en el siglo X," in *"In principio erat verbum": El Reino de León y sus Beatos*, ed. Maurilio Pérez González, Carlos M. Reglero de la Fuente, and Margarita Torres (Madrid: Sociedad Estatal de Conmemoraciones Culturales, 2010). Though Valeránica was closely affiliated with political movers and shakers of the tenth century (including the powerful Castilian count Fernán González), it was not, however, protected from the violence of that border: Florentius was not long in his grave when his workplace was devastated by Almanzor's raiding parties in the last years of the century.

11. Florentius is the only scribe from Valeránica whose name is known. Barbara Shailor's 1975 dissertation surveys the corpus of codices traceable to Valeránica: "The Scriptorium of San Pedro de Berlangas" (Ph.D., University of Cincinnati, 1975). See also Díaz y Díaz, "Escriptorio"; Justo Pérez de Urbel, "El monasterio de Valeránica y su escritorio," in *Homenaje a Don Agustín Millares Carlo* (Madrid: Caja Insular de Ahorros de Gran Canaria, 1975). A bifolio from a tenth-century Orational discovered at Tordómar in 2006 has been associated with Valeránica; Manuel Zabalza Duque, "Restos de un oracional visigótico de Valeránica," in *Alma Littera: Estudios dedicados al Profesor José Manuel Ruiz Asencio*, ed. Marta Herrero de la Fuente et al. (Valladolid: Ediciones Universidad de Valladolid, 2014).

12. For more on Florentius's lost Cassiodorus and the fragmentary Bible of 943 [Silos, Archivo del Monasterio, frag. 19 (1 folio) and Rome, Hermandad de Sacerdotes Operarios Diocesanos (no shelf number; 11 folios)], see Chapter 3.

13. Shailor, "Scriptorium of Berlangas," 39; García Molinos, "Florencio de Valeránica," 323.

14. Bookending an illuminated codex with the apocalyptic letters is characteristic of Iberian illumination in this period; Mireille Mentré, *Illuminated Manuscripts of Medieval Spain* (London: Thames and Hudson, 1996), 97–98.

15. Florentius is one of the earliest scribes to use this characteristically Iberian form of alphabetic carpet page. Domínguez Bordona lists sixteen extant Iberian manuscripts with labyrinths and six lost manuscripts; J. Domínguez Bordona, "Exlibris mozárabes," *Archivo Español de Arte y Arqueología* 2 (1935). The form is usually, however, used as an ex-libris panel, not to identify the scribe; John Williams, *Early Spanish Manuscript Illumination* (New York: G. Braziller, 1977), 50.

16. This expression is borrowed from the evocative title of Johanna Drucker's *The Alphabetic Labyrinth: The Letters in History and Imagination* (New York: Thames and Hudson, 1995).

17. García Molinos, "Florencio de Valeránica," 313. García Molinos's edition of Florentius's prologues and colophons is generously annotated with analogues from other Iberian and European scribes. Perhaps more readily accessible is the edition of Manuel C. Díaz y Díaz: "Los prólogos y colofones de los códices de Florencio," in *Códices visigóticos en la monarquía leonesa* (León: Centro de Estudios de Investigación "San Isidoro," 1983), 516–17.

18. For studies of this common colophon formula, see Lucien Reynhout, *Formules latines de colophons* (Turnhout: Brepols, 2006), 1:95–100, and Kurt Otto Seidel, "'Tres digiti scribunt totumque corpus laborat': Kolophone als Quelle für das Selbstverständnis mittelalterlicher Schreiber," *Das Mittelalter* 7, no. 2 (2002).

19. The rendering translated here yields era 963 = 925 CE. I cannot see any way to render the Latin to make it agree with the date of era 983 in the explicit (f. 499r). Díaz y Díaz suggests that Florentius got mired in his efforts trying to fancify the number "eighty" and suggests that what he was trying to say was 4 × 2 × 10: *bis quater dena* or *bis dena quater;* Díaz y Díaz, "Escriptorio," 72n89.

20. García Molinos, "Florencio de Valeránica," 314.

21. For more information on these historical figures, see Agustín Millares Carlo, "Un códice notable de los libros morales de San Gregorio Magno sobre Job," in *Estudios paleográficos* (Madrid: n.p., 1918), 55–56.

22. Martha Rust discusses an analogous Middle English expression "to rede in" as part of what she calls the "involved reading" practices of the Middle Ages; Rust, *Imaginary Worlds in Medieval Books: Exploring the Manuscript Matrix* (Basingstoke: Palgrave, 2007), 10.

23. García Molinos, "Florencio de Valeránica," 314–16. This part of Florentius's colophon also appears in a colophon to a copy of Gregory's *Homilies* made in northern Italy, probably in the mid-ninth century (Novara, Biblioteca Capitolare, LI [olim 33], f. 133r). If this dating is correct, the Novara colophon significantly predates Florentius's, but how the phrasing got to Castile remains a mystery.

24. García Molinos, "Florencio de Valeránica," 316–17.

25. For examples of the homeport analogy, see Lucien Reynhout, *Formules latines de colophons* (Turnhout: Brepols, 2006), vol. 1, no. 26; for the plea to watch our hands, see examples in Benedictines of Bouveret, *Colophons de manuscrits occidentaux des origines au XVIᵉ siècle* (Fribourg: Éditions Universitaires, 1965): nos. 4784 (Corbie, ninth c.), 12368 (Tours, tenth c.), and 23108 (ninth c.).

26. For detailed study of this formula, see Reynhout, *Formules latines*, vol. 1:95–100, and Kurt Otto Seidel, "'Tres digiti scribunt totumque corpus laborat': Kolophone als Quelle für das Selbstverständnis mittelalterlicher Schreiber," *Das Mittelalter* 7, no. 2 (2002). Díaz y Díaz observes testily that Florentius's "accumulation of scribal commonplaces beggars the imagination" [la acumulación de [tópicos de escriba] . . . rebasa cuanto pueda uno imaginar]; "Escriptorio," 70n57.

27. "Reading . . . demanded an interactive contact with the physical text, as the reader measured progress through the text with a finger, stopping often to caress or finger a particular word or image on the page, as the myriad rubbings and

erasures in medieval manuscripts attest. These punctuations, performances of speech and touch, structured the reader's understanding"; Peter Scott Brown, "The Verse Inscription from the Deposition Relief at Santo Domingo de Silos: Word, Image, and Act in Medieval Art," *Journal of Medieval Iberian Studies* 1, no. 1 (2009): 87–88. It's not surprising, then, that a copy of Cassian's *Collationes* completed at San Millán on August 17, 917 CE begs readers to wash their hands and keep them away from the letters: "Rogo te, lector, que et manus mudas in spatium teneas, ne littera deleas"; Madrid, RAH, MS 24, f. 149r.

28. Another possible context for the intervention, of course, is that it is a quotation. If it is, I have not been able to identify it, though there are evocative echoes for some of its phrases (e.g., Wisdom 6:21: "Therefore the desire of wisdom bringeth to the everlasting kingdom"). Antonio Viñayo González rather romantically takes it as directed toward the powerful Count Fernán González mentioned in the colophon. He translates, "The crown's brilliance made you lose your head. Settle your head and you will gain the crown" [El brillo de la corona te hizo perder la cabeza. Sienta la cabeza y lograrás la corona]; Viñayo González, "Florencio de Valeránica: Evocación y homenaje," *Memoria Ecclesiae* 3 (1993): 127.

29. Eight copies of the *Moralia* survive in the so-called "Riojan edition"; for an overview of those manuscripts, see Ana I. Suárez González, "La edición riojana de los *Moralia in Job* en un manuscrito calagurritano del siglo XI," *Berceo* 142 (2002). On the "edition" itself, see Díaz y Díaz, "Escriptorio," 59, and Díaz y Díaz, *Libros y librerías en la Rioja altomedieval* (Logroño: Diputación Provincial, 1979), 340–41.

30. *Crónica mozárabe de 754*, II.20; ed. José Eduardo López Pereira (León: Centro de Estudios e Investigación "San Isidoro," 2009), 192.

31. A good introduction to Taio, with ample bibliography, may be found in Carmen Codoñer Merino et al., eds., *La Hispania visigótica y mozárabe: Dos épocas en su literatura* (Salamanca: Ediciones Universidad de Salamanca, 2010), 196–202. For Taio's work with the *Moralia* more specifically, see José Madoz, "Tajón de Zaragoza y su viaje a Roma," in *Mélanges Joseph de Ghellinck, S.J.* (Gembloux: J. Duculot, 1951), and Manuel C. Díaz y Díaz, "Gregorio Magno y Tajón de Zaragoza," in *Libros y librerías*, 333–50.

32. Díaz y Díaz, "Gregorio Magno," 343.

33. Díaz y Díaz, "Gregorio Magno," 344.

34. Díaz y Díaz, "Gregorio Magno," 344.

35. Díaz y Díaz, "Gregorio Magno," 345.

36. López Pereira, *Crónica Mozárabe*, 196.

37. "Hay que reconocer que uno no se encuentra cada día con un tropel de santos tan bien dispuestos a la orientación bibliográfica"; Leonardo Funes, "En busca del códice perdido: Un viaje del siglo VII," *Siwa* 2 (2009), http://www.siwa .clubburton.com.ar/siwa_online/siwa_2.html.

38. López Pereira, *Crónica Mozárabe*, 196.

39. López Pereira, *Crónica Mozárabe*, 196.

40. López Pereira, *Crónica Mozárabe*, 192.

41. Francis L. Newton notices a similar "chain of command" recapitulation of the genesis and circulation of the Lindisfarne Gospels in their famous colophon—he calls it "pedigree"; Francis L. Newton, Francis L. Newton Jr., and Christopher R. J. Scheirer, "Domiciling the Evangelists in Anglo-Saxon England: A Fresh Reading of Aldred's Colophon in the 'Lindisfarne Gospels,'" *Anglo-Saxon England* 41 (2012).

42. Early medieval iconography insistently associates the sainted pope with images of book production in all its stages, from the mysteries of composition through dictation to scribes, authorial revision, and, finally, presentation. See, for example, Jean Vezin, "La réalisation matérielle des manuscrits latins pendant le haut Moyen Âge," *Codicologica* 2 (1978); Elizabeth Sears, "The Afterlife of Scribes: Swicher's Prayer in the Prüfening Isidore," in *Pen in Hand: Medieval Scribal Portraits, Colophons and Tools*, ed. Michael Gullick (Walkern, Herts.: Red Gull Press, 2006), 83–84; Camille, "Gregorian Definition Revised"; Johann Konrad Eberlein, *Miniatur und Arbeit* (Frankfurt am Main: Suhrkamp, 1995), 25–52.

43. Gregory the Great, *Moralia*, Ep. ad Leandrum 2: ed. Adriaen, vol. 143: 3; trans. Kerns, 49–50.

44. Gregory describes his dictation practices in *Homilies on the Gospel*, II. 21 and 22 and the Preface to the *Homilies on Ezekiel*.

45. Gregory the Great, *Moralia*, Ep. ad Leandrum 2: ed. Adriaen, vol. 143: 6; trans. Kerns, 54.

46. Gregory the Great, *Moralia*, Ep. ad Leandrum 2: ed. Adriaen, vol. 143: 6; trans. Kerns, 54. For discussion of Gregory's explicit identification with suffering in Job and Ezekiel, see Carole Ellen Straw, *Gregory the Great: Perfection in Imperfection* (Berkeley: University of California Press, 1988), 184–85.

47. Gregory the Great, *Moralia*, XXXV.20: ed. Adriaen, vol. 143B: 1,810–11; my trans.

2. MONKS AT WORK:
GRAMMATICA AND CONTEMPLATIVE MANUSCRIPTION

1. El Escorial, Biblioteca del Monasterio, a.I.13, f. 186v; Manuel C. Díaz y Díaz, "El Códice de Reglas signado por Leodegundia," in *Códices visigóticos en la monarquía leonesa* (León: Centro de Estudios de Investigación "San Isidoro," 1983), 107. Millares Carlo suggests correction of the date to "era DCCCXL" (=902 CE). For the purposes of this argument, the exact date of completion is not crucial.

2. For possible locations of Bobatella, see Díaz y Díaz, "El Códice de Reglas," 108–10.

3. Manchester, Rylands, MS lat. 83. Gomez's colophon is now missing but was transcribed in the early eighteenth century. It reads, "The final part of the book of Morals by Pope Gregory happily concludes. Thanks be to God. I, Gomez, deacon and sinner, wrote this work, era DCCCCLII, the VI of the kalends of December, at

the command of abbot Damianus" [Explicit foeliciter Liber Moralium pape Gregorii pars ultima: Deo gratias, Gomez Diaconus, peccator, hoc opus Era DCCCC.LII VI Kalend. decembris, ob iussionem domni Damiani abbatis praescripsi]; Francisco de Berganza, *Antiguedades de España* (Madrid: F. del Hierro, 1719), vol. 1: 177.

4. M. R. James, *A Descriptive Catalogue of the Latin Manuscripts in the John Rylands Library at Manchester* (Manchester: Manchester University Press, 1921), vol. 1: 151.

5. XIIII kalendas maii, hora VI, die v feria, sub era TCXXVIIII[a]; London, BL, Add MS 11695, f. 277v; Latin in Ann Boylan, "Manuscript Illumination at Santo Domingo de Silos (Xth to XIIth centuries)" (Ph.D., University of Pittsburgh, 1990), 205.

6. London, BL, Add MS 11695, f. 277v; Latin in Boylan, "Manuscript Illumination," 205.

7. A later reader was engaged enough with Leodegundia's work to correct her dating in heavy black ink on the bottom margin of f. 186v: "Note: in writing the book is dated to era DCCCCL, but DCCL should be read" [nota scriptum librum era DCCCCL, sed legendum DCCCL].

8. Quoted in José Angel García de Cortázar, "La colonización monástica en los reinos de León y Castilla (siglos VIII a XIII): Dominio de tierras, señorío de hombres, control de almas," in *El monacato en los reinos de León y Castilla (siglos VII–XIII)*, ed. Ana I. Suárez González (Ávila: Fundación Sánchez-Albornoz, 2007), 19. For a very brief overview of monasticism in Iberia before 1080, see Elena García Molinos, "Florencio de Valeránica: Calígrafo castellano del siglo X," in *El Reino de León en la Edad Media, XI* (León: Centro de Estudios e Investigación "San Isidoro," 2004), 362–63. More detailed studies in Charles Julian Bishko, *Spanish and Portuguese Monastic History, 600–1300* (London: Variorum Reprints, 1984); José Orlandis, *Estudios sobre instituciones monásticas medievales* (Pamplona: Universidad de Navarra, 1971); and the essays collected in Ana I. Suárez González, ed., *El Monacato en los reinos de León y Castilla (siglos VII–XIII)* (Ávila: Fundación Sánchez-Albornoz, 2007), and José Angel García de Cortázar and Teja Ramón, eds., *Monjes y monasterios hispanos en la Alta Edad Media* (Aguilar de Campoo: Fundación Santa María la Real, 2006).

9. With the Gregorian reform of 1080, Cluniac Benedictinism was virtually imposed. Many foundations in the region covered by this study resisted forcefully: see Artemio Manuel Martínez Tejera, "Cenobios leoneses altomedievales ante la europeización: San Pedro y San Pablo de Montes, Santiago y San Martín de Peñalba y San Miguel de Escalada," *Hispania Sacra* 54 (2002). For the liturgical response to the Reform, which also replaced the traditional Hispanic liturgy, see Rose Walker, *Views of Transition: Liturgy and Illumination in Medieval Spain* (Toronto: University of Toronto Press, 1998).

10. Antonio Linage Conde spent much of a lifetime studying the "Benedictinization" of the Iberian peninsula; see especially *Los orígenes del monacato benedictino en la Península Ibérica* (León: Centro de Estudios e Investigación

"San Isidoro," 1973), 9–11, but see also José Mattoso, "L'introduction de la Règle de S. Benoît dans la péninsule ibérique," *Revue d'Histoire Ecclésiastique* 70, no. 3–4 (1975). Of the monasteries associated with the manuscripts studied in this book, the following privileged the Benedictine Rule: San Millán (Benedictine by 971), Albelda in 955 (Antonio Ubieto Arieta, *Cartulario de Albelda* [Valencia: n.p., 1960], no. 21), Escalada in the early tenth century; Martínez Tejera, "Cenobios leoneses."

11. For an overview of Iberian rules (with abundant bibliography), see José Carlos Martín, "Reglas monásticas," in *La Hispania visigótica y mozárabe: Dos épocas en su literatura*, ed. Carmen Codoñer Merino (Salamanca: Ediciones Universidad de Salamanca, 2010). The major Iberian rules are usefully edited and translated in Julio Campos Ruiz and Ismael Roca Meliá, *Santos Padres españoles*, vol. 2, *San Leandro, San Isidoro y San Fructuoso: Reglas mozárabes de la España visigoda* (Madrid: Biblioteca de Autores Cristianos, 1971).

12. In the pactual system, future monastics are bound by a written pact detailing mutual obligations of monastics and their superiors to which they append their marks as a sign of agreement. Pacts are often copied in *codices regularum* along with monastic Rules proper; Charles Julian Bishko, "Gallegan Pactual Monasticism in the Repopulation of Castille," in *Estudios dedicados a Menéndez Pidal*, vol. 1 (Madrid: Consejo Superior de Investigaciones Científicas, 1951).

13. For Leodegundia's book as a *codex regularum*, see Guillermo Antolín, *Un Codex regularum del siglo IX: Opúsculos desconocidos de S. Jerónimo; Historia, estudio y descripción* (Madrid: Helénica, 1908). Escorial MS a.I.13 is a composite of at least two separately conceived monastic codices. The first part, now ff. 1–187, is the one that Leodegundia had a hand in copying; ff. 188–204, from roughly the same period, is composed mostly of Psalm commentaries by St. Jerome and others. Díaz y Díaz suggests that the two parts were not bound together until the sixteenth century; *Códices visigóticos*, 93. See also Adalbert de Vogüé, "Le codex de Leodegundia (Escorial a.I.13): Identification et interprétation de quelques morceaux," *Revue Bénédictine* 96, no. 1–2 (1986).

14. Jerome, letter 125, in *Epistulae*, ed. I. Hilberg, CSEL 56 (Vienna: Hoelder-Pichler-Tempsky, 1918), 142. Leodegundia copied this text at the bottom of f. 186v of her *Codex Regularum* (Escorial a .I.13).

15. On monastic labor, see especially José Orlandis, "El trabajo en el monacato visigótico," in *La Iglesia en la España visigótica y medieval* (Pamplona: Ediciones Universidad de Navarra, 1976), and Willibrod Witters, "Travail et *lectio divina* dans le monachisme de St Benoît," in *Atti del 7 Congresso Internazionale di Studi sull'Alto Medioevo* (Spoleto: Presso la sede del centro,1982).

16. Isidore, *Regula* V.1: ed. Campos Ruiz and Roca Meliá, *Santos Padres españoles. II*, 97; trans. Aaron W. Godfrey, "The Rule of Isidore," *Monastic Studies* 18 (1988): 12.

17. Isidore of Seville, *Regula* V.5: ed. Campos Ruiz and Roca Meliá, *Santos Padres españoles II*, 99; trans. Godfrey, "Rule of Isidore," 13.

18. Fructuosus of Braga, *Regula Complutensis* IV: ed. Campos Ruiz and Roca Meliá, *Santos Padres españoles II*, 143; trans. Claude W. Barlow, in *Iberian Fathers: Braulio of Saragossa, Fructuosus of Braga* (Washington, D.C.: The Catholic University of America Press, 1969), 161–62.

19. Isidore of Seville, *De ecclesiasticis officiis* II.16.12: ed. C. W. Lawson, CCSL 113 (Turnhout: Brepols, 1989), 77; trans. Thomas Knoebel (New York: Newman Press, 2008), 88.

20. *Regula Ferreoli* 28: ed. Vincent Desprez, "La 'Regula Ferioli': Texte critique," *Revue Mabillon* 60, no. 287–88 (1982): 139. The first surviving text in what we now call Italian (the so-called *indovinello Veronese*) is a riddle turning on this very identification of pen with plow. It was written in an Italian cursive in an orational in Visigothic hand; Verona, Biblioteca Capitolare, MS 89.

21. Cassiodorus, *Cassiodori Senatoris Institutiones* I.i.30: ed. Roger Aubrey Baskerville Mynors (Oxford: Clarendon, 1937), 75; trans. Leslie Webber Jones (New York: Columbia University Press, 1946), 133.

22. Munnionus signs off again on f. 48v of RAH, MS 60, writing the words, "Remember unworthy Munnionus" [Munionem indignum memorare] over an erasure a little over a full line long. This, too, is the way and the work of the monastic.

23. Jerome, letter 125: ed. Hilberg, *Epistulae*, vol. 56: 131.

24. Claudia Rapp, "Holy Texts, Holy Men, and Holy Scribes: Aspects of Scriptural Holiness in Late Antiquity," in *The Early Christian Book*, ed. William E. Klingshirn and Linda Safran (Washington, D.C.: The Catholic University of America Press, 2007), 195.

25. Guy G. Stroumsa, *The Scriptural Universe of Ancient Christianity* (Cambridge, Mass.: Harvard University Press, 2016), 86.

26. Ivan Illich, *In the Vineyard of the Text: A Commentary to Hugh's "Didascalicon"* (Chicago: University of Chicago Press, 1993), 68.

27. "Si trata di leggere, pronunciando le parole almeno interiormente, di 'ruminarle,' cioè di ripeterle in maniera tale da fare passare alla memoria in sé e da metterle in pratica"; Jean Leclercq, "*Lectio divina* in occidente," in *Dizionario degli istituti di perfezione*, ed. Guerrino Pelliccia and Giancarlo Rocca (Rome: Edizioni Paoline, 1974), 564.

28. Isidore of Seville, *Sententiae* III.8.3: ed. Pierre Cazier, CCSL 111 (Turnhout: Brepols, 1998), 229; trans. Thomas Knoebel (New York: Newman Press, 2018), 160.

29. Jean Leclercq, *The Love of Learning and the Desire for God*, trans. Catherine Mizrahi (New York: Fordham University Press, 1961), 17.

30. I have been doing this myself with the Mahayana Buddhist *Diamond Sutra*. I will have finished memorizing the whole thing by the time you read these lines.

31. Early medieval Iberian monastics loved and learned from Cassian's *Collationes*. Two complete manuscripts survive in Visigothic hand: Madrid, RAH, MS 24 and Paris, BnF, nal 2170, as well as three fragments: Madrid, AHN, 1452B.10; Las Palmas de Gran Canaria, Seminario Millares Carlo, no shelf number; and Barcelona, Museu Diocesà, no shelf number.

32. Cassian, *Collationes* X.11: ed. M. Petschenig, CSEL 13 (Vienna: Gerold, 1886), 305; trans. Duncan Robertson, *"Lectio divina": The Medieval Experience of Reading* (Collegeville, Minn.: Liturgical Press, 2011), 86.

33. Isidore, *Sententiae* III.9.1–2, "On Assiduous Reading": "No one is able to know the meaning of the Sacred Scriptures except through familiarity of reading it. . . . To the extent that one has become more assiduous in the sacred writings, he will possess greater and greater knowledge from them, just as the earth, as it is more greatly cultivated, bears fruit more abundantly" [Nemo potest sensum scripturae sanctae cognoscere, nisi legendi familiaritate . . . Quanto quisque magis in sacris eloquiis adsiduus fuerit, tanto ex eis uberiorem intellegentiam capit; sicut terra, quae quanto amplius excolitur, tanto uberius fructificatur]: ed. Cazier, 230–31; trans. Knoebel, *Sententiae*, 161.

34. Cassian, for example, urges that the practitioner work with the phrase "O God, make speed to save me: O Lord, Make haste to help me" (Ps 69:2) throughout the day, applying it to whatever situation might arise; Cassian, *Collationes* X.10: ed. Petschenig, 297.

35. Gregory the Great, *Moralia* I.24, ed. Marc Adriaen, CCSL 143 (Turnhout: Brepols, 1979–81), 43.

36. Cassian, *Collationes* XIV.10.2: ed. Petschenig, 410; trans. C. S. Gibson in *The Nicene and Post-Nicene Fathers*, ed. Philip Schaff and Henry Wace (New York: The Christian Literature Company, 1890), second series, vol. 11: 440.

37. Cassian, *Collationes* X.11: ed. Petschenig, 304; trans. Robertson, *Lectio divina*, 86.

38. Elipandus taught a Christology that had long been part of Iberian Christianity. Beatus, however, thought it heretical. Their argument has since been called the "Adoptionist" controversy. For a good orientation, see John C. Cavadini, *The Last Christology of the West: Adoptionism in Spain and Gaul, 785–820* (Philadelphia: University of Pennsylvania Press, 1993).

39. Beatus of Liébana, *Adversus Elipandum* I.66: ed. Bengt Löfstedt, CCCM 59 (Turnhout: Brepols, 1984), 50.

40. Beatus of Liébana, *Adversus Elipandum* I.71: ed. Löfstedt, 55.

41. Beatus is quoting from Augustine's sermon 229: ed. Germain Morin (Rome: Tipografia Poliglotta Vaticana, 1930), 30. Though marginal annotations in the manuscript of the *Adversus Elipandum* regularly identify *auctores*, this citation goes unnoticed in both manuscript (BNE MS 10018, f. 29r) and the modern edition (Beatus of Liébana, *Adversus Elipandum*, ed. Löfstedt, 50).

42. Beatus of Liébana, *Adversus Elipandum* I.71, ed. Löfstedt, 55. Augustine's conclusion of the passage that Beatus cites here drives a doctrinal point, reminding us that, like the wheat, we too were created: "Remember: you were not, and you were created; you were transported to the Sunday threshing floor by the labor of oxen, that is, you were milled by the news of the gospels" [recordamini, et uos: non fuistis, et creati estis, ad aream dominicam conportati estis, laboribus boum, id est, annuntiantium euangelium triturati estis]: ed. Morin, 30. Beatus turns the

quote more contemplatively, saying simply, "All of this, you are" [Hoc totum uos estis]: ed. Löfstedt, 50.

43. Books like the *Moralia* or a *codex regularum* like the one copied by Leodegundia were volumes of great authority that would serve the community for generations. Scribes entrusted with such an important commission would of course to be highly skilled writers. But it would not be surprising if they were chosen for their meditative maturity as well, not only because careful reading of the exemplar ensures a trustworthy final product, but also because a book copied with meditative devotion would surely instill the same reverence in its reader.

44. Madrid, BNE, MS 80, f. 500v.

45. There was also, of course, a pragmatic reason for placing such stress upon recording scribal labor—it offers proof lest scribes be thought to be messing around in the scriptorium and not working; Paul Edward Dutton, "The Desert War of a Carolingian Monk," *Journal of Medieval and Early Modern Studies* 47, no. 1 (2017).

46. Rapp, "Holy Texts," 211; see also Guglielmo Cavallo, "Entre lectura y escritura: Los usos del libro en el monacato primitivo y en las fundaciones benedictinas de la alta edad media," in *Silos—un milenio*, vol. 1 (Burgos: Universidad de Burgos, 2003).

47. Letter from Taio to Eugenius of Toledo, in Manuel C. Díaz y Díaz, "Gregorio Magno y Tajón de Zaragoza," in *Libros y librerías en la Rioja altomedieval* (Logroño: Diputación Provincial, 1979), 344.

48. Gregory the Great, *Moralia* I.24: ed. Adriaen, vol. 143: 43.

49. Jerome, "Prologus in libro Iob de graeco emendato": Latin in *Biblia sacra iuxta Latinam Vulgatam versionem*, ed. Francis Gasquet (Rome: Typis Polyglottis Vaticanis, 1951), vol. 9: 74–75; trans. Megan Hale Williams, *The Monk and the Book: Jerome and the Making of Christian Scholarship* (Chicago: University of Chicago Press, 2006), 167. Florentius (or his exemplar) edited out Jerome's female audience, replacing the address to Paula and Eustochium with the simple masculine plural *dulcissimi*.

50. Madrid, BNE, MS 80, f. 500v; ed. García Molinos, "Florencio de Valeránica, 316.

51. Isidore, *Regula monachorum* V: ed. Campos Ruiz and Roca Meliá, *Santos Padres españoles II*, 98; trans. Godfrey, "The Rule of Isidore," 12–13.

52. The corporeality of reading cannot be ignored even in our age of cloud computing—witness the new diagnosis "text neck," a poetic name that Florentius would appreciate. See, e.g., Bridget Carey, "It's not too late to stop your phone from wrecking your neck," *cnet*, June 9, 2017, https://www.cnet.com/how-to/fix -tech-neck-pain-phone-stretches-posture/.

53. Madrid, BNE, MS 80, f. 500v; García Molinos, "Florencio de Valeránica," 314–15.

54. Isidore, *Regula monachorum* V: ed. Campos Ruiz and Roca Meliá, *Santos Padres españoles II*, 98; trans. Godfrey, "Rule of Isidore," 12–13.

55. Robertson, *Lectio divina*, xv.

56. Mary J. Carruthers, "The Concept of Ductus, or, Journeying through a Work of Art," in *Rhetoric Beyond Words: Delight and Persuasion in the Arts of the Middle Ages*, Cambridge Studies in Medieval Literature (Cambridge: Cambridge University Press, 2010), 190.

57. Many thanks to Will Fitzgerald for engaging with Florentius with such energy and enthusiasm. For how the program counting iterations in the labyrinth works, see his post at https://github.com/willf/florentius/blob/master/investigation.md, accessed July 19, 2018. An animation of the paths as they accumulate may be found at https://beta.observablehq.com/@wiseman/florensis-labyrinth, accessed January 6, 2020.

58. *Machina* is defined by Lewis and Short as "any artificial contrivance for performing work"; Charlton Lewis and Charles Short, *A Latin Dictionary* (Oxford: Clarendon, 1993). Monastic practice as lived by the people studied in this book was full of machines in this broad sense. The holy building itself was in these terms a machine. Thus a church at Cangas de Onís consecrated on Sunday, October 27, 737 CE, bore the inscription, "This holy machine rises by divine command, / adorned in its little work by faithful promises" [Resurgit ex preceptis diuinis hec macina sacra: / Opere exiguo comtum fidelibus uotis]; Manuel C. Díaz y Díaz, "La inscripción de la Santa Cruz de Cangas de Onís," in *Asturias en el siglo VIII, la cultura literaria* (Oviedo: Sueve, 2001), 32.

59. Mary Carruthers, *The Craft of Thought: Meditation, Rhetoric, and the Making of Images, 400–1200* (Cambridge: Cambridge University Press, 1998), 221. Carruthers characterizes pages like Florentius's labyrinth as "games of ingenious meditation" (*The Craft of Thought*, 129). For other treatments of the carpet page as meditative machine, see Jean-Claude Bonne, "Noeuds d'ecritures (Le fragment I de l'Evangeliaire de Durham)," in *Texte-Image: Bild-Text*, ed. Sybil Dümchen and Michael Nerlich (Berlin: Institut für romanische Literaturwissenschaft, 1990); Jean-Claude Bonne, "De l'ornemental dans l'art medieval (VII–XII siècle): Le modèle insulaire," *Cahiers du Léopard d'Or* 5 (1996); Emanuelle Pirotte, "Hidden Order, Order Revealed: New Light on Carpet Pages," in *Pattern and Purpose in Insular Art*, ed. M. Redknap (Oxford: Oxbow, 2001).

60. Regula Ferreoli XI: ed. Desprez, "La 'Regula Ferrioli,'" 13.

61. For the habitation of letters, see John Dagenais, "That Bothersome Residue: Toward a Theory of the Physical Text," in *Vox intexta: Orality and Textuality in the Middle Ages*, ed. Alger Nicolaus Doane and Carol Braun Pasternack (Madison: University of Wisconsin Press, 1991), and Catherine Brown, "Scratching the Surface," *Exemplaria* 26, no. 2–3 (2014).

62. David Damrosch, "Scriptworlds: Writing Systems and the Formation of World Literature," *Modern Language Quarterly* 68, no. 2 (2007): 200.

63. Pierre Bourdieu, *The Logic of Practice* (Stanford, Calif.: Stanford University Press, 1990), 56.

64. Illich, *In the Vineyard of the Text*, 70. Equally vivid, if from a slightly later period than the one studied here, are the images collected in Laura Cleaver,

Education in Twelfth-Century Art and Architecture: Images of Learning in Europe, c.1100–1220 (Woodbridge: Boydell, 2016).

65. See, for example, Quintilian, *Institutio Oratoria* I.i.26–29, ed. and trans. H. E. Butler (Cambridge, Mass.: Harvard University Press, 1996).

66. Jerome letter 107: ed. Hilberg, *Epistulae*, vol. 55: 294; trans. W. H. Fremantle in *The Nicene and Post-Nicene Fathers*, ed. Philip Schaff and Henry Wace (New York: The Christian Literature Company, 1893), second series, vol. 6: 191.

67. If Paula had been Jewish with a Jewish tutor, she might have learned her letters by taste, too: "During the Middle Ages, there developed a picturesque ceremony of introducing the child to his Jewish studies; it included the custom of writing the letters of the alphabet on a slate and covering them with honey. These the child licked with his tongue so that the words of the Scriptures might be as 'sweet as honey'"; Tikva S. Frymer and Louis Isaac Rabinowitz, "Honey," in *Encyclopaedia Judaica*, ed. Michael Berenbaum and Fred Skolnik (Detroit: Macmillan Reference, 2007), 9:517–18.

68. Jerome, letter 107: ed. Hilberg, *Epistulae*, vol. 55: 294; trans. Fremantle, 191.

69. Jerome, letter 107: ed. Hilberg, *Epistulae*, vol. 55: 294; trans. Fremantle, 191. Cassian makes a very similar move comparing the practice of spiritual reading with grammatical education in *Collationes* X.10: "Wherefore in accordance with that system, which you admirably compared to teaching children (who . . . trace out their characters with a steady hand if they have, by means of some copies and shapes carefully impressed on wax, got accustomed to express their figures, by constantly looking at them and imitating them daily), we must give you also the form of this spiritual contemplation, on which you may always fix your gaze with the utmost steadiness, and both learn to consider it to your profit in unbroken continuance, and also manage by the practice of it and by meditation to climb to a still loftier insight"; trans. Gibson, 405.

70. On character and *kharassein*, see David Ganz, "'Mind in Character': Ancient and Medieval Ideas about the Status of the Autograph and the Expression of Personality," in *Of the Making of Books: Medieval Manuscripts, Their Scribes and Readers; Essays Presented to M. B. Parkes*, ed. Pamela Robinson and Rivkah Zim (Aldershot, England: Scolar Press, 1997).

71. Jerome, *Commentary on Habakkuk*, I.2: ed. Sincero Mantelli, *Commentarii in prophetas minores*, CCSL 76 (Turnhout: Brepols, 2018), 30.

72. Córdoba, AC MS 1, f. 3r; García Molinos, "Florencio de Valeránica," 368.

73. For medieval *grammatica* as theory, see Martin Irvine, *The Making of Textual Culture: "Grammatica" and Literary Theory, 350–1100* (Cambridge: Cambridge University Press, 1994); Martin Irvine and David Thomson, "*Grammatica* and Literary Theory," in *The Cambridge History of Literary Criticism*, vol. 2, *The Middle Ages*, ed. Alastair Minnis et al. (Cambridge: Cambridge University Press, 2005). Working with the primary texts of grammatical theory is now much facilitated by Rita Copeland and I. Sluiter, *Medieval Grammar and Rhetoric: Language Arts and Literary Theory, AD 300–1475* (Oxford and New York: Oxford

University Press, 2009). Elegant studies of trans-Pyrenean early medieval grammar pedagogy are available; for example, Vivien Law, *Grammar and Grammarians in the Early Middle Ages* (London: Longman, 1997); Anna Grotans, *Reading in Medieval St. Gall* (Cambridge: Cambridge University Press, 2006); and Catherine M. Chin, *Grammar and Christianity in the Late Roman World* (Philadelphia: University of Pennsylvania Press, 2007). Michel Zimmermann has begun the task for Catalonia, but no equivalents have yet appeared for early medieval Castile-León; Zimmermann, *Ecrire et lire en Catalogne: IX^e–XII^e siècles* (Madrid: Casa de Velázquez, 2003).

74. *OED*, s.v. articulation.

75. As in the rest of Europe, the main grammatical *auctores* in Iberia were Donatus and Priscian. Absent the documentation preserved at St. Gall (Grotans, *Reading*), it is difficult to work out exactly how grammatical pedagogy was conducted in early medieval Iberia, though, because only one grammatical codex (containing texts of Donatus and fragments of Priscian and Servius) survives in Visigothic hand: Toledo, Archivo Capitular, 99.30. Natively Iberian is the grammar attributed to Julian of Toledo (d. 690), which reworks Donatus with citations from Hispanic authors; Maria A. H. Maestre Yenes, *Ars Iuliani Toletani Episcopi: Una gramática latina de la España visigoda* (Toledo: Diputación Provincial, 1973).

76. Donatus, *Ars maior* I.1: ed. Henricus Keil, *Grammatici latini* (Leipzig: Teubner, 1857), vol. 4: 367; trans. after Copeland and Sluiter, *Medieval Grammar and Rhetoric*, 87.

77. Maestre Yenes, *Ars Iuliani*, 114. Julian is quoting Servius, *Explanationes in arte Donati*: "Articulate speech is what can be written, that which is subject to joints [*articulis*], that is, the fingers which write, or because it carries out an art [*artem*] or acts as a model": ed. Keil, *Grammatici latini*, vol. 4: 519; trans. Irvine and Thomson, "*Grammatica* and Literary Theory," 31.

78. Priscian, *Institutiones grammaticae* I: ed. Keil, *Grammatici latini*, vol. 2: 6; trans. Copeland and Sluiter, *Medieval Grammar and Rhetoric*, 173.

79. Priscian, *Institutiones grammaticae* I; emphasis added: ed. Keil, *Grammatici latini*, vol. 2: 6; trans. Copeland and Sluiter, *Medieval Grammar and Rhetoric*, 173.

80. Irvine and Thomson, "*Grammatica* and Literary Theory," 32.

81. Servius, *Explanationes*: ed. Keil, *Grammatici latini*, vol. 4: 519; trans. Irvine and Thomson, "*Grammatica* and Literary Theory," 31.

82. The *vox* as stricken air (*aer ictus*): Priscian, *Institutiones* I: ed. Keil, *Grammatici latini*, vol. 2: 6.

83. Isidore of Seville, *Etymologies* XI.1: ed. W. M. Lindsay (Oxford: Clarendon, 1911); trans. Stephen A. Barney et al. (Cambridge: Cambridge University Press, 2006), 236.

84. Terentianus Maurus, *De litteris* praefatio, lines 15–16: ed. Keil, *Grammatici latini*, vol. 6: 32; trans. Copeland and Sluiter, *Medieval Grammar and Rhetoric*, 74.

85. Terentianus, *De litteris* praef., lines 27–29, 33–35: ed. Keil, *Grammatici latini*, vol. 6: 325–26; trans. Copeland and Sluiter, *Medieval Grammar and Rhetoric*, 74–75.

86. Terentianus, *De litteris* praef., lines 36–39, 46–47: ed. Keil, *Grammatici latini*, vol. 6: 326.; trans. Copeland and Sluiter, *Medieval Grammar and Rhetoric*, 75.

87. Jerome letter 125: ed. Hilberg, *Epistulae*, vol. 56: 131.

88. Ed. Keil, *Grammatici latini*, vol. 4: 519; trans. Irvine and Thomson, "*Grammatica* and Literary Theory," 31.

89. Here, perhaps surprisingly, late ancient literary theory meets the twentieth-century theory of Jean-Luc Nancy: "'Articulation' means, in some way, 'writing,' which is to say, the inscription of a meaning whose transcendence or presence is indefinitely and constitutively deferred"; Nancy, *The Inoperative Community*, trans. Peter Connor (Minneapolis: University of Minnesota Press, 1991), 80.

90. Ed. Keil, *Grammatici latini*, vol. 2: 6; trans. Copeland and Sluiter, *Medieval Grammar and Rhetoric*, 173.

91. Isidore of Seville, *Etymologies* I.3.1–4: ed. Lindsay; trans. Barney et al., 39. John Henderson's punningly playful translation captures Isidore's wit: "Called letters, for short, mind—really they are *legiters* because readers must leg it, or let's iterate"; Henderson, *The Medieval World of Isidore of Seville: Truth from Words* (Cambridge: Cambridge University Press, 2007), 32.

92. So it is still for Derrida: "Writing manuscripts," he writes, converting the familiar noun into a verb. Like the hand, writing "ties together the letters, conserves and gathers together"; Jacques Derrida, "Geschlecht II: Heidegger's Hand," in *Deconstruction and Philosophy: The Texts of Jacques Derrida*, ed. John Sallis (Chicago: University of Chicago Press, 1987), 178.

93. Augustine, *In Iohannis euangelium tractatus*, XLVIII.7: ed. R. Willems, CCSL 36 (Turnhout: Brepols, 1954), 416.

94. "I call such a sign," says C. S. Peirce, "an *index*, a pointing finger being the type of the class." "The index," he adds, "asserts nothing; it only says 'There!' It takes hold of our eyes, as it were, and forcibly directs them to a particular object, and there it stops"; Peirce, "On the Algebra of Logic: A Contribution to the Philosophy of Notation," *American Journal of Mathematics* 7 (1885).

95. Isidore of Seville, *Etymologies* I.3: ed. Lindsay; trans. Barney et al., 39.

96. Seventeen codices of the *Etymologies* survive in Visigothic hand, according to the *Corpus de códices visigóticos*. Several of them will participate in our conversation in this book: the ones made by Aeximino (Madrid, RAH, MS 25), Endura and Didaco (Madrid, RAH, MS 76), and Ericonus (Paris, BnF, nal 2169).

97. Seneca the Younger, Letter 40; trans. Richard M. Gummere, Loeb Classical Library (Cambridge, Mass.: Harvard University Press, 1934), vol. 1: 262–65.

98. Isidore letter 2: Latin in PL 80: 649B; trans. after Barlow, *Iberian Fathers*, vol. 2: 16.

99. Jesper Svenbro, *Phrasikleia: An Anthropology of Reading in Ancient Greece*, trans. Janet Lloyd (Ithaca, N.Y.: Cornell University Press, 1993), 44.

100. Madrid, RAH, MS 25, f. 22r: ed. Díaz y Díaz, *Libros y librerías*, 284. Thanks to Donka Markus for help with this very difficult Latin. I have not yet been able

to arrive at a decent translation of the remainder. Here is the whole poem in Díaz y Díaz's edition, if you want to try:

En ora paginis	Alacer insedenS
Xistentesque fessos	Bis meis artus siC
Inmixtis omnibus	Bonis adiungieR
Minax [erasure] aufugiam	Atraque baratrI
In precor fratribvs-	Toth uos idem ritU
Nomen caput sicetaneor	In medio [erasure] abbA
Ora tu dignior	Sic memet fertitE

101. Madrid, RAH, 25, f. 295v. Latin from Díaz y Díaz, *Libros y librerías*, 284. Thanks to Philipp Nothaft for assistance with the translation.

102. "Thing theory" is laid out most programmatically in Bill Brown, "Thing Theory," *Critical Inquiry* 28, no. 1 (2001) and beautifully developed for medieval studies in Andrew Cole, "The Call of Things: A Critique of Object-Oriented Ontologies," *Minnesota Review* 80 (2013).

103. Jerome, "Prologus in Iob": ed. Gasquet, *Biblia sacra iuxta Latinam Vulgatam versionem*, vol. 9: 74–75.

3. THE GARDEN OF COLOPHONS

1. Jerome, "Prologus in libro Iob," in *Biblia sacra iuxta Vulgatam versionem*, ed. Bonifatius Fischer et al. (1975), 732. The printed text of the last sentence applies the advice to be more studious than spiteful to the reader: "eligat unusquisque quod uult et studiosum *se* magis quam maliuolum probet." Florentius's Jerome, however, is talking about himself: "studiosum *me* magis quam maliuolum probet." I have altered the quoted Latin to follow the manuscript on this one point.

2. Elena García Molinos identifies one other hand in the Córdoba Homiliary, intervening between ff. 409r and 450r; "Florencio de Valeránica: Calígrafo castellano del siglo X," in *El Reino de León en la Edad Media, XI* (León: Centro de Estudios e Investigación "San Isidoro," 2004), 377–79. The Homiliary was executed after the *Moralia*; reasons for this dating will be discussed later. The codex is finally receiving the close attention it deserves. Elena García Molinos gives it rigorously detailed codicological analysis ("Florencio de Valeránica," 360–80). José Julio Martín Barba studies other salient aspects: "Los prólogos e iluminaciones de Florencio de Valeránica en el Smaragdo de la Catedral de Córdoba," *Studia Cordubensia* 8 (2015); "El Smaragdo de Córdoba en la almoneda de los bienes de Isabel la Católica: Las vicisitudes del códice de Florencio, de Valeránica," in *Nasara, extranjeros en su tierra: Estudios sobre cultura mozárabe y catálogo de la exposición*, ed. Eduardo Cerrato and Diego Asensio (Córdoba: Catedral de Córdoba, 2018); and "El texto del Canto de la Sibila en el Smaragdo de Córdoba de Florencio de Valeránica," in Cerrato and Asensio, *Nasara, extranjeros en su tierra*.

3. The most readily accessible edition of Florentius's Homiliary prologues may be found in Manuel C. Díaz y Díaz, "Los prólogos y colofones de los códices de

Florencio," in *Códices visigóticos en la monarquía leonesa* (León: Centro de Estudios de Investigación "San Isidoro," 1983); more generously annotated is the text in García Molinos, "Florencio de Valeránica," 366–70. Martín Barba offers a modern Spanish translation in "Los prólogos."

4. Córdoba, AC, MS 1, f. 2r; García Molinos, "Florencio de Valeránica," 367.

5. García Molinos, "Florencio de Valeránica," 367.

6. Charlton Lewis and Charles Short, *A Latin Dictionary* (Oxford: Clarendon, 1993), s.v. *studiosus*.

7. *Pace* Shailor, who thought it an early production; this evidence supports a mid-career placement of the Córdoba Homiliary like that proposed by Martín Barba, who dates it to 954–60; Barbara A. Shailor, "The Scriptorium of San Pedro de Berlangas" (Ph.D., University of Cincinnati, 1975), 130; Martín Barba, "Los prólogos," 30.

8. Claudia Rapp, "Holy Texts, Holy Men, and Holy Scribes: Aspects of Scriptural Holiness in Late Antiquity," in *The Early Christian Book*, ed. William E. Klingshirn and Linda Safran (Washington, D.C.: The Catholic University of America Press, 2007), 211.

9. Cassian, *Collationes* XIV.13: ed. M. Petschenig, CSEL 13 (Vienna: Gerold, 1886), 415; trans. C. S. Gibson in *The Nicene and Post-Nicene Fathers*, ed. Philip Schaff and Henry Wace (New York: Christian Literature, 1890), 2nd series, vol. 11: 442.

10. García Molinos, "Florencio de Valeránica," 367. The fourth word in this sentence (*peregi*) is a problem. Though I prefer to cite from García Molinos's edition, I have not followed her reading of the word as *peregrino*, preferring García y García's rendering, *peregi*; Antonio García y García, Francisco Cantelar Rodríguez, Manuel Nieto Cumplido, et al., *Catálogo de los manscritos e incunables de la Catedral de Córdoba* (Salamanca: Monte de Piedad y Caja de Ahorros de Córdoba, 1976). On the manuscript page, the first five letters of the word are clear; the rest is not. Both renderings make good sense in context. I prefer *peregi* ("I have completed") for the prolepsis it creates, though we have no idea when Florentius copied this page (and he might indeed have copied it after doing the rest); this verb, so frequent in colophons to mark the end of the scribe's labor, throws us forward to imagine the end of the codex even as we are beginning it.

11. Córdoba, AC, MS 1 f. 3r: García Molinos, "Florencio de Valeránica," 367–68.

12. García Molinos, "Florencio de Valeránica," 368.

13. García Molinos, "Florencio de Valeránica," 368.

14. García Molinos, "Florencio de Valeránica," 369.

15. García Molinos, "Florencio de Valeránica," 369–70.

16. García Molinos, "Florencio de Valeránica," 370.

17. The errors were clearly spotted after the page was complete. Undecipherable traces of letter forms remain beneath the erasure.

18. García Molinos, "Florencio de Valeránica," 370.

19. Studies on the Oña Bible: García Molinos, "Florencio de Valeránica," 275–300; John Williams, "A Model for the León Bibles," *Madrider Mitteilungen* 8 (1967); and Teófilo Ayuso Marazuela, *La Biblia de Oña: Notable fragmento casi desconocido de un códice visigótico* (Zaragoza: Consejo Superior de Investigaciones Científicas, 1945).

20. Quoted in García Molinos, "Florencio de Valeránica," 276, who prints a reconstructed text of the colophon on 278–79.

21. Quoted in García Molinos, "Florencio de Valeránica," 276.

22. Iñigo de Barreda y Lombera, *Memorias Diplomáticas, Apologias, y Dissertaciones Históricas, que se ventilan entre los Antiquarios Historiadores a favor de la verdad.* No copies of this work survive. Constancio Gutiérrez's 1960 article tells a wonderfully bibliophilic (if ever so slightly improbable) story of encountering a manuscript copy of Barreda's book through the good offices of a friend who was parish priest in the town of Comillas; Gutiérrez, "¿Cuándo se escribió la llamada Biblia de Oña?," *Estudios Eclesiásticos* 34 (1960). Gutiérrez lost track of the manuscript after the death of its owner in 1949. Fortunately, he says, he microfilmed it before its disappearance.

23. Quoted in Gutiérrez, "¿Cuándo se escribió?," 407.

24. Gutiérrez, "¿Cuándo se escribió?," 407, emphasis added.

25. Argaiz notes that Florentius "wrote the whole Bible on parchment, in very small letters, illustrating the main stories of the Old Testament with images that, although very different from our tastes today, were much appreciated in his time" [escribió toda la Biblia en pergamino, de letra muy menuda, imaginando las principales historias del Testamento Viejo, y aunque con pinturas diferentes del pincel de aora, pero estimadas de los curiosos de entonces]; Gregorio de Argaiz, *La Soledad laureada por San Benito y sus hijos* (Madrid: Bernardo de Herbada, 1675), f. 289v.

26. The translation takes some liberties with the somewhat contorted Latin. Writing acrostics in Latin is hard, as we shall see in Chapter 8.

27. Argaiz, *Soledad laureada*, f. 289r. Florentius's archpriest Eximino is not likely to be the same as Aeximino who made the copy of Isidore's *Etymologies* studied at the end of Chapter 2 (Madrid, RAH, MS 25). (A)eximino—Jimeno— then as now—is not an uncommon name in Iberia.

28. Argaiz explains: "He left on the folios some Acrostic verses, the five that I have given above. In five ranks he says what he wants" [Dexó en los folios vnos versos Acrósticos, que son los cinco que he puesto. En cinco órdenes dize lo que quiere]; *Soledad laureada*, f. 289v. For the diagram, see García Molinos, "Floren-cio de Valeránica," 280. The technical term for the kind of compound acrostic poem Florentius has made here is *acromesotelestich*—the letters at the beginning (*acro-*), middle (*meso-*), and end (*tele-*) of each line made sense vertically as well as horizontally. We shall return to this kind of carefully woven poem, so in vogue in early medieval Europe, in Chapter 8.

29. Argaiz, *Soledad laureada*, f. 289v.

30. Argaiz, *Soledad laureada*, f. 289v.

31. Argaiz, *Soledad laureada*, ff. 289v–90r.

32. Argaiz, *Soledad laureada*, f. 290r.

33. Argaiz, *Soledad laureada*, f. 290r.

34. Argaiz, *Soledad laureada*, ff. 289v–90r. García Molinos points out that Argaiz is likely making a mistake here, since both Morales and Barrera transcribe the date as era 981 [= 943 CE]; "Florencio de Valeránica," 280.

35. Martín Barba remarks on what he calls Florentius's "alto grado de autoestima" ("Los prólogos," 51) and "su natural vanidad de artista y su espiritualidad monacal sincera" ("Los prólogos," 69).

36. See, for example, the boastful inscription left by Master Nicolaus in both the Verona and Ferrara cathedrals: ARTIFICEM GNARVM QVI SCVLPSERIT HEC NICOLAVM HVNC CONCVRRENTES LAVDANT PER SECVLA GENTES [The learned *artifex* who made sculpture, this Nicholaus, May people gathering here through the centuries praise (him)]; Anna Lee Spiro, "Reconsidering the Career of the Artifex Nicholaus (active c. 1122–c. 1164) in the Context of Later Twelfth-Century North Italian Politics" (Ph.D., Columbia University, 2014), 1. On Master Mateo of Santiago de Compostela, see, for example, Manuel Castiñeiras, "Autores homónimos: El doble retrato de 'Mateo' en el Pórtico de la Gloria," in *Entre la letra y el pincel: El artista medieval; Leyenda, identidad y estatus*, ed. Manuel Antonio Castiñeiras González (El Ejido: Círculo Rojo, 2017).

37. For a concise overview of Endura's career (including charters from his hand), see the discussion in CCV no. 107. His work is also discussed by Ángel Fábrega Grau, *Pasionario hispánico (siglos VII–XI)* (Madrid: Instituto P. Enrique Flórez, 1953) vol.1: 25–33; Justo Pérez de Urbel, "El monasterio de Valeránica y su escritorio," in *Homenaje a Don Agustín Millares Carlo* (Madrid: Caja Insular de Ahorros de Gran Canaria, 1975); Barbara A. Shailor, "The Scriptorium of San Pedro de Cardeña," *Bulletin of the John Rylands Library Manchester* 61 (1978–79); Shailor, "Scriptorium of Berlangas"; García Molinos, "Florencio de Valeránica," 356–57. The name Endura is recorded in four tenth-century Iberian colophons from the region around Cardeña, three of which can still be seen in situ; one, like Florentius's colophon for the Oña Bible, survives only in transcription. The dates as written in the manuscripts do not line up to suggest that all four were written by the same person; there's significant disagreement among scholars about whether the dates are wrong or we have two skilled scribes named Endura working in the same region, one slightly older than the other.

38. Florentius and Endura were exact contemporaries, and the books with similar language were executed during the same five or ten years. Since we cannot assign an exact date to the Homiliary, it is hard to say for certain who comes first.

39. Díaz y Díaz makes the case for a close collaboration between Endura and Florentius; Manuel Díaz y Díaz, "El escriptorio de Valeránica," in *Codex biblicus legionensis: Veinte estudios* (León: Real Colegiata de San Isidoro, 1999). Pérez de

Urbel imagines them not only as colleagues but also as friends; "El monasterio de Valeránica," 81.

40. Elisa Ruiz García, *Catálogo de la sección de códices de la Real Academia de la Historia* (Madrid: La Academia, 1997), 385.

41. Florentius and his student Sanctius use the phrase again in the León Bible of 960: "Benedicamus celi / quoque regem nos, qui ad istius libri finem venire permisit incolomes"; León, S. Isidoro, MS 2, f. 514r). On August 24, 1072 CE, a scribe at Santo Domingo de Silos named Ericonus grafts this language onto the colophon of his copy of Isidore's *Etymologies* (Paris, BnF, nal 2169, f. 385r). We meet Ericonus again in Chapter 6.

42. Madrid, RAH, MS 76, f. 159v; Ruiz García, *Catálogo de la Real Academia*, 385.

43. Ruiz García, *Catálogo de la Real Academia*, 385.

44. Gustav Loewe and Wilhelm von Hartel, *Bibliotheca Patrum latinorum hispaniensis* (Vienna: Carl Gerold's Sohn, 1887), 525.

45. Francisco de Berganza, *Antiguedades de España* (Madrid: F. del Hierro, 1719), 221.

46. Berganza, *Antiguedades de España*, 221. It should be noted that Berganza's information about this text is secondhand: he says he got it from Lope de Frías's *Historia de Cardeña*; Berganza, *Antiguedades de España*, 222.

47. Berganza, *Antiguedades de España*, 222.

48. Córdoba, AC, MS 1, f. 3r; García Molinos, "Florencio de Valeránica," 368.

49. Berganza states that the letters are Greek but transcribes them in Latin script; *Antiguedades de España*, 222.

50. The main obstacle to identifying the Rylands Cassiodorus with the one whose colophon Berganza transcribes is the fact that paleographers as expert as James and Shailor have not been able to see the work of two hands in it; M. R. James, *A Descriptive Catalogue of the Latin Manuscripts in the John Rylands Library at Manchester* (Manchester: Manchester University Press, 1921), vol. 1: 165; Shailor, "Scriptorium of Cardeña," 469–70. García Molinos, however, accepts the identification; "Florencio de Valeránica," 355–59.

51. James, *Descriptive Catalogue*, vol. 1: 162.

52. Manuel Risco, *Iglesia de León, y monasterios antiguos y modernos de la misma ciudad* (Madrid: Blas Roman, 1792), 155–56. For studies on Florentius's Cassiodorus, see Díaz y Díaz, "Los prólogos y colofones," and García Molinos ("Florencio de Valeránica," 355–59), who includes Risco's text of the colophon.

53. The date as transcribed—era DCCCCLXI—resolves to 923 CE, which is impossible if Florentius was born, as the date on BNE MS 80 suggests, around 920 or 921. Risco notes this elsewhere, commenting that Florentius wrote "el número X sin el rasguillo que le da el valor de cuarenta" (quoted in CCV vol. 1: 78). This correction yields era 991, or 953 CE, which is in fact the third year of Ordoño III's reign.

54. Endura's colophon says he worked *sollerter*, skillfully; either Florentius changed the adverb to *collecter*, concisely, or Risco misreads as he transcribes.

Since Florentius follows Endura's wording more closely in the Homiliary ("libri huius praescribere *sollerter* cepi initium," he writes on f. 3r of Córdoba, AC, MS 1), the latter seems more probable. It also seems unlikely that Florentius would present concision as a praiseworthy quality of his work.

55. Risco, *Iglesia de Léon*, 155–56; emphasis added.

56. "Visigothic" script was officially replaced in 1080 by Caroline minuscule just as the native Hispanic rite was replaced by the Roman. Copying a manuscript as intimately tied to Hispanic liturgical practice as the Beatus commentary in the time immediately after this watershed year was undoubtedly politically complex. Still essential is Meyer Schapiro, "From Mozarabic to Romanesque in Silos," *Art Bulletin* 21 (1939), to be balanced by resistance from John Williams, "Meyer Schapiro in Silos: Pursuing an Iconography of Style," *Art Bulletin* 85, no. 3 (2003), and Ann Boylan, "The Silos Beatus and the Silos Scriptorium," in *Church, State, Vellum, and Stone: Essays on Medieval Spain in Honor of John Williams*, ed. Therese Martin and Julie Harris (Leiden and Boston: Brill, 2005).

57. The Silos Beatus is available online in virtual facsimile at http://www.bl.uk /manuscripts/FullDisplay.aspx?ref=Add_MS_11695. For an introduction to this gorgeous manuscript, see John Williams, *The Illustrated Beatus: A Corpus of the Illustrations of the Commentary on the Apocalypse* (London: Harvey Miller, 1994), vol. 4: 31–40. For more detail, see Boylan, "Silos Beatus" and "Manuscript Illumination at Santo Domingo de Silos (X[th] to XIIth centuries)" (Ph.D., University of Pittsburgh, 1990); O. K. Werckmeister, "The Image of the 'Jugglers' in the Beatus of Silos," in *Reading Medieval Images: The Art Historian and the Object*, ed. Elizabeth Sears and Thelma K. Thomas (University of Michigan Press, 2002), and, most recently, Ainoa Castro Correa, "The Scribes of the Silos Apocalypse (London, BL Add. MS 11695) and the Scriptorium of Silos in the Late 11th Century," *Speculum* 95, no. 2 (2020).

58. Production of the Silos Beatus spread over almost twenty years and is recorded in an extraordinary collection of scribal prologues and colophons on ff. 6v, 265v–66r, 275v, 276r, 277v, and 278r. I will hereafter cite these colophons as they are edited in Boylan, "Manuscript Illumination," 203–7. The codex also includes a copy of a long legal document recording internal strife at the monastery and dated Thursday, July 24, 1158, on f. 267v (for the text, see CCV no. 106).

59. Master Petrus the prior did most of the illumination, as he explains in one of the colophons dated 1 July 1109: "It is blessedly concluded, amen. Thanks be always to God. Pray for the scribes if you wish to reign with Christ, amen. In the name of the Lord this book of the Apocalypse began by the order of the abbot Fortunius; but, on his death, only the smallest part of it was completed. Work continued under abbot Nunnius. At last, in the time of abbot John, master Petrus the prior, kinsman of abbot Nunnius, completed it and in completing it wholly illuminated it. And it was finished on the very kalends of the month of July, when glorious Adefonsus, emperor of all of Spain, died, in the year TCXLVII" [Explicit feliciter, amen. Deo gratias semper. Orate pro illos si regnetis cum Christo amen.

In nomine Domini hic liber Apocalipsis abuit inicium iussu Fortunii abbatis; sed, morte eius interveniente, minima pars ex eo facta fuit. Eodemque modo contigit in tempore Nunni abbatis. Ad ultimum yero, tempore Iohannis abbatis, domnus Petrus prior, consanguineus Nunni abbatis complevit et conplendo ab integro illuminabit. Explicitusque est in ipsis kalendis iulii mensis guando obiit gloriosus Adefonsus, totius Yspanie imperator, era T^{ma}CXLVII^{a}] (f. 275v: ed. Boylan, "Manuscript Illumination," 204). Petrus also began but apparently did not complete a double prologue (ff. 6v–7r) that mirrored the double colophon executed by Dominicus and Munnius in 1091 (ff. 277v–78r).

60. London, BL, Add MS 11695, f. 6v: ed. Boylan, "Manuscript Illumination," 203; cf. Florentius: "In nomine ingeniti prolisque ac procedentis unius semper natura deitatis" (Córdoba, AC, MS 1, f. 3v). The prologues of Florentius's Homiliary made the rounds at Silos in the eleventh century. On f. 177r of a liturgical manuscript (Silos, Archivo del Monasterio, MS 3), the scribe Johannes condensed it down to its bones in the month of January 1039: "We come to the end of the book made with great sweat, for just as the sailor longs for port, so longs the scribe for the last line. Indeed, three fingers write but the whole body labors. I beg you, whoever you are who might read this, keep your fingers away, lest you damage the letter. Indeed, one who does not know how to write thinks it no labor. Pray for presbyter Johannes the writer, if Christ is your protector. Life to the scribe, peace to the reader, victory to the possessor. Written in the month of January, in era TLXX VII" [Uenimus ad portum libelli nimio sudore confecti, quia sicut nauiganti desiderabilis est portus, ita scriptori nobissimus uersus. Tria quidem digiti scribunt, sed totum corpus laborat. Obsecro quisquis legeris, retro tene digitos, ne litteram ledas. Qui enim nescit scribere nullam reputat laborem. Ora pro Iohanne presbitero scriptore, si Christus habeas protectorem. Scriptori uita, legenti pax, possidenti uictoria. Fuit scriptum in mense ianuario, in era TLXXa. VIIa] (Latin in CCV no. 297).

61. f. 6v: ed. Boylan, "Manuscript Illumination," 203.

62. This unusual formulation may be a reference to Jesus's silence before Pilate (Matt 27:11: "Jesus autem stetit ante praesidem"), but if so, it is a curiously passive moment to use to summon divine assistance. Pérez de Urbel sees it as a quote from a poem by Vicentius of Córdoba: "Qui pro nobis siluit ante judicem, in sorte sanctorum coronandum consuscitet"; "El monasterio de Valeránica," 84.

63. f. 277v: ed. Boylan, "Manuscript Illumination," 204.

64. Berganza, *Antiguedades de España*, 222.

65. f. 277v: ed. Boylan, "Manuscript Illumination," 205.

66. f. 277v: ed. Boylan, "Manuscript Illumination," 205.

67. f. 277v: ed. Boylan, "Manuscript Illumination," 205. While the sense of the passage is clear, the Latin is muddled. The translation reflects my understanding of the sense.

68. f. 277v: ed. Boylan, "Manuscript Illumination," 205.

69. Williams, *Illustrated Beatus*, vol. 4: 31. For twelfth-century examples of this kind of flowery naming puzzle, see James D'Emilio, "Writing Is the Precious

Treasury of Memory: Scribes and Notaries in Lugo (1150–1240)," in *La collaboration dans la production de l'écrit médiéval: Actes du XIII^e colloque du Comité international de paléographie latine (Weingarten, 22–25 septembre 2000)*, ed. Herrad Spilling (Paris: École des Chartes, 2003), 386n38.

70. The León Bible of 960 is an astonishingly beautiful book. It is painful to keep discussion of it so brief. It is not available online at this writing; if you have the time, by all means go to León or locate a facsimile and start reading it. The essays in César Álvarez Álvarez, ed., *Codex biblicus legionensis: Veinte estudios* (León: Real Colegiata de San Isidoro, 1999) are all excellent; for its Arabic annotations, see J. M. Casciaro Ramírez, "Las glosas marginales árabes del codex visigothicus legionensis de la Vulgata," *Scripta Theologica* 2 (1970).

71. The scribe Endura names Sebastianus as his beloved student in a lost copy of Cassiodorus's commentary on the Psalms, as recorded in Berganza, *Antiguedades de España*, 222.

72. The text from Theodulf, Carmen 41: "This terrible trumpet resounds through the worldly crossroads / and sends the earthly race to heavenly realms. . . . This drink coming from the fountain of Eden, / The more someone approaches, the more he thirsts for all good" [Hec tuba terribilis mugit per completa mundi / mittit terrigenum ad celica regna genus . . . hic paradisigeno veniens degurgite potus / quem quo plus quis adit plus sitit omne bonum], ed. Ernst Dümmler in *Poetae Latini Aevi Carolini* (Berlin: Weidmann, 1881), vol. 1: 536; trans. Theodore Murdock Andersson, Åslaug Ommundsen, and Leslie S. B. MacCoull, *Theodulf of Orléans: The Verse* (Tempe: Arizona Center for Medieval and Renaissance Studies, 2014), 132. Although Carolingian influence was strongest in Catalonia, Leonese and Castilian book artists had strong connections on the other side of the Pyrenees, especially with Tours: Jacques Fontaine, "Mozarabe hispanique et monde carolingien: Les échanges culturels entre la France et l'Espagne du VIII^e au X^e siècle," *Anuario de estudios medievales* 13 (1983); Junco Kume, "Aspectos de la influencia iconográfica carolingia en la miniatura hispánica de los siglos X y XI," in *El arte foráneo en España: Presencia e influencia*, ed. Miguel Cabañas Bravo (Madrid: Departamento de Historia del Arte, Instituto de Historia, 2005); John Williams, "Tours and the Early Medieval Art of Spain," in *Florilegium in honorem Carl Nordenfalk octogenarii contextum*, ed. Per Bjurström, Nils Göran Hökby, and Florentine Mütherich (Stockholm: Nationalmuseum, 1987).

73. León, S. Isidoro, MS 2, f. 12r, my transcription.

74. The translation of the puzzling phrase *gaudio retaxando* follows the suggestion of Martín Barba, "Los prólogos," 50.

75. León, San Isidoro, MS 2, f. 513v; Latin in CCV no. 96.

76. León, San Isidoro, MS 2, f. 513v. Millares's transcription reads *coniugant* (CCV no. 96); the *n* that would make the verb plural, however, is not visible in the manuscript. I quote the Latin in the transcription of Maurilio Pérez González, personal communication, Dec. 9, 2013. My translation follows his suggestions.

77. Thanks to Donka Markus for her help making sense of this difficult Latin.

4. *MANU MEA*:
CHARTERS, PRESENCE, AND THE AUTHORITY OF INSCRIPTION

1. Letters, says Isidore of Seville, "have so much force" that through them "the utterances of those who are absent speak to us without a voice" [quibus tanta vis est, ut nobis dicta absentium sine voce loquantur]; *Etymologies* I.3.1–4: ed. W. M. Lindsay (Oxford: Clarendon, 1911); trans. Stephen Barney et al. (Cambridge: Cambridge University Press, 2006), 39.

2. *Auctor*: "Celui qui fait l'action consignée dans l'écrit"; A. de Boüard, *Manuel de diplomatique francaise et pontificale* (Paris: A. Picard, 1929), 39.

3. For overviews of early medieval Iberian diplomatics, see José Antonio Fernández Flórez, *La Elaboración de los documentos en los reinos hispánicos occidentales (ss. VI–XIII)* (Burgos: Diputación Provincial de Burgos, 2002); Angel Canellas López, *Diplomática hispano-visigoda* (Zaragoza: Institución Fernando el Católico, 1979). On the evolution of the Iberian notariate, see José Bono y Huerta, *Historia del derecho notarial español*: vol. 1, *La Edad Media* (Madrid: Junta de Decanos de los Colegios Notariales de España, 1979), 110–14; Ángel Riesco Terrero, "Notariado y documentación notarial castellano-leonesa de los siglos X–XIII," in *I Jornadas Científicas sobre Documentación jurídico-administrativa, económico-financiera y judicial del reino castellano-leonés (siglos X–XIII)* (Madrid: Universidad Complutense, 2002). Excellent case studies exist in Wendy Davies, "Local Priests and the Writing of Charters in Northern Iberia in the Tenth Century," in *Chartes et cartulaires comme instruments de pouvoir. Espagne et Occident chrétien (VIIIᵉ–XIIᵉ siècles)*, ed. Julio Escalona and H. Sirantoine (Toulouse: Presses Méridiennes de Toulouse/CSIC, 2013), and Davies, *Acts of Giving: Individual, Community, and Church in Tenth-Century Christian Spain* (Oxford: Oxford University Press, 2007).

4. Self-identification as notaries: Florentius: Oña Bible colophon transcribed by Barreda; quoted in Constancio Gutiérrez, "¿Cuándo se escribió la llamada Biblia de Oña?," *Estudios Eclesiásticos* 34 (1960), 407. Sanctius: León, San Isidoro, MS 2, f. 513v; Sebastianus: transcribed in Francisco de Berganza, *Antiguedades de España* (Madrid: F. del Hierro, 1719), 222.

5. The work of Wendy Davies offers a particularly helpful example of *reading* formulaic language rather than simply recognizing and taxonomizing it. See, for example, her *Acts of Giving*, 88–112.

6. "Por sua naturaleza, os textos documentais não são destinados à leitura, mas à produção de um acto performativo—validacão de uma acção socialmente válida"; Aires Augusto Nascimento, "*Minus grammatice agere nec minus utiliter*: O latim documental em regime performativo," in *Estudios de Latín Medieval Hispánico: Actas del V Congreso Hispánico de Latín Medieval, Barcelona, 7–10 de septiembre de 2009*, ed. José Martínez Gázquez, Oscar de la Cruz Palma, and Cándida Ferrero Hernández (Florence: SISMEL, 2011), 833. For a detailed study of how the performative *vis* of charters works (albeit in a Carolingian context), see Geoffrey Koziol, *The Politics of Memory and Identity in Carolingian Royal Diplomas: The West Frankish Kingdom (840–987)* (Turnhout: Brepols, 2012).

7. In a charter with dispositive force, "il y a alors simultanéité de l'acte juridique qui manifeste la volonté de son auteur, et de l'acte écrit qui le constate et lui donne tous ses effets"; Maria Milagros Cárcel Ortí, "Vocabulaire international de la diplomatique" (Valencia: Universitat de València, 1997), http://www.cei.lmu.de /VID/, s.v. *acte écrit*. In probative force, "la mise par écrit a pour fin d'apporter la preuve de l'acte juridique qu'il n'a point fait naître et qui serait parfait sans cette formalité"; Cárcel Orti, "Vocabulaire," s.v. *acte écrit*. The probative dominates in Visigothic and early medieval documents, but there is some evidence of charters with *vis dispositiva* as well; Canellas López, *Diplomática hispano-visigoda*, 35.

8. Olivier Guyotjeannin, "Le vocabulaire de la diplomatique," in *Vocabulaire du livre et de l'ecriture au moyen âge: Actes de la table ronde, Paris 24–26 Septembre 1987*, ed. Olga Weijers (Turnhout: Brepols, 1989).

9. Brigitte Bedos-Rezak, "Medieval Identity: A Sign and a Concept," *American Historical Review* 105, no. 5 (2000): 1,509.

10. Isidore of Seville, *Etymologies* I.3.1–4: ed. Lindsay; trans. Barney et al., 39.

11. "Le problème pourrait être formulé ainsi: Comment faire pour que le discours survive à son sujet comme s'il l'énonçait?," Béatrice Fraenkel, *La signature: Génèse d'un signe* (Paris: Gallimard, 1992), 31.

12. Sonja Neef and José van Dijck, "Introduction," in *Sign Here!: Handwriting in the Age of New Media*, ed. Sonja Neef, José van Dijck, and F. C. J. Ketelaar (Amsterdam: Amsterdam University Press, 2006), 8.

13. Fraenkel locates the shift in the sixteenth century; *La signature*, 10.

14. The theoretical complexity of this premodern system of authentication has been closely studied by Béatrice Fraenkel, and the following discussion is indebted to her work. Fraenkel's semiotic approach can be fruitfully balanced by the deconstructive method of the essays collected in Neef and van Dijck, *Sign Here!*, many of which riff deliciously on Derrida's essay "Signature, Event, Context," in *Limited Inc.* (Evanston, Ill.: Northwestern University Press, 1988).

15. For the interplay between medieval senses of actor, author, and authority, see, of course, Marie-Dominique Chenu, "Auctor, actor, autor," *Bulletin du Cange* 3 (1927), but also, more recently, Patrick J. Geary, "*Auctor* et *auctoritas* dans les cartulaires du haut moyen-âge," in *Auctor et auctoritas: Invention et conformisme dans l'écriture médiévale; Actes du colloque tenu à l'Université de Versailles-Saint-Quentin-en-Yvelines, 14–16 juin 1999*, ed. Michel Zimmermann (Paris: Ecole des Chartes, 2001); András Vizkelety, "Scriptor—Redactor—Auctor," in *Le statut du scripteur au Moyen Âge: Actes du XIIᵉ colloque scientifique du Comité international de paléographie latine (Cluny, 17–20 juillet 1998)*, ed. Marie-Clotilde Hubert, Emmanuel Poulle, and Marc H. Smith (Paris: École des Chartes, 2000).

16. Thus, for example, the *Lex Romana Wisigothorum* (issued in 506 CE) stipulates that "the donation should be subscribed to by the donor himself, if he knows letters; if not, then let him choose, before the presence of many, one who might subscribe for him" [Quam tamen donationem, si literas novit donator, ipse subscribat; si vero ignorat, praesentibus plurimis eligat, qui pro ipso subscribat]; *Lex Romana* VIII, Tit. 5, Interpretatio, in *Legis romanae wisigothorum fragmenta*

ex codice palimpsesto sanctae legionensis ecclesiae, ed. Francisco de Cárdenas y Espejo and Fidel Fita y Colomé (Madrid: Real Academia Española, 1896), 95–97. The *Lex Romana* is reusing the Theodosian Code, VIII.12.1.

17. On the rarity of autograph subscriptions in early medieval Latin Iberia, see Concepción Mendo Carmona, "La suscripción altomedieval," *SIGNO: Revista de Historia de la Cultura Escrita* 4 (1997): 221–22, and Luis Casado de Otaola, "*Per visibilia ad invisibilia*: Representaciones figurativas en documentos altomedievales como símbolos de validación y autoría," *SIGNO: Revista de Historia de la Cultura Escrita* 4 (1997). Ainoa Castro Correa's research into early medieval Galician charters is revealing striking numbers of autograph subscriptions—and subscriptions by laypeople; "The Secret Life of Writing: A Holistic Paleography Project" (lecture, Medieval Manuscripts Seminar, School of Advanced Study, University of London, March 2, 2021).

18. On the corporeal rituals associated with donation in Iberia, see Rogelio Pacheco Sampedro, "El *signum manuum* en el Cartulario del Monasterio de San Juan de Caaveiro (s. IX–XIII)," *SIGNO: Revista de Historia de la Cultura Escrita* 4 (1997), and Fernández Flórez, *La Elaboración de los documentos.* As Michael T. Clanchy and others have shown, early medieval European legal theory and practice fused performance-based Germanic legal rituals with the written documentation characteristic of the Roman Empire. No equally detailed and theoretical exploration akin to Clanchy's epochal study (*From Memory to Written Record, England 1066–1307* [Oxford: Blackwell, 1993]) has yet been published for early medieval Iberia. Nicholas Everett, *Literacy in Lombard Italy, c. 568–774* (Cambridge: Cambridge University Press, 2003) is a useful Italian analogue in a slightly earlier period. Michel Banniard, *Viva voce: Communication écrite et communication orale du IV^e au IX^e siècle en occident latin* (Paris: Institut des Études Augustiniennes, 1992) provides a rich, though contested, beginning focused on Isidore of Seville (181–251) and "Mozarabic" ninth-century Córdoba (423–84). The work of Roger Wright on relations between oral and written Latin on the peninsula in this period is essential for any such study—e.g., *Late Latin and Early Romance in Spain and Carolingian France* (Liverpool: F. Cairns, 1982).

19. Madrid, AHN, MS L 1439, f. 90v; cited in Pacheco Sampedro, "El *signum manuum*," 30.

20. Pacheco Sampedro, "El *signum manuum*," 30.

21. It is difficult to know how much argumentative weight can be supported by this kind of grammatical close reading. Iberian Latin is in flux in the period, the case system in particular undergoing radical simplification. In addition, the formulaic nature of these documents means that certain phrases may well have been used more phatically than grammatically. For example: *in hac carta manus meas roboraui*—*manus meas* here is in the accusative, so a linguistically attentive translation would be, "I have validated my hands in this charter." But that doesn't make sense, so I translate as if the case were ablative.

22. These are immersive texts. Florentius, too, imagined us reading *in* his codices (*qui in hoc codice legeritis*, Madrid, BNE, MS 80, f. 500v and Córdoba, AC, MS 1, f. 4r).

23. Isidore of Seville, *Etymologies* I.3.1–4: ed. Lindsay; trans. Barney et al., 2:39.

24. Brigitte Bedos-Rezak, "Toward an Archaeology of the Medieval Charter: Textual Production and Reproduction in Northern French *Chartriers*," in *Charters, Cartularies, and Archives: The Preservation and Transmission of Documents in the Medieval West*, ed. Adam J. Kosto and Anders Winroth (Toronto: Pontifical Inst. of Medieval Studies, 2002), 59.

25. "La representación del *signum manus* no puede significar otra cosa que la plasmación gráfica del juramento manual que el otorgante realiza sobre el documento escrito, que por el mero hecho de llevar signos de validación está respaldado por la legislación vigente y tiene fuerza y valor indestructible"; María Isabel Ostolaza, "La validación en los documentos del occidente hispánico (s. X–XII): Del *signum crucis* al *signum manus*," in *Graphische Symbole in mittelalterlichen Urkunden: Beiträge zur diplomatischen Semiotik*, ed. Peter Rück (Sigmaringen: Thorbecke, 1996), 461.

26. Pacheco Sampedro, "El *signum manuum*," 33.

27. On the *signum manus* in early medieval Iberia, see Pacheco Sampedro, "El *signum manuum*"; Ostolaza, "La validación"; Mendo Carmona, "La suscripción altomedieval"; Casado de Otaola, "*Per visibilia ad invisibilia.*" Ostolaza argues convincingly that the *signum manus* and the representation of the *impositio manuum* are developed elaborately in cartularies and other collections of copies of legal documents as visual guarantees of the authenticity of the copies within. The early twelfth-century *Liber testamentorum* of Oviedo (Archivo de la Catedral, MS 1) contains particularly spectacular examples of both, including the subscription for Bishop Pelayo that encases the name in an arm ending in a pointing finger (f. 99v). The fabulous illuminations of the Oviedo *Liber testamentorum* may be studied in a readily available facsimile: *Liber testamentorum Oventensis* (Barcelona: M. Moleiro, 1994). Casado notes a royal charter in which, between the words *manu mea* and *roboravi*, is a facial sketch of the king, the donor; "*Per visibilia ad invisibilia*," 46. See also José Manuel Cerda Costabal and Gerardo Boto Varela, "*Propria manu cartam hanc roboro et confirmo.* La mano en el signo rodado de la reina Leonor Plantagenet," *De Medio Aevo* 10, no. 2 (2021). For a theoretical treatment of similar *signa* in France, see Fraenkel, *La signature*, 125–89.

28. *Signa* constructed this way—in looped designs based on the three s's of *subscripsi*—are performing subscription stripped down to its performative basics: to use one is to sign with the word "signature," as Fraenkel notes; *La signature*, 150.

29. "El proceso de clarificación de los oscuros signos visigóticos va a ser iniciado por los propios amanuenses redactores del documento, que en su signatura comienzan a expresar de manera palpable que su labor se realiza de manera manual y con la mano derecha, que aparece dibujada de forma perfectamente reconocible"; Ostolaza, "La validación," 456.

30. Similarly, the first-person pronoun points simultaneously to *auctor* and scribe when Florentius silently adopts Jerome's instructions to future readers as his own in one of the scribal prologues of his Homiliary (Córdoba, AC, MS 1, f. 2r; discussed in Chapter 3).

31. For these two phrases, see Fernández Flórez, *La Elaboración de los documentos*, 63.

32. The tasks of composing the document and drawing it up in writing could be undertaken by different people. For standard terminology for agents involved in the charter, see Cárcel Ortí, "Vocabulaire international," s.v. "l'élaboration des actes," and Fernández Flórez, *La Elaboración de los documentos*, 62–68. In practice, though, the distinctions are irregularly made; Davies, "Local Priests," 31.

33. "Se puede afirmar que este escriba o notario gozaba, ya en época altomedieval, de una 'autoridad' y 'credibilidad' reconocida localmente, en tanto que conocía la escritura y las fórmulas preestablecidas para la confección de los documentos. Las partes confiaban a ellos la puesta por escrito del negocio jurídico y su suscripción y signo otorgaban al escrito una fuerza probatoria"; Mendo Carmona, "La suscripción altomedieval," 223.

34. Documents in which Florentius is named as notary are collected and edited by Elena García Molinos; "Florencio de Valeránica: Calígrafo castellano del siglo X," in *El Reino de León en la Edad Media, XI* (León: Centro de Estudios e Investigación "San Isidoro," 2004), 381–414. She lists three of them as surviving in his hand. The original of the document she identifies as Charter 1 has been located by Julio Escalona and Isabel Velázquez Soriano and is reproduced, edited, and closely compared with other documents from Florentius's hand in Escalona, Velázquez Soriano, and Paloma Juárez Benitez, "Identification of the Sole Extant Original Charter Issued by Fernán González, Count of Castile (932–970)," *Journal of Medieval Iberian Studies* 4, no. 2 (2012).

35. Escalona, Velázquez Soriano, and Juárez Benitez, "Identification," 287.

36. Escalona, Velázquez Soriano, and Juárez Benitez, "Identification," 287.

37. Escalona, Velázquez Soriano, and Juárez Benitez, "Identification," 274. Escalona and Velásquez resolve the abbreviation as *scripsit*; it could just as well have been *scripsi*, "I wrote." The use of first instead of third person is not uncommon in scribal subscriptions. Rafael Conde and Josep Trenchs Odena, "Signos personales en las suscripciones altomedievales catalanas," in *Graphische Symbole in mittelalterlichen Urkunden: Beiträge zur diplomatischen Semiotik*, ed. Peter Rück (Sigmaringen: Thorbecke, 1996), 447. The crenelations still frame the subscription in the 1255 cartulary copy of this document, also reproduced by Escalona, Velázquez Soriano, and Juárez Benitez, "Identification," 267.

38. Manuel C. Díaz y Díaz, "El escriptorio de Valeránica," in *Codex biblicus legionensis: Veinte estudios* (León: Real Colegiata de San Isidoro, 1999), 66.

39. Escalona, Velázquez Soriano, and Juárez Benitez gently correct the master on this point; "Identification," 274. See also the evidence for diplomatic usage of

the verb in Maurilio Pérez González, *Lexicon latinitatis medii regni Legionis* (Turnhout: Brepols, 2010), s.v. *depingo*.

40. Many thanks to Padre Clementino González of the Parroquia Colegiata de San Cosme y San Damián in Covarrubias for generously sharing photographs of this document.

41. García Molinos, "Florencio de Valeránica," 404.

42. García Molinos, "Florencio de Valeránica," 410. The scribe uses the same formula to subscribe to a charter dated November 24, 978 (Burgos, AC, vol. 69, 1ª parte, f. 85r). However, he made a mistake between his name and the word *scriba* and crossed out the error with red ink; Escalona, Velázquez Soriano, and Juárez Benitez, "Identification," figure 5.

43. García Molinos, "Florencio de Valeránica," 404. This invocation formula is also used in a charter written by Florentius and dated September 7, 972 CE; Burgos, AC, vol. 69, 1ª parte, f. 87; García Molinos, "Florencio de Valeránica," 401–3. A charter dated March 15, 942, though not signed by Florentius, is attributed to him by John Williams, "A Contribution to the History of the Castilian Monastery of Valeránica and the Scribe Florentius," *Madrider Mitteilungen* 11 (1970). The original is not preserved, so we cannot use the hand to attribute it. But the florid style feels very Florentian: *Sub sancte et indesecabilis Trinitatis, videlicet, patris, Filii, adnectens Spiritus Sancti, simul adglomerans Trinitas . . .* ; Luciano Serrano, *Cartulario de San Pedro de Arlanza, antiguo monasterio benedictino* (Madrid: Rafael Ibañez de Aldecoa, 1925), 45.

44. Mendo Carmona, "La suscripción altomedieval," 226. The document itself is no. 552 in the Archivo Catedralicio of León.

45. Lugo, AC, Libro X de pergaminos, leg. 2, no. 3. Many thanks to Ainoa Castro Correa for generously sharing images and her transcription of this document.

46. "Lorsqu'il trace le mot *ego* de sa main, ce terme renvoie à sa qualité d'officier—sa personne fictive—tout comme le 'je' de l'écriture ne renvoie à rien d'autre qu'à une catégorie linguistique"; Fraenkel, *La signature*, 229.

47. Florentius: *in hoc codice* legeritis (Córdoba, AC, 1 f. 4r); Endura: scribenti *in hoc uolumine* (Manchester, Rylands, MS lat. 89, f. 4r); scribes of the Silos Beatus: qui *in hoc libro* . . . avide legeritis (London, BL, Add. MS 11695, f. 277v).

48. Pacheco Sampedro, "El *signum manuum*," 30.

5. MAKERS AND THE INSCRIBED ENVIRONMENT

1. On character and *kharassein*, see David Ganz, "'Mind in Character': Ancient and Medieval Ideas about the Status of the Autograph and the Expression of Personality," in *Of the Making of Books: Medieval Manuscripts, Their Scribes and Readers: Essays Presented to M. B. Parkes*, ed. Pamela Robinson and Rivkah Zim (Aldershot, England: Scolar Press, 1997).

2. Ramsay MacMullen coined the term "epigraphic habit" to support an inquiry into the sociology of inscriptions on stone in ancient Rome; MacMullen, "The Epigraphic Habit in the Roman Empire," *American Journal of Philology* 103, no. 3

(1982). MacMullen's work is helpfully expanded in Dennis Trout, "Inscribing Identity: The Latin Epigraphic Habit in Late Antiquity," in *A Companion to Late Antiquity*, ed. Philip Rousseau and Jutta Raithel (Chichester: Wiley-Blackwell, 2009), and Peter Kruschwitz, "Inhabiting a Lettered World: Exploring the Fringes of Roman Writing Habits," *Bulletin of the Institute of Classical Studies* 59 (2016). For the epigraphic habit in early medieval Iberia, see Javier de Santiago Fernández, "El hábito epigráfico en la Hispania visigoda," in *VIII Jornadas Científicas sobre Documentación de la Hispania altomedieval (siglos VI–X)*, ed. J. C. Galende Díaz and Javier de Santiago Fernández (Madrid: Universidad Complutense, 2009), and Helena Gimeno Pascual, "El hábito epigráfico en el contexto arquitectónico hispánico del siglo VII," in *El Siglo VII frente al siglo VII*, ed. Caballero Zoreda Luis, Mateos Cruz Pedro, and Utrero Agudo María Angeles (Madrid: Consejo Superior de Investigaciones Científicas, 2009).

3. Augustine, Sermon 319; PL 38: 1442.

4. For what remains at Valeránica, see John Williams, "A Contribution to the History of the Castilian Monastery of Valeránica and the Scribe Florentius," *Madrider Mitteilungen* 11 (1970).

5. For more on the inscriptions at Escalada, see Chapter 6. On Silos, see Gerardo Boto, "Ora et memora: Il chiostro di San Domenico di Silos; Castellum, paradisum, monumentum," in *Medioevo: Immagine e memoria*, ed. Quintavalle Arturo Carlo (Milan: Electa, 2009); Vicente García Lobo, "Las *explanationes* del claustro de Silos: Nueva lectura," in *Silos—un milenio*, vol. 2 (Burgos: Universidad de Burgos, 2003); Encarnación Martín López, "Las inscripciones medievales del monasterio de Santo Domingo de Silos," in *Silos—un milenio*, vol. 2 (Burgos: Universidad de Burgos, 2003). For later Galicia, especially Santiago de Compostela, see James D'Emilio, "Inscriptions and the Romanesque Church: Patrons, Prelates, and Craftsmen in Romanesque Galicia," in *Spanish Medieval Art: Recent Studies*, ed. Colum Hourihane (Tempe: Arizona Center for Medieval and Renaissance Studies, 2007).

6. The fragments have been removed from the church and are housed in the Casa de Cultura of the town. Throughout this discussion I cite from Francisco Diego Santos, *Inscripciones medievales de Asturias* (Oviedo: Principado de Asturias, 1993), 163–68. Excellent color photographs of the inscriptions may be found in Lorenzo Arias Páramo, "Salas," in *Enciclopedia del Románico. Prerrománico Asturias*, ed. Miguel Ángel García Guinea et al. (Aguilar de Campóo Fundación Santa María la Real, 2006).

7. Diego Santos argues that this Adefonsus is the blinded son of King Fruela II, who is named on the foundational stone of the church at El Valle (Asturias) dated 951 CE; *Inscripciones medievales*, 163. For our purposes, the historical identity of Adefonsus is less important than the auctorial identity constructed for him by the inscriptions.

8. Diego Santos, *Inscripciones medievales*, 163, no. 158. The capitalization of these inscriptions is an important part of their effect, but it also makes for difficult

reading. Throughout this chapter, I will try to respect both the text as carved and the modern reader's ease by printing only the Latin in all caps. The abundant abbreviations will be resolved following the suggestions of each editor.

9. Diego Santos, *Inscripciones medievales*, 163, no. 159.

10. Diego Santos, *Inscripciones medievales*, 166, no. 165.

11. Diego Santos, *Inscripciones medievales*, 164, no. 161.

12. Diego Santos, *Inscripciones medievales*, 164, no. 162.

13. The formula "si regnum XPI sine fine possideatis" occurs again and again in colophons; Lucien Reynhout, *Formules latines de colophons* (Turnhout: Brepols, 2006), vol. 1: 66–81.

14. Diego Santos, *Inscripciones medievales*, 167, no. 167.

15. For Florentius we are "you who will read in this codex" [qui in hoc codice legeritis] (Córdoba, AC, MS 1, f. 4r, BNE MS 80, f. 550v); for Sisvertus, we are those who will read and carry his document in our hands [qui hunc testamentum legerit et in manibus portauerit]; Lugo, Archivo de la Catedral, Libro X de pergaminos, 2/3.

16. Isidore of Seville, *Etymologies* I.3: *Etymologiarum sive Originvm libri XX*, ed. W. M. Lindsay (Oxford: Clarendon, 1911); trans. Stephen A. Barney et al. (Cambridge: Cambridge University Press, 2006), 39. For a powerful study of the monastic inscribed environment as generator of affective response from viewers, see Peter Scott Brown, "The Verse Inscription from the Deposition Relief at Santo Domingo De Silos: Word, Image, and Act in Medieval Art," *Journal of Medieval Iberian Studies* 1, no. 1 (2009).

17. Diego Santos, *Inscripciones medievales*, no. 219.

18. Doorways are common places for such inscriptions. As we shall see, the inscriptions themselves often call attention to their liminal location. On "the arch as a bearer of meaning," see Mickey Abel, "Within, Around, Between: Micro Pilgrimage and the Archivolted Portal," *Hispanic Research Journal* 10, no. 5 (2009): 393–401, and Vincent Debiais, "Writing on Medieval Doors," in *Writing Matters: Presenting and Perceiving Monumental Inscriptions in Antiquity and the Middle Ages*, ed. Irene Berti et al. (Berlin: Walter de Gruyter, 2017).

19. Maurilio Pérez González, "El latín del siglo X leonés a la luz de las inscripciones," in *Actas III Congreso hispánico de latín medieval (León, 26–29 de Septiembre de 2001)*, ed. Maurilio Pérez González (León: Universidad de León, 2002), 164–65.

20. That these inscriptions were composed with the care that merits such close reading is even clearer if we accept the argument of Pérez González ("El latín del siglo X") that they were composed in metered *cursus*.

21. José Antonio Fernández Flórez, *La Elaboración de los documentos en los reinos hispánicos occidentales (ss. VI–XIII)* (Burgos: Diputación Provincial de Burgos, 2002), 66. Charters themselves were also occasionally inscribed onto the walls of churches. For a general discussion of the relations between the language of charters and that of monumental inscriptions, see Robert Favreau,

Epigraphie médiévale (Turnhout: Brépols, 1997), 165–90. A particularly spectacular example dating from our period may be found at the little church of San Salvador de Fuentes (Asturias); Diego Santos, *Inscripciones medievales*, 214–21, nos. 240–44).

22. I have not been able to find any architectural senses of the verb *exaro* in the Latin dictionaries available to me. The metaphorical connection clearly runs through the hard physical labor of transforming matter—soil, parchment, stone—by human labor.

23. Lauro Anta Lorenzo, "El Monasterio de San Martín de Castañeda en el siglo X," *Studia Zamorensia* 3 (1996): 40.

24. For a comparative study of the inscriptions at Castañeda, Montes, and Escalada, which were all erected in the same generation and share the same formulaic language, see Pérez González, "El latín del siglo X."

25. While the rebuilding and reconsecration at Castañeda, Montes, and Escalada were a result of the Christian conquest and colonization of the region, the reconstruction at Corullón is caused by a conquest of a very different sort: the imposition in 1080 of the Roman rite and the consequent eclipse of the native "Mozarabic" liturgy.

26. The last part of this inscription is ambiguous in the Latin. At the risk of making things difficult for readers, the translation does not clarify.

27. Rafael González Rodríguez, "El epígrafe fundacional de San Esteban de Corullón," *A Curuxa* 66 (2009): 55.

28. It is not uncommon for epigraphic dates to be rendered distributively in words rather than numbers: the three great Leonese foundation inscriptions of San Miguel de Escalada (914), San Martín de Castañeda (916), and San Pedro de Montes (919) all do it; so does the foundation inscription of San Esteban de Corullón (1086). The practice extends into the twelfth-century epitaph of Abbot Stephanus at Peñalba de Santiago (discussed later).

29. Other evidence (discussed later) suggests that Petrus and the presbyter are the same person, but the grammar of the inscription is not much help. For discussion of ways to render this passage, see González Rodríguez, "El epígrafe fundacional."

30. González Rodríguez, "El epígrafe fundacional," 56. The resolution of the abbreviations is mine.

31. An inscription at the Ermita de Santa Cruz at Cangas de Onís, consecrated Sunday, October 27, 737 CE, calls the building a "holy machine": "This holy machine rises by divine command, / adorned in its little work by faithful promises" [Resurgit ex preceptis diuinis hec macina sacra: / Opere exiguo comtum fidelibus uotis]; Manuel C. Díaz y Díaz, "La inscripción de la Santa Cruz de Cangas de Onís," in *Asturias en el siglo VIII, la cultura literaria* (Oviedo: Sueve, 2001), 32.

32. Josemi Lorenzo Arribas, "Canecillo románico (año 1081) de la iglesia de San Miguel (San Esteban de Gormaz, Soria)," in *Paisaje interior: Soria, Concatedral de San Pedro* (Soria: Gráficos Varona, 2009), 576.

33. Again, the exact date is not as important to this discussion as the fact that someone thought it important enough to record it and connect it with a personal

name. The writing is oriented to be read by the hooded figure, not by the viewer—who, since the inscription is on a corbel, would have to be either God or a worker on the vault.

34. Emilie Mineo has thought deeply about the complexities of *facio* and the challenges it poses to scholars: "Las inscripciones con *me fecit*: ¿Artistas o comitentes?," *Románico* 20 (2015); "Oeuvre signée/oeuvre anonyme: Une opposition apparente; À propos des signatures épigraphiques d'artistes au Moyen Âge," in *L'anonymat de l'œuvre dans la littérature et les arts au Moyen Âge*, ed. Sébastien Douchet and Valérie Naudet (Aix-en-Provence: Presses Universitaires de Provence, 2016). Therese Martin is especially interested in the gender of making. A special number of *Journal of Medieval History*, which includes her "The Margin to Act: A Framework of Investigation for Women's (and Men's) Medieval Art-Making," *Journal of Medieval History* 42, no. 1 (2016) is devoted to the new ways of thinking about *makers* that Martin proposes. Also relevant: András Vizkelety, "Scriptor—Redactor—Auctor," in *Le statut du scripteur au Moyen Âge*, ed. Marie-Clotilde Hubert, Emmanuel Poulle, and Marc H. Smith (Paris: École des Chartes, 2000), and Pascale Bourgain, "Les verbes en rapport avec le concept d'auteur," in *Auctor et auctoritas: Invention et conformisme dans l'écriture médiévale*, ed. Michel Zimmermann (Paris: Ecole des Chartes, 2001).

35. "Cette définition a l'avantage d'évacuer, au moins provisoirement, des étiquettes trop anachroniques, telles qu' 'artiste' ou 'commanditaire,' permettant ainsi d'envisager les signatures en tant que phénomène social et culturel par le biais d'une analyse sérielle et comparative'"; Mineo, "Oeuvre signée," 45.

36. Things change in the twelfth century, when inscriptions show artisans proudly identifying with the mastery displayed in their work. Two well-known examples: Master Mateo in Santiago de Compostela and Nicholaus in Italy. See, for Mateo, Manuel Castiñeiras, "Autores homónimos: El doble retrato de 'Mateo' en el Pórtico de la Gloria," in *Entre la letra y el pincel: El artista medieval; Leyenda, identidad y estatus*, ed. Manuel Antonio Castiñeiras González (El Ejido: Círculo Rojo, 2017); D'Emilio, "Inscriptions"; and, on Nicholaus, Anna Lee Spiro, "Reconsidering the Career of the Artifex Nicholaus (active c. 1122–c. 1164) in the Context of Later Twelfth-Century North Italian Politics" (Ph.D., Columbia University, 2014).

37. Diego Santos, *Inscripciones medievales*, no. 193.

38. Diego Santos, *Inscripciones medievales*, no. 198.

39. For an overview of artisan subscriptions, see Favreau, *Epigraphie*, 124–40; Dietl's monumental study, though focused on Italy, devotes a volume to non-Italian inscriptions; Albert Dietl, *Die Sprache der Signatur: Die mittelalterlichen Künstlerinschriften Italiens* (Berlin: Deutscher Kunstverlag, 2009). Early medieval Iberia is less well studied, but see Alberto Peña Fernández, "Promotores, artífices materiales y destinatarios de las inscripciones medievales," in *Mundos medievales: Espacios, sociedades y poder; Homenaje al profesor José Ángel García de Cortázar y Ruiz de Aguirre*, ed. Beatriz Arízaga Bolumburu et al. (Santander: Universidad

de Cantabria, 2013); Vicente García Lobo and María Encarnación Martín López, "Las suscriptiones: Relación entre el epígrafe y la obra de arte," in *Epigraphie et iconographie: Actes du Colloque tenu à Poitiers les 5–8 octobre 1995*, ed. Robert Favreau (Poitiers: Centre d'Etudes Supérieures de Civilisation Médiévale, 1996). For a slightly later period, D'Emilio, "Inscriptions," considers Galician Romanesque inscriptions, including artisan subscriptions.

40. Serafín Moralejo Alvarez, "Sobre las recientes revisiones de la inscripción de Santa María de Iguácel," *Príncipe de Viana* 37, no. 142–43 (1976): 130. The surviving inscription is quite damaged, and there is disagreement about how to render both the first clause and the date. Neither of these *cruces* affects the argument I want to make. See also Eulogio Zudaire Huarte, "Inscripción de Santa María de Iguacel," *Príncipe de Viana* 35, no. 136–37 (1974); A. Kingsley Porter, "Iguácel and More Romanesque Art of Aragón," *Burlington Magazine for Connoisseurs* 52, no. 300 (1928); and Mineo, "Las inscripciones con *me fecit*," 106–7.

41. Transcription mine, from the photo at http://www.arquivoltas.com/igua.jpg. It is perhaps revealing that none of the essays about this inscription published in the 1970s includes this section of the text in the edition of the inscription. Porter, "Iguácel and More Romanesque Art of Aragón" treats it in passing; neither Zudaire Huarte, "Inscripción," nor Moralejo Alvarez, "Sobre las recientes revisions," mentions it.

42. Porter, "Iguácel and More Romanesque Art of Aragón," 115.

43. The stone inscription is inventoried with no. CE000011 at the Museo de Navarra in Pamplona. For the dating, see Soledad de Silva y Verástegui, *Iconografía del s. X en el reino de Pamplona-Nájera* (Pamplona: Diputación Foral de Navarra, 1984), 93.

44. Favreau, *Epigraphie*, 128. For review of other readings of the inscription and a discussion of the inscription in the context of the surviving figurative reliefs at Villatuerta, see Silva y Verástegui, *Iconografía*, 92–95.

45. Favreau, *Epigraphie*, 128.

46. I have not attempted to disambiguate the text in the translation. The only punctuation visible in the photograph at my disposal is a *punt volat* between FECIT and BELENGUERES.

47. P. Germán de Pamplona, "La fecha de la construcción de San Miguel de Villatuerta," *Príncipe de Viana* 25, no. 96–97 (1954).

48. For transcriptions and images of the San Cipriano inscriptions, see Maximinio Gutiérrez Alvarez, ed., *Zamora: Colección epigráfica* (Turnhout: Brepols, 1997), 1:21–24.

49. Gutiérrez Alvarez, *Zamora*, no. 9.

50. The inscription has been severely damaged. I quote here and throughout in the reconstruction of Gutiérrez Álvarez. Text: Gutiérrez Alvarez, *Zamora*, no. 9; for an image, see his plate X.

51. Text: Gutiérrez Alvarez, *Zamora*, no. 10; for an image, see his plate Va.

52. Gutiérrez Alvarez, *Zamora*, no. 11, plate Vb. Slightly later examples of apparent mason-maker images: at Revilla de Santullán (Palencia), a mason, chisel in one

hand and hammer in the other, looks right at the viewer under an inscription reading MICHAELIS ME FECI. A relief of a mason swinging his hammer tops a pilaster on the left side of the portico of the little Romanesque church of Vilar de Donas (Palas de Rei, Galicia).

53. Gutiérrez Alvarez, *Zamora*, no. 10.

54. Medieval church graffiti in Iberia have yet to receive the monographic treatment that they have in England, for example: Matthew Champion, *Medieval Graffiti: The Lost Voices of Britain's Churches* (London: Ebury, 2015). For a good start, see the essays collected in Pablo Ozcáriz Gil, ed., *La memoria en la piedra: Estudios sobre grafitos históricos* (Pamplona: Dirección General de Cultura-Institución Príncipe de Viana, 2012), and Francisco Reyes Téllez, Gonzalo Viñuales Ferreiro, and Félix Palomero Aragón, eds., *Grafitos históricos hispánicos*, vol. 1, *Homenaje a Félix Palomero* (Madrid: OMMPress, 2016). The most notable Iberian ensembles of early medieval church graffiti are found at San Miguel de Escalada (León), San Millán de la Cogolla (Rioja), and Santiago de Peñalba (León). Good guides for thinking about and with premodern graffiti: Véronique Plesch, "Memory on the Wall: Graffiti on Religious Wall Paintings," *Journal of Medieval and Early Modern Studies* 32, no. 1 (2002) (medieval churches), and Jennifer A. Baird and Claire Taylor, eds., *Ancient Graffiti in Context* (New York: Routledge, 2011) (ancient Mediterranean). It's still happening. Michael Wilson, "Furtive Pleas to the Saints, Scribbled on Their Statues," *New York Times*, September 25, 2015.

55. The restoration process at Gormaz is described and the resulting graffiti edited in José Ángel Esteras et al., "La piel que habla: Grafitos de los siglos XI–XIII sobre el revoco románico de la iglesia de San Miguel de San Esteban de Gormaz (Soria)," in *La memoria en la Piedra: Estudios sobre grafitos históricos*, ed. Pablo Ozcáriz Gil (Pamplona: Gobierno de Navarra Departamento de Educación y Cultura, 2012). Wonderful images appear in Ángel Esteras et al., "La piel que habla: Un recorrido por los grafitos medievales en la iglesia de San Miguel de San Esteban de Gormaz (Soria)," 2010, accessed Jan. 24, 2014, http://issuu.com/funduqsoria /docs/piel_que_habla__para_web_reducido_y_corregido_?e=1260395/2690071# (slideshow). For more detailed studies, see Josemi Lorenzo Arribas, "*Maniculae* monumentales: Traslación de signos librarios a conjuntos murales medievales," in *Doce siglos de materialidad del libro: Estudios sobre manuscritos e impresos entre los siglos VIII y XIX*, ed. Manuel José Pedraza Gracia, Helena Carvajal González, and Camino Sánchez Oliveira (Zaragoza: Prensas de la Universidad de Zaragoza, 2017), and José Francisco Yusta Bonilla and Josemi Lorenzo Arribas, "La tribuna perimetral románica de la iglesia de San Miguel de San Esteban de Gormaz (Soria)," in *Actas del Undécimo Congreso Nacional de Historia de la Construcción*, ed. Santiago Huerta Fernández and Ignacio Javier Gil Crespo (Madrid: Instituto Juan de Herrera, 2019).

56. Esteras et al., "La piel que habla: Grafitos": hatchmarks, 103–4; hunting scene, 103; warrior, 100.

57. Esteras et al., "La piel que habla: Grafitos," 99. A clearer color image of the cross may be found in Esteras et al., "La piel que habla: Un recorrido," slide 15.

58. Esteras et al., "La piel que habla: Grafitos," 91.

59. Esteras et al., "La piel que habla: Grafitos," 100–101.

60. Thanks to Josemi Lorenzo for the photograph of the gesticulating graffito in Figure 21. Lorenzo Arribas, "*Maniculae* monumentales," discusses these figures together with the free-floating hands painted in red on the wall of a little fifteenth-century church in the province of Burgos to argue for the migration of *manicula* from the margins of manuscripts to more public sites.

61. Stephen C. Levinson, *Pragmatics* (Cambridge: Cambridge University Press, 1983), 55.

62. Esteras et al., "La piel que habla: Grafitos," 95.

63. Esteras et al., "La piel que habla: Grafitos": *era mc*, 94; *mciii*, 97; *mcci*, 94; *obit mes: era mcciiii*, 96.

64. For death-day as birthday, see A. C. Rush, "Death as Birth: The Day of Death as *dies natalis*," in *Death and Burial in Christian Antiquity* (Washington, D.C.: The Catholic University of America Press, 1941). Javier de Santiago Fernández asserts that the number of dated epitaphs in Hispania is higher than any other region in the Roman world; "El hábito epigráfico," 311.

65. The classic version of this trope in an inscription from Sardinia: "Qui legis hunc titulum, mortalem te esse memento" (CLE, no. 808). The thematic index of the CLEH lists dozens of epitaphs that directly address a passerby; "Topica sepulchralia IV, Viatorem defunctus alloquitur": http://cle.us.es/clehispaniae/show-index.jsf?idx=IX14, accessed April 10, 2021.

66. Text and translation: CLEH, no. BE1; http://cle.us.es/clehispaniae/comment.jsf?idioma=2&code=BE1, accessed April 8, 2021.

67. Ludger Lieb and Ricarda Wagner, "Dead Writing Matters? Materiality and Presence in Medieval German Narrations of Epitaphs," in *Writing Matters: Presenting and Perceiving Monumental Inscriptions in Antiquity and the Middle Ages*, ed. Irene Berti et al. (Berlin: De Gruyter, 2017), 15.

68. For the epitaph as puzzle, see especially Gabriel Sanders, *Lapides memores: Païens et chrétiens face à la mort; Le témoignage de l'épigraphie funéraire latine* (Faenza: Fratelli Lega, 1991), 33–34. Examples of self-decoding acrostic epitaphs in Mark A. Handley, *Death, Society and Culture: Inscriptions and Epitaphs in Gaul and Spain, AD 300–750* (Oxford: Archaeopress, 2003), 175. Iberian acrostic epitaphs from the Roman and Visigothic periods: ICERV nos. 274, 281, 282, 509. The acrostic was also a very common genre for poets like Eugenius of Toledo and Venantius Fortunatus, whose epitaph for himself is an acrostic. We return to acrostic poems in Chapter 8.

69. Arogontina's epitaph is catalogued in AEHTAM as no. 2619. An image of the inscription may be found at https://commons.wikimedia.org/w/index.php?curid=2179903.

70. Diego Santos, *Inscripciones medievales*, no. 154.

71. The second clause could also be rendered, "Read this stone placed at the body-head."

72. Isidore of Seville, *Etymologies* I.iii.1–3; ed. Lindsay, trans. Barney, 39.

73. The church at Peñalba de Santiago is another excellent example of an early medieval inscribed environment. It contains inscriptions marking its consecration (937 CE) and reconsecration under Abbot Stephanus (1105), the former with traces of paint that give an idea of how colorful these spaces once were. Recent excavations have also uncovered a rich collection of medieval graffiti from the period after its reconsecration, including a quotation from Smaragdus of St-Mihiel in neat Carolingian capitals. On the graffiti: Vanessa Jimeno Guerra, "Un patrimonio oculto y recuperado: Los graffiti de la iglesia de Santiago de Peñalba," *Medievalismo* 25 (2015); Milagros Guardia, "Los grafitos de la iglesia de Santiago de Peñalba: Scariphare et pingere en la Edad Media," *Revista Patrimonio* 9, no. 33 (2008); M. Suárez-Inclán y Ruiz de la Peña, "Los grabados de la Iglesia de Santiago de Peñalba en León," *Revista Patrimonio* 7, no. 26 (2006); and Josemi Lorenzo Arribas, "Translatio in parietem: Dos grafitos medievales en las iglesias de San Millán de Suso (La Rioja) y Peñalba de Santiago (León)," *Medievalia* 16 (2013). On the effects of the introduction of the Roman rite on this and other churches in León-Castile, see Artemio Martínez Tejera, "Dedicaciones, consagraciones y 'monumenta consecrationes' (ss. VI–XII): Testimonios epigráficos altomedievales en los antiguos reinos de Asturias y León," *Brigecio* 6 (1996), and Martínez Tejera, "Cenobios leoneses altomedievales ante la europeización: San Pedro y San Pablo de Montes, Santiago y San Martín de Peñalba y San Miguel de Escalada," *Hispania Sacra* 54 (2002).

74. Adelino Alvarez Rodríguez, "El epitafio del abad Esteban de Santiago Peñalba: Estudio y edición," *Analecta Malacitana (AnMal electrónica)* 24 (2008): 2–3.

75. Alvarez Rodríguez, "El epitafio del abad Esteban," 3.

76. Alvarez Rodríguez, "El epitafio del abad Esteban," 3. For that oddly orphaned *qui*, not uncommon in inscriptions of this sort, see "El epitafio del abad Esteban," 8.

77. Isidore of Seville, *Etymologies* I.iii.1–3; ed. Lindsay, trans. Barney, 39.

6. REMEMBER MAIUS: THE LIBRARY AND THE TOMB

1. On Escalada, see especially Vicente García Lobo and Gregoria Cavero Domínguez, eds., *San Miguel de Escalada (913–2013)* (León: Universidad de León Instituto de Estudios Medievales, 2014). For the architecture of the church, see Artemio Manuel Martínez Tejera, *El templo del "monasterium" de San Miguel de Escalada: "Arquitectura de fusion" en el reino de León (siglos X–XI)* (Madrid: Asociación para el Estudio y Difusión del Arte Tardoantiguo y Medieval, 2005). Archaeological studies of the remains of the monastery: Felipe San Román Fernández and Emilio Campomanes Alvaredo, "Avance de las excavaciones arqueológicas en San Miguel de Escalada (Campañas 2002–2004)," *Tierras de León: Revista de la Diputación Provincial* 45, no. 124–25 (2007), and Juan Luis Puente López and José María Suárez de Paz, "Marcas de cantero en la torre y

panteón de abades del monasterio de San Miguel de Escalada," *Tierras de León: Revista de la Diputación Provincial* 23, no. 51 (1983).

2. Beatus of Liébana, *Tractatus de Apocalypsin*, Praef. 6–7: ed. Roger Gryson and Marie-Claire de Bièvre. CSEL 107B (Turnhout: Brepols, 2012), 2.

3. John Williams was particularly interested in connections between Florentius and Maius: "Tours and the Early Medieval Art of Spain," in *Florilegium in honorem Carl Nordenfalk octogenarii contextum*, ed. Per Bjurström, Nils Göran Hökby, and Florentine Mütherich (Stockholm: Nationalmuseum, 1987); Williams, *The Illustrated Beatus: A Corpus of the Illustrations of the Commentary on the Apocalypse* (London: Harvey Miller, 1994), vol. 1: 78–93.

4. Vicente García Lobo argued that Escalada was Maius's home as well as the home of his Apocalypse and thought he saw the master's hand in the display capitals inscribed on a tombstone there; *Las inscripciones de San Miguel de Escalada: Estudio crítico* (Barcelona: El Albir, 1982), 66. Tempting as this is, it's unlikely—as is his suggestion that a Petrus CSR obitted in the wall inscriptions is the same one whose death is recorded on f. 293v of M644; Vicente García Lobo, "El 'Beato' de San Miguel de Escalada," *Archivos Leoneses* 33, no. 66 (1979): 206.

5. Maurilio Pérez González, "El latín del siglo X leonés a la luz de las inscripciones," in *Actas III Congreso hispánico de latín medieval (León, 26–29 de Septiembre de 2001)*, ed. Maurilio Pérez González (León: Universidad de León, 2002), 160; translation in John Williams and Barbara A. Shailor, eds., *A Spanish Apocalypse: The Morgan Beatus Manuscript* (New York: G. Braziller, 1991), 13. The inscription itself does not survive; we know of it from the text published by Manuel Risco and Enrique Flórez in 1786: *España sagrada: Memorias de la Santa Iglesia esenta de León* (Madrid: Pedro Marín, 1786), vol. 35: 311. Other studies of the dedication inscription: Gregoria Cavero Domínguez, "La dedicación de la iglesia en el monasterio de San Miguel de Escalada el 20 de noviembre de 913," in *San Miguel de Escalada (913–2013)*; Artemio Manuel Martínez Tejera, "Los epígrafes (fundacional y de restauración) del templum de San Miguel de Escalada (prov. de León)," in *Congreso Internacional "La Catedral de León en la Edad Media,"* ed. Joaquín Yarza Luaces, María Victoria Herráz Ortega, and Gerardo Boto Varela (León: Universidad de León, 2004).

6. The texts of the Escalada inscription program are edited in García Lobo, *Las inscripciones*. See also María Encarnación Martín López, "Las inscripciones de San Miguel de Escalada: Nueva lectura," in *San Miguel de Escalada (913–2013)*. Graffiti survive as well, and are studied in Vanessa Jimeno Guerra, "A propósito de los graffiti del templo de San Miguel de Escalada (León)," *Estudios Humanísticos: Historia* 10 (2011).

7. Ruled space also survives in the zones dedicated to obits in the cloister at Silos, as if the cloister walls were understood as gatherings ruled and ready for inscription; Encarnación Martín López, "Las inscripciones medievales del monasterio de Santo Domingo de Silos," in *Silos-Un milenio*, vol. 2 (Burgos: Universidad de Burgos, 2003).

8. Modern visitors have followed suit. The carved outlines of one of the odd human figures on the portico have been in recent times retraced by someone wielding a blue ballpoint pen; Jimeno Guerra, "A propósito de los graffiti," 286. Vandalism though this might be, it also demonstrates the attraction that the ancient trace has for modern fingers. Modern graffiti at Escalada are documented in a blog post by "Citizen L" of León: http://ciudadanoele.blogspot.com/2012/02 /grafiteros-en-escalada.html; accessed March 6, 2020.

9. Jimeno Guerra, "A propósito de los graffiti," 287–88.

10. Jimeno Guerra, "A propósito de los graffiti," 288.

11. Barbara Shailor identifies one other hand at work in the beginning of the codex (ff. 11r–26v and 28r–30v); Shailor, "Maius and the Scriptorium of Tábara," in *Apocalipsis* (Valencia: Testimonio, 2000), 635–36. The final quire (ff. 294r–299v) was added shortly after the codex was bound and is written in yet another Visigothic hand.

12. Umberto Eco, who wrote generously about the illuminated Beatus commentaries, famously dismissed the compiler himself as "an unbearable writer." Beatus's "ideas are confused, he lacked critical sensitivity and was unable to make an interpretive decision every time his sources were mutually contradictory"; Eco, "Waiting for the Millennium," in *The Apocalyptic Year 1000: Religious Expectation and Social Change, 950–1050*, ed. Richard Allen Landes, Andrew Colin Gow, and David C. Van Meter (Oxford: Oxford University Press, 2003), 121–22. For a more sympathetic introduction to Beatus as a writer, see J. A. Fernández Flórez, "Beato de Liébana, teólogo, escriturista y poeta en la Hispania del último tercio del siglo VIII," in *Escritura y Sociedad: El Clero*, ed. Alicia Marchant Rivera and Lorena Barco Cebrián (Granada: Comares, 2017). Readers of Spanish can now move more efficiently through Beatus's corpus with the aid of easily accessible bilingual editions of his works; *Obras completes*, trans. Joaquín González Echegaray, Alberto del Campo Hernández, and Leslie G. Freeman, Biblioteca de Autores Cristianos, vols. 47 and 77 (Madrid: Biblioteca de Autores Cristianos, 1995, 2004).

13. The extraordinarily rich tradition of Beatus illumination is beyond the scope of this book. For a recent survey of the corpus, see Ana I. Suárez González, "Beatos: La historia interminable," in *Seis estudios sobre Beatos medievales*, ed. Maurilio Pérez González (León: Universidad de León, 2010). John Williams devoted a scholarly life's work to the study of these codices and their visual vocabulary; the five volumes of his *Illustrated Beatus* are essential.

14. This part of the plan is clear from the preface, where, quoting Isidore, Beatus writes that texts "return more easily to the memory when they are read in short form" [facilius ad memoria redeunt, dum breui sermone leguntur]; *Tractatus de Apocalipsin*, Praef.: ed. Gryson and de Bièvre, vol. 107B: 1–2.

15. Mary Carruthers walks through the meditative way the Beatus commentary works, with special reference to Maius's copy; Carruthers, *The Craft of Thought: Meditation, Rhetoric, and the Making of Images, 400–1200* (Cambridge: Cambridge University Press, 1998), 150–55.

16. The Apocalypse had been required reading in Iberian churches from Easter to Pentecost since 633, but the division of the text in Beatus's commentary does not line up with the readings in the Hispanic liturgy, so it seems unlikely that it was composed as a lectionary. Williams believed it was mainly used for individual contemplative reading (*Illustrated Beatus*, vol. 1: 113); see also Jacques Fontaine, "Fuentes y tradiciones paleocristianas en el método espiritual de Beato," in *Actas del Simposio para el Estudio de los Códices del "Comentario al Apocalipsis" de Beato de Liébana*, ed. Carlos Romero de Lecea (Madrid: Joyas Bibliográficas, 1978). All but one of the Beatus codices produced before the twelfth century (the Facundus, Madrid, BNE, VITR 14/2) were made for and used in monasteries.

17. London, BL, Add MS 11695, f. 277v.

18. Beatus of Liébana, *Tractatus de Apocalipsin*, I.5: ed. Gryson and de Bièvre, vol. 107B: 2.

19. Beatus of Liébana, *Tractatus de Apocalipsin*, I.6–7; ed. Gryson and de Bièvre, vol. 107B: 2.

20. Isidore of Seville, *Etymologies* VI.3.1–2: ed. W. M. Lindsay (Oxford: Clarendon, 1911); trans. Stephen A. Barney et al. (Cambridge: Cambridge University Press, 2006), 138.

21. *Bibliot(h)eca* was first used for the Bible by the ninth-century scholar Sedulius, according to Albert Blaise, *Dictionnaire latin-français des auteurs chrétiens*, ed. Paul Tombeur (Turnhout: Brepols, 1954), s.v. *bibliotheca*. Beatus himself uses the word in this sense when he writes elsewhere that "the entire *biblioteca* is a single book, veiled at the beginning and revealed at the end" [tota biblioteca unus liber est, in capite uelatus, in fine manifestus]; Beatus of Liébana, *Adversus Elipandum* I.99, ed. Bengt Löfstedt, CCCM 59 (Turnhout: Brepols, 1984), 76. Florentius's student Sanctius said as much on one of the elaborately lettered title pages of the Bible he copied with Florentius in 960. His title presents the Bible as a "*biblioteca* in which are contained seventy-two books" [biblioteca in quo continentur libri septuaginta duo] (León, San Isidoro, MS 2, f. 3v).

22. A useful catalogue of similar ex-libris labyrinth pages appears in J. Domínguez Bordona, "Exlibris mozárabes," *Archivo Español de Arte y Arqueología* 2 (1935). Sheila Wolfe, however, understands this not as an ex libris so much as a dedication of the book to St. Michael in his capacity as conveyor of souls to heaven; Wolfe, "The Early Morgan Beatus (M644): Problems of Its Place in the Beatus Pictorial Tradition" (Ph.D., Ohio State University, 1988), 29–31.

23. Maius's Apocalypse has long been associated with Escalada. We know that was in the library there in the thirteenth century at least, judging by the necrological inscriptions on f. 293v (discussed later). Doubts have been raised, however, that Escalada was in fact the St. Michael's for which the book was made. Augusto Quintana Prieto suggested it was San Miguel de Camarzana; "San Miguel de Camarzana y su scriptorium," *Anuario de Estudios Medievales* 5 (1968). More recently, José Ferrero Gutiérrez proposed Moreruela de Tábara, six kilometers

from Maius's probable home monastery at Tábara; "El Beato de San Miguel y los monasterios de Valdetábara," *Brigecio* 20 (2010).

24. The codex has been damaged here: the leaf devoted to the angels with Matthew's Gospel (recto) and Mark with a witness (verso) has been lost, so the sequence as preserved does not unroll as it was designed to do. It's important to note that ff. 1–9 are neither ruled nor catchworded; they were clearly conceived as a unit (two gatherings of six pages each, according to Barbara Shailor, "The Codicology of the Morgan Beatus Manuscript," in *A Spanish Apocalypse: The Morgan Beatus Manuscript*, ed. John Williams and Barbara A. Shailor (New York: G. Braziller, 1991). Díaz y Díaz argued from this that they were not part of the original plan for M644; "La tradición de texto de los comentarios al Apocalipsis," in *Actas del Simposio para el Estudio de los Códices del "Comentario al Apocalipsis" de Beato de Liébana*, ed. Carlos Romero de Lecea (Madrid: Joyas Bibliográficas, 1978). The sequence is, however, part of every manuscript in the family that includes Maius's codex. The discussion here will, I hope, support the integral participation of this section in the plan of Maius's book.

25. "It is not too much to say that the author of the Apocalypse . . . may be the most textually self-conscious Christian writer of the early period. In no other early Christian text do the notions of books, writing, and reading occur so prominently"; Harry Y. Gamble, *Books and Readers in the Early Church* (New Haven: Yale University Press, 1997), 104. A classic treatment of books in the Apocalypse is Ernst Robert Curtius, "The Book as Symbol," in *European Literature and the Latin Middle Ages* (Princeton: Princeton University Press, 1973); for more specialized studies, see Leo Koepp, *Das himmlische Buch in Antike und Christentum* (Bonn: P. Hanstein, 1952), and Leslie Baynes, *The Heavenly Book Motif in Judeo-Christian Apocalypses, 200 B.C.E.–200 C.E.* (Leiden: Brill, 2011).

26. The early medieval Iberian visual tradition offers a rich counterpoint to the representations of books studied in *"Imago libri": Représentations carolingiennes du livre*, ed. Charlotte Denoël, Anne-Orange Poilpré, and Sumi Shimahara (Turnhout: Brepols, 2018).

27. "Mozarabic" visual imagery, writes Mireille Mentré, "operates essentially at the level of ideas rather than that of tangible realities . . . [it tends] to be highly schematic, demanding reflection and understanding, rather than recreating the setting for a scene. Mozarabic painting takes this perspective further, perhaps, than any other art in the Middle Ages"; Mentré, *Illuminated Manuscripts of Medieval Spain* (London: Thames and Hudson, 1996), 137.

28. Similarly self-referential is the book featured in the presentation scene of the late tenth-century Conciliar collection, the Codex Regio (Madrid, BNE, MS 1872, f. 238r): a red-framed tablet whose represented text reads LIB|ER. The neo-Visigothic *Liber Testamentorum* (Oviedo, AC; twelfth century) prominently features an image of open codex whose text is the single word TEXTUM (f. 18v).

29. Also in the Codex Regio (Madrid, BNE, MS 1872, f. 67r), an angel in profile holds a codex by the frame in one hand and a quill in the other.

30. Compare, for example, the book forms in the Romanesque Las Huelgas Beatus of 1220 (New York, Morgan Library, MS M429) with those of the Tábara Beatus of 970 (Madrid, AHN, MS L.1097) from which it was copied.

31. It is not coincidental that the Oviedo agate coffer, as expensive and labor-intensive a treasure as a luxury codex, bears an elaborate votive inscription naming the donors and dating the gift; César García de Castro Valdés, "La Arqueta de las Ágatas de la Cámara Santa de la Catedral de Oviedo," *Anales de Historia del Arte* 24, no. 1 (2014). On Iberian casket reliquaries in the eleventh century, see Melanie Hanan, "Romanesque Casket Reliquaries: Forms, Meanings, and Development" (Ph.D., New York University, 2013). Though it's Merovingian and not Iberian, the *arca* of Theuderic at the Abbey of Saint-Maurice d'Agaune (early ninth century) is also a lovely comparison because its votive inscription names both donors and makers and lays out the inscription letter by letter in a grid just like the alphabetic labyrinths of our Iberian codices; Robert Favreau, *Épigraphie médiévale* (Turnhout: Brepols, 1997), 113–14.

32. On book boxes, see John Lowden, "The Word Made Visible: The Exterior of the Early Christian Book as Visual Argument," in *The Early Christian Book*, ed. William E. Klingshirn and Linda Safran (Washington, D.C.: The Catholic University of America Press, 2007), and David Ganz, *Buch-Gewänder: Prachtein-bände im Mittelalter* (Berlin: Reimer, 2015).

33. Armando Petrucci, "The Christian Conception of the Book in the Sixth and Seventh Centuries," in *Writers and Readers in Medieval Italy: Studies in the History of Written Culture* (New Haven: Yale University Press, 1995), 29.

34. Petrucci, "The Christian Conception of the Book," 30.

35. I am not aware of any scholarly work upon this remarkable iconographic form. Mireille Mentré remarks on the unusual pentagonal form of Noah's ark in the Beatus commentaries but does not comment on the other uses of the same form in the tradition; Mentré, "La présentation de l'Arche de Noé dans les Beatus," in *Actas del Simposio para el estudio de los códices del Comentario al Apocalipsis de Beato de Liébana* (Madrid: Joyas Bibliográficas, 1978). Similarly, César García de Castro Valdés notes the similarity between the Oviedo agate coffer and the pentagonal form given to the Ark in the Beatus iconography but does not comment on its use to represent the codex; García de Castro Valdés, "La Arqueta de las Ágatas de la Cámara Santa de la Catedral de Oviedo," 212–13.

36. For the codex as *vas sacrum*, see Herbert L. Kessler, *Seeing Medieval Art* (Peterborough, Ont.: Broadview Press, 2004), 87. The verbal transformations rung by Hugh of St. Victor on the *arca* (Carruthers, *The Craft of Thought*, 243–46) are analogous to what Maius does here visually, I think.

37. Carruthers, *The Craft of Thought*, 269.

38. Isidore of Seville, *Etymologies* XVIII.9: ed. Lindsay; trans. Barney et al., 363.

39. "The book as a book is a mirror of itself," wrote James Finn Cotter about self-referential ancient images in books of people with books; Cotter, "The Book

within the Book in Mediaeval Illumination," *Florilegium: Carleton University Annual Papers on Classical Antiquity and the Middle Ages* 12 (1993): 108.

40. *Tractatus de Apocalypsin* XII.5.34, ed. Gryson and de Bièvre, vol. 107C: 940. A correction in what looks like Maius's hand emends the nonsense-word INCISTONE to "incisto ordine."

41. In his edition of the text, Roger Gryson explains this curious claim by saying that for Beatus the church *is* in a sense twelve—from the twelve apostles (*Tractatus de Apocalipsin*, vol. 107B: xcv) and offers in support quotes from Beatus's *Adversus Elipandum*—e.g., the church is "in duodenario numero apostolorum constituta" (*Adversus Elipandum* II.33; ed. Löfstedt, 128). The hitch, of course, is that here Beatus refers to a singular church, and the Apocalypse commentary explicitly refers to a plural. The crux remains unresolved. But it troubles modern scholars more than it did medieval scribes, for the text appears in just this wording in all surviving witnesses.

42. Text and translation: Shailor, "Codicology," 25, translation modified.

43. Magpie though Beatus may have been, it is unlikely that he was responsible for incorporating this quotation from Isidore. Maius's is the earliest version of the commentary in which this passage appears. I would love to think that it is his addition, but Díaz y Díaz's suggestion makes good sense: it began as a gloss on the preceding text ("Explicit codix Apocalpsin," f. 233v), and wandered from margin to text block over generations of copying ("La tradición de texto"). The earliest printed edition of the commentary (Madrid, 1770) omits it, a logical move if one is working from a modern concern with the Commentary on the Apocalypse as a "Work." Later editions, however, all include it.

44. Díaz y Díaz, "La tradición de texto," 179.

45. *Nomina essentiant res* for Isidore, and his names are very often puns. They're epistemologically essential puns, though: "One's insight into anything is clearer when its etymology is known" [Nam dum videris unde ortum est nomen, citius vim eius intellegis. Omnis enim rei inspectio etymologia cognita planior est]; Isidore of Seville, *Etymologies* I.29: ed. Lindsay; trans. Barney et al., 55.

46. Gregory the Great, *Moralia* Praef. I.1, ed. Marc Adriaen, CCCM 143 (Turnhout: Brepols, 1979–81), 8; copied by Florentius on f. 18v of BNE MS 80.

47. On *res*, things, and meaning: Mary Carruthers, *The Book of Memory: A Study of Memory in Medieval Culture* (Cambridge: Cambridge University Press, 1990), 189–91, and Carruthers, *The Craft of Thought*, 29–32; Aden Kumler and Christopher R. Lakey, "*Res et significatio*: The Material Sense of Things in the Middle Ages," *Gesta* 51, no. 1 (2012).

48. Grammatically, it is not quite clear what's going on here. Is this a single sentence, "Remember Maius"? If so, it's a request for prayer, and suitably humble— though the grammar is improvisational. Or perhaps the two words refer to two parallel speech acts: a subscription (MAIUS) and a command (REMEMBER). Whichever way we take it, what matters most is that we are being given a name on which to hang our attention.

49. *Tractatus de Apocalypsin* XII.5.32; ed. Gryson and de Bièvre vol. 107C: 939; cf. Apoc. 22:19.

50. *Etymologies* IX.5–6; copied in Morgan M644 in ff. 234r–37r. Like Isidore's codicology lesson, also copied after the commentary's explicit, this addition is not as far-fetched as it might at first seem. The *De adfinitatibus* articulates itself explicitly with the Apocalypse—again through analogy: "Just as the creation of the world and the status of humankind comes to an end through six ages," Isidore and Maius write, "so kinship in a family is terminated by the same number of degrees" [Ideo autem usque ad sextum generis gradum consanguinitas constituta est, ut sicut sex aetatibus mundi generatio et hominis status finitur, ita propinquitas generis tot gradibus terminaretur]; Isidore of Seville, *Etymologies* IX.6: ed. Lindsay; trans. Barney et al., 210.

51. For comparison of Maius's Daniel program with the altogether different one in Florentius and Sanctius's 960 Bible of León, see Javier Vallejo Bozal, "El ciclo de Daniel en las miniaturas del códice," in *Codex biblicus legionensis: Veinte estudios*, ed. César Álvarez Álvarez (León: Real Colegiata de San Isidoro, 1999).

52. Another gathering was added, still, judging by the hand, in the tenth century. It contains an unusual synoptic commentary on the Apocalypse. For an edition and study of this text, see Manuel C. Díaz y Díaz, "El Libro del Apocalipsis del códice de Magio en Nueva York," in *Códices visigóticos en la monarquía leonesa* (León: Centro de Estudios de Investigación "San Isidoro," 1983).

53. Throughout the discussion of this colophon, I cite the edition of Maurilio Pérez González and follow him in the translation: Pérez González, "Tres colofones de Beatos: Su texto, traducción y comentario," in *Seis estudios sobre Beatos medievales* (León: Universidad de León, 2010), 221–24. For a compelling discussion of this poem and the structure of the Beatus commentary in the context of meditative memory technologies, see Carruthers, *The Craft of Thought*, 150–55.

54. Maria A. H. Maestre Yenes, *Ars Iuliani Toletani Episcopi: Una gramática latina de la España visigoda* (Toledo: Diputación Provincial, 1973), 114.

55. *Maius* is the comparative form of *magnus*: great, powerful. The alternate spelling *Magius*, used by the scribe's student Emeterius to refer to him in the Tábara Beatus (discussed at the end of this chapter), is equally auspicious, being as it is the comparative form of *magus*, magical. Greater and more magical!

56. The large red R at the top left of the page, almost in the gutter, is clearly attached to the invocational cross; I do not read it as part of the acrostic. Some scholars have struggled to include this R in the acrostic. García Lobo, for example, suggests that Maius is the same man as the Abbot Recesvintus of Escalada mentioned in another text of the period; "El 'Beato' de San Miguel de Escalada," 267. Díaz y Díaz argues that the poem is incomplete and that the acrostic might have spelled out SCRIPTOR MAIUS; "El Libro del Apocalipsis," 377.

57. In line 3 of the colophon-poem, "Quorum quidem hic degetis," the adverb *hic* could be either temporal (now) or locative (here). The future tense of the verb inclines toward a locative sense, but since the reach to the reader always involves the reader's present moment, the translation evokes the "now" as well.

58. Or: "at the command of Abbot Victor"—but for this to be the case we would have to overlook the fact that *Uictoris* is in the genitive case, while *abba* is in the nominative.

59. Pérez González, "Tres colofones," 221–22.

60. Gregory the Great, *Moralia* Praef. I.1, ed. Adriaen, vol. 143: 8.

61. Pérez González thinks this is the case ("Tres colofones," 221–24); so does García Lobo ("El 'Beato' de San Miguel de Escalada," 253–54).

62. It is also possible to associate the *duo gemina* of line 9 with the numbers of the date supplied in line 10. Thus John Williams translates: "Thus this book from beginning to end is completed in the era of twice two three times three hundred and three times twice ten"; *Illustrated Beatus*, vol. 2: 21. But it is also true that Maius's punctuation clearly separates "duo gemina" from "ter terna."

63. Peter K. Klein, "Eschatological Expectations and the Revised Beatus," in *Church, State, Vellum, and Stone: Essays on Medieval Spain in Honor of John Williams*, ed. Therese Martin and Julie Harris (Leiden and Boston: Brill, 2005), 151.

64. García Lobo, "El 'Beato' de San Miguel de Escalada," 253–54.

65. The scene that García Lobo imagines here may have occurred, but it could not have been in the process of making Maius's Apocalypse, since, as Williams points out, our manuscript is not the archetype even for its own family; *Illustrated Beatus*, vol. 2: 29. Fully evaluating this claim would require a careful collation and comparison of the text and images in Maius's version with the others in its family, branches IIa and IIb.

66. Pérez González, "Tres colofones," 222. Maius's codex is usually dated to the mid-940s on paleographic and artistic grounds. For debates about resolving the date, see the discussion in CCV, no. 230, and John Williams, "The History of the Morgan Beatus Manuscript," in *A Spanish Apocalypse: The Morgan Beatus*, 17 and 21.

67. Marginalia survive that testify to exactly this kind of affective response—not in Morgan M644, however, but in the eleventh-century Silos Beatus from the same manuscript family, whose annotations remark that one passage is *timendum ualde* (London, BL, Add MS 11695, f. 43v) and urge the reader into holy fear and fearful speech *Nota lector time et dic* (f. 55r).

68. Compare to this very public announcement the private-sounding exclamation written upside down in the outer margin of f. 97v of Morgan M644 in a humanist hand: *a mia grave pena forte doloroso vita mia* (after the first words it is hard to read; this is how García Lobo resolves it; "El 'Beato' de San Miguel de Escalada," 235). To this same hand we may also owe the graceful little dog running down the outer margin of f. 42v.

69. For medieval and early modern graffiti as a form of memorialization *ad sanctos*, see especially Armando Petrucci, *Writing the Dead: Death and Writing Strategies in the Western Tradition* (Stanford, Calif.: Stanford University Press, 1998), 28; Mark A. Handley, *Death, Society and Culture: Inscriptions and Epitaphs in Gaul and Spain, AD 300–750* (Oxford: Archaeopress, 2003), 166–80; and Véronique Plesch, "Memory on the Wall: Graffiti on Religious Wall Paintings," *Journal of*

Medieval and Early Modern Studies 32, no. 1 (2002). A contemporary form of the practice is recorded in Michael Wilson, "Furtive Pleas to the Saints, Scribbled on Their Statues," *New York Times*, September 25, 2015.

70. Elizabeth Sears, "The Afterlife of Scribes: Swicher's Prayer in the Prüfening Isidore," in *Pen in Hand: Medieval Scribal Portraits, Colophons and Tools*, ed. Michael Gullick (Walkern, Herts.: Red Gull Press, 2006), 93.

71. *Etymologies* XV.11.1: ed. Lindsay; trans. Barney et al., 313.

72. Both compositions are bordered by wide bands of interlace dominated by a deep yellow, both use the same color palette, both place the letters in uncolored blocks. The arrangement of the letters, however, is different.

73. Miguel Carlos Vivancos Gómez, *Glosas y notas marginales de los manuscritos visigóticos del Monasterio de Silos* (Abadía Benedictina de Silos: Aldecoa, 1995), 214.

74. "Benedico celi quoque regem qui ad istius libri finem uenire me permisit incolomen." Cf. Florentius: BNE MS 80, f. 499r and León, San Isidoro, MS 2, f. 514 r. There is no doubt that Florentius's work was known at Silos; as we saw in Chapter 1, the Beatus written there in 1091 repurposes great chunks of Florentius's colophon, including this same formulation (London, BL, Add MS 11695, f. 266r). Similar language is used in the copy of the *Etymologies* completed at Cardeña by Endura and Didaco in 962 (Madrid, RAH, 76, f. 159v).

75. This lovely gesture can also occur in epitaphs, as in this early Christian inscription: "Here rests in peace Beatila Lucilla XXII, who lived blessedly and died blessedly. Blessed be those who read [this]" [Hic requiescit in pace Beatila Lucilla XXII, que beate vixsit, beate obit. beati qui legunt] (ILCV no. 2383).

76. Vivancos Gómez, *Glosas y notas*, 399.

77. Verse epitaphs circulated on parchment as much as they stood in stone; Ana I. Suárez González, "¿Del pergamino a la piedra? ¿De la piedra al pergamino? entre diplomas, obituarios y epitafios medievales de San Isidoro de León," *Anuario de estudios medievales* 33, no. 1 (2003). Composing such epitaphs was in vogue among the literati in Visigothic Iberia; for orientation, see Salvador Iranzo Abellán, "Inscripciones métricas," in *La Hispania visigótica y mozárabe: Dos épocas en su literatura*, ed. Carmen Codoñer Merino (Salamanca: Ediciones Universidad de Salamanca, 2010). A good number—including Braulio's for Isidore and his siblings—are preserved in the so-called *Anthologia Hispana* (Leiden: Bibliothek der Rijksuniversiteit, MS Voss F. 111 (CXI)—e.g., between ff. 24v and 32v.

78. The Latin follows the edition of Vivancos Gómez, *Glosas y notas*, 399–400. For an overview of other manuscripts in which this epitaph appears and an edition of a slightly different text, see José Carlos Martín, "El 'Epitaphium Isidori, Leandri et Florentinae' (ICERV 272) o la compleja tradición manuscrita de un texto epigráfico: Nueva edición y estudio," *Euphronsyne* 32 (2010).

79. Vivancos Gómez, *Glosas y notas*, 399–400.

80. It is difficult to see the word *finit* under the dark reagent stain on f. 385r of BnF, nal 2169. Vivancos is editing the poem from this manuscript, though, and

I have chosen to trust him. The Omega page at the end of Florentius's *Moralia* is anchored at its corners by the letters F-I-N-I-S (BNE MS 80, f. 501r).

81. Vivancos Gómez, *Glosas y notas*, 220.

82. As Claudia Rapp has suggested, the codex can be a virtual coffin, containing—in the case of hagiography—the story of a saint as the coffin contains her or his physical body; Rapp, "Holy Texts, Holy Men, and Holy Scribes: Aspects of Scriptural Holiness in Late Antiquity," in *The Early Christian Book*, 221. The most spectacular example of this practice of regarding the codex as a sort of virtual tomb may well be the Hedwig Codex (commissioned 1353), which is built around a full-page "effigy" illumination of its titular saint; Jeffrey F. Hamburger, "Representations of Reading—Reading Representations: The Female Reader from the Hedwig Codex to Châtillon's Léopoldine au Livre d'Heures," in *Die lesende Frau*, ed. Gabriela Signori (Wiesbaden: Harrassowitz Verlag in Kommission, 2009).

83. Escalada became a dependency of St. Ruf of Avignon in 1156; memorial inscriptions preserved at Escalada include this abbreviation. See, e.g., inscriptions nos. 14–17 in García Lobo's catalog; *Las inscripciones*, 71–74.

84. One of the wall inscriptions at Escalada memorializes the death of another canon of St. Ruf, a presbyter named Petrus Facundi, on May 29, 1166. The engraver forgot the surname the first time around and had to add it above the line; García Lobo, *Las inscripciones*, no. 15.

85. There is some disagreement among scholars about whether the colophon and the tower image were originally part of the book we now call the Tábara Beatus (AHN MS L.1097). What matters for this argument, however, is that they were clearly conceived together.

86. Text from Pérez González, "Tres colofones," 224, including his emendations.

87. García Lobo, *Las inscripciones*, 69.

88. I borrow the term "impaginated" from Virginie Greene, who uses it suggestively in passing: Greene, "Un cimetière livresque: La liste nécrologique médiévale," *Le Moyen Age: Revue d'histoire et de philologie* 105, no. 2 (1999): 325.

89. Pérez González, "Tres colofones," 225.

90. Pérez González, "Tres colofones," 225.

91. An illegible stretch after the year may have given the very hour of the codex's completion. Pérez González emends the last number to "VIIIIa," adding that he does not see the specification of the hour in the Latin ("Tres colofones," 225). The copy of this manuscript made for Las Huelgas in 1220 (New York, Morgan Library, MS M429), which renders the colophon verbatim on f. 182v, gives the date of completion as "era millesima VIIIa ora VIIIIa"—nones, or 3 P.M.

92. Very little is left of the built environment at Tábara that Emeterius and Maius would have known. The bell tower that still stands there is a twelfth-century production, and most of the church is later still. However, fragmentary inscriptions have been recently discovered that date paleographically to the tenth century—one,

phrased in the first person of one Abbot Arandisclo, and another, an epitaph. Neither is dated. See Antonio Blanco Freijeiro and Ramón Corzo Sánchez, "Lápida fundacional de San Salvador de Távara," in *Simposio para el estudio de los códices del 'Comentario sobre el Apocalipsis' de Beato de Liébana* (Madrid: Joyas Bibliográficas, 1980); Maurilio Pérez González, "Cenobios tabarenses: Sobre un nuevo epígrafe hallado en Tábara (Zamora)," *Brigecio* 7 (1997); and Pérez González, "El latín del siglo X," 170–73.

93. Isidore, *Etymologies* VI.13–14; ed. Lindsay; New York, Morgan Library, MS M644, f. 233v.

94. Shailor identifies three hands in the Tábara Beatus: Maius: ff. 2r–68r; Monnius, who is named on ff. 166r and 170r and who copied much of the remainder; and Emeterius, who brought the writing to completion; Shailor, "Maius and the Scriptorium," 638. García Lobo, too, sees Maius at work up until f. 69r; "El 'Beato' de San Miguel de Escalada," 247n7.

7. THE STRANGE TIME OF HANDWRITING

1. Shane Butler, *The Matter of the Page: Essays in Search of Ancient and Medieval Authors* (Madison: University of Wisconsin Press, 2011), 104.

2. New York, Morgan Library, MS M644, f. 293r; Maurilio Pérez González, "Tres colofones de Beatos: Su texto, traducción y comentario," in *Seis estudios sobre Beatos medievales* (León: Universidad de León, 2010), 221–22.

3. Jerome, Letter 60, in *Epistulae*, ed. I. Hilberg, CSEL vol. 54: 574; compare Seneca the Younger, Letter 40; trans. Richard M. Gummere, Loeb Classical Library (Cambridge, Mass.: Harvard University Press, 1934), vol. 1: 262–65.

4. John Keats, *Complete Poems and Selected Letters*, Modern Library Classics (New York: Modern Library, 2001), 365, lines 7–8. The poem is preserved in his handwriting, written upside down in a manuscript of his comic *Cap and Bells* (Cambridge, Mass., Houghton Library, MS Keats 2.29.1–2.29.2, seq. 6), https://nrs.harvard.edu/urn-3:FHCL.HOUGH:3714864?n=6; accessed April 21, 2021.

5. Karen Swann, "The Strange Time of Reading," *European Romantic Review* 9, no. 2 (1998): 277. Thanks to Yopie Prins for suggesting this essay.

6. Carolyn Dinshaw, *How Soon Is Now?: Medieval Texts, Amateur Readers, and the Queerness of Time* (Durham, N.C.: Duke University Press, 2012), 64.

7. Dinshaw, *How Soon Is Now?*, 37. Although Dinshaw's queer temporality is not focused on materiality, the queer time explored here is manuscript sister to what she elsewhere calls "temporal copresence"; Dinshaw, "Are We Having Fun Yet? A Response to Prendergast and Trigg," *New Medieval Literatures* 9 (2007): 64.

8. There is a tiny marginal note just at the beginning of this passage at the words "et tamen aeternos nos esse credimus" [and nevertheless we believe ourselves eternal]; it remains tantalizingly illegible on the microfilm (the original cannot be consulted because of its sadly damaged condition).

9. Swann, "The Strange Time," 279.

10. Roland Barthes, *Camera Lucida: Reflections on Photography*, trans. Richard Howard (New York: Hill and Wang, 1981), 96.

11. For more on these figures and the graffiti at Gormaz, see Chapter 5.

12. It is difficult to give a firm number in response to the question, "How fast did scribes copy?" Good starting places toward an answer appear in Carla Bozzolo and Ezio Ornato, *Pour une histoire du livre manuscrit au Moyen Age: Trois essais de codicologie quantitative* (Paris: Éditions du Centre National de la Recherche Scientifique, 1980); Michael Gullick, "How Fast Did Scribes Write?: Evidence from Romanesque Manuscripts," in *Making the Medieval Book: Techniques of Production*, ed. Linda L. Brownrigg (Los Altos Hills, Calif.: Red Gull Press, 1995); and Jan Peter Gumbert, "The Speed of Scribes," in *Scribi e colofoni: Le sottoscrizioni di copisti dalle origini all'avvento della stampa*, ed. Emma Condello and Giuseppe De Gregorio (Spoleto: Centro italiano di studi sull'alto Medioevo, 1995).

13. Augustine, *De civitate Dei* I.Praef., ed. Bernhard Dombart and Alfons Kalb (Stuttgart: Teubner, 1981), 1:1. The translation here is mine; hereafter I will cite in English from Augustine, *Concerning the City of God against the Pagans*, trans. Henry Bettenson (Harmondsworth: Penguin, 1972).

14. Augustine's letter 174 to Firmus about another massive work, *De trinitate*, discusses his dictation practices.

15. Madrid, RAH, MS 29, f. 1v. A later writer took advantage of the blank first page to write on f. 1r in a dark Caroline minuscule that is too worn to be legible. Elisa Ruiz García has been able to make out the beginning and identifies it as a Marian litany; Ruiz García, *Catálogo de la sección de códices de la Real Academia de la Historia* (Madrid: La Academia, 1997), 216.

16. The other *City of God* in Visigothic hand is a ninth-century codex, containing books XII–XXI only (El Escorial, Biblioteca del Monasterio, s.I.16).

17. Augustine, Letter 1A, ed. J. Divjak, in Dombart and Kalb, *De civitate*, vol. 1: xxxvi; trans. in Harry Y. Gamble, *Books and Readers in the Early Church* (New Haven: Yale University Press, 1997), 134–35.

18. RAH MS 29 is incomplete, ending abruptly at *De civitate* XXII.30.51. The final gathering was lost long ago, to judge by the wear on the now-final f. 291v.

19. There are, however, some wonderful little drawings that beg to be described as doodles—for example, a bare-breasted lady of high fashion with an elaborate headdress . . . with no relation to the accompanying text that I can see (f. 189v).

20. You can do this yourself now, thanks to the recent digitization of the RAH's manuscript collection: the entire codex is available online, page by page at http://bibliotecadigital.rah.es/es/consulta/registro.do?id=135.

21. For a codicological and paleographic introduction to RAH 29, see Ruiz García, *Catálogo de la Real Academia*, 215–17. The annotations are discussed by Jean Vezin and Manuel Díaz y Díaz; Jean Vezin, "La répartition du travail dans les *scriptoria* carolingiens," *Journal des Savants* 3 (1973) and "L'emploi du temps d'un copiste au XIᵉ siècle," in *Scribi e colofoni: Le sottoscrizioni di copisti dalle origini all'avvento della stampa*, ed. Emma Condello and Giuseppe De Gregorio (Spoleto: Centro italiano di studi sull'alto Medioevo, 1995); Díaz y Díaz, *Libros y librerías en la Rioja altomedieval* (Logroño: Diputación Provincial, 1979), 147–54. Díaz y Díaz's careful study of the reception of Augustine evinced by the annotations in

RAH 29 has been especially helpful for this project: "Agustín entre los mozárabes: Un testimonio," *Augustinus* 25 (1980).

22. Augustine, *De civitate* I.35; ed. Dombart and Kalb, vol. 1: 51; trans. Bettenson, 46.

23. Isidore of Seville, *Etymologies* V.31: ed. W. M. Lindsay (Oxford: Clarendon, 1911); trans. Stephen A. Barney et al. (Cambridge: Cambridge University Press, 2006), 127.

24. In this the scribes from San Millán may also be taking their cue from Augustine, who articulates the length of *City of God* with his own progress in it in a strikingly self-reflexive way: "For here we are," he says, "with the nineteenth book in hand on the subject of the City of God" [nam unde ista Dei ciuitas, de qua huius operis ecce iam undevicensimum librum uersamus in manibus]; *De civitate* XIX.5; ed. Dombart and Kalb, vol. 2: 362–63; trans. Bettenson, 858. Gillian Clark observes that this sentence "uses the length of *City of God* as evidence for the long development of the City of God: 'Here we are with the nineteenth book on the *City of God* in our hands.' The Latin . . . can mean 'I am working on book 19'; it could also remind readers that they are in action as readers, turning over the pages of book 19 and aware of how much has gone before"; Clark, "City of Books: Augustine and the World as Text," in *The Early Christian Book*, ed. William E. Klingshirn and Linda Safran (Washington, D.C.: The Catholic University of America Press, 2007), 120.

25. On f. 88v, another hand also takes over. The marginal annotation reads: "Here another scribe began to write on the Sabbath after the octave of Easter" [Hic inquoabit alius scriba ad scribere, sabbato post octabas pasce].

26. In addition to Moterrafe and Aloysius, two to three more hands have been detected in RAH 29; Ruiz García, *Catálogo de la Real Academia*, 216.

27. Vezin, "La répartition du travail"; "L'emploi du temps."

28. Vezin, "La répartition du travail," 215.

29. For two case studies on the difficulties of *simultaneously* transcribing different quires of the same copy-text by different scribes, see Jean Vezin, "Une faute de copiste et le travail dans les scriptoria du haut moyen âge," in *Sous la règle de Saint Benoit: Structures monastiques et sociétés en France du Moyen âge à l'époque moderne* (Geneva: Droz, 1982).

30. This is no scrawled complaint: not only is it as neatly written as the text on which it comments (*De civitate* X.26), it is also encased in an attention-getting border that follows the outline of the letters, giving the effect, for a twenty-first-century reader schooled in the conventions of the graphic novel, of a thought-balloon emanating from the page itself.

31. An equally particular and even more affective annotation from another tenth-century codex from San Millán: *in histo loco requiesci*. Here I rested (Paris, BnF, nal. 2180, f. 118v). Perhaps this is one of our *City of God* scribes.

32. *Confessions* XI.14; ed. James J. O'Donnell (Oxford: Clarendon, 1992), vol. 1: 155; Augustine, *Confessions*, trans. Sarah Ruden (New York: Modern Library,

2017), 360. The bibliography on this famous quotation is vast. Most relevant to our concerns here is the discussion in Dinshaw, *How Soon Is Now?*, 12–16.

33. Isidore of Seville, for example, draws heavily on the *Confessions'* celebrated discussions of time and memory in his *Sententiae*, I.6–8, trans. Thomas L. Knoebel (New York: Newman Press, 2018), 43–44.

34. RAH 29's apparatus of glosses includes six cross-references to the *Confessions*, three of them in sections on time: ff. 116r, 121r, 138v; Díaz y Díaz, "Agustín entre los mozárabes," 168.

35. To a later passage in this same discussion ("death is a reality; and so troublesome a reality that it cannot be explained by any verbal formula, nor got rid of by any rational argument") (Augustine, *De civitate* XIII.11; trans. Bettenson, 520), the gloss in RAH 29 observes that Augustine writes "very acutely, deeply, and profoundly" [acute satis et halte hac profunde] (f. 139r, central column). Indeed.

36. Augustine, *De civitate* XIII.11; ed. Dombart and Kalb, vol. 1: 569; trans. Bettenson, 520.

37. The whole gloss reads: *uide karissime quia cum deo solo et in deo solo est anima rationalis*; Díaz y Díaz, "Agustín entre los mozárabes," 175.

38. Augustine, *De civitate* XI.5; ed. Dombach and Kalb, vol. 1: 468; trans. Bettenson, 435.

39. Augustine, *De civitate* XIV.24; ed. Dombart and Kalb, vol. 2: 51; trans. Bettenson, 588.

40. Díaz y Díaz, "Agustín entre los mozárabes," 176. The glossator is responding to *De civitate* XI.10.

41. Díaz y Díaz, "Agustín entre los mozárabes," 176.

42. Augustine, *De civitate* XXII.30; ed. Dombart and Kalb, vol. 2: 634; trans. Bettenson, 1,090. Cf. Ps 89:4, 2 Peter 3:8. On the "Millenial week," see J. Danielou, "La typologie millénariste de la semaine dans le Christianisme primitif," *Vigiliae Christianae* 2 (1948); for abundant information and bibliography on this apocalyptic uses of this passage, see Richard Allen Landes, "Lest the Millennium Be Fulfilled: Apocalyptic Expectations and the Pattern of Western Chronography 100–800 CE," in *The Use and Abuse of Eschatology in the Middle Ages*, ed. Werner Verbeke, D. Verhelst, and Andries Welkenhuysen, Mediaevalia Lovaniensia (Leuven: Leuven University Press, 1988).

43. Augustine, *De civitate Dei* XXII.30; ed. Dombart and Kalb, vol. 2: 635; trans. Bettenson, 1,091.

44. Augustine, *De civitate* XXII.30; ed. Dombart and Kalb, vol. 2: 635; trans. Bettenson, 1,091.

45. Augustine, *De civitate* XXII.30; ed. Dombart and Kalb, vol. 2: 635; trans. Bettenson, 1,091.

46. The manuscript is held by the Diocesan Museum at La Seu d'Urgell. Since this archive does not use shelf numbers, the codex is most easily researched starting with its entry in the CCV (no. 73). The colophon is found on f. 153r.

47. M. T. Clanchy, *From Memory to Written Record, England 1066–1307* (Oxford: Blackwell, 1993), 238.

48. León, San Isidoro, MS 3, f. 3r; Julio Pérez Llamazares, *Catálogo de los códices y documentos de la Real Colegiata de San Isidoro de León* (1923), 19.

49. Beatus of Liébana, *Tractatus de Apocalypsin* IV.5; ed. Roger Gryson and Marie-Claire de Bièvre, CSEL 107B (Turnhout: Brepols, 2012), 518. For more on this eschatological *computus*, very widespread in early medieval Iberian monasteries, see Jean-Baptiste Piggin, "The Great Stemma: A Late Antique Diagrammatic Chronicle of Pre-Christian Time," *Studia Patristica* 62 (2013).

50. Beatus himself probably supervised various editions of the commentary, and the dates of those revisions are reflected in the differing versions of this passage in the manuscript tradition. Gryson and de Bièvre offer the following variants (labeled with their sigla): Q (Navarra, copied late twelfth century): era 823; L (Lorvão, copied 1189): era 839; O (Burgo de Osma, copied 1086): era 829; K (Rome/Sahagún, twelfth century): era 828 (Beatus of Liébana, *Tractaus de Apocalypsin,* ed. Gryson and de Bièvre). Striking, however, is the fact that this "present era" is never updated to the year of copying.

51. *Pace* Peter Orton, who argues that colophons were "untransferable," "true only of the manuscripts in that they were originally written," and suggests that scribes who copied them unaltered from their exemplars did so because they weren't fully literate; Orton, *Writing in a Speaking World: The Pragmatics of Literacy in Anglo-Saxon Inscriptions and Old English Poetry* (Tempe: Arizona Center for Medieval and Renaissance Studies, 2014), 196.

52. New York, Morgan Library, MS M429, f. 184r; text from John Williams, *The Illustrated Beatus: A Corpus of the Illustrations of the Commentary on the Apocalypse,* vol. 5 (London: Harvey Miller, 1994): Latin (38) and translation (41n1, modified).

53. New York, Morgan Library, MS M429, f. 184r; my transcription. Parentheses and punctuation as in original. Sylvie Merian, the librarian I consulted at the Morgan, said the hand looked to be either that of Belle da Costa Green (1883–1950) or Meta Harrsen (1891–1977).

54. New York, Morgan Library, MS M429, f. 184r; my transcription.

55. Mementote enim mihi.... Quorum quidem hic degetis ... / Ad paboremque patroni arcisummi scribens ego. ... Inter eius decus uerba mirifica storiarumque depinxi per seriem. / Ut scientibus terreant iudicii futuri aduentui; New York, Morgan Library, MS M644, f. 293r.; Pérez González, "Tres colofones," 221–22.

8. THE WEAVERS OF ALBELDA

1. The scribe is not consistent in the spelling of his name: sometimes he writes "Vigila" and sometimes "Vigilanus." The Codex Vigilanus is the only surviving codex from his hand, but he was an active notary. A document dated 950 formalizing Albelda's absorption of a neighboring monastery concludes with the words, "I, Vigila the scribe, made this sign with my own hand" [Vigila scriba manu mea

signum feci]; Antonio Ubieto Arieta, *Cartulario de Albelda*, (Valencia: n.p., 1960), 56. Based on paleographical analysis, Fernández Flórez is confident that this notary is the same Vigila who made books at Albelda; J. A. Fernández Flórez and M. Herrero de la Fuente, "Copistas y colaboradores vinculados con el monasterio de Albelda en torno al año 1000," in *La Collaboration dans la production de l'écrit medieval: Actes du XIIIe Colloque Internationale de Paléographie Latine*, ed. H. Spilling (Paris: École des Chartes, 2003), 119.

2. "Texte veut dire Tissu; mais alors que jusqu'ici on a toujours pris ce tissu pour un produit, un voile tout fait, derrière lequel se tient, plus ou moins caché, le sens (la verité), nous accentuons maintenant, dans le tissu, l'idée générative que le texte se fait, se travaille à travers un entrelacs perpétuel"; Roland Barthes, *Le plaisir du texte* (Paris: Seuil, 1973), 100–101; trans. Richard Miller (New York: Hill and Wang, 1975), 64.

3. For the productive tension between the authoritative construction of text understood as "the revealed truth and unmoved center of faith" and the textile "weave and pattern, a warp and weft," etymologically buried within it, see D. C. Greetham, "Romancing the Text, Medievalizing the Book," in *The Pleasures of Contamination: Evidence, Text, and Voice in Textual Studies* (Bloomington: Indiana University Press, 2010), 246. On the weaving metaphor in Old English literature, see Megan Cavell, *Weaving Words and Binding Bodies: The Poetics of Human Experience in Old English Literature* (Toronto: University of Toronto Press, 2016).

4. A good introduction to the Iberian Councils may be found in David Paniagua, "Concilios hispánicos de época visigoda y mozárabe," in *La Hispania visigótica y mozárabe: Dos épocas en su literatura*, ed. Carmen Codoñer Merino (Salamanca: Ediciones Universidad de Salamanca, 2010). The Council collections survive in multiple recensions. The Codex Vigilanus contains the *Hispana Chronologica*, Julian recension. For the text as presented in the Codex Vigilanus, see Gonzalo Martínez Díez, "La Colección canónica 'Hispana,'" in *El Códice Albeldense, 976*, ed. Claudio García Turza (Madrid: Testimonio, 2002). An Arabic translation of the Councils, in circulation by 1049, is fascinating evidence that a significant number of Iberian ecclesiastics in this period were more comfortable in Arabic than in Latin; P. S. Van Koningsveld, "La literatura cristiana-árabe de la España medieval y el significado de la transmisión textual en árabe de la Collectio Conciliorum," in *Concilio III de Toledo: XIV centenario, 589–1989* (Toledo: Arzobispado de Toledo, 1991).

5. Copies in Visigothic hand of Council collections (cited by CCV catalogue number for ease of reference): CCV nos. 48 (Codex Emilianensis), 49 (Codex Vigilanus), 50, 51, 66, 139, 157, 168, 316, and of the *Liber iudicum*: nos. 6, 38, 120, 150, 169, 193, 246–48, 279.

6. Augustine, *De civitate Dei* I.35; ed. Bernhard Dombart and Alfons Kalb (Stuttgart: Teubner, 1981), vol. 1: 51; trans. Henry Bettenson (Harmondsworth: Penguin, 1972), 46.

7. Much of this work joining the two law codes is done by the *Chronicon Albeldensis*, included in the Codex Vigilanus between the Council Collection and the Decretals (ff. 238v–43r). For an edition of the *Chronicon*, see Yves Bonnaz, *Chroniques Asturiennes: Fin IX^e siècle* (Paris: Éditions du Centre National de la Recherche Scientifique, 1987), 10–30.

8. On the late ancient invention of the legal pandect and the parallel with the biblical pandect, see Caroline Humfress, "Judging by the Book: Christian Codices and Late Antique Legal Culture," in *The Early Christian Book*, ed. William E. Klingshirn and Linda Safran (Washington, D.C.: The Catholic University of America Press, 2007), 143–44.

9. Vigila, says Díaz y Díaz, "planeó el Codex Albeldensis de manera muy original, que estamos tentados de considerar propia"; Manuel C. Díaz y Díaz, "Escritores del monasterio de Albelda: Vigilán y Sarracino," in *El Códice Albeldense, 976*, 87.

10. El Escorial, Biblioteca del Monasterio, MS d.I.2, f. XXIIv. This page is preceded in the current binding of the codex by twenty-one pages of scholarly description written in the sixteenth century by Juan Vásquez de Mármol and Ambrosio Morales. Those pages are numbered in Roman numerals; the remainder of the codex in Arabic numerals. Whoever did the numbering seems to have thought of this page as more related to the sixteenth-century prefatory material than to the rest of the codex. Both Vásquez (f. Ir) and Morales (f. XIIIr) remark that when they examined the codex, this image was on the reverse of the first leaf.

11. The anxious St. Matthew of the Carolingian Ebbo Gospels (816–35) makes a very nice comparison (Épernay, Bibliothèque Municipale, MS 1, f. 18v).

12. *Fusorem pargamentum* is an odd phrase. *Fusor* comes from the verb *fundo*, which means to cast metals or to scatter. Fernández González and Galván Freile follow the former sense and read the phrase as a metaphorical equation of writing with sculpting; "Iconografía, ornamentación, y valor simbólica de la imagen," in *El Códice Albeldense, 976*, 208. My reading of *fusorem* as "scatterer"—i.e., waster—is guided by the context of fear (*verebar*) and doubt (*dubietate*). Alternately, the speaker here could be in fear of "The Waster of Parchment" himself—the Devil.

13. El Escorial, Biblioteca del Monasterio, d.I.2, f. XXIIv; Manuel C. Díaz y Díaz, *Libros y librerías en la Rioja altomedieval* (Logroño: Diputación Provincial, 1979), 288.

14. These lines might also be rendered, "So, in the beginning of this book, there arose in me, Vigila the scribe, the desire to write. . . ." Thanks to Donka Markus for advice on the translation.

15. Vigila sounds a lot like Gregory the Great here. Compare the letter to Leander that precedes the *Moralia* in most Iberian editions of the work: "As soon as I understood . . . the scope and the difficulties of the work I was to undertake . . . I confess that I was overcome by the mere hearing of what I was asked to do, and I gave in exhausted by the sheer magnitude of the task. But although caught between fear and devotion, I immediately raised the eyes of my mind to the giver of gifts and put all hesitation aside, certain that a thing could not be impossible that the

love in the hearts of my brothers had asked of me"; Gregory the Great, *Moral Reflections on the Book of Job*, vol. 1, *Preface and Books 1–5*, trans. Brian Kerns (Collegeville, Minn.: Liturgical Press, 2014), 49. Vigila would almost certainly have known this text well and may even—as Florentius did—have had occasion to copy it.

16. Soledad de Silva points out the remarkably innovative iconography of the frontispiece; Soledad de Silva y Verástegui, *Iconografía del s. X en el reino de Pamplona-Nájera* (Pamplona: Diputación Foral de Navarra, 1984), 47. A very relevant discussion of the "hero-scribe" in Insular manuscript culture may be found in Michelle Brown, "Spreading the Word," in *In the Beginning: Bibles Before the Year 1000*, ed. Michelle Brown (Washington, D.C.: Freer Gallery of Art and Arthur M. Sackler Gallery, Smithsonian Institution, 2006), especially the section entitled "Being the Book: the Scribe as Evangelist," 68–70.

17. Manuel C. Díaz y Díaz published the acrostic poems of the Codex Vigilanus twice in the same year in slightly different formats: "Vigilán y Sarracino: Sobre composiciones figurativas en la Rioja del s. X," in *Lateinische Dichtungen des X. und XI. Jarhhunderts: Festgabe für Walter Bulst* (Heidelberg: Schneider, 1979); "Composiciones figurativas en Albelda en el siglo X," in *Libros y librerías en la Rioja altomedieval* (Logroño: Diputación Provincial, 1979). I will cite from "Vigilán y Sarracino" because its apparatus is more detailed. Díaz y Díaz makes valiant translations of some of the poems in "Escritores del monasterio."

18. The style of poetry practiced in the Codex Vigilanus has its roots in the formal experiments of Optatian in the fourth century and, after him, Venantius Fortunatus. Rabanus Maurus's *De laudibus sanctae crucis* is probably the most well-known work in this genre; Theodulf of Orléans also dabbled in the form (for example, see his poem 23, "Teodulfus episcopus hos versos conposuit"). For a straightforward introduction, see Ulrich Ernst, "The Figured Poem," *Visible Language* 20, no. 1 (1986).

19. For Optatian's term *versus intexti*, see Aaron Pelttari, *The Space That Remains: Reading Latin Poetry in Late Antiquity* (Ithaca: Cornell University Press, 2014), 75. Also helpful for thinking with Optatian is William Levitan, "Dancing at the End of the Rope: Optatian Porfyry and the Field of Roman Verse," *Transactions of the American Philological Association* 115 (1985).

20. Venantius Fortunatus, Epistle 5.6a: *Opera poetica*, ed. Friedrich Leo, Monumenta Germaniae Historica (Berlin: Weidmann, 1881), vol. 4: 115; trans. in Margaret Graver, "*Quaelibet Audendi*: Fortunatus and the Acrostic," *Transactions of the American Philological Association* 123 (1993): 237; emphasis added.

21. Tim Ingold connects labyrinth and loom in his interdisciplinary exploration of the line as an agent of epistemological movement; Ingold, *Lines: A Brief History* (London: Routledge, 2007), 39–71. Jeffrey Hamburger observes that acrostics like this undercut the linearity of script and replace it with "an open web of linked associations"; Hamburger, *Script as Image* (Leuven: Peeters, 2014), 49.

22. The Biblioteca Nacional de España paid what might be an unconscious homage to the labor of these scribes when, in the early 2000s, it used an acrostic

bookmark to encourage readers to handle books with care. Letters are laid out crossword-style in rows across the bookmark. Random letters are grayed out. Red letters highlighted in yellow spell out the sentence MANIPULA LA ENCUADER-NACIÓN CON CUIDADO. Green letters remind users of the material nature of their LIBROS: PERGAMINO.

23. Monarchs of the kingdom of Pamplona (Navarra): García Sánchez I (d. 970) [*Garsea*]; Sancho Garcés de Navarra (938–94) [*Sancio*] and his wife, Urraca (d. 1007), daughter of Fernán González (the Count of Castille for whom Florentius wrote up a document); Ramiro Garcés (d. 981), lord of the evanescent little kingdom of Viguera, 7.5 kilometers as the crow flies from Albelda [*Ranimirus*].

24. Vigila liked classical meter, although, as Díaz y Díaz explains, he understood it as more accentual and syllabic than quantitative; "Vigilán y Sarracino," 62. Three of his compositions (acrostics 1, 7, 8) in the Codex Vigilanus include ostentatiously erudite notes identifying and explaining their meter. The note to poem 1 reads, "Metrum trocaicum, quod ex troceo nomen accepit, locis omnibus ponitur, et in septimo cum catalecton huius exemplum: Psallat altitudo celi, sallant omnes angeli"; Díaz y Díaz, "Vigilán y Sarracino," 70.

25. Translations of all the poems in the Codex Vigilanus are mine, with the patient and skilled assistance of Ellen Cole Lee, Harriet Fertig, and Donka Markus. The formal strictures the poets imposed upon themselves make for some very contorted language, and translation is difficult. I have done the best I could not to misrepresent their work.

26. Díaz y Díaz, "Vigilán y Sarracino," 70. Discussing these acrostic poems in modern print presents significant typographical challenges. Díaz y Díaz presents them both in typographical gridded facsimile, all in capitals, and in a more conventional poetic form. To make things easier for readers, I will take the latter route in presenting the poems, preserving the capitals in the Latin only.

27. In an untranslatable bit of Latin wordplay in line 5, high-thundering God literally surrounds little Vigila [ALTITONANS EXIGUOQUE VIGILANI DEUS], the divine noun and adjective divided by the mortal writer.

28. Though perhaps not *this* codex. While the Codex Vigilanus is certainly a "single nourishing book," it does not, as advertised here, contain the Old and New Testaments. It seems likely that Vigila is repurposing a poem written for another codex, which does not, alas, survive. That manuscript might have originally been introduced by a great Alpha, as the poem suggests—and is in fact the case in other codices of the period (for example, Florentius's *Moralia* and many of the Apocalypse commentaries).

29. Díaz y Díaz, "Vigilán y Sarracino," 72, line 1.

30. Díaz y Díaz, "Vigilán y Sarracino," 72. My translation follows Díaz y Díaz's suggestion that the puzzling *gracilam* that follows the name of the scribe is perhaps a surname ("Escritores del monasterio," 85). The two words are both in the accusative and clearly go together, but if the second word is the adjective *gracilis*, the form should be *gracil<u>em</u>* to match *Vigilanem* in gender as well as case. It may

be that the stress of the weaving here has led the poet to bend the rules of grammar; in this case, the translation should be "oh holy cross, protect humble Vigila."

31. "Tree of life, grant the prayers of Sancio / fragrant flower of the holy cross, inspire Ranimirus" [ARBOR UITAE LARGIRE PRAECIBUS SANCIONIS / AMOMUM CRUCIS FLOS SACRE ADFLA RANIMIRUM]; Díaz y Díaz, "Vigilán y Sarracino," 72.

32. The figure of the tree in poem 3 spells out, "ARBOR PARDIS TENSA RAMIS HINCUE SIUE ET HINC—SALBATOR SANCIONI DA UICTORIAE PALMAS—SANCTA MARIA, URRACAM ANCILLAM RESPICE TUAM—AGIE, FABE ANGELO, MICAEL, RANIMRO TUO—VATUM FRUANTUR PRECATU FAMILIE PALMAS"; Díaz y Díaz, "Vigilán y Sarracino," 76.

33. Díaz y Díaz, "Vigilán y Sarracino," 75, lines 4–5.

34. Díaz y Díaz, "Vigilán y Sarracino," 75, lines 8–10.

35. Poem 5 begins, "O Alpha and Omega, wisdom of God the father, the most high, inspire duly, O Christ, covering *me* with your hand. Behold now *I* pray that you might be present to *me* in prayer, Daniel, that I might perpetually and zealously enjoy your gift. O holy King, illuminate *me*, Sarracinus: I earnestly implore that your zealous aid, father, might be here for *me*" [O ALFA ET ω, ALTISSIMI DEI PATRIS SAPIENTIA, / RITE INSPIRA, O CRISTE, MICI TEGENS TUA MANU. / EN NUNC ORO CEU UT MICI ADSIS ORANTI, DANIEL, / XENIA NAUITER UT FRUAR OBANS PERPETIM TUA. / GENITE REX ALME, TU INLUMINA ME SARRACINUM: / ENIXE INPLORO TUA UT MICI PATER HIC ADSINT]; Díaz y Díaz, "Vigilán y Sarracino," 81, lines 1–6; emphasis added in translation.

36. Díaz y Díaz, "Vigilán y Sarracino," 84.

37. Díaz y Díaz, "Vigilán y Sarracino," 75, lines 34–35.

38. Levitan, "Dancing at the End of the Rope," 266. In the copy of the Codex Vigilanus completed at San Millán in 994 CE (El Escorial, Biblioteca del Monasterio, MS d.I.1), the grids for the poems were laid out on the page but never filled in. The loom is easy to set up, but the weaving is hard.

39. The task of acrostic composition becomes almost unimaginably difficult if we imagine Vigila or Sarracinus to be native Arabic speakers emigrated from al-Andalus. The name Sarracinus could suggest an Andalusian origin. It is a fairly common name in documents from this part of Iberia at this time and is even attested as a surname in Britain; R. E. Latham, D. R. Howlett, and R. K. Ashdowne, eds., *Dictionary of Medieval Latin from British Sources* (Oxford: Oxford University Press, 1975–2013), s.v. *sarracenus*.

40. Venantius Fortunatus, Carmina V.6; ed. Leo, vol. 4: 117. The letter-commentary about the poem, precedes the poem in Leo's edition (112–15). Margaret Graver's discussion of Fortunatus ("*Quaelibet Audendi*") has been very helpful.

41. Ed. Leo; vol. 4: 114; trans. Graver, "*Quaelibet Audendi*," 241.

42. Levitan, "Dancing at the End of the Rope," 266; emphasis added.

43. Ed. Leo; vol. 4: 113–14; trans. Graver, "*Quaelibet Audendi*," 240.

44. Optatian, *Carmina* III.28–29; cited and translated in Pelttari, *Space That Remains*, 81 (translation slightly modified).

45. Optatian, *Carmina* 22; cited and translated in Graver, "*Quaelibet Audendi*," 224.

46. Jerome, Letter 125; in *Epistulae*, ed. I. Hilberg, CSEL 56 (Vienna: Hoelder-Pichler-Tempsky, 1918), 142.

47. Terentianus, *De litteris* Praef., lines 27–29; ed. Henricus Keil, *Grammatici latini* (Leipzig: Teubner, 1857), vol. 6: 325; trans. Rita Copeland and I. Sluiter, *Medieval Grammar and Rhetoric: Language Arts and Literary Theory, AD 300–1475* (Oxford and New York: Oxford University Press, 2009), 74.

48. For a study of AHN 1007B, see Díaz y Díaz, *Libros y librerías*, 117–22. The codex is multiply foliated at the upper and lower corners, which makes locating things difficult. The poem by Vigila is on ff. 74v–75r according to the numbers in the upper margin, and on 159v–60r according to the lower foliation. Aeximino's poem follows on f. 75v (or 160v).

49. Edition of Aeximino's poem in Díaz y Díaz, *Libros y librerías*, 289–92; see also D. de Bruyne, "Manuscrits Wisigothiques," *Revue Bénédictine* 36 (1924): 18–20. Aeximino's poem is a prologue to a codex that has since been lost but, judging by the text, contained many of the same works contained in AHN 1007B. The poem describes the volume's contents, asks for prayers on the scribe's behalf, and concludes with a teasing notice that we should read vertically for the name of the scribe and the date. "Wretched Aeximinus wrote this," reads the acrostic, "in era nine hundred seventy," continues the mesostic. The telestic concludes, "in the nineteenth year of the lunar cycle, on the kalends of April" [April 1, 932] [Aeximinus hoc misellus scribsit / era nonagesima septuagesima / cursu nono decimo kalenda Aprili].

50. "The era twice five hundred years was passing away / together with ten more and twice four / when these records were completed by Vigila / with the help of God" [Occubente labentia bis nam quina centena / semel dena scilicet bis rite quaterna era / acta sunt a Vigilane deo dante edita]; Díaz y Díaz, "Vigilán y Sarracino," 92, lines 85–87. Someone later does the math in Arabic numerals on the lower margin of 75r (160 r): "500 + 500+10 + 8 = 1018."

51. The text is, however, conceived as verse, as Vigila's characteristically pedantic headnote indicates ("Metrum trocaycum decapenta syllaba et trimetrum habet locis omnibus ponitur ulti talecton"); Díaz y Díaz, "Vigilán y Sarracino," 89n. Vigila set himself the additional challenge of ending every line on each stanza with the same letter. Diáz y Díaz's edition restores the verse form in twenty-nine three-line stanzas.

52. Díaz y Díaz, "Vigilán y Sarracino," 89–91. An early modern reader (probably the same one who figured the date on f. 75r) makes sure that we do not miss what he has seen and writes above the first line of Visigothic text "litere initiales dicunt: *Membrana missa a Vigilane Montano.*"

53. The cartulary of Albelda records an abbot Vigila in the year 983; Ubieto Arieta, *Cartulario de Albelda*, 73. If this abbot is our scribe, as Fernández Flórez has suggested, then it is not surprising that he should hold forth on matters of

monastic discipline; "Un calígrafo-miniaturista del año mil: Vigila de Albelda," *Codex Aquilarensis* 16 (2000): 180.

54. Díaz y Díaz, "Vigilán y Sarracino," 89–91, lines 43–45.

55. It is no accident that the tightly woven late gothic hand is known not only as *textualis* but also as *textura*, weaving; Michelle Brown, *A Guide to Western Historical Scripts from Antiquity to 1600* (Toronto: University of Toronto Press, 1990), 80–89.

56. Elisa Ruiz García has suggested that the interlace represents the ornamented outside of the volume; "La escritura: Una *vox Dei* (siglos X–XIII)," in *I Jornadas jurídico-administrativa, económico-financiera y judicial del reino castellano-leonés (siglos X–XIII)* (Madrid: Departamento de Ciencias y Técnicas Historiográficas y de Arqueología, Universidad Complutense, 2002), 78. But given the iconographic tradition that Vigila is playing with here (evangelists at their desks are usually at work on an open volume), and given that other instances of the interlace-book (e.g., at f. 20v, discussed in the conclusion) are clearly open codices, this is, in my view, unlikely.

57. Elizabeth Sears, "The Afterlife of Scribes: Swicher's Prayer in the Prüfening Isidore," in *Pen in Hand: Medieval Scribal Portraits, Colophons and Tools*, ed. Michael Gullick (Walkern, Herts.: Red Gull Press, 2006), 84.

58. "The kings who wanted the *Liber Iudicum* to be made" are all seventh-century Hispano-Visigothic monarchs: Cindasvinctus (d. 653), Recesvinctus (d. 672), and Egica (d. 702). The *Chronicon Albeldensis*, copied earlier in this codex by our scribes (ff. 238v–43r), discusses these three lawgiving kings; see Bonnaz, *Chroniques Asturiennes*, 22.

59. Unusual as the inclusion of scribes in this otherwise royal page is, González Diéz discusses only the images of royalty and leaves the scribes out completely; Emiliano González Diéz, "El Liber Iudicorum de Vigilano," in *El Códice Albeldense, 976*, 166–67.

60. Gregory the Great, *Moralia* Praef. 1.1, ed. Marc Adriaen, CCSL 143 (Turnhout: Brepols, 1979–81), 8.

61. In the margin beside the images of Urraca, Sancio, and Ranimirus, the gloss explains: "In the time of these kings and this queen the work of this book was completed during the era TXIIII" [in tempore horum regum atque regine perfectum est opus libri huius discurrente era TXIIIIa].

62. It is helpful to remember that in this period the word *codex* can refer both to the book and to the law code that it contains; Ruiz García, "La escritura: Una *vox Dei* (siglos X–XIII)," 78.

63. Díaz y Díaz, "Vigilán y Sarracino," 86, lines 1–2.

64. Díaz y Díaz, "Vigilán y Sarracino," 86, lines 23–26.

65. Díaz y Díaz, "Vigilán y Sarracino," 86, lines 1–4.

66. Díaz y Díaz, "Vigilán y Sarracino," 86, lines 15–17. The Salvus referred to here is the ruling abbot of Albelda; Charles Julian Bishko, "Salvus of Albelda and Frontier Monasticism in Tenth-Century Navarre," *Speculum* 23 (1948). His biography,

perhaps written by Vigila, is included in the Codex Vigilanus (f. 343). The Latin here is very difficult. This is the best I can do. Thanks to Ellen Cole Lee for her assistance.

67. Díaz y Díaz, "Vigilán y Sarracino," 86, line 14.

68. Díaz y Díaz, "Vigilán y Sarracino," 87–88.

69. For example, in the ground poem: Sacre ac aule Martini episcopi / Quius precatu tua protecta manu / Vigeat alma turba hic monchorum / et gaudens sacris uirtutibus floreat; Díaz y Díaz, "Vigilán y Sarracino," 87-8, lines 22–25. In the telestic: martini sanctissimi atrium tuere ac salua monacorum acmen.

70. The Iberian scribes are not the only ones to do this. Francis L. Newton observes that Aldred, the scribe of the Lindisfarne Gospels, "regarded the book as a dynamic object within a living historical narrative, and . . . saw himself as part of that narrative"; Newton, Francis L. Newton Jr., and Christopher R. J. Scheirer, "Domiciling the Evangelists in Anglo-Saxon England: A Fresh Reading of Aldred's Colophon in the 'Lindisfarne Gospels,'" *Anglo-Saxon England* 41 (2012): 103. See also Newton, "A Giant among Scribes: Colophon and Iconographical Programme in the Eadui Gospels," in *Writing in Context: Insular Manuscript Culture, 500–1200*, ed. Erik Kwakkel (Leiden: Leiden University Press, 2013).

71. The final number is very hard to read, as the page has been deeply stained. What matters in this argument, however, is the simple fact that the writer is concerned to articulate his work with the beginning of human life on earth.

72. Mary Carruthers, *The Craft of Thought: Meditation, Rhetoric, and the Making of Images, 400–1200* (Cambridge: Cambridge University Press, 1998), 34.

73. Carruthers, *The Craft of Thought*, 34–35.

74. Greetham, *Pleasures of Contamination*, 263.

75. Isidore of Seville, *Etymologies* XII.5: ed. W. M. Lindsay (Oxford: Clarendon, 1911); trans. Stephen A. Barney et al. (Cambridge: Cambridge University Press, 2006), 258.

76. After he punningly roots text in its etymology, Barthes, too, takes the spider's self-suspension as a figure for the reading and writing subject: "Lost in this tissue—this texture—the subject unmakes himself, like a spider dissolving in the constructive secretions of its web" [perdu dans ce tissu—cette texture—le sujet s'y défait, telle une araignée qui se dissouderait elle-même dans les sécrétions constructives de sa toile]; Barthes, *Plaisir*, 101; trans. Miller, 64.

77. Ingold, *Lines*, 16.

CONCLUSION: THE HANDY MANUSCRIPT

1. Isidore of Seville, *Etymologies* I.3; ed. W. M. Lindsay (Oxford: Clarendon, 1911); trans. Stephen A. Barney et al. (Cambridge: Cambridge University Press, 2006), 39.

2. Madrid, RAH, MS 25, f. 22r; Manuel C. Díaz y Díaz, *Libros y librerías en la Rioja altomedieval* (Logroño: Diputación Provincial, 1979), 284.

3. The *excerpta canonum* and their introductory poems are edited in Gonzalo Martínez Díez, *La Colección canónica hispana*, vol. 2, part 1, *Colecciones Derivadas* (Madrid: Consejo Superior de Investigaciones Científicas, 1966), 43–214.

4. The *excerpta* poems were probably composed by a student of Eugenius of Toledo (d. 657 CE); Martínez Díez, *La colección canónica*, vol. 2.1: 32.

5. Though the introductory poems appear in other Conciliar codices of the period, the illuminations that accompany them in the Vigilanus (and in its copy, the Emilianensis) are found nowhere else. Soledad de Silva notes that the images that accompany the *excerpta* in the Codex Vigilanus have not been studied as much as they deserve, perhaps because scholars are "overwhelmed by their originality"; Soledad de Silva y Verástegui, *Iconografía del s. X en el reino de Pamplona-Nájera* (Pamplona: Diputación Foral de Navarra, 1984), 47. They have, however, been treated in Kristin Böse, "Recht Sprechen: Diskurse von Autorschaft in den Illuminationen einer Spanischen Rechtshandschrifte des 10. Jahrhunderts," in *Ausbildung des Rechts: Systematisierung und Vermittlung von Wissen in mittelalterlichen Rechtshandschriften*, ed. Kristin Böse and Susanne Wittekind (Frankfurt am Main: Peter Lang, 2009); Etelvina Fernández González and Fernando Galván Freile, "Iconografía, ornamentación, y valor simbólica de la imagen," in *El Códice Albeldense, 976*, ed. Claudio García Turza (Madrid: Testimonio, 2002); Elisa Ruiz García, "La escritura: Una *vox Dei* (siglos X–XIII)," in *I Jornadas jurídico-administrativa, económico-financiera y judicial del reino castellano-leonés (siglos X–XIII)* (Madrid: Departamento de Ciencias y Técnicas Historiográficas y de Arqueología, Universidad Complutense, 2002); Soledad de Silva y Verástegui, "L'illustration des manuscrits de la Collection Canonique Hispana," *Cahiers de Civilisation Médiévale* 32, no. 127 (1989): 255–56.

6. For Roman iconography of manual speech, see Gregory S. Aldrete, *Gestures and Acclamations in Ancient Rome* (Baltimore: Johns Hopkins University Press, 1999). Most helpful for the medieval period has been François Garnier, *Le langage de l'image au Moyen Age*, 2 vols. (Paris: Léopard d'Or, 1982). See also Jean-Claude Schmitt, *La raison des gestes dans l'Occident médiéval* (Paris: Gallimard, 1990). For the Iberian twelfth century, see especially Alicia Miguélez Cavero, *La gestualidad en el arte románico de los reinos hispanos* (Madrid: Publicaciones del Círculo Románico, 2010). On the index finger: Alicia Miguélez Cavero, "El dedo índice como atributo de poder en la iconografía románica de la Península Ibérica," in *Imágenes del poder en la Edad Media*, vol. 2, *Estudios in Memoriam del Prof. Dr. Fernando Galván Freile* (León: Universidad de León, 2011). On the hand of God, see Ruiz García, "La escritura: Una *vox Dei* (siglos X–XIII)"; Jeffrey F. Hamburger, "The Hand of God and the Hand of the Scribe: Craft and Collaboration at Arnstein," in *Die Bibliothek des Mittelalters als dynamischer Prozess*, ed. Michael Embach et al. (Wiesbaden: Reichert, 2012); Schmitt, *La raison des gestes*, 93–133. The only other period example I have found of the handy talking object outside the Vigilanus and the Emilianensis occurs in the León Antiphoner (León, AC,

MS 8, f. 105r), where a speaking hand emerges from a tree to wake a sleeping figure. The speaking codex motif also appears much later in *Les Douze Dames de Rhétorique* (1463) (Cambridge, Royal Library, MS Nn 3.2, f. 26v).

7. Jan-Dirk Müller, "The Body of the Book: The Media Transition from Manuscript to Print," in *The Book History Reader*, ed. David Finkelstein and Alistair McCleery (London: Routledge, 2002), 147. Müller exemplifies his statement with this quote from Richard de Bury's fourteenth-century *Philobiblon*: "Books are masters, who instruct us without rod or ferule, without angry words, without clothes or money. If you come to them they are not asleep; if you ask and inquire of them, they do not withdraw themselves; they do not chide if you make mistakes; they do not laugh at you if you are ignorant"; Müller, "The Body of the Book," 147. Books also speak in the *Philobiblon*—mostly, however, to complain about their ill-use by readers.

8. Marshall McLuhan, *The Gutenberg Galaxy: The Making of Typographic Man* (Toronto: University of Toronto Press, 2011), 96.

9. The knotwork that represents Codex's text is itself a kind of labyrinth. Josemi Lorenzo demonstrates that the building-block of Vigila's represented Codex, Solomon's knot, was often associated in both text and image with the endless movement of the maze; Josemi Lorenzo, "El nudo de Salomón," *Revista Digital de Iconografía Medieval* 12, no. 22 (2020).

10. Martínez Díez, *La colección canónica*, vol. 2.1: 43–44; lines 11–12.

11. Jerome, *Commentary on Habakkuk*, I.2, in *Commentarii in prophetas minores*, ed. Sincero Mantelli, CCSL 76 (Turnhout: Brepols, 2018), 30.

12. *Moralia* I:24; Gregory the Great, *Moralia in Job*, ed. Marcus Adriaen, CCSL 143 (Turnhout: Brepols, 1979–81), 43.

13. Martínez Díez, *La colección canónica*, vol. 2.1: 45, lines 50–54.

14. Martínez Díez, *La colección canónica*, vol. 2.1: 45, line 55.

15. Martínez Díez, *La colección canónica*, vol. 2.1: 45, line 58.

16. Manuel C. Díaz y Díaz, "Vigilán y Sarracino: Sobre composiciones figurativas en la Rioja del s. X," in *Lateinische Dichtungen des X. und XI. Jarhhunderts: Festgabe für Walter Bulst* (Heidelberg: Schneider, 1979), 86, lines 3–4.

17. Similarly, Maius gave one of his represented books text that read simply LIBRUM (New York, Morgan Library, M644, f. 146r; see Chapter 4), creating a meta-book whose self-referential text is nothing but "book." The Codex Vigilanus will do the same when, on f. 334r, it illustrates the presentation of the "codex canonum" required in the ritual for holding a council.

18. Isidore of Seville, *Etymologies* I.3; ed. Lindsay; trans. Barney, 2:39.

19. Dan. 5:5–6.

20. Dan. 5:1.

21. Jerome, *Commentarii in Danielem* II.5; ed. F. Glorie, CCSL 75A (Turnhout: Brepols, 1964), 823.

22. Dan. 5:5–6.

23. New York, Morgan Library, MS M644, f. 293r; ed. Maurilio Pérez González, "Tres colofones de Beatos: Su texto, traducción y comentario," in *Seis estudios sobre Beatos medievales* (León: Universidad de León, 2010), 221–22.

24. "There is no need to seek a book: may the room itself be your book" [Non opus est ut quaeratur codex: camera illa codex uester sit]; Augustine, Sermon 319; PL 38: 1,442.

25. Einsiedeln, Stiftsbibliothek, MS 266 [1296], 203; translated by Martin Irvine, in *The Making of Textual Culture: "Grammatica" and Literary Theory, 350–1100* (Cambridge: Cambridge University Press, 1994), 104.

MANUSCRIPTS CITED

The number following the abbreviation CCV remits to the catalog entry in Agustín Millares Carlo, *Corpus de códices visigóticos*. Vol. 1. Las Palmas: Universidad de Educación a Distancia, 1999.

Barcelona	Museu Diocesà	no shelf no.	CCV 11
Cambridge	Trinity College	MS R.17.1	
Cambridge, Mass.	Houghton Library, Harvard University	MS Keats 2.29.1–2.29.2	
Córdoba	Archivo Catedralicio	MS 1	CCV 39
Covarrubias	Colegiata de San Cosme y San Damián	leg. I no. 4	
Einsiedeln	Stiftsbibliothek	MS 266	
El Escorial	Biblioteca del Monasterio	MS a.I.13	CCV 42
El Escorial	Biblioteca del Monasterio	MS d.I.1	CCV 48
El Escorial	Biblioteca del Monasterio	MS d.I.2	CCV 49
El Escorial	Biblioteca del Monasterio	MS S.I.16	CCV 61
Girona	Arxiu Capitular	MS 7	CCV 69
La Seu d'Urgell	Museu Diocesà	no shelf no.	CCV 74
La Seu d'Urgell	Museu Diocesà	no shelf no.	CCV 73
Las Palmas de Gran Canaria	Seminario Millares Carlo	no shelf no.	CCV 76
Leiden	Bibliothek der Rijksuniversiteit	MS Voss F. 111 (CXI)	CCV 78
León	Archivo Catedralicio	MS 8	CCV 81
León	Real Colegiata de San Isidoro	MS 2	CCV 96
León	Real Colegiata de San Isidoro	MS 3	
London	British Library	Add MS 11695	CCV 106
London	British Library	Add Ch 71356	
Madrid	Archivo Histórico Nacional	MS 1007B	CCV 127

(*continued*)

Madrid	Archivo Histórico Nacional	MS L.1097	CCV 128
Madrid	Archivo Histórico Nacional	MS 1452B.10	CCV 136
Madrid	Archivo Histórico Nacional	MS L.1439	
Madrid	Biblioteca Nacional de España	MS 80	CCV 152
Madrid	Biblioteca Nacional de España	MS 6126	CCV 159
Madrid	Biblioteca Nacional de España	MS 10018	CCV 166
Madrid	Biblioteca Nacional de España	MS 1872	CCV 157
Madrid	Biblioteca Nacional de España	MS Vitr/14/1	CCV 147
Madrid	Biblioteca Nacional de España	MS Vitr/14/2	CCV 148
Madrid	Real Academia de la Historia	MS 24	CCV 184
Madrid	Real Academia de la Historia	MS 25	CCV 185
Madrid	Real Academia de la Historia	MS 29	CCV 188
Madrid	Real Academia de la Historia	MS 60	CCV 202
Madrid	Real Academia de la Historia	MS 76	CCV 209
Manchester	John Rylands Library	MS lat. 83	CCV 219
Manchester	John Rylands Library	MS lat. 89	CCV 220
New York	Morgan Library	MS M429	
New York	Morgan Library	MS M644	CCV 230
Novara	Biblioteca Capitolare	MS LI	
Oviedo	Archivo Catedralicio	MS 1	
Paris	Bibliothèque nationale de France	MS lat. 1	
Paris	Bibliothèque nationale de France	MS nal 2169	CCV 261
Paris	Bibliothèque nationale de France	MS nal 2170	CCV 262
Paris	Bibliothèque nationale de France	MS nal 2180	CCV 266
Salamanca	Hermandad de Sacerdotes Operarios	no shelf no.	CCV 281
Silos	Archivo del Monasterio	MS 3	CCV 297
Silos	Archivo del Monasterio	MS fragment 4	
Silos	Archivo del Monasterio	MS fragment 19	CCV 281
Toledo	Archivo Capitular	MS 99.3	CCV 328
Verona	Biblioteca Capitolare	MS 89	CCV 334

BIBLIOGRAPHY

PRIMARY SOURCES

Archivo Epigráfico de Hispania tardoantigua y medieval. Edited by David Sevillano, Rocío Gutiérrez, and Eduardo Orduña. http://hesperia.ucm.es /consulta_aehtam/web_aehtam/.

Augustine. *Concerning the City of God against the Pagans*. Translated by Henry Bettenson. Harmondsworth: Penguin, 1972.

———. *Confessions*. Edited by James J. O'Donnell. 3 vols. Oxford: Clarendon, 1992.

———. *Confessions*. Translated by Sarah Ruden. New York: Modern Library, 2017.

———. *De civitate Dei*. Edited by Bernhard Dombart and Alfons Kalb. 2 vols. Stuttgart: Teubner, 1981.

———. *In Iohannis euangelium tractatus*. Edited by R. Willems. CCSL 36. Turnhout: Brepols, 1954.

———. *Sancti Augustini Sermones post Maurinos Reperti*. Edited by Germain Morin. Miscellanea Agostiniana. Rome: Tipografia Poliglotta Vaticana, 1930.

Beatus of Liébana. *Adversus Elipandum*. Edited by Bengt Löfstedt. CCCM 59. Turnhout: Brepols, 1984.

———. *In Apocalipsin libri duodecim*. Edited by Henry Sanders. Papers and Monographs 7. Rome: American Academy in Rome, 1930.

———. *Obras completas*. Translated by Joaquín González Echegaray, Alberto del Campo Hernández, and Leslie G. Freeman. Biblioteca de Autores Cristianos serie maior. Vol. 47. Madrid: Biblioteca de Autores Cristianos, 1995.

———. *Obras completas y complementarias: Documentos de su entorno histórico y literario*. Translated by Joaquín González Echegaray, Alberto del Campo Hernández, Leslie G. Freeman, and José Luis Casado Soto. Biblioteca de Autores Cristianos serie maior 77. Madrid: Biblioteca de Autores Cristianos, 2004.

———. *Sancti Beati a Liebana commentarius in Apocalipsin*. Edited by Eugenio Romero-Pose. Scriptores graeci et latini. 2 vols. Rome: Typis Officinae Polygraphicae, 1985.

———. *Sancti Beati presbyteri hispani liebanensis in Apocalypsin*. Edited by Enrique Flórez. Madrid: Ibarra, 1770.

———. *Tractatus de Apocalipsin*. Edited by Roger Gryson and Marie-Claire de Bièvre. CCSL 107B, 107C. 2 vols. Turnhout: Brepols, 2012.

Benedictines of Bouveret. *Colophons de manuscrits occidentaux des origines au XVIᵉ siècle*. 7 vols. Fribourg: Éditions Universitaires, 1965.

Benedictines of Silos. *Antiphonarium mozarabicum de la catedral de León*. Burgos: Aldecoa, 1928.

Buecheler, Franz, ed. *Carmina Latina Epigraphica*. Anthologia latina sive Poesis latinae svpplementvm pars II. Leipzig: Teubner, 1895–97.

Biblia Sacra iuxta vulgatam versionem. Edited by Bonifatius Fischer, Robert Weber, and Roger Gryson. Stuttgart: Deutsche Bibelgesellschaft, 1994.

———. Douay-Rheims translation. Los Angeles: C.F. Horan, 1941.

Campos Ruiz, Julio, and Ismael Roca Meliá, eds. and trans. *Santos Padres españoles.* Vol. 2, *San Leandro, San Isidoro y San Fructuoso: Reglas mozárabes de la España visigoda. Los tres libros de las "Sentencias."* Madrid: Biblioteca de Autores Cristianos, 1971.

Cárdenas y Espejo, Francisco de, and Fidel Fita y Colomé, eds. *Legis romanae wisigothorum fragmenta ex codice palimpsesto sanctae legionensis ecclesiae.* Madrid: Real Academia Española, 1896.

Cassian. *Collationes.* Edited by M. Petschenig. CSEL 13. Vienna: Gerold, 1886.

———. *Conferences.* Edited by Philip Schaff and Henry Wace. Translated by C. S. Gibson. *A Select Library of Nicene and Post-Nicene Fathers of the Christian Church.* Second Series. Vol. 11. New York: Christian Literature Company, 1890.

Cassiodorus. *Cassiodori Senatoris Institutiones.* Edited by Roger Aubrey Baskerville Mynors. Oxford: Clarendon, 1937.

———. *Divine and Human Letters.* Translated by Leslie Webber Jones. Records of Civilization. New York: Columbia University Press, 1946.

Desprez, Vincent. "La 'Regula Ferrioli': Texte critique." *Revue Mabillon* 60, no. 287–88 (1982): 117–28; 29–48.

Diehl, Ernst, ed. *Inscriptiones Latinae Christianae Veteres.* 4 vols. Berlin: Weidmann, 1961–67.

Dümmler, Ernst, and Adolf von Hirsch-Gereuth, eds. *Epistolae Karolini Aevi tomus V.* Monumenta Germaniae Historica. Berlin: Weidmann, 1898.

Fellman, Isaac. *Dead Collections.* New York: Penguin Random House, 2022.

Fernández Martínez, C., J. Gómez Pallarès, and J. del Hoyo Calleja, eds. *Carmina Latina Epigraphica Hispaniae.* http://cle.us.es/clehispaniae/index.jsf.

Fructuosus of Braga. "Rule for the Monastery of Compludo." In *Iberian Fathers: Braulio of Saragossa, Fructuosus of Braga,* translated by Claude W. Barlow, 155–75. The Fathers of the Church. Iberian Fathers 2. Washington, D.C.: The Catholic University of America Press, 1969.

Gregory the Great. *Moral Reflections on the Book of Job.* Vol. 1, *Preface and Books 1–5.* Translated by Brian Kerns. Cistercian Studies. Collegeville, Minn.: Liturgical Press, 2014.

———. *Moralia in Job.* Edited by Marcus Adriaen. CCSL. 3 vols. Vol. 143, 143A, 143B. Turnhout: Brepols, 1979–81.

Hugh of St. Victor. *Didascalicon.* Edited by H. C. Buttimer. Washington, D.C.: The Catholic University of America Press, 1939.

Isidore of Seville. *De ecclesiasticis officiis.* Translated by Thomas L. Knoebel. New York: Newman Press, 2008.

———. *De ecclesiasticis officiis.* Edited by C. W. Lawson. CCSL 113. Turnhout: Brepols, 1989.

———. *Etymologiarum sive Originvm libri XX.* Edited by W. M. Lindsay. 2 vols. Oxford: Clarendon, 1911.

———. *The Etymologies of Isidore of Seville.* Translated by Stephen A. Barney, W. J. Lewis, J. A. Berghof Beach, and Muriel Hall. Cambridge: Cambridge University Press, 2006.

———. *Regula monachorum.* Translated by Aaron W. Godfrey: "The Rule of Isidore." *Monastic Studies* 18 (1988): 7–29.

———. *Sententiae.* Translated by Thomas L. Knoebel. New York: Newman Press, 2018.

———. *Sententiae.* Edited by Pierre Cazier. CCSL 111. Turnhout: Brepols, 1998.

Jerome. *Commentarii in Danielem.* Edited by F. Glorie. CCSL 75A. Turnhout: Brepols, 1964.

———. *Commentarii in prophetas minores.* Edited by Sincero Mantelli. CCSL 76. Turnhout: Brepols, 2018.

———. *Epistulae.* Edited by I. Hilberg. CSEL 54–56. Vienna: Hoelder-Pichler-Tempsky, 1910–18.

———. *Letters.* Edited by Philip Schaff and Henry Wace. Translated by W. H. Fremantle. In *Select Library of Nicene and Post-Nicene Fathers of the Christian Church* 6 (Second Series). New York: Christian Literature, 1893.

———. "Prologus in libro Iob." In *Biblia sacra iuxta Vulgatam versionem*, edited by Bonifatius Fischer, J. Gribomont, H. F. D. Sparks, W. Thiele, and R. Weber, 731–32. Stuttgart: Deutsche Bibelgesellschaft, 1975.

———. "Prologus in libro Iob de graeco emendato." In *Biblia sacra iuxta Latinam Vulgatam versionem*, edited by Francis Aidan Gasquet, vol. 9: 74–76. Rome: Typis Polyglottis Vaticanis, 1951.

Keats, John. *Complete Poems and Selected Letters.* Modern Library Classics. New York: Modern Library, 2001.

Keil, Henricus, ed. *Grammatici latini.* 7 vols. Leipzig: Teubner, 1857.

Lamb, Charles. *Works.* Edited by William Macdonald. Vol. 1. London and New York: J. M. Dent, 1907.

López Pereira, José Eduardo, ed. and trans. *Crónica mozárabe de 754: Continuatio isidoriana hispana.* Fuentes y estudios de historia leonesa 127. León: Centro de Estudios e Investigación "San Isidoro," 2009.

Maestre Yenes, Maria A. H. *Ars Iuliani Toletani Episcopi: Una gramática latina de la España visigoda.* Toledo: Diputación Provincial, 1973.

Martínez Díez, Gonzalo. *La Colección canónica hispana.* Vol. 2, part 1, *Colecciones Derivadas.* Monumenta Hispaniae sacra Serie canónica. Madrid: Consejo Superior de Investigaciones Científicas, 1966.

Migne, J. P. *Patrologiae cursus completus.* Series latina. 221 vols. Paris: Garnier, 1844–1904.

Quintilian. *Institutio Oratoria.* Translated by H. E. Butler. Loeb Classical Library. 4 vols. Cambridge, Mass.: Harvard University Press, 1996.

Serrano, Luciano. *Cartulario de San Pedro de Arlanza, antiguo monasterio benedictino*. Madrid: Rafael Ibañez de Aldecoa, 1925.

Theodulf of Orléans. "Carmina." In *Poetae Latini Aevi Carolini*, edited by Ernst Dümmler, 445–583. Berlin: Weidmann, 1881.

———. *Theodulf of Orléans: The Verse*. Translated by Theodore Murdock Andersson, Åslaug Ommundsen, and Leslie S. B. MacCoull. Medieval and Renaissance Texts and Studies. Tempe: Arizona Center for Medieval and Renaissance Studies, 2014.

Ubieto Arieta, Antonio. *Cartulario de Albelda*. Textos Medievales. Valencia: n.p., 1960.

Venantius Fortunatus. *Opera poetica*. Edited by Friedrich Leo. Monumenta Germaniae Historica. Vol. 4, part 1. Berlin: Weidmann, 1881.

Vives, José. *Inscripciones cristianas de la España romana y visigoda*. Barcelona: Balmes, 1941.

SECONDARY SOURCES

Abel, Mickey. "Within, Around, Between: Micro Pilgrimage and the Archivolted Portal." *Hispanic Research Journal* 10, no. 5 (2009): 385–416.

Aillet, Cyrille. "Quelques repères pour l'étude des gloses arabes dans les manuscrits ibériques latins (IXe–XIIIe siècles)." In *Von Mozarabern zu Mozarabismen*, edited by Matthias Maser, Klaus Herbers, Michele C. Ferrari, and Hartmut Bobzin, 189–210. Münster: Aschendorff, 2014.

———. "Recherches sur le christianisme arabisé (IXe–XIIe siècles): Les manuscrits hispaniques annotés en arabe." In *¿Existe una identidad mozárabe?: Historia, lengua y cultura de los cristianos de al-Andalus (siglos IX–XII)*, edited by Cyrille Aillet, María Teresa Penelas, and Philippe Roisse, 91–134. Madrid: Casa de Velánquez, 2008.

Aillet, Cyrille, María Teresa Penelas, and Philippe Roisse, eds. *¿Existe una identidad mozárabe?: Historia, lengua y cultura de los cristianos de al-Andalus (siglos IX–XII)*. Collection de la Casa de Velázquez 101. Madrid: Casa de Velázquez, 2008.

Aldrete, Gregory S. *Gestures and Acclamations in Ancient Rome*. Ancient Society and History. Baltimore: Johns Hopkins University Press, 1999.

Alturo i Perucho, Jesús. "La escritura visigótica. Estado de la cuestión." *Archiv für Diplomatik* 50 (2004): 347–86.

Alturo i Perucho, Jesús, Ainoa Castro Correa, and Miquel Torras i Cortina, eds. *La escritura visigótica en la Península Ibérica: Nuevas aportaciones*. Bellaterra: Universitat Autònoma de Barcelona, 2012.

Álvarez Álvarez, César, ed. *Codex biblicus legionensis: Veinte estudios*. León: Real Colegiata de San Isidoro, 1999.

Alvarez Rodríguez, Adelino. "El epitafio del abad Esteban de Santiago Peñalba: Estudio y edición." *Analecta Malacitana (AnMal electrónica)* 24 (2008): 1–24.

Anta Lorenzo, Lauro. "El Monasterio de San Martín de Castañeda en el siglo X." *Studia Zamorensia* 3 (1996): 31–52.

Antolín, Guillermo. *Un Codex regularum del siglo IX: Opúsculos desconocidos de S. Jerónimo; Historia, estudio y descripción.* Madrid: Helénica, 1908.

Argaiz, Gregorio de. *La Soledad laureada por San Benito y sus hijos, en las Iglesias de España y Teatro monastico de la provincia Cartaginense.* Madrid: Bernardo de Herbada, 1675.

Arias Páramo, Lorenzo. "Salas." In *Enciclopedia del Románico. Prerománico Asturias,* edited by Miguel Ángel García Guinea and José María Pérez González, 555–95. Aguilar de Campóo Fundación Santa María la Real, 2006.

Ayuso Marazuela, Teófilo. *La Biblia de Oña: Notable fragmento casi desconocido de un códice visigótico homogéneo de la Biblia de San Isidoro de León.* Zaragoza: Consejo Superior de Investigaciones Científicas, 1945.

Baird, Jennifer A., and Claire Taylor, eds. *Ancient Graffiti in Context.* Routledge Studies in Ancient History 2. New York: Routledge, 2011.

———. "Ancient Graffiti in Context: Introduction." In *Ancient Graffiti in Context,* edited by Jennifer A. Baird and Claire Taylor, 1–19. New York: Routledge, 2011.

Banniard, Michel. *Viva voce: Communication écrite et communication orale du IVᵉ au IXᵉ siècle en occident latin.* Collection des Études Augustiniennes. Série Moyen-age et Temps modernes 25. Paris: Institut des Études Augustiniennes, 1992.

Barthes, Roland. *Camera Lucida: Reflections on Photography.* Translated by Richard Howard. New York: Hill and Wang, 1981.

———. *Le plaisir du texte.* Paris: Seuil, 1973.

———. *The Pleasure of the Text.* Translated by Richard Miller. New York: Hill & Wang, 1975.

Baynes, Leslie. *The Heavenly Book Motif in Judeo-Christian Apocalypses, 200 B.C.E.–200 C.E.* Leiden: Brill, 2011.

Bedos-Rezak, Brigitte. "Medieval Identity: A Sign and a Concept." *American Historical Review* 105, no. 5 (2000): 1,489–533.

———. "Toward an Archaeology of the Medieval Charter: Textual Production and Reproduction in Northern French *Chartriers.*" In *Charters, Cartularies, and Archives: The Preservation and Transmission of Documents in the Medieval West,* edited by Adam J. Kosto and Anders Winroth, 43–60. Toronto: Pontifical Institute of Medieval Studies, 2002.

Berganza, Francisco de. *Antiguedades de España.* Vol. I. Madrid: F. del Hierro, 1719.

Bishko, Charles Julian. "Gallegan Pactual Monasticism in the Repopulation of Castille." In *Estudios dedicados a Menéndez Pidal,* vol. 1: 513–31. Madrid: Consejo Superior de Investigaciones Científicas, 1951.

———. "Salvus of Albelda and Frontier Monasticism in Tenth-Century Navarre." *Speculum* 23 (1948): 559–90.

———. *Spanish and Portuguese Monastic History, 600–1300.* London: Variorum Reprints, 1984.

Blaise, Albert. *Dictionnaire latin-français des auteurs chrétiens.* Edited by Paul Timber. Turnhout: Brepols, 1954.

Blanco Freijeiro, Antonio, and Ramón Corzo Sánchez. "Lápida fundacional de San Salvador de Távara." In *Simposio para el estudio de los códices del 'Comentario sobre el Apocalipsis' de Beato de Liébana*, 275–77. Madrid: Joyas Bibliográficas, 1980.

Bonnaz, Yves. *Chroniques Asturiennes: Fin IXe siècle*. Sources d'Histoire Médiévale. Paris: Éditions du Centre National de la Recherche Scientifique, 1987.

Bonne, Jean-Claude. "De l'ornemental dans l'art médiéval (VII–XII siècle): Le modèle insulaire." *Cahiers du Léopard d'Or* 5 (1996): 207–40.

———. "Noeuds d'écritures (Le fragment I de l'Evangeliaire de Durham)." In *Texte-Image: Bild-Text*, edited by Sybil Dümchen and Michael Nerlich, 85–105. Berlin: Institut für romanische Literaturwissenschaft, 1990.

Bono y Huerta, José. *Historia del derecho notarial español. 1. La Edad Media. 1. Introducción, preliminar y fuentes.* Madrid: Junta de Decanos de los Colegios Notariales de España, 1979.

Böse, Kristin. "Recht Sprechen: Diskurse von Autorschaft in den Illuminationen einer Spanischen Rechtshandschrifte des 10. Jahrhunderts." In *Ausbildung des Rechts: Systematisierung und Vermittlung von Wissen in mittelalterlichen Rechtshandschriften*, edited by Kristin Böse and Susanne Wittekind, 108–37. Frankfurt am Main: Peter Lang, 2009.

Boto, Gerardo. "Ora et memora: Il chiostro di San Domenico di Silos; Castellum, paradisum, monumentum." In *Medioevo: Immagine e memoria*, edited by Quintavalle Arturo Carlo, 213–32. Milan: Electa, 2009.

Boüard, A. de. *Manuel de diplomatique francaise et pontificale.* Paris: A. Picard, 1929.

Bourdieu, Pierre. *The Logic of Practice.* Stanford, Calif.: Stanford University Press, 1990.

Bourgain, Pascale. "Les verbes en rapport avec le concept d'auteur." In *Auctor et auctoritas: Invention et conformisme dans l'écriture médiévale; Actes du colloque tenu à l'Université de Versailles-Saint-Quentin-en-Yvelines, 14–16 juin 1999*, edited by Michel Zimmermann, 361–74. Paris: Ecole des Chartes, 2001.

Boylan, Ann. "Manuscript Illumination at Santo Domingo de Silos (Xth to XIIth centuries)." Ph.D., University of Pittsburgh, 1990.

———. "The Silos Beatus and the Silos Scriptorium." In *Church, State, Vellum, And Stone: Essays on Medieval Spain in Honor of John Williams*, edited by Therese Martin and Julie Harris, 173–206. Leiden and Boston: Brill, 2005.

Bozzolo, Carla, and Ezio Ornato. *Pour une histoire du livre manuscrit au Moyen Age: Trois essais de codicologie quantitative.* Paris: Éditions du Centre National de la Recherche Scientifique, 1980.

Brown, Bill. "Thing Theory." *Critical Inquiry* 28, no. 1 (2001): 1–22.

Brown, Catherine. "Scratching the Surface." *Exemplaria* 26, no. 2–3 (2014): 199–214.

Brown, Michelle. *A Guide to Western Historical Scripts from Antiquity to 1600.* Toronto: University of Toronto Press, 1990.

———. "Spreading the Word." In *In the Beginning: Bibles Before the Year 1000*, edited by Michelle Brown, 45–76, 176–221. Washington, D.C.: Freer Gallery of Art and Arthur M. Sackler Gallery, Smithsonian Institution, 2006.

Brown, Peter Scott. "The Verse Inscription from the Deposition Relief at Santo Domingo De Silos: Word, Image, and Act in Medieval Art." *Journal of Medieval Iberian Studies* 1, no. 1 (2009): 87–111.

Burman, Thomas E. *Religious Polemic and the Intellectual History of the Mozarabs, c. 1050–1200*. Leiden: Brill, 1994.

Butler, Shane. *The Matter of the Page: Essays in Search of Ancient and Medieval Authors*. Madison: University of Wisconsin Press, 2011.

Camille, Michael. "The Gregorian Definition Revised: Writing and the Medieval Image." In *L'image: Fonctions et usages des images dans l'occident médiévale*, 89–107. Paris: Le Léopard d'Or, 1996.

———. *Image on the Edge: The Margins of Medieval Art*. Essays in Art and Culture. Cambridge, Mass.: Harvard University Press, 1992.

———. "Sensations of the Page: Imaging Technologies and Medieval Illuminated Manuscripts." In *The Iconic Page in Manuscript, Print, and Digital Culture*, edited by George Bornstein and Theresa Tinkle, 33–53. Ann Arbor: University of Michigan Press, 1998.

Canellas López, Angel. *Diplomática hispano-visigoda*. Zaragoza: Institución Fernando el Católico, 1979.

Cárcel Ortí, Maria Milagros. "Vocabulaire international de la diplomatique." Valencia: Universitat de València, 1997. http://www.cei.lmu.de/VID/.

Carey, Bridget, "It's not too late to stop your phone from wrecking your neck." *cnet*, June 9, 2017. https://www.cnet.com/how-to/fix-tech-neck-pain-phone-stretches-posture/.

Carruthers, Mary. *The Book of Memory: A Study of Memory in Medieval Culture*. Cambridge: Cambridge University Press, 1990.

———. "The Concept of Ductus, or, Journeying through a Work of Art." In *Rhetoric Beyond Words: Delight and Persuasion in the Arts of the Middle Ages*, edited by Mary Carruthers, 190–213. Cambridge Studies In Medieval Literature. Cambridge: Cambridge University Press, 2010.

———. *The Craft of Thought: Meditation, Rhetoric, and the Making of Images, 400–1200*. Cambridge: Cambridge University Press, 1998.

Casado de Otaola, Luis. "*Per visibilia ad invisibilia*: Representaciones figurativas en documentos altomedievales como símbolos de validación y autoría." *SIGNO: Revista de Historia de la Cultura Escrita* 4 (1997): 39–56.

Casciaro Ramírez, J. M. "Las glosas marginales árabes del codex visigothicus legionensis de la Vulgata." *Scripta Theologica* 2 (1970): 303–39.

Castiñeiras, Manuel. "Autores homónimos: El doble retrato de "Mateo" en el Pórtico de la Gloria." In *Entre la letra y el pincel: El artista medieval; Leyenda, identidad y estatus*, edited by Manuel Antonio Castiñeiras González. El Ejido: Círculo Rojo, 2017.

Castro Correa, Ainoa. "Dejando el pasado atrás, adaptándose al futuro: Escribas de transición y escribas poligráficos visigótica-carolina." *Anuario de estudios medievales* 50, no. 2 (2020): 631–64.

———. "Littera visigothica." Accessed June 8, 2020. http://www.litteravisigothica .com/.

———. "The Scribes of the Silos Apocalypse (London, British Library Add. MS 11695) and the Scriptorium of Silos in the Late 11th Century." *Speculum* 95, no. 2 (2020): 321–70.

———. "The Secret Life of Writing: A Holistic Paleography Project." Lecture, Medieval Manuscripts Seminar, School of Advanced Study, University of London, March 2, 2021.

———. "Visigothic Script versus Caroline Minuscule: The Collision of Two Cultural Worlds in Twelfth-Century Galicia." *Mediaeval Studies* 78 (2016): 203–42.

———. "VisigothicPal." Accessed June 8, 2021. http://visigothicpal.com/.

Cavadini, John C. *The Last Christology of the West: Adoptionism in Spain and Gaul, 785–820.* Philadelphia: University of Pennsylvania Press, 1993.

Cavallo, Guglielmo. "Entre lectura y escritura: Los usos del libro en el monacato primitivo y en las fundaciones benedictinas de la alta edad media." In *Silos—un milenio*, vol. 2: 131–42. Burgos: Universidad de Burgos, 2003.

Cavell, Megan. *Weaving Words and Binding Bodies: The Poetics of Human Experience in Old English Literature.* Toronto Anglo-Saxon Series. Toronto: University of Toronto Press, 2016.

Cavero Domínguez, Gregoria. "La dedicación de la iglesia en el monasterio de San Miguel de Escalada el 20 de noviembre de 913." In *San Miguel de Escalada (913–2013)*, edited by Vicente García Lobo and Gregoria Cavero Domínguez, 17–37. Folia medievalia. León: Universidad de León Instituto de Estudios Medievales, 2014.

Champion, Matthew. *Medieval Graffiti: The Lost Voices of Britain's Churches.* London: Ebury, 2015.

Chazelle, Celia. "Pictures, Books and the Illiterate: Pope Gregory I's Letters to Serenus of Marseilles." *Word & Image* 6 (1990): 138–50.

Chenu, Marie-Dominique. "Auctor, actor, autor." *Bulletin du Cange* 3 (1927): 81–86.

Chin, Catherine M. *Grammar and Christianity in the Late Roman World.* Philadelphia: University of Pennsylvania Press, 2007.

Clanchy, Michael T. *From Memory to Written Record, England 1066–1307.* Oxford: Blackwell, 1993.

Clark, Gillian. "City of Books: Augustine and the World as Text." In *The Early Christian Book*, edited by William E. Klingshirn and Linda Safran, 117–40. Washington, D.C.: The Catholic University of America Press, 2007.

Cleaver, Laura. *Education in Twelfth-Century Art and Architecture: Images of Learning in Europe, c.1100–1220.* Boydell Studies in Medieval Art and Architecture. Woodbridge: Boydell, 2016.

Codoñer Merino, Carmen, María Adelaida Andrés Sanz, Salvador Iranzo Abellán, José Carlos Martín, and David Paniagua, eds. *La Hispania visigótica y mozárabe: Dos épocas en su literatura*. Salamanca: Ediciones Universidad de Salamanca, 2010.

Cole, Andrew. "The Call of Things: A Critique of Object-Oriented Ontologies." *Minnesota Review* 80 (2013): 106–18.

Conde, Rafael, and Josep Trenchs Odena. "Signos personales en las suscripciones altomedievales catalanas." In *Graphische Symbole in mittelalterlichen Urkunden: Beiträge zur diplomatischen Semiotik*, edited by Peter Rück, 443–51. Sigmaringen: Thorbecke, 1996.

Copeland, Rita, and I. Sluiter. *Medieval Grammar and Rhetoric: Language Arts and Literary Theory, AD 300–1475*. Oxford and New York: Oxford University Press, 2009.

Cotter, James Finn. "The Book within the Book in Mediaeval Illumination." *Florilegium: Carleton University Annual Papers on Classical Antiquity and the Middle Ages* 12 (1993): 107–40.

Curtius, Ernst Robert. "The Book as Symbol." In *European Literature and the Latin Middle Ages*, 302–47. Princeton: Princeton University Press, 1973.

Dagenais, John. "Decolonizing the Medieval Page." In *The Future of the Page*, edited by Peter Stoicheff and Andrew Taylor, 37–70. Toronto: University of Toronto Press, 2004.

———. *The Ethics of Reading in Manuscript Culture: Glossing the "Libro de buen amor."* Princeton: Princeton University Press, 1994.

———. "That Bothersome Residue: Toward a Theory of the Physical Text." In *Vox intexta: Orality and Textuality in the Middle Ages*, edited by Alger Nicolaus Doane and Carol Braun Pasternack, 246–59. Madison: University of Wisconsin Press, 1991.

Damrosch, David. "Scriptworlds: Writing Systems and the Formation of World Literature." *Modern Language Quarterly* 68, no. 2 (2007): 195–219.

Danielou, J. "La typologie millénariste de la semaine dans le Christianisme primitif." *Vigiliae Christianae* 2 (1948): 1–16.

Davies, Wendy. *Acts of Giving: Individual, Community, and Church in Tenth-Century Christian Spain*. Oxford: Oxford University Press, 2007.

———. "Local Priests and the Writing of Charters in Northern Iberia in the Tenth Century." In *Chartes et cartulaires comme instruments de pouvoir: Espagne et Occident chrétien (VIIIᵉ–XIIᵉ siècles)*, edited by Julio Escalona and H. Sirantoine, 29–43. Toulouse: Presses Méridiennes de Toulouse / Consejo Superior de Investigaciones Científicas, 2013.

de Bruyne, D. "Manuscrits Wisigothiques." *Revue Bénédictine* 36 (1924): 5–20.

Debiais, Vincent. "Writing on Medieval Doors." In *Writing Matters: Presenting and Perceiving Monumental Inscriptions in Antiquity and the Middle Ages*,

edited by Irene Berti, Katharina Bolle, Fanny Opdenhoff, and Fabian Stroth, 285–308. Materiale Textkulturen. Berlin: Walter de Gruyter, 2017.

Delaissé, Leon M. J. "Towards a History of the Medieval Book." *Divinitas* 11 (1967): 423–35.

D'Emilio, James. "Inscriptions and the Romanesque Church: Patrons, Prelates, and Craftsmen in Romanesque Galicia." In *Spanish Medieval Art: Recent Studies*, edited by Colum Hourihane, 1–33. Tempe: Arizona Center for Medieval and Renaissance Studies, 2007.

———. "Writing Is the Precious Treasury of Memory: Scribes and Notaries in Lugo (1150–1240)." In *La collaboration dans la production de l'écrit médiéval: Actes du XIII^e colloque du Comité international de paléographie latine (Weingarten, 22–25 septembre 2000)*, edited by Herrad Spilling, 379–410. Paris: École des Chartes, 2003.

Derrida, Jacques. *Archive Fever: A Freudian Impression.* Translated by Eric Prenowitz. Chicago: University of Chicago Press, 1996.

———. "Geschlecht II: Heidegger's Hand." In *Deconstruction and Philosophy: The Texts of Jacques Derrida*, edited by John Sallis, 161–96. Chicago: University of Chicago Press, 1987.

———. "Signature, Event, Context." In *Limited Inc.*, 1–23. Evanston, Ill.: Northwestern University Press, 1988.

Díaz y Díaz, Manuel C. "Agustín entre los mozárabes: un testimonio." *Augustinus* 25 (1980): 157–80.

———. "Composiciones figurativas en Albelda en el siglo X." In *Libros y librerías en la Rioja altomedieval*, 351–70. Logroño: Diputación Provincial, 1979.

———. "El Códice de Reglas signado por Leodegundia." In *Códices visigóticos en la monarquía leonesa*, 91–114. León: Centro de Estudios de Investigación "San Isidoro," 1983.

———. "El cultivo del latín en el siglo X." *Anuario de estudios filológicos* 4 (1981): 71–81.

———. "El escriptorio de Valeránica." In *Codex biblicus legionensis: Veinte estudios*, 53–72. León: Real Colegiata de San Isidoro, 1999.

———. "El Libro del Apocalipsis del códice de Magio en Nueva York." In *Códices visigóticos en la monarquía leonesa*, 483–503. León: Centro de Estudios de Investigación "San Isidoro," 1983.

———. "Escritores del monasterio de Albelda: Vigilán y Sarracino." In *El Códice Albeldense, 976*, edited by Claudio García Turza, 73–133. Madrid: Testimonio, 2002.

———. "Gregorio Magno y Tajón de Zaragoza." In *Libros y librerías en la Rioja altomedieval*, 333–50. Logroño: Diputación Provincial, 1979.

———. "La inscripción de la Santa Cruz de Cangas de Onís." In *Asturias en el siglo VIII, la cultura literaria*, 31–41. Oviedo: Sueve, 2001.

———. "La tradición de texto de los comentarios al Apocalipsis." In *Actas del Simposio para el Estudio de los Códices del "Comentario al Apocalipsis" de*

Beato de Liébana, edited by Carlos Romero de Lecea, 165–84. Madrid: Joyas Bibliográficas, 1978.

———. *Libros y librerías en la Rioja altomedieval*. Logroño: Diputación Provincial, 1979.

———. "Los prólogos y colofones de los códices de Florencio." In *Códices visigóticos en la monarquía leonesa*, 514–17. León: Centro de Estudios de Investigación "San Isidoro," 1983.

———. "Vigilán y Sarracino: Sobre composiciones figurativas en la Rioja del s. X." In *Lateinische Dichtungen des X. und XI Jarhhunderts: Festgabe für Walter Bulst*, 60–92. Heidelberg: Schneider, 1979.

Diego Santos, Francisco. *Inscripciones medievales de Asturias*. Oviedo: Principado de Asturias, 1993.

Dietl, Albert. *Die Sprache der Signatur: Die mittelalterlichen Künstlerinschriften Italiens*. Italienische Forschungen. 4 vols. Berlin: Deutscher Kunstverlag, 2009.

Dinshaw, Carolyn. "Are We Having Fun Yet? A Response to Prendergast and Trigg." *New Medieval Literatures* 9 (2007): 231–41.

———. *How Soon Is Now?: Medieval Texts, Amateur Readers, and the Queerness of Time*. Durham, N.C.: Duke University Press, 2012.

Domínguez Bordona, J. "Exlibris mozárabes." *Archivo Español de Arte y Arqueología* 2 (1935): 49–170.

Drucker, Johanna. *The Alphabetic Labyrinth: The Letters in History and Imagination*. New York: Thames and Hudson, 1995.

Duggan, Lawrence. "Was Art Really 'The Book of the Illiterate'?" *Word & Image* 5 (1989): 227–51.

Dutton, Paul Edward. "The Desert War of a Carolingian Monk." *Journal of Medieval and Early Modern Studies* 47, no. 1 (2017): 75–119.

Eberlein, Johann Konrad. *Miniatur und Arbeit*. Frankfurt am Main: Suhrkamp, 1995.

Echard, Siân. "House Arrest: Modern Archives, Medieval Manuscripts." *Journal of Medieval and Early Modern Studies* 30, no. 2 (2000): 185–210.

Eco, Umberto. "Waiting for the Millennium." In *The Apocalyptic Year 1000: Religious Expectation and Social Change, 950–1050*, edited by Richard Allen Landes, Andrew Colin Gow, and David C. Van Meter, 121–35. Oxford: Oxford University Press, 2003.

Ernst, Ulrich. "The Figured Poem." *Visible Language* 20, no. 1 (1986): 8–27.

Escalona, Julio, Isabel Velázquez Soriano, and Paloma Juárez Benitez. "Identification of the Sole Extant Original Charter Issued by Fernán González, Count of Castile (932–970)." *Journal of Medieval Iberian Studies* 4, no. 2 (2012): 259–88.

Esteras, José Ángel, César Gonzalo, Josemi Lorenzo, Inés Santa-Olalla, and J. Francisco Yusta. "La piel que habla: Grafitos de los siglos XI–XIII sobre el revoco románico de la iglesia de San Miguel de San Esteban de Gormaz

(Soria)." In *La memoria en la piedra: Estudios sobre grafitos históricos*, edited by Pablo Ozcáriz Gil, 88–107. Pamplona: Gobierno de Navarra, Departamento de Educación y Cultura, 2012.

———. "La piel que habla: Un recorrido por los grafitos medievales en la iglesia de San Miguel de San Esteban de Gormaz (Soria)." 2010. Accessed Jan. 24, 2014. http://issuu.com/funduqsoria/docs/piel_que_habla__para_web_reducido_y _corregido_?e=1260395/2690071# (slideshow).

Everett, Nicholas. *Literacy in Lombard Italy, c. 568–774.* Cambridge Studies in Medieval Life and Thought 53. 4th series. Cambridge: Cambridge University Press, 2003.

Fábrega Grau, Ángel. *Pasionario hispánico (siglos VII–XI).* Monumenta Hispaniae Sacra. Serie litúrgica 6. Madrid: Instituto P. Enrique Flórez, 1953.

Favreau, Robert. *Epigraphie médiévale.* L'atelier du médiéviste 5. Turnhout: Brepols, 1997.

Fernández Flórez, J. A. (José Antonio). "Beato de Liébana, teólogo, escriturista y poeta en la Hispania del último tercio del siglo VIII." In *Escritura y Sociedad: El Clero*, edited by Alicia Marchant Rivera and Lorena Barco Cebrián, 10–35. Granada: Comares, 2017.

———. *La Elaboración de los documentos en los reinos hispánicos occidentales (ss. VI–XIII).* Burgos: Diputación Provincial de Burgos, 2002.

———. "Un calígrafo-miniaturista del año mil: Vigila de Albelda." *Codex Aquilarensis* 16 (2000): 153–80.

Fernández Flórez, J. A., and M. Herrero de la Fuente. "Copistas y colaboradores vinculados con el monasterio de Albelda en torno al año 1000." In *La Collaboration dans la production de l'écrit médiéval: Actes du XIII^e Colloque Internationale de Paléographie Latine*, edited by H. Spilling, 105–30. Matériaux pour l'Histoire 4. Paris: École des Chartes, 2003.

Fernández González, Etelvina, and Fernando Galván Freile. "Iconografía, ornamentación, y valor simbólica de la imagen." In *El Códice Albeldense, 976*, edited by Claudio García Turza, 203–77. Madrid: Testimonio, 2002.

Ferrero Gutiérrez, José. "El Beato de San Miguel y los monasterios de Valdetábara." *Brigecio* 20 (2010): 139–59.

Fontaine, Jacques. "Fuentes y tradiciones paleocristianas en el método espiritual de Beato." In *Actas del Simposio para el Estudio de los Códices del "Comentario al Apocalipsis" de Beato de Liébana*, edited by Carlos Romero de Lecea, 75–101. Madrid: Joyas Bibliográficas, 1978.

———. "Mozarabe hispanique et monde carolingien: Les échanges culturels entre la France et l'Espagne du VIIIe au Xe siecle." *Anuario de estudios medievales* 13 (1983): 17–46.

Fraenkel, Béatrice. *La signature: Génèse d'un signe.* Paris: Gallimard, 1992.

Frymer, Tikva S., and Louis Isaac Rabinowitz. "Honey." In *Encyclopaedia Judaica*, edited by Michael Berenbaum and Fred Skolnik, 517–18. Detroit: Macmillan Reference, 2007.

Funes, Leonardo. "En busca del códice perdido: Un viaje del siglo VII." *Siwa* 2 (2009): 10. Accessed Oct. 18, 2013. http://www.siwa.clubburton.com.ar/siwa _online/siwa_2.html.

Gamble, Harry Y. *Books and Readers in the Early Church.* New Haven: Yale University Press, 1997.

Ganz, David. *Buch-Gewänder: Prachteinbände im Mittelalter.* Berlin: Reimer, 2015.

———. "'Mind in Character': Ancient and Medieval Ideas about the Status of the Autograph and the Expression of Personality." In *Of the Making of Books: Medieval Manuscripts, Their Scribes and Readers: Essays Presented to M. B. Parkes,* edited by Pamela Robinson and Rivkah Zim, 280–99. Aldershot, England: Scolar Press, 1997.

García de Castro Valdés, César. "La Arqueta de las Ágatas de la Cámara Santa de la Catedral de Oviedo." *Anales de Historia del Arte* 24, no. 1 (2014): 173–226.

García de Cortázar, José Angel. "La colonización monástica en los reinos de León y Castilla (siglos VIII a XIII): Dominio de tierras, señorío de hombres, control de almas." In *El monacato en los reinos de León y Castilla (siglos VII–XIII),* edited by Ana I. Suárez González, 17–48. Ávila: Fundación Sánchez-Albornoz, 2007.

García de Cortázar, José Angel, and Ramón Teja, eds. *Monjes y monasterios hispanos en la Alta Edad Media.* Aguilar de Campoo: Fundación Santa María la Real, 2006.

García Lobo, Vicente. "El 'Beato' de San Miguel de Escalada." *Archivos Leoneses* 33, no. 66 (1979): 205–70.

———. "Las *explanationes* del claustro de Silos: Nueva lectura." In *Silos—un milenio,* vol. 2: 483–94. Burgos: Universidad de Burgos, 2003.

———. *Las inscripciones de San Miguel de Escalada: Estudio crítico.* Barcelona: El Albir, 1982.

García Lobo, Vicente, and Gregoria Cavero Domínguez, eds. *San Miguel de Escalada (913–2013).* Folia Medievalia 2. León: Universidad de León, Instituto de Estudios Medievales, 2014.

García Lobo, Vicente, and María Encarnación Martín López. "Las suscriptiones. Relación entre el epígrafe y la obra de arte." In *Epigraphie et iconographie: Actes du Colloque tenu à Poitiers les 5–8 octobre 1995,* edited by Robert Favreau, 75–100. Poitiers: Centre d'Etudes Supérieures de Civilisation Médiévale, 1996.

García Molinos, Elena. "Florencio de Valeránica: Calígrafo castellano del siglo X." In *El Reino de León en la Edad Media, XI.* Fuentes y Estudios de Historia Leonesa, 241–429. León: Centro de Estudios e Investigación "San Isidoro," 2004.

García y García, Antonio, Francisco Cantelar Rodríguez, and Manuel Nieto Cumplido. *Catálogo de los manscritos e incunables de la Catedral de Córdoba.* Bibliotheca Salamanticensis VI. Estudios 5. Salamanca: Monte de Piedad y Caja de Ahorros de Córdoba, 1976.

Garnier, François. *Le langage de l'image au Moyen Age.* 2 vols. Paris: Léopard d'or, 1982.

Geary, Patrick J. "*Auctor* et *auctoritas* dans les cartulaires du haut moyen-âge." In *Auctor et auctoritas: Invention et conformisme dans l'écriture médiévale; Actes du colloque tenu à l'Université de Versailles-Saint-Quentin-en-Yvelines, 14–16 juin 1999*, edited by Michel Zimmermann, 61–71. Paris: Ecole des Chartes, 2001.

Geertz, Clifford. "Thick Description: Toward an Interpretive Theory of Culture." In *The Interpretation of Cultures: Selected Essays*, 3–32. New York: Basic Books, 1973.

Germán de Pamplona, P. "La fecha de la construcción de San Miguel de Villatuerta." *Príncipe de Viana* 25, no. 96–97 (1954): 213–24.

Gimeno Pascual, Helena. "El hábito epigráfico en el contexto arquitectónico hispánico del siglo VII." In *El Siglo VII frente al siglo VII*, edited by Caballero Zoreda Luis, Mateos Cruz Pedro, and Utrero Agudo María Angeles. Madrid: Consejo Superior de Investigaciones Científicas, 2009.

Goetsch, Emily Baldwin. "Extra-Apocalyptic Iconography in the Tenth-Century Beatus Commentaries on the Apocalypse as Indicators of Christian-Muslim Relations in Medieval Iberia." Ph.D., University of Edinburgh, 2014.

Goldberg, Jonathan. *Writing Matter: From the Hands of the English Renaissance.* Stanford, Calif.: Stanford University Press, 1990.

González Diéz, Emiliano. "El Liber Iudicorum de Vigilano." In *El Códice Albeldense, 976*, edited by Claudio García Turza, 163–84. Madrid: Testimonio, 2002.

González Rodríguez, Rafael. "El epígrafe fundacional de San Esteban de Corullón." *A Curuxa* 66 (2009): 54–56.

Graver, Margaret. "*Quaelibet Audendi*: Fortunatus and the Acrostic." *Transactions of the American Philological Association* 123 (1993): 219–45.

Greene, Virginie. "Un cimetière livresque: La liste nécrologique médiévale." *Le Moyen Age: Revue d'histoire et de philologie* 105, no. 2 (1999): 307–30.

Greetham, D. C. "Romancing the Text, Medievalizing the Book." In *The Pleasures of Contamination: Evidence, Text, and Voice in Textual Studies*, 246–66. Textual Cultures: Theory and Praxis. Bloomington: Indiana University Press, 2010.

Griffith, Sidney Harrison. *The Bible in Arabic: The Scriptures of the "People of the Book" in the Language of Islam.* Princeton: Princeton University Press, 2013.

Grotans, Anna. *Reading in Medieval St. Gall.* Cambridge: Cambridge University Press, 2006.

Guardia, Milagros. "Los grafitos de la iglesia de Santiago de Peñalba: *Scariphare* et *pingere* en la Edad Media." *Revista Patrimonio* 9, no. 33 (2008): 51–58.

Gullick, Michael. "How Fast Did Scribes Write?: Evidence from Romanesque Manuscripts." In *Making the Medieval Book: Techniques of Production*, edited by Linda L. Brownrigg, 39–58. Los Altos Hills, Calif.: Red Gull Press, 1995.

Gumbert, Jan Peter. "The Speed of Scribes." In *Scribi e colofoni: Le sottoscrizioni di copisti dalle origini all'avvento della stampa*, edited by Emma Condello and Giuseppe De Gregorio, 57–70. Spoleto: Centro italiano di studi sull'alto Medioevo, 1995.

Gutiérrez, Constancio. "¿Cuándo se escribió la llamada Biblia de Oña?" *Estudios Eclesiásticos* 34 (1960): 403–11.

Gutiérrez Alvarez, Maximinio, ed. *Zamora: Colección epigráfica*. Monumenta Palaeographica Medii Aevi Series Hispanica. Corpus inscriptionum Hispaniae mediaevalium. Vol. 1. Turnhout: Brepols, 1997.

Guyotjeannin, Olivier. "Le vocabulaire de la diplomatique." In *Vocabulaire du livre et de l'ecriture au moyen âge: Actes de la table ronde, Paris 24–26 Septembre 1987*, edited by Olga Weijers, 128–29. Turnhout: Brepols, 1989.

Hamburger, Jeffrey F. "The Hand of God and the Hand of the Scribe: Craft and Collaboration at Arnstein." In *Die Bibliothek des Mittelalters als dynamischer Prozess*, edited by Michael Embach, Claudine Moulin, and Andrea Rapp, 55–80. Trierer Beiträge zu den historischen Kulturwissenschaften 3. Wiesbaden: Reichert, 2012.

———. "Representations of Reading—Reading Representations: The Female Reader from the Hedwig Codex to Châtillon's Léopoldine au Livre d'Heures." In *Die lesende Frau*, edited by Gabriela Signori, 177–239. Wiesbaden: Harrassowitz Verlag in Kommission, 2009.

———. *Script as Image*. Corpus of Illuminated Manuscripts. Leuven: Peeters, 2014.

Hanan, Melanie. "Romanesque Casket Reliquaries: Forms, Meanings, and Development." Ph.D., New York University, 2013.

Handley, Mark A. *Death, Society and Culture: Inscriptions and Epitaphs in Gaul and Spain, AD 300–750*. BAR International Series. Oxford: Archaeopress, 2003.

Henderson, John. *The Medieval World of Isidore of Seville: Truth from Words*. Cambridge: Cambridge University Press, 2007.

Hitchcock, Richard. *Mozarabs in Medieval and Early Modern Spain*. Burlington, Vt.: Ashgate, 2008.

Humfress, Caroline. "Judging by the Book: Christian Codices and Late Antique Legal Culture." In *The Early Christian Book*, edited by William E. Klingshirn and Linda Safran, 141–58. Catholic University of America Studies in Early Christianity. Washington, D.C.: The Catholic University of America Press, 2007.

"Imago libri": Représentations carolingiennes du livre. Edited by Charlotte Denoël, Anne-Orange Poilpré, and Sumi Shimahara. Bibliologia elementa ad librorum studia pertinentia 47. Turnhout: Brepols, 2018.

Illich, Ivan. *In the Vineyard of the Text: A Commentary to Hugh's "Didascalicon."* Chicago: University of Chicago Press, 1993.

Ingold, Tim. *Lines: A Brief History*. London: Routledge, 2007.

———. *Making: Anthropology, Archaeology, Art and Architecture*. London: Routledge, 2013.

Iranzo Abellán, Salvador. "Inscripciones métricas." In *La Hispania visigótica y mozárabe: Dos épocas en su literatura*, edited by Carmen Codoñer Merino, 387–95. Salamanca: Ediciones Universidad de Salamanca, 2010.

Irvine, Martin. *The Making of Textual Culture: "Grammatica" and Literary Theory, 350–1100*. Cambridge: Cambridge University Press, 1994.

Irvine, Martin, and David Thomson. "*Grammatica* and Literary Theory." In *The Cambridge History of Literary Criticism*. Vol. 2, *The Middle Ages*, edited by Alastair Minnis and Ian Johnson, 15–41. Cambridge: Cambridge University Press, 2005.

James, M. R. *A Descriptive Catalogue of the Latin Manuscripts in the John Rylands Library at Manchester*. 2 vols. Manchester: Manchester University Press, 1921.

Jimeno Guerra, Vanessa. "A propósito de los graffiti del templo de San Miguel de Escalada (León)." *Estudios Humanísticos: Historia* 10 (2011): 277–96.

———. "Un patrimonio oculto y recuperado: Los graffiti de la iglesia de Santiago de Peñalba." *Medievalismo* 25 (2015): 233–59.

Kessler, Herbert L. *Seeing Medieval Art*. Rethinking the Middle Ages 1. Peterborough, Ont.: Broadview Press, 2004.

Klein, Peter K. "Eschatological Expectations and the Revised Beatus." In *Church, State, Vellum, and Stone: Essays on Medieval Spain in Honor of John Williams*, edited by Therese Martin and Julie Harris, 147–71. Leiden and Boston: Brill, 2005.

Koepp, Leo. *Das himmlische Buch in Antike und Christentum: Eine religionsgeschichtliche Untersuchung zur altchristlichen Bildersprache*. Theophaneia Beiträge zur Religions- und Kirchengeschichte des Altertums. Bonn: P. Hanstein, 1952.

Koziol, Geoffrey. *The Politics of Memory and Identity in Carolingian Royal Diplomas: The West Frankish Kingdom (840–987)*. Turnhout: Brepols, 2012.

Kruschwitz, Peter. "Inhabiting A Lettered World: Exploring the Fringes of Roman Writing Habits." *Bulletin of the Institute of Classical Studies* 59 (2016): 26–41.

Kume, Junco. "Aspectos de la influencia iconográfica carolingia en la miniatura hispánica de los siglos X y XI." In *El arte foráneo en España: Presencia e influencia*, edited by Miguel Cabañas Bravo, 207–14. Biblioteca de historia del arte. Madrid: Departamento de Historia del Arte, Instituto de Historia, 2005.

Kumler, Aden. "Handling the Letter." In *St. Albans and the Markyate Psalter: Seeing and Reading in Twelfth-Century England*, edited by Kristen M. Collins and Matthew Fisher, 69–100. Kalamazoo, Mich.: Medieval Institute Publications, 2017.

Kumler, Aden, and Christopher R. Lakey. "*Res et significatio*: The Material Sense of Things in the Middle Ages." *Gesta* 51, no. 1 (2012): 1–17.

Landes, Richard Allen. "Lest the Millennium Be Fulfilled: Apocalyptic Expectations and the Pattern of Western Chronography 100–800 CE." In *The Use and Abuse of Eschatology in the Middle Ages*, edited by Werner Verbeke, D. Verhelst, and Andries Welkenhuysen, 137–211. Mediaevalia Lovaniensia. Leuven: Leuven University Press, 1988.

Latham, R. E., D. R. Howlett, and R. K. Ashdowne, eds. *Dictionary of Medieval Latin from British Sources*. Oxford: Oxford University Press, 1975–2013.

Law, Vivien. *Grammar and Grammarians in the Early Middle Ages*. London: Longman, 1997.

Leclercq, Jean. "*Lectio divina* in occidente." In *Dizionario degli istituti di perfezione*, edited by Guerrino Pelliccia and Giancarlo Rocca, 562–66. Rome: Edizioni Paoline, 1974.

———. *The Love of Learning and the Desire for God*. Translated by Catherine Mizrahi. New York: Fordham University Press, 1961.

Levinson, Stephen C. *Pragmatics*. Cambridge: Cambridge University Press, 1983.

Levitan, William. "Dancing at the End of the Rope: Optatian Porfyry and the Field of Roman Verse." *Transactions of the American Philological Association* 115 (1985): 245–69.

Lewis, Charlton, and Charles Short. *A Latin Dictionary*. Oxford: Clarendon, 1993.

Liber testamentorum Oventensis. Barcelona: M. Moleiro, 1994.

Lieb, Ludger, and Ricarda Wagner. "Dead Writing Matters? Materiality and Presence in Medieval German Narrations of Epitaphs." In *Writing Matters: Presenting and Perceiving Monumental Inscriptions in Antiquity and the Middle Ages*, edited by Irene Berti, Katharina Bolle, Fanny Opdenhoff and Fabian Stroth, 15–26. Materiale Textkulturen 14. Berlin: De Gruyter, 2017.

Linage Conde, Antonio. *Los orígenes del monacato benedictino en la Península Ibérica*. Colección Fuentes y Estudios de Historia Leonesa. 3 vols. León: Centro de Estudios e Investigación "San Isidoro," 1973.

Loewe, Gustav, and Wilhelm von Hartel. *Bibliotheca Patrum latinorum hispaniensis*. Vol. 1. Vienna: Carl Gerold's Sohn, 1887.

Lorenzo Arribas, Josemi. "Canecillo románico (año 1081) de la iglesia de San Miguel (San Esteban de Gormaz, Soria)." In *Paisaje interior: Soria, Concatedral de San Pedro*, 576–78. Soria: Gráficos Varona, 2009.

———. "El nudo de Salomón." *Revista Digital de Iconografía Medieval* 12, no. 22 (2020): 1–38.

———. "*Maniculae* monumentales: Traslación de signos librarios a conjuntos murales medievales." In *Doce siglos de materialidad del libro: Estudios sobre manuscritos e impresos entre los siglos VIII y XIX*, edited by Manuel José Pedraza Gracia, Helena Carvajal González, and Camino Sánchez Oliveira, 217–21. Zaragoza: Prensas de la Universidad de Zaragoza, 2017.

———. "*Translatio in parietem*: Dos grafitos medievales en las iglesias de San Millán de Suso (La Rioja) y Peñalba de Santiago (León)." *Medievalia* 16 (2013): 91–102.

Lowden, John. "The Word Made Visible: The Exterior of the Early Christian Book as Visual Argument." In *The Early Christian Book*, edited by William E. Klingshirn and Linda Safran, 13–47. Catholic University of America Studies in Early Christianity. Washington, D.C.: The Catholic University of America Press, 2007.

MacMullen, Ramsay. "The Epigraphic Habit in the Roman Empire." *American Journal of Philology* 103, no. 3 (1982): 233–46.

Madoz, José. "Tajón de Zaragoza y su viaje a Roma." In *Mélanges Joseph de Ghellinck, S.J.* Museum Lessianum, 345–60. Section historique, no. 13–14. Gembloux: J. Duculot, 1951.

Martín, José Carlos. "El 'Epitaphium Isidori, Leandri et Florentinae' (ICERV 272) o la compleja tradición manuscrita de un texto epigráfico: Nueva edición y estudio." *Euphronsyne* 32 (2010): 139–63.

———. "Reglas monásticas." In *La Hispania visigótica y mozárabe: Dos épocas en su literatura*, edited by Carmen Codoñer Merino, 401–21. Salamanca: Ediciones Universidad de Salamanca, 2010.

Martin, Therese. "The Margin to Act: A Framework of Investigation for Women's (and Men's) Medieval Art-Making." *Journal of Medieval History* 42, no. 1 (2016): 1–25.

Martín Barba, José Julio. "El Smaragdo de Córdoba en la almoneda de los bienes de Isabel la Católica: Las vicisitudes del códice de Florencio de Valeránica." In *Nasara, extranjeros en su tierra: Estudios sobre cultura mozárabe y catálogo de la exposición*, edited by Eduardo Cerrato and Diego Asensio, 187–220. Córdoba: Catedral de Córdoba, 2018.

———. "El texto del Canto de la Sibila en el Smaragdo de Córdoba de Florencio de Valeránica." In *Nasara, extranjeros en su tierra: Estudios sobre cultura mozárabe y catálogo de la exposición*, edited by Eduardo Cerrato and Diego Asensio, 135–55. Córdoba: Catedral de Córdoba, 2018.

———. "Los prólogos e iluminaciones de Florencio de Valeránica en el Smaragdo de la Catedral de Córdoba." *Studia Cordubensia* 8 (2015): 23–85.

Martín López, Encarnación. "Las inscripciones de San Miguel de Escalada: Nueva lectura." In *San Miguel de Escalada (913–2013)*, edited by Vicente García Lobo and Gregoria Cavero Domínguez, 197–238. Folia Medievalia. León: Universidad de León, 2014.

———. "Las inscripciones medievales del monasterio de Santo Domingo de Silos." In *Silos-Un milenio*, vol. 2: 469–82. Burgos: Universidad de Burgos, 2003.

Martínez Díez, Gonzalo. "La Colección canónica 'Hispana.'" In *El Códice Albeldense, 976*, edited by Claudio García Turza, 155–64. Madrid: Testimonio, 2002.

Martínez Tejera, Artemio. "Cenobios leoneses altomedievales ante la europeización: San Pedro y San Pablo de Montes, Santiago y San Martín de Peñalba y San Miguel de Escalada." *Hispania Sacra* 54 (2002): 87–108.

———. "Dedicaciones, consagraciones y 'monumenta consecrationes' (ss. VI–XII): Testimonios epigráficos altomedievales en los antiguos reinos de Asturias y León." *Brigecio* 6 (1996): 77–102.

———. *El templo del "monasterium" de San Miguel de Escalada: "Arquitectura de fusion" en el reino de León (siglos X–XI)*. Madrid: Asociación para el Estudio y Difusión del Arte Tardoantiguo y Medieval, 2005.

———. "Los epígrafes (fundacional y de restauración) del templum de San Miguel de Escalada (prov. de León)." In *Congreso Internacional "La Catedral*

de León en la Edad Media," edited by Joaquín Yarza Luaces, María Victoria Herráz Ortega, and Gerardo Boto Varela, 613–21. León: Universidad de León, 2004.

Maser, Matthias, and Klaus Herbers, eds. *Die Mozaraber: Definitionen und Perspektiven der Forschung.* Geschichte und Kultur der Iberischen Welt. Berlin: Lit Verlag, 2011.

Mattoso, José. "L'introduction de la Règle de S. Benoît dans la péninsule ibérique." *Revue d'Histoire Ecclésiastique* 70, no. 3–4 (1975): 731–42.

McLuhan, Marshall. *The Gutenberg Galaxy: The Making of Typographic Man.* New ed. Toronto: University of Toronto Press, 2011.

Mendo Carmona, Concepción. "La suscripción altomedieval." *SIGNO: Revista de Historia de la Cultura Escrita* 4 (1997): 207–29.

Mentré, Mireille. *Illuminated Manuscripts of Medieval Spain.* London: Thames and Hudson, 1996.

———. "La présentation de l'Arche de Noé dans les Beatus." In *Actas del Simposio para el estudio de los códices del Comentario al Apocalipsis de Beato de Liébana,* 165–200. Madrid: Joyas Bibliográficas, 1978.

Miguélez Cavero, Alicia. "El dedo índice como atributo de poder en la iconografía románica de la Península Ibérica." In *Imágenes del poder en la Edad Media.* Vol. 2, *Estudios in Memoriam del Prof. Dr. Fernando Galván Freile,* 325–40. León: Universidad de León, 2011.

———. *La gestualidad en el arte románico de los reinos hispanos.* Madrid: Publicaciones del Círculo Románico, 2010.

Millares Carlo, Agustín. *Corpus de códices visigóticos.* 2 vols. Las Palmas: Universidad de Educación a Distancia, 1999.

———. "Un códice notable de los libros morales de San Gregorio Magno sobre Job." In *Estudios paleográficos,* 27–63. Madrid: n.p., 1918.

Mineo, Emilie. "Las inscripciones con *me fecit:* ¿Artistas o comitentes?" *Románico* 20 (2015): 106–12.

———. "Oeuvre signée / oeuvre anonyme: Une opposition apparente; À propos des signatures épigraphiques d'artistes au Moyen Âge." In *L'anonymat de l'œuvre dans la littérature et les arts au Moyen Âge,* edited by Sébastien Douchet and Valérie Naudet, 37–52. Aix-en-Provence: Presses Universitaires de Provence, 2016.

Miquel Serra, Domènec. "El llibre al monestir de Sant Cugat: La biblioteca, l'escriptori, l'escola." *Gausac* 25 (2004): 11–18.

Monferrer Sala, Juan Pedro. "Unas notas sobre los 'textos árabes cristianos andalusíes.'" *Asociación Española de Orientalistas* 38 (2002): 155–68.

Moralejo Alvarez, Serafín. "Sobre las recientes revisiones de la inscripción de Santa María de Iguácel." *Príncipe de Viana* 37, no. 142–43 (1976): 129–30.

Müller, Jan-Dirk. "The Body of the Book: The Media Transition from Manuscript to Print." In *The Book History Reader,* edited by David Finkelstein and Alistair McCleery, 143–50. London: Routledge, 2002.

Mundó, A. M. "El jutge Bonsom de Barcelona, cal.lígraf i copista del 979 al 1024." In *Scribi e colofoni: Le sottoscrizioni di copisti dalle origini all'avvento della stampa*, edited by Emma Condello and Giuseppe De Gregorio, 269–89. Biblioteca del "Centro per il collegamento degli studi medievali e umanistici in Umbria." Spoleto: Centro italiano di studi sull'alto Medioevo, 1995.

———. "Le Statut du scripteur en Catalogne du IXe au XIe siècle." In *Le statut du scripteur au Moyen Age: Actes du XIIe colloque scientifique du Comité International de Paléographie Latine (Cluny, 17–20 juillet 1998)*, edited by Marie-Clotilde Hubert, Emmanuel Poulle, and Marc H. Smith, 21–28. Paris: École des Chartes, 2000.

Nancy, Jean-Luc. *The Inoperative Community*. Translated by Peter Connor. Minneapolis: University of Minnesota Press, 1991.

Nascimento, Aires Augusto. "*Minus grammatice agere nec minus utiliter*: O latim documental em regime performativo." In *Estudios de Latín Medieval Hispánico: Actas del V Congreso Hispánico de Latín Medieval, Barcelona, 7–10 de septiembre de 2009*, edited by José Martínez Gázquez, Oscar de la Cruz Palma, and Cándida Ferrero Hernández, 823–42. Florence: SISMEL, 2011.

Neef, Sonja, and José van Dijck. "Introduction." In *Sign Here!: Handwriting in the Age of New Media*, edited by Sonja Neef, José van Dijck, and F. C. J. Ketelaar, 7–18. Transformations in Art and Culture. Amsterdam: Amsterdam University Press, 2006.

Neef, Sonja, José van Dijck, and F. C. J. Ketelaar, eds. *Sign Here!: Handwriting in the Age of New Media*. Transformations in Art and Culture. Amsterdam: Amsterdam University Press, 2006.

Newton, Francis. "A Giant among Scribes: Colophon and Iconographical Programme in the Eadui Gospels." In *Writing in Context: Insular Manuscript Culture, 500–1200*, edited by Erik Kwakkel, 127–50. Studies in Medieval and Renaissance Book Culture. Leiden: Leiden University Press, 2013.

Newton, Francis L., Francis L. Newton Jr., and Christopher R. J. Scheirer. "Domiciling the Evangelists in Anglo-Saxon England: A Fresh Reading of Aldred's Colophon in the 'Lindisfarne Gospels.'" *Anglo-Saxon England* 41 (2012): 101–44.

Nichols, Stephen G. "Dynamic Reading of Medieval Manuscripts." *Florilegium: The Journal of the Canadian Society of Medievalists / La revue de la Société canadienne des médiévistes* 32 (2015): 19–57.

———. "Introduction: Philology in Manuscript Culture." *Speculum* 65, no. 1 (1990): 1–10.

Orlandis, José. "El trabajo en el monacato visigótico." In *La Iglesia en la España visigótica y medieval*, 239–56. Colección Historia de la Iglesia 8. Pamplona: Ediciones Universidad de Navarra, 1976.

———. *Estudios sobre instituciones monásticas medievales*. Pamplona: Universidad de Navarra, 1971.

Orton, Peter. *Writing in a Speaking World: The Pragmatics of Literacy in Anglo-Saxon Inscriptions and Old English Poetry.* Tempe: Arizona Center for Medieval and Renaissance Studies, 2014.

Ostolaza, María Isabel. "La validación en los documentos del occidente hispánico (s. X–XII). Del *signum crucis* al *signum manus.*" In *Graphische Symbole in mittelalterlichen Urkunden: Beiträge zur diplomatischen Semiotik,* edited by Peter Rück, 453–62. Sigmaringen: Thorbecke, 1996.

Oxford English Dictionary. Edited by J. A. Simpson and E. S. C. Weiner. 2nd ed. 20 vols. Oxford: Clarendon, 1989–.

Ozcáriz Gil, Pablo, ed. *La memoria en la piedra: Estudios sobre grafitos históricos.* Pamplona: Dirección General de Cultura-Institución Príncipe de Viana, 2012.

Pacheco Sampedro, Rogelio. "El *signum manuum* en el Cartulario del Monasterio de San Juan de Caaveiro (s. IX–XIII)." *SIGNO: Revista de Historia de la Cultura Escrita* 4 (1997): 27–37.

Paniagua, David. "Concilios hispánicos de época visigoda y mozárabe." In *La Hispania visigótica y mozárabe: Dos épocas en su literatura,* edited by Carmen Codoñer Merino, 297–333. Salamanca: Ediciones Universidad de Salamanca, 2010.

Peirce, Charles Sanders. *Collected Papers.* Vol. 4, *The Simplest Mathematics,* edited by Charles Hartshorne and Paul Weiss. Cambridge, Mass.: Harvard University Press, 1933.

———. "On the Algebra of Logic: A Contribution to the Philosophy of Notation." *American Journal of Mathematics* 7 (1885): 180–202.

Pelttari, Aaron. *The Space That Remains: Reading Latin Poetry in Late Antiquity.* Ithaca: Cornell University Press, 2014.

Peña Fernández, Alberto. "Promotores, artífices materiales y destinatarios de las inscripciones medievales." In *Mundos medievales: Espacios, sociedades y poder; Homenaje al profesor José Ángel García de Cortázar y Ruiz de Aguirre,* edited by Beatriz Arízaga Bolumburu, Jesús Ángel Solórzano Telechea, Dolores Mariño Veiras, Carmen Díez Herrera, Esther Peña Bocos, Susana Guijarro González, and Javier Añíbarro Rodríguez, vol. 1: 187–204. Santander: Universidad de Cantabria, 2013.

Pérez de Urbel, Justo. "El monasterio de Valeránica y su escritorio." In *Homenaje a Don Agustín Millares Carlo,* 2:71–89. Madrid: Caja Insular de Ahorros de Gran Canaria, 1975.

Pérez González, Maurilio. "Cenobios tabarenses: Sobre un nuevo epígrafe hallado en Tábara (Zamora)." *Brigecio* 7 (1997): 65–90.

———. "El latín del siglo X leonés a la luz de las inscripciones." In *Actas III Congreso hispánico de latín medieval (León, 26–29 de Septiembre de 2001),* edited by Maurilio Pérez González, 157–74. León: Universidad de León, 2002.

———. "El latín medieval diplomático." *Bulletin Du Cange* 66 (2008): 47–101.

———. "La escritura y los escritos durante el siglo X." In *"In principio erat verbum": El Reino de León y sus beatos,* edited by Maurilio Pérez González, Carlos M.

Reglero de la Fuente, and Margarita Torres, 43–55. Madrid: Sociedad Estatal de Conmemoraciones Culturales, 2010.

———. *Lexicon latinitatis medii regni Legionis.* Corpus Christianorum. Lexica Latina Medii Aevi. Turnhout: Brepols, 2010.

———. "Tres colofones de Beatos: Su texto, traducción y comentario." In *Seis estudios sobre Beatos medievales*, 221–31. León: Universidad de León, 2010.

Pérez Llamazares, Julio. *Catálogo de los códices y documentos de la Real Colegiata de San Isidoro de León.* León: Imprenta Católica, 1923.

Petrucci, Armando. "The Christian Conception of the Book in the Sixth and Seventh Centuries." In *Writers and Readers in Medieval Italy: Studies in the History of Written Culture*, 19–42. New Haven: Yale University Press, 1995.

———. *Writing the Dead: Death and Writing Strategies in the Western Tradition.* Stanford, Calif.: Stanford University Press, 1998.

Piggin, Jean-Baptiste. "The Great Stemma: A Late Antique Diagrammatic Chronicle of Pre-Christian Time." *Studia Patristica* 62 (2013): 259–78.

Pirotte, Emanuelle. "Hidden Order, Order Revealed: New Light on Carpet Pages." In *Pattern and Purpose in Insular Art*, edited by M. Redknap, 203–7. Oxford: Oxbow, 2001.

Plesch, Véronique. "Memory on the Wall: Graffiti on Religious Wall Paintings." *Journal of Medieval and Early Modern Studies* 32, no. 1 (2002): 167–97.

Porter, A. Kingsley. "Iguácel and More Romanesque Art of Aragón." *Burlington Magazine for Connoisseurs* 52, no. 300 (1928): 111–27.

Puente López, Juan Luis, and José María Suárez de Paz. "Marcas de cantero en la torre y panteón de abades del monasterio de San Miguel de Escalada." *Tierras de León: Revista de la Diputación Provincial* 23, no. 51 (1983): 71–86.

Quintana Prieto, Augusto. "San Miguel de Camarzana y su scriptorium." *Anuario de Estudios Medievales* 5 (1968): 65–106.

Rapp, Claudia. "Holy Texts, Holy Men, and Holy Scribes: Aspects of Scriptural Holiness in Late Antiquity." In *The Early Christian Book*, edited by William E. Klingshirn and Linda Safran, 194–224. Washington, D.C.: The Catholic University of America Press, 2007.

Reglero de la Fuente, Carlos M. "Iglesia y monasterios en el reino de León en el siglo X." In *"In principio erat verbum": El Reino de León y sus beatos*, edited by Maurilio Pérez González, Carlos M. Reglero de la Fuente, and Margarita Torres, 31–42. Madrid: Sociedad Estatal de Conmemoraciones Culturales, 2010.

Reyes Téllez, Francisco, Gonzalo Viñuales Ferreiro, and Félix Palomero Aragón, eds. *Grafitos históricos hispánicos.* Vol. 1, *Homenaje a Félix Palomero.* Madrid: OMMPress, 2016.

Reynhout, Lucien. *Formules latines de colophons.* Bibliologia. 2 vols. Turnhout: Brepols, 2006.

Riesco Terrero, Ángel. "Notariado y documentación notarial castellano-leonesa de los siglos X–XIII." In *I Jornadas Científicas sobre Documentación jurídico-administrativa, económico-financiera y judicial del reino castellano-leonés (siglos X–XIII)*, 129–63. Madrid: Universidad Complutense, 2002.

Risco, Manuel. *Iglesia de Léon, y monasterios antiguos y modernos de la misma ciudad*. Madrid: Blas Roman, 1792.

Risco, Manuel, and Enrique Flórez. *España sagrada: Memorias de la Santa Iglesia esenta de León, concernientes a los siglos XI, XII y XIII, fundadas en escrituras y documentos originales*. Vol. 35. Madrid: Pedro Marín, 1786.

Robertson, Duncan. *"Lectio divina": The Medieval Experience of Reading*. Cistercian Studies Series 238. Collegeville, Minn.: Liturgical Press, 2011.

Rodríguez Díaz, E. "Los manuscritos mozárabes: Una encrucijada de culturas." In *Die Mozaraber: Definitionen und Perspektiven der Forschung*, edited by Klaus Herbers and Matthias Maser, 75–103. Munich: Lit Verlag, 2011.

Roget, Peter Mark, John Lewis Roget, Samuel Romilly Roget, and Willard Jerome Heggen. *Thesaurus of Words and Phrases*. New York: Grosset & Dunlap, 1947.

Rudy, Kathryn M. "Kissing Images, Unfurling Rolls, Measuring Wounds, Sewing Badges and Carrying Talismans: Considering Some Harley Manuscripts through the Physical Rituals They Reveal." *Electronic British Library Journal* (2011).

———. *Piety in Pieces: How Medieval Readers Customized Their Manuscripts*. Cambridge: Open Book Publishers, 2016.

Ruiz de la Peña Solar, Juan Ignacio. "'Ecclesia crescit et regnum ampliatur': Teoría y práctica del programa político de la monarquía astur-leonesa en torno al 900." In *San Miguel de Escalada (913–2013)*, edited by Vicente García Lobo and Gregoria Cavero Domínguez, 17–37. Folia medievalia. León: Universidad de León Instituto de Estudios Medievales, 2014.

Ruiz García, Elisa. *Catálogo de la sección de códices de la Real Academia de la Historia*. Madrid: La Academia, 1997.

———. "La escritura: Una *vox Dei* (siglos X–XIII)." In *I Jornadas jurídico-administrativa, económico-financiera y judicial del reino castellano-leonés (siglos X–XIII)*, 71–92. Madrid: Departamento de Ciencias y Técnicas Historiográficas y de Arqueología, Universidad Complutense, 2002.

Rush, A. C. "Death as Birth: The Day of Death as *dies natalis*." In *Death and Burial in Christian Antiquity*, 72–87. Washington, D.C.: The Catholic University of America Press, 1941.

Rust, Martha. *Imaginary Worlds in Medieval Books: Exploring the Manuscript Matrix*. Basingstoke: Palgrave, 2007.

San Román Fernández, Felipe, and Emilio Campomanes Alvaredo. "Avance de las excavaciones arqueológicas en San Miguel de Escalada (Campañas 2002–2004)." *Tierras de León: Revista de la Diputación Provincial* 45, no. 124–25 (2007): 1–32.

Sanders, Gabriel. *Lapides memores: Païens et chrétiens face à la mort; Le témoignage de l'épigraphie funéraire latine*. Faenza: Fratelli Lega, 1991.

Santiago Fernández, Javier de. "El hábito epigráfico en la Hispania visigoda." In *VIII Jornadas Científicas sobre Documentación de la Hispania altomedieval*

(siglos VI–X), edited by J. C. Galende Díaz and Javier de Santiago Fernández, 291–344. Madrid: Universidad Complutense, 2009.

Schapiro, Meyer. "From Mozarabic to Romanesque in Silos." *Art Bulletin* 21 (1939): 312–74.

Schleif, Corine. "Haptic Communities: Hands Joined in and on Manuscripts." In *Manuscripts Changing Hands*, edited by Corine Schleif and Volker Schier. Wolfenbütteler Mittelalter-Studien, 1–77. Wiesbaden: Harrassowitz Verlag in Kommission, 2016.

Schmitt, Jean-Claude. *La raison des gestes dans l'Occident médiéval*. Bibliothèque des histoires. Paris: Gallimard, 1990.

Sears, Elizabeth. "The Afterlife of Scribes: Swicher's Prayer in the Prüfening Isidore." In *Pen in Hand: Medieval Scribal Portraits, Colophons and Tools*, edited by Michael Gullick, 75–96. Walkern, Herts.: Red Gull Press, 2006.

Seidel, Kurt Otto. "'Tres digiti scribunt totumque corpus laborat': Kolophone als Quelle für das Selbstverständnis mittelalterlicher Schreiber." *Das Mittelalter* 7, no. 2 (2002): 145–56.

Şeşen, Ramazan. "Esquisse d'un histoire du développement des colophons dans les manuscrits musulmans." In *Scribes et manuscrits du Moyen-Orient*, edited by François Déroche and Francis Richard, 189–222. Etudes et recherches. Paris: Bibliothèque Nationale de France, 1997.

Shailor, Barbara A. "The Codicology of the Morgan Beatus Manuscript." In *A Spanish Apocalypse: The Morgan Beatus Manuscript*, edited by John Williams and Barbara A. Shailor, 23–32. New York: G. Braziller, 1991.

———. "Maius and the Scriptorium of Tábara." In *Apocalipsis*, edited by Vicente García Lobo and John Williams. vol. 2: 635–39. Valencia: Testimonio, 2000.

———. "The Scriptorium of San Pedro de Berlangas." Ph.D., University of Cincinnati, 1975.

———. "The Scriptorium of San Pedro de Cardeña." *Bulletin of the John Rylands Library Manchester* 61 (1978–79): 444–73.

Silva y Verástegui, Soledad de. *Iconografía del s. X en el reino de Pamplona-Nájera*. Pamplona: Diputación Foral de Navarra, 1984.

———. "L'illustration des manuscrits de la Collection Canonique Hispana." *Cahiers de Civilisation Médiévale* 32, no. 127 (1989): 247–62.

Spiro, Anna Lee. "Reconsidering the Career of the Artifex Nicholaus (Active c. 1122–c. 1164) in the Context of Later Twelfth-Century North Italian Politics." Ph.D., Columbia University, 2014.

Straw, Carole Ellen. *Gregory the Great: Perfection in Imperfection*. Transformation of the Classical Heritage 14. Berkeley: University of California Press, 1988.

Stroumsa, Guy G. *The Scriptural Universe of Ancient Christianity*. Cambridge, Mass.: Harvard University Press, 2016.

Suárez González, Ana I. "Beatos: La historia interminable." In *Seis estudios sobre Beatos medievales*, edited by Maurilio Pérez González, 71–130. León: Universidad de León, 2010.

———. "¿Del pergamino a la piedra? ¿De la piedra al pergamino? entre diplomas, obituarios y epitafios medievales de San Isidoro de León." *Anuario de estudios medievales* 33, no. 1 (2003): 365–415.

———, ed. *El Monacato en los reinos de León y Castilla (siglos VII–XIII).* Ávila: Fundación Sánchez-Albornoz, 2007.

———. "La edición riojana de los *Moralia in Job* en un manuscrito calagurritano del siglo XI." *Berceo* 142 (2002): 77–92.

Suárez-Inclán y Ruiz de la Peña, M. "Los grabados de la Iglesia de Santiago de Peñalba en León." *Revista Patrimonio* 7, no. 26 (2006): 13–15.

Svenbro, Jesper. *Phrasikleia: An Anthropology of Reading in Ancient Greece.* Translated by Janet Lloyd. Ithaca, N.Y.: Cornell University Press, 1993.

Swann, Karen. "The Strange Time of Reading." *European Romantic Review* 9, no. 2 (1998): 275–82.

Tilghman, Ben C. "Pattern, Process, and the Creation of Meaning in the Lindisfarne Gospels." *West 86th* 24, no. 1 (2017): 3–29.

Troupeau, Gérard. "Les colophons des manuscrits arabes chrétiens." In *Scribes et manuscrits du Moyen-Orient,* edited by François Déroche and Francis Richard, 223–31. Etudes et recherches. Paris: Bibliothèque Nationale de France, 1997.

Trout, Dennis. "Inscribing Identity: The Latin Epigraphic Habit in Late Antiquity." In *A Companion to Late Antiquity,* edited by Philip Rousseau and Jutta Raithel, 170–86. Chichester: Wiley-Blackwell, 2009.

Vallejo Bozal, Javier. "El ciclo de Daniel en las miniaturas del códice." In *Codex biblicus legionensis: Veinte estudios,* edited by César Álvarez Álvarez, 175–86. León: Real Colegiata de San Isidoro, 1999.

van Koningsveld, P. S. "Christian-Arabic Manuscripts from the Iberian Peninsula and North Africa." *Al-Qantara* 15 (1994): 423–49.

———. "La literatura cristiana-árabe de la España medieval y el significado de la transmisión textual en árabe de la *Collectio Conciliorum.*" In *Concilio III de Toledo: XIV centenario, 589–1989,* 695–710. Toledo: Arzobispado de Toledo, 1991.

Vezin, Jean. "La réalisation matérielle des manuscrits latins pendant le haut Moyen Age." *Codicologica* 2 (1978): 15–51.

———. "La répartition du travail dans les *scriptoria* carolingiens." *Journal des Savants* 3 (1973): 212–37.

———. "L'emploi du temps d'un copiste au XIᵉ siècle." In *Scribi e colofoni: Le sottoscrizioni di copisti dalle origini all'avvento della stampa,* edited by Emma Condello and Giuseppe De Gregorio, 71–79. Spoleto: Centro italiano di studi sull'alto Medioevo, 1995.

———. "Une faute de copiste et le travail dans les scriptoria du haut moyen âge." In *Sous la règle de Saint Benoit: Structures monastiques et sociétés en France du Moyen âge à l'époque moderne,* 427–31. Geneva: Droz, 1982.

Viñayo González, Antonio. "Florencio de Valeránica: Evocación y homenaje." *Memoria Ecclesiae* 3 (1993): 123–34.

Vivancos Gómez, Miguel Carlos. *Glosas y notas marginales de los manuscritos visigóticos del Monasterio de Silos*. Studia Silensia 19. Abadía Benedictina de Silos: Aldecoa, 1995.

Vizkelety, András. "Scriptor—Redactor—Auctor." In *Le statut du scripteur au Moyen Âge: Actes du XIIe colloque scientifique du Comité international de paléographie latine (Cluny, 17–20 juillet 1998)*, edited by Marie-Clotilde Hubert, Emmanuel Poulle, and Marc H. Smith, 145–50. Matériaux pour l'histoire. Paris: École des Chartes, 2000.

Vogüé, Adalbert de. "Le codex de Leodegundia (Escorial A.I.13): Identification et interprétation de quelques morceaux." *Revue Bénédictine* 96, no. 1–2 (1986): 100–105.

Walker, Rose. *Views of Transition: Liturgy and Illumination in Medieval Spain*. Toronto: University of Toronto Press, 1998.

Ward, Flora. "Transcription, Testimony and Truth: The Hands of the Liber Testamentorum." Conference paper. International Congress of Medieval Studies, Kalamazoo, Mich., 2008.

Werckmeister, Otto K. "Art of the Frontier: Mozarabic Monasticism." In *The Art of Medieval Spain, A. D. 500–1200*, edited by John P. O'Neill, Kathleen Howard, and Ann M. Lucke, 121–32. New York: Metropolitan Museum of Art, 1993.

———. "The Image of the 'Jugglers' in the Beatus of Silos." In *Reading Medieval Images: The Art Historian and the Object*, edited by Elizabeth Sears and Thelma K. Thomas, 128–39. Ann Arbor: University of Michigan Press, 2002.

———. "The Islamic Rider in the Beatus of Girona." *Gesta* 36, no. 2 (1997): 101–92.

Williams, John. "A Contribution to the History of the Castilian Monastery of Valeránica and the Scribe Florentius." *Madrider Mitteilungen* 11 (1970): 231–48.

———. *Early Spanish Manuscript Illumination*. New York: G. Braziller, 1977.

———. "The History of the Morgan Beatus Manuscript." In *A Spanish Apocalypse: The Morgan Beatus Manuscript*, edited by John Williams and Barbara A. Shailor, 11–22. New York: G. Braziller, 1991.

———. *The Illustrated Beatus: A Corpus of the Illustrations of the Commentary on the Apocalypse*. 5 vols. London: Harvey Miller, 1994.

———. "Meyer Schapiro in Silos: Pursuing an Iconography of Style." *Art Bulletin* 85, no. 3 (2003): 442–68.

———. "A Model for the León Bibles." *Madrider Mitteilungen* 8 (1967): 281–86.

———. "Tours and the Early Medieval Art of Spain." In *Florilegium in honorem Carl Nordenfalk octogenarii contextum*, edited by Per Bjurström, Nils Göran Hökby, and Florentine Mütherich, 197–208. Stockholm: Nationalmuseum, 1987.

Williams, John, and Barbara A. Shailor, eds. *A Spanish Apocalypse: The Morgan Beatus Manuscript*. New York: G. Braziller, 1991.

Williams, Maggie M., and Karen Eileen Overbey, eds. *Transparent Things: A Cabinet*. Brooklyn: punctum, 2013.

Williams, Megan Hale. *The Monk and the Book: Jerome and the Making of Christian Scholarship*. Chicago: University of Chicago Press, 2006.

Wilson, Michael. "Furtive Pleas to the Saints, Scribbled on Their Statues." *New York Times*, September 25, 2015.

Witters, Willibrod. "Travail et *lectio divina* dans le monachisme de St Benoît." In *Atti del 7 Congresso Internazionale di Studi sull'Alto Medioevo*, 551–61. Spoleto: Presso la sede del Centro studi, 1982.

Wolfe, Sheila. "The Early Morgan Beatus (M644): Problems of its Place in the Beatus Pictorial Tradition." Ph.D., Ohio State University, 1988.

Wright, Roger. *Late Latin and Early Romance in Spain and Carolingian France.* ARCA Classical and Medieval Texts. Papers and Monographs 8. Liverpool: F. Cairns, 1982.

Yusta Bonilla, José Francisco, and Josemi Lorenzo Arribas. "La tribuna perimetral románica de la iglesia de San Miguel de San Esteban de Gormaz (Soria)." In *Actas del Úndécimo Congreso Nacional de Historia de la Construcción*, edited by Santiago Huerta Fernández and Ignacio Javier Gil Crespo, 1,123–32. Madrid: Instituto Juan de Herrera, 2019.

Zabalza Duque, Manuel. "Restos de un oracional visigótico de Valeránica." In *Alma Littera: Estudios dedicados al Profesor José Manuel Ruiz Asencio*, edited by Marta Herrero de la Fuente, Mauricio Herrero Jiménez, Irene Ruiz Albi, and Francisco Javier Molina de la Torre, 723–30. Valladolid: Ediciones Universidad de Valladolid, 2014.

Zimmermann, Michel. *Ecrire et lire en Catalogne: IX^e–XII^e siècles.* 2 vols. Madrid: Casa de Velázquez, 2003.

Zudaire Huarte, Eulogio. "Inscripción de Santa María de Iguacel." *Príncipe de Viana* 35, no. 136–37 (1974): 405–8.

INDEX

Note: Information in figures and tables is indicated by *f* and *t*, respectively.

acrostics, 189–190, 192–193, 198–199, 205, 208, 283n39

Adversus Elipandum (Beatus of Liébana), 41–42, 236nn41–42

Aeximino (scribe), 56–61, 60*f*, 196, 241n96, 244n27, 284n49

Aillet, Cyrille, 222n1

al-Andalus, 1–2, 16, 176

alphabet, 18–21, 46–50, 87–88, 229n15

Alpha-Omega, 18–19, 68

Alvarus, Paulus, 176

Arabic, 1–2, 222n1

Argaiz, Gregorio de, 73, 75–76, 78, 87, 244nn25,28

Arnoul of Bohériss, 227n36

Arogontina, 125–126, 152

Ars Grammatica (Donatus), 51–52

articulation, 3, 51–52, 54, 79, 92, 99, 134, 149, 153, 187, 196

Augustine, 29, 35, 42, 52, 106–108, 127, 166–176, 236nn41–42. See also *City of God* (Augustine); *Confessions* (Augustine); *In Iohannis euangelium* (Augustine)

authority of inscription, 92–93, 102–105

autograph, 95–97

Baird, Jennifer, 225n16

Banniard, Michael, 252n18

Barcelona, 1

Barreda y Lombera, Iñigo de, 72–73, 244n22

Barthes, Roland, 164, 286n76

Basilio of Muñon, 23

Beatus of Liébana, 5, 41–42, 85–88, 128, 131, 176, 178–179, 236nn41–42, 247n57, 266n21, 269n43. See also *Adversus Elipandum* (Beatus of Liébana); *In Apocalypsin* (Beatus of Liébana)

(commentary); *In Apocalypsin* (Beatus of Liébana) (illuminated manuscripts)

Bedos Rezak, Brigitte, 95

Beja: epitaph at, 124–125

Benedictinism, 39–40, 233n9

Berganza, Francisco de, 80–81, 83, 246n50

Bible of 960. *See* León, San Isidoro, MS 2

Bible of Oña, 15*t*, 72–79, 74*f*, 244n25

Blaise, Albert, 266n21

book: representations of. *See* codex (iconography)

Brown, Peter Scott, 230n27

Butler, Shane, 160

Caliphate of Córdoba, 1, 16

Cangas de Onis, 238n58

Caroline hand, 2, 223n5, 224n8

Carruthers, Mary, 47, 139, 204, 226n32, 265n15

Casado de Otaola, Luis, 253n27

Cassian, John, 5–6, 41, 67–68, 226n2, 235n31, 239n67. See also *Collationes* (Cassian)

Cassiodorus, 15*t*, 37, 39. See also *Commentary on the Psalms* (Cassiodorus); Manchester, Rylands, MS lat. 89

Castile, 1, 16, 229n10

Castro Correa, Ainoa, 223n6, 255n435

Catalonia, 1–2, 223n5

charters, 93–94, 255n43, 257n21

chi-rho, 19, 20*f*

chrismon, 19, 20*f*

Chronicle of 754, 27

City of God (Augustine), 176–177, 185–186, 276n24. *See also* El Escorial, Biblioteca del Monasterio, s.I.16; Madrid, RAH, MS 29

Clanchy, Michael T., 177–178, 252n18

Catherine Brown is Associate Professor in the Department of Comparative Literature and the Residential College at the University of Michigan, Ann Arbor.

Ronald B. Begley and Joseph W. Koterski, S.J. (eds.), *Medieval Education*

Teodolinda Barolini and H. Wayne Storey (eds.), *Dante for the New Millennium*

Richard F. Gyug (ed.), *Medieval Cultures in Contact*

Seeta Chaganti (ed.), *Medieval Poetics and Social Practice: Responding to the Work of Penn R. Szittya*

Devorah Schoenfeld, *Isaac on Jewish and Christian Altars: Polemic and Exegesis in Rashi and the "Glossa Ordinaria"*

Martin Chase, S.J. (ed.), *Eddic, Skaldic, and Beyond: Poetic Variety in Medieval Iceland and Norway*

Felice Lifshitz, *Religious Women in Early Carolingian Francia: A Study of Manuscript Transmission and Monastic Culture*

Sam Zeno Conedera, S.J., *Ecclesiastical Knights: The Military Orders in Castile, 1150–1330*

J. Patrick Hornbeck II and Michael van Dussen (eds.), *Europe After Wyclif*

Laura K. Morreale and Nicholas L. Paul (eds.), *The French of Outremer: Communities and Communications in the Crusading Mediterranean*

Ayelet Even-Ezra, *Ecstasy in the Classroom: Trance, Self, and the Academic Profession in Medieval Paris*

Jordan Kirk, *Medieval Nonsense: Signifying Nothing in Fourteenth-Century England*

Andrew Albin, Mary C. Erler, Thomas O'Donnell, Nicholas L. Paul, and Nina Rowe (eds.), *Whose Middle Ages? Teachable Moments for an Ill-Used Past*

Miguel Gómez, Kyle C. Lincoln, and Damian J. Smith (eds.), *King Alfonso VIII of Castile: Government, Family, and War*

Kate Heslop, *Viking Mediologies: A New History of Skaldic Poetics*

Catherine Brown, *Remember the Hand: Manuscript in Early Medieval Iberia*

CPSIA information can be obtained
at www.ICGtesting.com
Printed in the USA
LVHW071039220723
752801LV00022B/133/J